The Palace Museum's Essential Collections

CHINESE CALLIGRAPHY

The Commercial Press

Chinese Calligraphy

Chief Editor	Wang Lianqi 王連起
Deputy Chief Editors	Fu Hongzhan 傅紅展 , Wang Qi 汪亓
Editorial Board	Wang Yimin 王亦旻 , Li Yanxia 李豔霞 , Jin Yunchang 金運昌 , Hua Ning 華寧 , Fu Chong 伏沖 , Yang Fan 楊帆 , Wang Zhe 王喆 , Hao Yanfeng 郝炎峰
Photographers	Hu Chui 胡錘 , Liu Zhigang 劉志崗 , Zhao Shan 趙山 , Feng Hui 馮輝
Translator	Tina Liem 林海燕
Editorial Consultant	Hang Kan 杭侃
Project Editors	Xu Xinyu 徐昕宇 , Wang Yuechen 王悦晨
Cover Design	Zhang Yi 張毅
Published by	The Commercial Press (Hong Kong) Ltd. 8/F., Eastern Central Plaza, 3 Yiu Hing Rd, Shau Kei Wan, Hong Kong http://www.commercialpress.com.hk
Printed by	C & C Offset Printing Co., Ltd. C & C Building, 36 Ting Lai Road, Tai Po, N.T., Hong Kong
Edition	First Edition in July 2016
	© 2016 The Commercial Press (Hong Kong) Ltd.
	All rights reserved.
	ISBN 978 962 07 5680 1
	Printed in Hong Kong

Introducing the Palace Museum to the World

SHAN JIXIANG

Built in 1925, the Palace Museum is a comprehensive collection of treasures from the Ming and Qing Dynasties and the world's largest treasury of ancient Chinese art. To illustrate ancient Chinese art for people home and abroad, the Palace Museum and The Commercial Press (Hong Kong) Ltd. jointly published *The Complete Collection of Treasures of the Palace Museum*. The series contains 60 books, covering the rarest treasures of the Museum's collection. Having taken 14 years to complete, the series has been under the limelight among Sinologists. It has also been cherished by museum and art experts.

After publishing *The Complete Collection of Treasures of the Palace Museum*, it is understood that westerners, when learning about Chinese traditional art and culture, are particularly fond of calligraphy, paintings, ceramics, bronze wares, jade wares, furniture, and handicrafts. That is why The Commercial Press (Hong Kong) Ltd. has discussed with the Palace Museum to further co-operate and publish a new series, *The Palace Museum's Essential Collections*, in English, hoping to overcome language barriers and help more readers to know about traditional Chinese culture. Both parties regard the publishing of the series as an indispensable mission for Chinese history with significance in the following aspects:

First, with more than 3,000 pictures, the series has become the largest picture books ever in the publishing industry in China. The explanations show the very best knowledge from four generations of scholars spanning 90 years since the construction of the Museum.

Second, the English version helps overcome language and cultural barriers between the east and the west, facilitating the general public's knowledge of Chinese culture. By doing so, traditional Chinese art will be given a fresher image, becoming more approachable among international art circles.

Third, the series is going to further people's knowledge about the Palace Museum. According to the latest statistics, the Palace Museum holds more than 1.8 million pieces of artifacts (among which 228,771 pieces have been donated by the general public and purchased or transferred by the government since 1949). The series selects nearly 3,000 pieces of the rare treasures, together with more than 12,000 pieces from *The Complete Collection of Treasures of the Palace Museum*. It is believed that the series will give readers a more comprehensive view of the Palace Museum.

Just as *The Palace Museum's Essential Collections* is going to be published, I cannot help but think of Professor Qi Gong from Beijing Normal University; famous scholars and researchers of the Palace Museum Mr. Xu Bangda, Mr. Zhu Jiajin, and Mr. Liu Jiu'an; and well-known intellectuals Mr. Wu Kong (Deputy Director of Central Research Institute of Culture and History), and Mr. Xu Qixian (Director of Research Office of the Palace Museum). Their knowledge and relentless efforts are much appreciated for showing the treasures of the Palace Museum to the world.

Looking at History through Art

YANG XIN

The Palace Museum is a comprehensive collection of the treasures of the Ming and Qing Dynasties. It is also the largest museum of traditional art and culture in China. Located in the urban centre of Beijing, this treasury of ancient Chinese culture covers 720,000 square metres and holds nearly 2 million pieces of artifacts.

In the fourth year of the reign of Yongle (1406 A.D.), Emperor Chengzu of Ming, named Zhu Di, ordered to upgrade the city of Beiping to Beijing. His move led to the relocation of the capital of the country. In the following year, a grand, new palace started to be built at the site of the old palace in Dadu of the Yuan Dynasty. In the 18th year of Yongle (1420 A.D.), the palace was complete and named as the Forbidden City. Since then the capital of the Ming Dynasty moved from Nanjing to Beijing. In 1644 A.D., the Qing Dynasty superceded the Ming empire and continued using Beijing as the capital and the Forbidden City as the palace.

In accordance with the traditional ritual system, the Forbidden City is divided into the front part and the rear part. The front consists of three main halls, namely Hall of Supreme Harmony, Hall of Central Harmony, and Hall of Preserving Harmony, with two auxiliary halls, Hall of Literary Flourishing and Hall of Martial Valour. The rear part comprises three main halls, namely Hall of Heavenly Purity, Hall of Union, Hall of Earthly Tranquillity, and a cluster of six halls divided into the Eastern and Western Palaces, collectively called the Inner Court. From Emperor Chengzu of Ming to Emperor Puyi, the last emperor of Qing, 24 emperors together with their queens and concubines, lived in the palace. The Xinhai Revolution in 1911 overthrew the Qing Dynasty and more than 2,000 years of feudal governance came to an end. However, members of the court such as Emperor Puyi were allowed to stay in the rear part of the Forbidden City. In 1914, Beiyang government of the Republic of China transferred some of the objects from the Imperial Palace in Shenyang and the Summer Palace in Chengde to form the Institute for Exhibiting Antiquities, located in the front part of the Forbidden City. In 1924, Puyi was expelled from the Inner Court. In 1925, the rear part of the Forbidden City was transformed into the Palace Museum.

Emperors across dynasties called themselves "sons of heaven," thinking that "all under the heaven are the emperor's land; all within the border of the seashore are the emperor's servants"("Decade of Northern Hills, Minor Elegance," Book of Poetry). From an emperor's point of view, he owns all people and land within the empire. Therefore, delicate creations of historic and artistic value and bizarre treasures were offered to the palace from all over the country. The palace also gathered the best artists and craftsmen to create novel art pieces exclusively for the court. Although changing of rulers and years of wars caused damage to the country and unimaginable loss of the court collection, art objects to the palace were soon gathered again, thanks to the vastness and long history of the country, and the innovativeness of the people. During the reign of Emperor Qianlong of the Qing Dynasty (1736–1796), the scale of court collection reached its peak. In the final years of the Qing Dynasty, however, the invasion of Anglo-French Alliance and the Eight-Nation Alliance into Beijing led to the loss and damage of many art objects. When Puyi abdicated from his throne, he took away plenty of the objects from the palace under the name of giving them out as presents or entitling them to others. His servants followed suit. Up till 1923, the keepers of treasures of Palace of Established Happinesss in the Inner Court who actually stole the objects, set fire on them and caused serious damage to the Qing Court col-

lection. Numerous art objects were lost within a little more than 60 years. In spite of all these losses, there was still a handsome amount of collection in the Qing Court. During the preparation of construction of the Palace Museum, the "Qing Rehabilitation Committee" checked that there were around 1.17 million items and the Committee published the results in the Palace Items Auditing Report, comprising 28 volumes in 6 editions.

During the Sino-Japanese War, there were 13,427 boxes and 64 packages of treasures, including calligraphy and paintings, picture books, and files, were transferred to Shanghai and Nanjing in five batches in fear of damages and loot. Some of them were scattered to other provinces such as Sichuan and Guizhou. The art objects were returned to Nanjing after the Sino-Japanese War. Owing to the changing political situation, 2,972 pieces of treasures temporarily stored in Nanjing were transferred to Taiwan from 1948 to 1949. In the 1950s, most of the antiques were returned to Beijing, leaving only 2,211 boxes of them still in the storage room in Nanjing built by the Palace of Museum.

Since the establishment of the People's Republic of China, the organization of the Palace Museum has been changed. In line with the requirement of the top management, part of the Qing Court books were transferred to the National Library of China in Beijing. As to files and essays in the Palace Museum, they were gathered and preserved in another unit called "The First Historical Archives of China."

In the 1950s and 1960s, the Palace Museum made a new inventory list for objects kept in the museum in Beijing. Under the new categorization system, objects which were previously labelled as "vessels", such as calligraphy and paintings, were grouped under the name of "Gu treasures." Among them, 711,388 pieces which belonged to old Qing collection and were labelled as "Old", of which more than 1,200 pieces were discovered from artifacts labelled as "objects" which were not registered before. As China's largest national museum, the Palace Museum has taken the responsibility of protecting and collecting scattered treasures in the society. Since 1949, the Museum has been enriching its collection through such methods as purchase, transfer, and acceptance of donation. New objects were given the label "New." At the end of 1994, there were 222,920 pieces of new items. After 2000, the Museum re-organized its collection. This time ancient books were also included in the category of calligraphy. In August 2014, there were a total of 1,823,981 pieces of objects in the museum collection. Among them, 890,729 pieces were "old," 228,771 pieces were "new," 563,990 were "books," and 140,491 pieces were ordinary objects and specimens.

The collection of nearly two million pieces of objects were important historical resources of traditional Chinese art, spanning 5,000 years of history from the primeval period to the dynasties of Shang, Zhou, Qin, Han, Wei, and Jin, Northern and Southern Dynasties, dynasties of Sui, Tang, Northern Song, Southern Song, Yuan, Ming, Qing, and the contemporary period. The best art wares of each of the periods were included in the collection without disconnection. The collection covers a comprehensive set categories, including bronze wares, jade wares, ceramics, inscribed tablets and sculptures, calligraphy and famous paintings, seals, lacquer wares, enamel wares, embroidery, carvings on bamboo, wood, ivory and horn, golden and silvery vessels, tools of the study, clocks and watches, pearl and jadeite jewellery, and furniture among others. Each of these categories has developed into its own system. It can be said that the collection itself is a huge treasury of oriental art and culture. It illustrates the development path of Chinese culture, strengthens the spirit of the Chinese people as a whole, and forms an indispensable part of human civilization.

The Palace Museum's Essential Collections Series features around 3,000 pieces of the most anticipated artifacts with nearly 4,000 pictures covering eight categories, namely ceramics, jade wares, bronze wares, furniture, embroidery, calligraphy, and rare treasures. The Commercial Press (Hong Kong) Ltd. has invited the most qualified translators and academics to translate the Series, striving for the ultimate goal of achieving faithfulness, expressiveness, and elegance in the translation.

We hope that our efforts can help the development of the culture industry in China, the spread of the sparkling culture of the Chinese people, and the facilitation of the cultural interchange between China and the world.

Again, we are grateful to The Commercial Press (Hong Kong) Ltd. for the sincerity and faithfulness in their cooperation. We appreciate everyone who have given us support and encouragement within the culture industry. Thanks also go to all Chinese culture lovers home and abroad.

Yang Xin former Deputy Director of the Palace Museum, Research Fellow of the Palace Museum, Connoisseur of ancient calligraphy and paintings.

C ontents

List of Calligraphy Works

THE MING DYNASTY

THE QING DYNASTY

An Overview of the Art of Ancient Chinese Calligraphy

WANG LIANQI

Each calligraphic work from ancient China is a crystallization of superb originality and imagination, be it a letter, a literary piece, a sutra, or a copy. Every time a scroll is unfurled and the delineation of space revealed, the viewer realizes how amazing the Chinese writing brush is and how amazingly it celebrates the beauty of our intellect and that of all other things and beings on earth through the marks it leaves behind.

In China, calligraphic masterpieces handed down from the antiquity are called "fashu," which is aptly translated into English as "model-calligraphies," implying that they are to be set up as models for learners of calligraphy. It is apparent from catalogues such as the Shiqu Catalogue of Imperial Collection of Painting and Calligraphy (Shiqu Baoji) of the Qianlong and Jiaqing reigns that the Ming and Qing imperial families were building up a collection of model-calligraphies dating since the Wei-Jin period. Some of the collections, however, were dispersed in the early 20th century around the time that the last Qing emperor abdicated. This was followed by the relocation of some others in the middle of the same century. Fortunately, thanks to efforts jointly made by the Chinese government and private collectors, quite a number of the masterpieces have been recovered so that the Palace Museum collection of calligraphy can be rebuilt to worldwide acclaim.

In terms of both size and quality, the Palace Museum is peerless for its collection of model-calligraphies. From the Western Jin, we have Lu Ji's Letter on Recovery, which is the earliest extant example of literati calligraphy. From the Tang Dynasty, our copy of Preface to the Orchid Pavilion Gathering by Wang Xizhi, the Sage of Calligraphy, is by far the best. Of the Three Rarities that were dearest to Qing Emperor Qianlong, two are in our collection, namely Wang Xianzhi's Mid-Autumn Letter and Wang Xun's Letter to Boyuan, not to mention masterpieces by Tang, Song, Yuan, Ming, and Qing masters. Last time, it was hard enough to make a critical selection of 494 pieces for publication in five volumes in the Palace Museum's Essential Collections. This time, to offer the reading public a general understanding of model-calligraphies housed in the Palace Museum and in turn the development of the art of Chinese calligraphy, we have further confined ourselves to no more than 150 pieces in a single volume, meaning only the finest and the most quintessential have been able to make it to the present series.

Bearing in mind that calligraphy is an art unique to Chinese culture, I would like to begin with a brief introduction before proceeding to discuss model-calligraphies in the Palace Museum collection.

As a form of writing, Chinese calligraphy has acquired the proportions of an art form owing to its unique nature. Generally speaking, a writing system is a set of symbols used for recording a spoken language. Without exceptions, every primitive written language began as a hieroglyphic form of writing. In the case of Chinese, mythology has it that it originated from Fuxi's hexagrams, Shennong's mnemonic knots, and Cangjie's script. As cultures and civilizations advanced, writing systems developed in disparate ways. Although easy to read and write and hence to change and adapt, the alphabetic writing systems of Europe are formally and culturally severed from their earliest past. The connection, however, is retained in Chinese characters, which have evolved from their earliest forms as hieroglyphs and mnemonic symbols to become the six categories of pictograms, ideograms, phonograms, associative compounds, loans and transfers. As for script forms, the six that are known today, four are the outcomes of paleographic development, namely the oracle-bone, the seal (both big and small), the clerical, and the regular in chronological order; whereas two are calligraphic variants, namely the cursive (including the ancient-, draft-, and modern-cursive), and the running scripts. Although changes in forms did occur over the millennia that Chinese characters have existed, modern readers can still read and understand oracle-bone inscriptions, bronze inscriptions, and pre-Qin literature that have preceded them by two to three millennia with the aid of historical linguistics. This is a key contributing factor to Chinese being the only survivor of the four ancient civilizations. In this sense, Chinese characters are of great importance for the preservation of Chinese history and culture.

For all their historical profundity and structural complexity, Chinese characters conform to logical rules. The use of the brush as writing implement allows an impressive array of formal variations for the component strokes such that writing becomes a visual art form for expressing abstract thoughts.

Invented in the pre-Qin and continually perfected in Western Han, Eastern Han, and the Wei-Jin periods, the brush is soft and flexible enough to respond to the user's conscious variation in tempo, pressure, and direction to produce dots and lines that are dissimilar in uniformity, thickness, and value. Taking advantage of such a quality that is absent in quills, pencils, painting brushes, and pens, calligraphers have produced calligraphic works of art according to their own aesthetic preferences, artistic inspiration, and technical competence.

Once written down, Chinese characters are static and motionless. Yet a calligrapher can shape and structure the strokes in such a way that an intrinsic impetus (shi) is suggested. Once endowed with impetus, calligraphy evokes motion, manner, and strength. Thus, the static characters become vibrant and have a life of their own. This explains why imageries associated with the human body and bearing often come up in ancient Chinese appraisals of calligraphy. To sum up, calligraphy is regarded as art for four essential qualities: brush methods, character structuring, overall composition, and spirit resonance. Of the four, brush methods and character structuring are most decisive.

First, brush methods. In Chinese calligraphy, there are the so-called "Eight Methods,"," or the "Eight Methods of the Character 'Yong'" with reference to the strokes that make up the first character of the iconic masterpiece Preface to the Orchid Pavilion Gathering by Wang Xizhi. Each stroke is given a special name such as "ce" for the dot, "le" for the horizontal, "nu" for the vertical, and so on. The number of methods was expanded to 32 in the Yuan Dynasty and further to 72 in the Ming so that there were now 15 styles instead of nine for writing and shaping a dot. In other words, the writing of a character was no longer a simple equation of dots plus lines but rather an artistic activity in its own right. When discussing calligraphy, the ancients had motion in mind. They would compare a ce-dot to

a rock plunging from a summit, a le-horizontal to a formidable stratus-formation, or a nu-vertical to a vine withered since antiquity. Failing to master the "Eight Methods" would result in the "Eight Ills," which is yet another instance of ancient wisdom, but I would refrain from elaborating owing to space constraints.

Second, character structuring. Regarding this decisive aspect that makes or breaks a masterpiece, there is a wealth of ancient theories to draw on. To name but a few, there are Ouyang Xun's "Thirty-six Methods," Li Chun's "Eighty-four Methods for Large Characters," and Huang Ziyuan's "Ninety-two Methods for Character Structuring." There are also a list of jargons for describing the multifarious do's and don'ts such as "stacking," "accommodating," "crowning," "intersecting," "backing and fronting," "bowing," "avoiding," and so on.

Next are overall composition and spirit resonance. Overall composition is an important consideration if a calligraphic piece is to be rhythmically and aesthetically consistent, whereas spirit resonance determines its artistic pitch and class.

Being a byproduct of the Chinese writing system, Chinese calligraphy was subject to the evolution of Chinese characters in its early development. Writing during the pre-Han periods was yet to be perfected. Its earliest form is called shuqie, or carved writing, as seen in oracle-bone inscriptions carved into tortoise shells or animal bones chiefly for documenting and divination. Such crude specimens, except for a few, used to be valued for practical rather than aesthetic reasons. Calligraphy as an art genre was simply out of the question. Even though the superseding pre-Qin large seal script, including the stone-drum and bronze scripts, and the small seal script of the Qin Dynasty were more standardized in form, the writing method remained to be relatively monotonous. As a matter of fact, the meaning of "seal," or "zhuan," according to the lexicon An Explanatory Dictionary of Chinese Characters (Shuowen Jiezi), is to make a straightforward mark with neither variation in pressure and tempo nor hooks and diagonals, and it suffices so long as the purpose of communication is served. The most pressing issue at the time was

to expand the character set so as to meet recording needs. This continued to be a priority into the Han Dynasty with the court, on many occasions, inviting those who were highly literate to the capital city to contribute all the character that they knew. Towards the end of the Western Han, Yang Xiong was finally able to produce Compilation of Glosses (Xun Zuan) to cover 5,340 characters. The number increased to 9,353 in Xu Shen's An Explanatory Dictionary of Chinese Characters dating from the latter half of the Eastern Han, basically meeting current language needs. By then, the clerical script was widely in use, and brush methods, a defining element of calligraphy as art, were beginning to build up. Fashionable concurrently, the running and cursive scripts became testing grounds for brush methods and character structuring. It was only then that calligraphy began to develop independently of Chinese characters.

And, it was only then that masters known for their calligraphy such as Liu Desheng, Cui Yuan, Du Du, Zhang Zhi, Cai Yong, and Zhong You began to emerge, ushering in the first calligraphy boom in history. Abuses were so rife that Zhao Yi expresses his disapproval in A Polemic against the Cursive Script (Fei Caoshu), complaining how excessive artifice has defeated the purpose of the draft-cursive style as an expedient way of writing when compared with the clerical script. It took so long to write that even Zhang Zhi, the Sage of the Cursive Script, would refrain from writing in the cursive style when he was pressed for time. Thus, corrections were made: The flaring ends typical of the clerical script and unnecessary connectives between strokes were dispensed with, while the causal fluidity of the running script was adopted, as best illustrated by Lu Ji's Letter on Recovery (Plate 1). This sprouted many varieties known in Chinese as "gaocao," "xingyashu," "xiangwenshu," and "zhangcao," or the draft-cursive script. They have been collectively called the ancient cursive script for demarcation from the modern cursive script practiced by Wang Xizhi and his son Wang Xianzhi, or the Two Wangs for short, as well as later calligraphers. Just as the ancient cursive was evolving into its modern version, the clerical script was undergoing transformation into the regular

script during the Wei-Jin period. With the shackles of structure and brush methods shattered in the process, there was a new room for expressiveness in writing calligraphy, and a new era for the works to be recognized as works of art had dawned.

The Wei-Jin Period (220–581)

The Wei-Jin period marks the transition when the clerical and the ancient cursive scripts morphed into respectively the regular and the modern cursive scripts. There was a profusion of calligraphers, the notable of whom include Zhong You, Liang Hu, Handan Chun, Wei Dan, Wei Ji, Huang Xiang, Lu Ji, Wei Guan, Wei Heng, Suo Jing, and Zhang Hua; but Lu Ji was the only one whose work Letter on Recovery can be seen today. Others will have to be conjectured from stele rubbings. Still others, the obscure ones, can be sampled from the calligraphy in anonymous copies of sutra or Daoist scriptures and bamboo or wooden slips that have been unearthed.

By this time, the seal script had receded further from the limelight and took on a more ornamental role in, say, stele titles. The mainstay now was the clerical script, the solemnity of which is preserved in steles such as Memorial for Accepting the Abdicated Throne and Conferring Honorific Titles. Despite the fact that naturalistic beauty had been eclipsed by mannerist preferences, they were embraced as models for the clerical script over a long period of time. Meanwhile, the draft-cursive script (or the xingyashu in the broad sense) was replaced by the ancient cursive while the prevalence of the running script expedited the transformation of the clerical script into the regular.

Given the rarity of Wei-Jin specimens, people were amazed and yet skeptical when they saw Lu Ji's Letter on Recovery. While agreeing that it should rank with Suo Jing's Eulogy on Dispatching the Troops, Zhang Chou of the Ming Dynasty doubted if it was a work from antiquity. Such doubts, however, should have dissipated with excavations from the ancient city of Loulan confirming that the style tallies with documents from the same period. But then again,

Hopefully, the above account on Chinese calligraphy can serve as an introduction to the following discussion of the style and development of the genre since the Jin and Tang periods with examples taken from the present volume.

the neat structure and composition differ from the anonymous handwritings discovered. Perhaps Wang Sengqian had a point in suggesting that Lu Ji wrote in a style that prevailed not in the China Proper but rather the Jiangdong area. In any case, we should congratulate ourselves that the handwriting of such a literary giant can still be seen more than 17 centuries later.

As for the overlapping years of the Han and Wei regimes, Zhong You was the most important calligrapher. In posterity, he has been mentioned in one breath with Wang Xizhi, marking between them a watershed dividing the old from the new. Yang Xin, a national of the state of Song during the Southern Dynasties period, observed that Zhong wrote in three styles depending on the purpose or objective. The first, or the most wondrous, was for inscriptions for stone carvings, the second for official documents and teaching purposes, and the third for correspondence. The first or the "inscription style" is exemplified by the steles Conferring Honorific Titles and Memorial for Ascending the Abdicated Throne in clerical script attributed to him, and the second or the "official style" by the carvings Memorial on an Announcement to Sun Quan, Memorial Celebrating a Victory, and Letter on Funeral Arrangements, which carry visible traces of the clerical script. In effect the running script, or an interim form of the clerical script in its evolvement into the regular script, the third or the "casual style" was a means of identification in instruments and correspondence. This has given rise to stories about Zhong You's son Zhong Hui, who was also a competent calligrapher and is known to be one of the earliest ghost-calligraphers for his remarkable imitation skills. According to A New Account of Tales of the World (Shishuo Xinyu), Zhong Hui wrote in

imitation of his nephew Xun Xu's style and swindled a sword worth a fortune from his aunt. Again by impersonating his victim's handwriting when the kingdom of Shu was destroyed, he succeeded in taking over the troops of Deng Ai, who was imprisoned by Sima Yi out of distrust, as told in Records of the Three Kingdoms.

The evolution from the clerical script to the regular and from the ancient cursive script to the modern initiated by Zhong You was curtailed in the China Proper by instability in the remaining years of the Western Jin, which was plagued by Rebellion of the Eight Princes and Uprising of the Five Barbarians. With the exodus of nobility and literati to the Jiangnan area in the south to set up the new regime of Eastern Jin, the process was soon completed in an economy and culture untouched by wars. It was this period that bred Wang Xizhi, the iconic calligrapher in Chinese history.

In his early years, Wang Xizhi wrote in the old style expounded by Zhang Zhi and Zhong You. It can be gathered from the extant Tang copy of Letter to My Aunt in Model-calligraphies of the Wang Family that his great artistry was not compromised by the conspicuous vestiges of the clerical script. His resemblance to Zhang Zhi in style was further acknowledged with sheer admiration by Yu Yi, who was previously unconvinced, on seeing a letter received by his brother Yu Liang from Wang. So talented was Wang that everybody was pinning their hopes on him for calligraphic reforms. Entreaties for departing from Zhong You, Zhang Zhi, and the ancient cursive script came from even within his family such as his cousin Wang Qia, who was Wang Xun's father, and his own son Wang Xianzhi. In recognition of his daring innovation and contribution towards the regular script and the modern cursive, Wang has been honoured as the Sage of Calligraphy ever since. As iconic as the Sage himself was his masterpiece Preface to the Orchid Pavilion Gathering. With the original buried as an imperial funerary object since the Tang Emperor Taizong was reluctant to part with it even after death, only copies of it have come down to us. Of the six copies from antiquity, four are in the collection of the Palace Museum. The best of the four, namely the Tang copy by Feng Chengsu (Plate 2), has been selected for publication in the present volume. Other than the iconic masterpiece, a dozen or so manuscripts by the great master have survived but they are all in the form of copies. Ranking with his father as the Two Wangs, the seventh son Wang Xianzhi was considered by Yang Xin to have surpassed his father in visual appeal. As a matter of fact, the son overshadowed the father for a good part of the Southern Dynasties period. His spontaneity unhindered by the stiff brush is showcased by the copy of his Letter on Planting Pine Trees (Plate 3).

To sum up, the late Han and Wei-Jin periods witnessed the metamorphosis of the clerical script into the regular and the draft-cursive script into the modern cursive. It was a time of transition when calligraphers enjoyed infinite liberty to structure their characters, modify their brush methods, diversify their strokes, and innovate the best they could. People of the period relished evaluating and theorizing, and did not hesitate to surprise others in words and actions whenever they had a chance. This peculiarity has led to the expression of the "Wei-Jin mien," and the calligraphy of the period has been described accordingly as "prominent in resonance."

From the end of the Western Jin to the Sixteen States Period, the north had practically been reduced to one huge battlefield. With culture declining alongside the economy, the development of calligraphy grounded to a halt and the transformation of the clerical script into the regular was left incomplete. Previously, calligraphy used to be widely practiced in the north. According to the History of the Northern Dynasties (Bei Shi), a certain Lu family in Fanyang was noted to be competent in calligraphy in Zhong You's style for seven generations, while a Cui family in Qinghe produced four generations of calligraphers. Unfortunately, both families were almost completely wiped out by warfare in the early Northern Wei. A further setback was the ban on private erection of steles from the late Han and Wei-Jin periods right up to the Eastern Jin and the Southern Dynasties periods, resulting in a total absence of carvings of the Two Wangs' works. When the ban was lifted in the north, people of just any means scrambled to erect their

own steles and would not mind having them coarsely carved offhand when calligraphers were unavailable or unaffordable. Undeniably, there are masterpieces among the Northern Wei steles, the exemplars being Stele for Zhang Menglong, Stele for Zheng Xi, and Epitaph for Zhang Xuan. Discrimination by content and quality, however, must be exercised in face of such a multitude of specimens by anonymous calligraphers. Further afield, the transition from the clerical script to the regular can also be detected from the great many sutra copies in the burgeoning Dunhuang grottoes.

THE SUI, TANG, AND FIVE DYNASTIES PERIODS (581–960)

In the year 589, the state of Chen in the south was annexed into the Sui empire. With China unifying for the first time in nearly four centuries since the Han, calligraphic styles of the north and the south began to converge. Marrying the regularity of the Northern Wei and the elegance of the southern casual style, calligraphy of the Sui Dynasty was set to rise to a pinnacle in the subsequent Tang Dynasty.

Eminent calligraphers of this period may either be already fully fledged as in the case of Monk Zhiyong, who was Wang Xizhi's seventh-generation grandson, or ready to soar in fame come the Tang Dynasty as in the case of Ouyang Xun and Yu Shinan. Sui specimens mainly survive in the form of stone carvings, and there are no more than two extant works in ink. One is Monk Zhiyong's Thousand-Character Essay in regular and cursive scripts, which is in Japan. The other is an anonymous copy of Suo Jing's Eulogy on Dispatching the Troops in draft-cursive script (Plate 6), which the Palace Museum recovered at the turn of the century. While the former serves as a window on Wang Xizhi's legacy in the new Wei-Jin style, the latter celebrates the old in the Wei-Jin tradition that was embraced by Wei Guan and Suo Jing. Of these two, the latter is to be cherished more, since the old draft-cursive script can be seen almost nowhere else, whereas the new style can be easily sampled through works of the Two Wangs or otherwise.

The Tang Dynasty marks another zenith for the art of calligraphy after the Wei-Jin period. The hallmark script for the period is the regular, in part a byproduct of the proliferation of monumental inscriptions and sutra copies at a time of stability, prosperity, and religious enthusiasm.

Another key factor to the flourish of calligraphy during this period was imperial passion. An aficionado of Wang Xizhi, Emperor Taizong left his personal insights on the calligrapher's biography in The Book of Jin (Jinshu) and had the legendary Preface to the Orchid Pavilion Gathering buried with him. According to The Six Statutes of the Tang (Tang Liudian), he decreed upon acceding to the throne that officials ranking grade five or above were to send their sons with calligraphic potential to study the regular script at the Institute for the Advancement of Literature (Hongwen Guan) under the tutorship of Yu Shinan and Ouyang Xun. At the time, state education was provided at two institutes in six disciplines, the fifth of which being calligraphy. At the Institute for the Advancement of Literature, model-calligraphies were reproduced in-house by specialists including Feng Chengsu, Zhao Mo, Zhuge Zhen, and Han Daozheng for Preface to the Orchid Pavilion Gathering, and Xie Wuwei for Letters of the Seventeenth under Chu Suiliang's supervision. These specialists were calligraphers in their own right. Zhao Mo, for instance, was the calligrapher of the tombstone of Gao Shilian, a prominent official from the early Tang. So much importance was attached to calligraphy that competence in the regular script was made a prerequisite to officialdom along with appearance, speaking, and writing competencies.

In the early Tang, Ouyang Xun, Yu Shinan, and Chu Suiliang, working invariably in the regular script for steles, were the most famous of the calligraphers. By comparison, Ouyang is defined by his prudence and propriety, Yu by his dignity and plumpness, and Chu by his confidence and slenderness. Stylistically, their characteristics are more readily distinguishable

in the running-cursive script than the regular; but ink specimens, as few as four, are available for Ouyang Xun only. As can be seen from Zhang Han (Plate 7) and Bu Shang (Plate 8), the calligrapher prefers his characters to be elongated with sporadic emphasis on the horizontals for a sense of motion.

As for the large regular script that is often seen in Tang steles, accomplished calligraphers abounded. Although lesser known than Ouyang and Chu, they have produced artistically quality works such as Wang Zhijing's Stele of Li Jing. As for the small regular script featured in sutra copies, an example is afforded by Guo Quan's Samantapāsādikā (Plate 9), where the skilled brushwork, comfortable structuring, and overall concord do not compare unfavourably with any contemporary masterpiece. Prior to the discovery of more and more Dunhuang sutras, people would attribute any unsigned yet masterly sutra that they had acquired to a known calligrapher either for raising its value or out of admiration for the calligraphy. For instance, Scripture of the Numinous Flight was once ascribed to Zhong Shaojing and Scripture of the Hidden Accordance to Chu Suiliang. Whoever the author, the calligraphy is a worthy reference for learners of the regular script.

Into the mid- and late Tang, talented calligraphers in the regular script continued to emerge in droves, the most notable being Xu Hao, Yan Zhenqing, Li Yong, and Zhang Congshen from the mid-Tang and Liu Gongquan from the late Tang. Prominent as not only a calligrapher but also a senior official, Yan Zhenqing has been known his calligraphy that has been dubbed "Yan's sinews" that demonstrates a convergent structuring in place of the Two Wangs' divergence and a squarely broadness in place of the conventional slanted form. His running-cursive script is regarded as particularly innovative for its expressiveness. Revered for his calligraphy that has been described as "Liu's bones," Liu Gongquan assimilated Ouyang Xun's calculated structuring but not his stinginess and incorporated Yan Zhenqing's broadness but not his obesity to attain vigour and charm. While there is no shortage of extant steles by the two masters, with Stele for the Duobao Pagoda and the Stele for the Xuanmi Pagoda topping the list, few of their ink works have survived and many of which are either imitations or copies. One such specimen is Yan Zhenqing's Collaborative Chain Poetry of the Zhushantang (Plate 11), which is most probably a copy. Although the overall composition can no longer be seen in the virtual patchwork and the brushwork is dull and inhibited, the piece, which is rare after all, is included in the present volume to mirror the style of the great master.

As did calligraphy, poetry reached its heyday in the Tang Dynasty, rendering calligraphic works by Tang poets all the more precious. In the history of Chinese literature, the giant poets of the high Tang were Li Bai and Du Fu, whose accomplishments were rivalled by another Li and another Du, namely Li Shangyin and Du Mu, in the mid- and late Tang. Shangyang Terrace (Plate 10) is the only surviving calligraphic work by Li Bai and carries the Song Emperor Huizong's inscription as proof of its provenance. Likewise to be one of its kind and of such a length is Du Mu's untrammelled Poem to Zhang Haohao (Plate 12) in a medley of running, cursive, and regular scripts, which is of immense value calligraphically, literally, and historically.

The cursive script also underwent new developments in the period. There was the legacy of the Two Wangs' small cursive script where the characters are freestanding while strokes may be interconnected as in Praising the Profundity of the Lotus Sutra (Plate 13). There was also the "large cursive" newly invented by Zhang Xu and Monk Huaisu with characters running flamboyantly on to the next. Thus, the emotionally expressive small cursive had now developed into the emotionally explosive large cursive, consolidating the perception of calligraphy as a means of self-expression for centuries to come.

Although not without renowned practitioners in Emperor Xuanzong, Li Yangbing, Han Zemu, Shi Weize, and others, the seal and clerical scripts were no longer in daily use except for writing stele titles during the period.

In the late Tang and the period of the Five Dynasties and Ten Kingdoms, China again fell into a warring and disintegrated state. The most

distinguished calligrapher from this period is Yang Ningshi. His father Yang She was prime minister to the Tang Emperor Zhaozong but was coerced into presenting the warlord Zhu Wen (the future Liang Emperor Taizu) with the imperial seal. In protest, the son feigned madness and has come to be known as Yang the Lunatic. For this, he was venerated and deemed to be on the same par with Yan Zhenqing in the Song Dynasty when legitimacy and orthodoxy were given the greatest priority. In the history of Chinese calligraphy, Yang has been considered vital for carrying forward the Tang tradition to the Song by inheriting the merits of the Two Wangs, Ouyang Xun, and Yang Zhenqing and at the same time inventing a new style where scripts freely borrow from each other without being confined by established rules and hence was best suited to the expressive need of the time. Of his three extant works, Chives is lost, but Letter on Summer Heat (Plate 14) and Regimen for Attaining Divine Immortality (Plate 15) can be seen here.

THE SONG DYNASTY (960–1279)

Comprising the Northern Song (960–1126) and the Southern Song (1127–1279), the Song Dynasty spanned about 320 years. To win over the intelligentsia in its infancy, the Song court expanded the scale of its recruitment of officials through civil examinations by dozens of folds. Meeting the cultural demand for calligraphy, painting, poetry, and books, this new privileged bureaucracy, which had quintupled in size, became a major stimulus for arts to flourish in the period.

With respect to calligraphy, the number of learners and practitioners soared dramatically, pushing demand for model-calligraphies up to a new unprecedented height. This was aggravated by the scarcity of authentic calligraphic works, many of which were destroyed along with other cultural relics during the tumultuous seven to eight decades that preceded the dynasty. Instead of producing tracing copies like the Tang people did, the Song people had no choice but to resort increasingly to rubbings from wood or stone carvings.

Blessed with commercial prosperity and scientific advancement, the Song people grew to be more materialistic and less religious. Monumental steles and sutra copies were in sharp decline and the few that continued to be produced were stripped of the solemnity characteristic of the Tang Dynasty. A further phenomenon was that, frustrated or otherwise, the scholar-officials were inclined to express their feelings through literature and calligraphy. Naturally, they favoured neither the prim regular script nor the cumbersome cursive. They turned instead to the spontaneous running script to vent their emotions. By and by, it became the single most important script during the Song Dynasty.

Incessant warfare also disrupted the lineage in which students and children acquired calligraphic skills directly from their teachers and fathers so much so that Ouyang Xiu lamented that calligraphy was at its lowest ebb. An unexpected advantage that came out was that, emancipated from the notion of lineage, aspirants were free to experiment on their own. From among the practically self-taught, esteemed masters like Su Shi, Huang Tingjian, and Mi Fu emerged.

The popularity of calligraphic carvings in the Song Dynasty is best exemplified by the production of the 10-volume Model-calligraphies from the Chunhua Archive in the third year of Emperor Taizong's Chunhua reign (992) to cover ancient calligraphic masterpieces in the imperial collection. Since the script form featured is predominantly the running or the cursive, the endeavor did contribute to the rise of expressive styles at the time. Yet the impact was not as great as some have argued, judging from the examples included in the present volume. First, while past emperors and courtiers account for as many as five volumes, Wang Xizhi three and Wang Xianzhi two in the collection, the great majority among Song learners of calligraphy, as observed by Mi Fu, were modelling on contemporary dignitaries rather than

the masters enshrined in the collection. Second, Yan Zhenqing and Yang Ningshi, who exerted the greatest influence at the time, are omitted altogether. That said, the availability of calligraphic carvings did break the golden rule that calligraphy must be learnt from authentic masterpieces, and, no longer faithfully retained as in tracing copies, brushwork was gradually disregarded to the extent of devastation. This is also why the Song period has been blamed for the disintegration of brushwork.

The most celebrated early Northern Song calligrapher is Li Jianzhong, whose excellence in the running script merits a mention in History of the Song (Song Shi) and earned respect from Ouyang Xiu. It can be seen from his Letter to a Fellow Qualifier (Plate 16) that, alongside vestiges of the Tang style, the expressive inclination of Song calligraphy has already sprouted in the spontaneous character structuring and brushwork.

A little later, notable calligraphers such as Zhou Yue, the brothers Su Shunyuan and Su Shunqin, and Song Shou and his son came onto the scene. More were to come as suggested by extant masterpieces left behind by their contemporaries, who can be officials such as Du Yan, Fan Zhongyan, Fu Bi, Wen Yanbo, and Han Qi, or poets like Lin Bu. The pervasive script form at the time was the regular, as evidenced by the letters written by chancellors such as Li Zonge, Lü Gongbi, Ye Qingchen, Zhao Bian, Han Jiang, and Sima Guang. The defining upright structure and skilled crispness can be sampled in Fu Yaoyu's Letter on a Sweltering Day (Plate 23) and Lü Dafang's Letter Seeking Advice (Plate 24).

By far the most prominent from among this crowd is Cai Xiang, who was to be known in the history of Chinese calligraphy as one of the Four Masters of the Song together with Su Shi, Huang Tingjian, and Mi Fu. Although he belongs to the lineage of Yu Shinan and Yan Zhenqing especially for the regular script, his Self-composed Poems (Plate 21) and Letter of Thanks (Plate 22) show distinctive features of his own when compared with Yan's. While Yan is relaxed, Cai is reserved; while the former is bold, the latter is refined.

Although Cai Jing, Cai Bian, Xue Shaopeng, Shen Liao, Zhang Dun and Qian Xie all left their

atypical marks, it was Su Shi, Huang Tingjian, and Mi Fu who brought about the golden age of Song calligraphy. Calligraphers of this period set great store by literary cultivation. In praising Mi Fu's calligraphy, Su Shi referred particularly to the calligrapher's literary originality, which is certainly even more relevant in the case of Su himself and Huang Tingjian. Su took pride in staying off the beaten track while Huang, an outstanding student of Su's, wrote his poetry as characteristically as his calligraphy. The latter's masterpiece Poem to He Lanxian by Du Fu (Plate 30), for instance, strikes with sheer energy and dynamism. In contravention of principles for the cursive script, the connectives are produced without lifting the brush such that they are almost identical in thickness with the strokes connected. Yet, in so doing, he has succeeded in injecting a continuous flow of momentum into his characters. When it comes to artistry, variation, innovation, and strength, Mi Fu was unchallenged throughout the Song Dynasty. As can be seen in his running-script masterpieces Poems on the Tiao Stream (Plate 33) and Letter Painted with a Coral (Plate 35), compactness is complemented by openness while vigour by delicacy.

At the top of the political hierarchy, emperors were also adept calligraphers. Among them, Emperor Huizong, or Zhao Ji, was the inventor of the slender gold script. The specimen Poem on the Leap Mid-Autumn Moon (Plate 40) impresses with its pronounced and exaggerated hooks and corners but any overdoing would make it a work of design rather than art. His son Zhao Gou, or Emperor Gaozong who started the Southern Song, acquired calligraphy by modelling on Huang Tingjian and Mi Fu before focusing exclusively on the Two Wangs. Bearing affinities to Monk Zhiyong in style, he had a profound influence on the development of calligraphy in the Southern Song. His artistic accomplishment can be sampled in Latter Fu-rhapsody on the Red Cliff (Plate 45), which is dynamic without sacrificing regularity under his assured hand.

A calligrapher commended by Emperor Gaozong was Wu Yue. Tenacious on the inside yet dexterous on the outside, his Letter Soliciting a Jade Ruler (Plate 47) is a celebration of the Two Wangs tradition. By

contrast, Wang Sheng, active since the late Northern Song, resembles Mi Fu in the running script and Tang masters in the cursive, tempting many to cut off the identifying inscriptions and pass their works off as dating from the Tang. There was also Lu You, a leading Southern Song poet excelling in calligraphy. Although he professed to have modelled on Zhang Xu and Yang Ningshi, the traits of Su Shi and Huang Tingjian are discernible, only more varied and conscious, in his Reminiscences of Chengdu (Plate 48).

Readers will also find in the present volume a selection of manuscripts by patriots, such as Han Shizhong, Liu Guangshi, and Wen Tianxiang, who defended the Southern Song empire from foreign invasions. The value of this kind of calligraphic works, however, is not to be determined by artistry alone.

Also dating from the Southern Song are calligraphies by personages, most of which tend to be flippantly personalized, the only identical feature being their inclination towards expressiveness. The most accomplished in this group is Zhang Jizhi. Those in favour trumpet his masterly and disciplined regular script, which is innovatively regenerated with features of the running script; those against frown on his stiff brushwork, affectations, and deprivation of refinement. If Ode to the Twin Pines Painting (Plate 60) is taken as an example, the overbearingness and the extraordinary structuring are indeed flawed by the lack of restraint. The end of the road seems to be near although the Song preference for self-expression did bring the art of calligraphy to a new height.

THE YUAN DYNASTY (1271–1368)

Despite the connection in time, the calligraphy of the Yuan is vastly different from that of the Southern Song and the Jin dynasties in terms of style, theory, and aesthetics. In the history of calligraphy, the Yuan subverted almost everything that the Song had held dear.

In their preference for self-expression, the Song masters largely went about their own ways with little regard for rules. The result was a reversal of the Jin-Tang ideal of perfection through conformance, elegance, and moderation with everybody preoccupied with self-expression to the extent of blatant indulgence. Calligraphy had degenerated to such a deplorable state that change became a pressing need. The one who took up the baton was Zhao Mengfu. An outstanding adept in the cursive, seal, clerical, draft-cursive scripts, and especially regular and running scripts, he has been described as surpassing the Song and Tang masters and rivalling Wang Xizhi of the Jin. Comprising his peers, students, and other latecomers, his following was huge, the notable among them include Xianyu Shu, Deng Wenyuan, Kangli Kuikui, Zhang Yu, Yu Ji, Zhou Boqi, Ke Jiusi, Yu He, and Rao Jie. Disparate

in style and achievement, they all tried to emulate the Jin-Tang masters in both skill and spirit, culminating in a distinct calligraphic identity for the Yuan period during which normality and conformity surged in currency after a dynasty of fury and tempest.

Zhao Mengfu was of monolithic importance in the Yuan Dynasty. Although adhering to the Wei-Jin rules, he wrote with vibrancy and agility. His large scripts on steles exude an alluring charm alongside their solemnity. These qualities of his are best exemplified by Fu-rhapsody on the Nymph of the Luo River (Plate 69) and two other masterpieces collected in the present volume. Xianyu Shu, who was at one point considered to be on the same par with Zhao, followed a separate path in his modelling of the past. While Zhao is revered for his resonance derived mainly from the Wei-Jin and more importantly the Two Wangs traditions, Xianyu is noted for his inherent strength originating from the Tang masters including Yu Shinan, Yan Zhenqing, Sun Guoting, Monk Huaisu, and Monk Gaoxian. His characteristic sparse structure, vigorous brushwork, and majestic aura can be glimpsed from Poem on Stopping by the Zhao Mausoleum by Du Fu (Plate 65), a quintessential

masterpiece in large running script.

In the early Yuan, many calligraphers were still subject to the lingering influence of the Southern song or Jin periods. For instance, Bai Ting, Li Ti, and Yuan Jue modelled on Mi Fu; whereas Pu Guang on Huang Tingjian, and Yao Shu and Qiu Yuan on Ouyang Xun. Among them, there may be literati of great repute since the late Southern Song like Bai Ting and Qiu Yuan or officials like Cheng Jufu. It is perceptible in Letter to Lu Hou in running-cursive script (Plate 66), the only surviving specimen, that Cheng Jufu wrote in Su Shi's style as was typical among Southern Song literati. It is worth noting that Cheng was instrumental in the Sinification of the Yuan ruling echelon. If not for his persuasion, Zhao Mengfu would not have taken up official office, and the history of calligraphy, painting, and art of the Yuan Dynasty would have to be rewritten.

In the late Yuan and especially among Zhao's ever growing following, degenerations set in since there was little desire to experiment, and stylistic development had stagnated. Furthermore, people were perturbed by the political chaos at the time. Psychological insecurity and dejection prompted an aesthetic swerve away from the moderate, elegant, and majestic. Calligraphers aspiring to be different began to avoid or rid themselves of Zhao Mengfu's neatness and refinement and to espouse tilt, looseness, archaism, or even oddity. In this regard, Yang Weizhen's "decadent" calligraphy, which is ostensibly distorted to eradicate balance and mellowness, serves as a revealing example. Towards the end of the Yuan Dynasty, Kangli Naonao's brisk calligraphy was the most influential. Following further development by calligraphers such as Rao Jie and Song Ke, the dynastic calligraphic style was ready to be renewed.

The Yuan Dynasty witnessed the reappearance of the seal, clerical, and draft-cursive scripts which had fallen into disuse, since the Song as calligraphers tried to remedy the unruly expressiveness of the Song by retracing the tradition back to its earlier origins. This has led to the calligraphy of the period being described as revivalist. Nevertheless, the Yuan seal, clerical, and draft-cursive scripts are a far cry from those of earlier periods owing to the difference in style,

implements, and especially aesthetic preferences. Writing them was now an artistic invention rather than a choice of script to meet functional needs.

The two defining peculiarities of the Yuan are modelling on the past and abiding by the rules, which are primarily manifested in the seal and clerical scripts. As far as the clerical script is concerned, the Yuan calligraphers modelled on the Wei-Jin or even Tang tradition when the clerical script was fully developed. From specimens by Xiao Ju, Wu Rui, and Yu He, it is apparent that despite the calligraphers' efforts, the monotony of the Jin and Tang cannot be entirely purged, and naturalness is compromised by conscious ornamentation. This is because when the clerical script was revived at a time when it was already superseded by the regular as the script for everyday use, the flaring ends typifying the clerical script tended to be over-emphasized to prevent the levelness of the regular script from creeping in. Such restrictions imposed by the time are a matter of course.

The draft-cursive script was also given a new lease of life under Zhao Mengfu's advocacy for modelling on the past. The phenomenon is evidenced by Deng Wenyuan and Yu He. In Deng's A Primer in draft-cursive script (Plate 73), although attention is paid to retaining the script's characteristic flaring ends, squat form, and freestanding characters, the rendering is too exquisite to be simplistic and to mask influences from the regular script in both form and brush methods. Neither did Yu He and others fare any better in bringing the ancient draft-cursive back to life. What they have achieved is nothing more than Yuan art and Yuan aesthetics.

Under the special circumstances of the Yuan period, the ethnic minorities yielded adept calligraphers for the first time in Chinese history. Among them, writing as many as 30,000 characters a day according to an account given in Tao Zongyi's Records during Farming Recesses (Nancun Chuogeng Lu), Kangli Kuikui exerted so pervasive an influence in the north that he once ranked with Zhao Mengfu in the south. His vigour and personality betray themselves in The Banished Dragon (Plate 81), in which characters written with the centre-tip

of the brush complement each other, despite sparing connectives and variety is afforded by interspersing the modern cursive with the big cursive. Other calligraphers in this group, such as Tai Buhua seen in Inscription for a Humble Dwelling in seal script (Plate 85) and Naixian seen in Eulogies on Southern City's Past in running-regular script (Plate 94), were also accomplished with a distinctive personal style.

THE MING AND QING DYNASTIES (1368–1911)

Stylistically, the Ming period can be divided into three phases: the early, the middle, and the late. Leading calligraphers from the early period are the Three Songs (i.e. Song Ke, Song Guang, and Song Sui) and the Two Shens (i.e. Shen Du and Shen Can). Excluded from the Three Songs is Song Sui's father Song Lian, whose calligraphy is akin to his Yuan counterparts, and likewise from the Two Shens is Shen Du's son Shen Zao, who wrote in the family's style. At the Ming court at the time, Shen Du had a predominant presence among calligraphers practicing the Chancellery style that is characterized by an appealing gracefulness derived from Yu Shinan. It had to wait until Jiang Ligang that references from Liu Gongquan were introduced but still changes were minimal. To trace the development chronologically, Song Ke, who straddled the Yuan and the Ming, borrowed his regular script from the Wei-Jin tradition and excelled in the draft-cursive script; Xie Jin, a talent from the early Ming, wrote his modern cursive script with little inhibition; the Two Zhangs, namely Zhang Bi and Zhang Jun, from the Zhengtong and Chenghua reigns heralded the arrival of the grotesque; and Xu Youzhen and Li Yingzhen were eager to bring about transformation.

The calligraphic current in the mid-Ming was steered by Zhu Yunming and Wen Zhengming and their fellow calligraphers in the School of Wu (present-day Suzhou and its environs) such as Tang Yin, Shen Zhou, and Chen Daofu. Emulative of Huang Tingjian and Mi Fu for his running-cursive script, Zhu is even more unimpeded than his grandfather Xu Youzhen and his father-in-law Li Yingzhen. Eager to prove his talent, he often wrote after many masters, forging a diverse style for himself in the process, as revealed in his sleek Self-composed Poems (Plate 109). Wen Zhengming's calligraphy is more disciplined by contrast. Dating from two different periods, his Two Letters to Wu Yu (Plate 112) features compact character structuring and painstaking precision separately. Unlike Zhu and their teacher, who modelled on the past, Wen's students, who were numerous, modelled on the present in trying to approximate their teacher. Their contemporaries Wang Chong and his brother Wang Shou turned to calligraphic carvings for learning materials so much so that their running-cursive script has been dismissed as stiff and dull as if carved in wood. The inferiority in both ethos and resonance betray themselves in Wang Chong's A Girl on a Stream in cursive script (Plate 115). It is therefore not improbable that the calligrapher's elevation to the ranks of Zhu Yunming and Wen Zhengming was based merely on his membership in the same Wu School as the two masters were.

The emergence of Dong Qichang in the late Ming dealt a further blow to the Wu School of painting and calligraphy. Claiming to start learning calligraphy as late as the age of 17, Dong soon grew contemptuous of both Zhu and Wen and strived to dwarf them as best he could. To establish a distinct style of his own, he shied away from Zhao Mengfu's refinement and opted for austere elegance. A similar aspiration is reflected in the untrammelled style of Zhang Ruitu, Huang Daozhou, and Ni Yuanlu. Even in the seal script, there was a shift from Cheng Minzheng's composed regularity to Zhao Yiguang's "cursive-seal script" that smacks strongly of the cursive script. Such "decadent" style engendered by a period in decay was perpetuated by Wang Duo and Fu Shan into the early Qing.

The last chapter in the history of ancient Chinese calligraphy is the Qing period that connected the Yuan and Ming dynasties with the Republican period.

In the late Ming and early Qing, the contagious

effect of political upheavals on the people's psychology fueled the prevalence of self-expression, or the so-called "decadent" style, in the calligraphic circles. The phenomenon became readily perceivable in a succession of calligraphers including Huang Daozhou, Ni Yuanlu, Wang Duo, and Fu Shan. As the Qing administration stabilized and consolidated with a series of cultural policies such as resumption of civil examinations to appease the literati, a wish to partake in the peace began to spread among the populace. A placid and dignified calligraphic style began to gain popularity, especially under the encouragement of Emperor Kangxi and his successors, leading to the endearment of Dong Qichang and Zhao Mengfu. Imperial favour is obvious with Zhao Mengfu accounting for five volumes and Dong Qichang four in the 32-volume Model-calligraphies of the Hall of Three Rarities (Sanxitang Fatie) compiled on Emperor Qianlong's decree.

Eminent calligraphers active in the transition between the Kangxi and Qianlong reigns included Kangxi's calligraphy teacher Shen Quan, the Three Chens of Haining (i.e. Chen Bangyan, Chen Yuanlong, and Chen Yixi), and Zhang Zhao, who was described by Qianlong as inheriting Mi Fu's vigour without being tarnished by his cursoriness and retaining Dong Qichang's neatness while discarding his feebleness, not to mention many others like Liang Shizheng, Yu Minzhong, Liu Yong, Wang Wenzhi, Liang Tongshu, Yongxing, and Tie Bao.

To contest for supremacy with the Song imperial Model-calligraphies from the Chunhua Archive and Model-calligraphies of the Daguan Reign, Emperor Qianlong decreed that two anthologies of model-calligraphies, respectively entitled after the Hall of the Three Rarities (Sanxitang) and the Studio of Marvelous Ink (Momiaoxuan), were to be compiled. In the process, extant calligraphic masterpieces from the past virtually became exclusive imperial properties. Model-calligraphies have thus been well conserved for posterity but not without negative effects. With learners of calligraphy having nothing but rubbings to refer to, only a handful of calligraphers proficient in the clerical script like Zheng Fu and Wan Jing managed to go further back

in time than the Yuan and Ming masters to tap the Jin-Tang and Han-Wei traditions. As for most other calligraphers, what had been left to them were only the rubbings that were available, they could be made from re-carvings of re-carvings or from steles chipped and damaged by repeated rubbings over the ages. With characters illegible or strokes missing, there is little brushwork or resonance to speak of, much less to learn. This was aggravated by the prevalence of the regular but spiritless Chancellery style, which was widely regarded as a gateway to officialdom. All these combined to procure uniformity and banality for calligraphy of the Tang Dynasty. The extent of the problem can be gathered from the criticism of Weng Fanggang, one of the Four Masters of the Qianlong and Jiaqing Reigns (the others being Liu Yong, Yongxing and Tie Bao or alternatively Liang Tongshu and Wang Wenzhi in place of the last two), as unoriginal to the last stroke.

Confronted by the decline, men of insights began to look for a way out. Jin Nong wrote his clerical-regular script with a modified lacquer brush. Zheng Xie devised the semi-clerical script by integrating features of the running and regular scripts into the clerical. Better noted for their painting and literature as members of the Eight Eccentrics of Yangzhou, they had little impact on the development of calligraphy at the time.

Under the tight grip on ideology, evidential research thrived during the Qing period. With perfectly legible epitaphs newly discovered from Northern Dynasties tombs, more and more people turned to the previously neglected steles from the Six Dynasties for archaism beginning from the Qianlong and Jiaqing reigns. Ruan Yuan kindled the fervor with his "On the Northern and Southern Schools of Calligraphy" (Nan Bei Shupai Lun) and "On the Northern Steles and Southern Model-calligraphies" (Beibei Nantie Lun). Bao Shichen followed suit with his discussions of literature and calligraphy in Two Oars for the Boat of Arts (Yizhou Shuangji). Kang Youwei joined in the discussion but confined himself to calligraphy with his Two Oars for the Boat of Arts by Extension (Guang Yizhou Shuangji). Although re-titled as "Single Oar for the Boat of Arts" has been

suggested in mockery, Kang's book has far-reaching impact, which is partly attributable to the author's eloquence as a scholar of new text Confucianism. At once, debates over the Stele School and the Model-book School ensued. The crux of the argument was whether Northern steles or model-books served learning better rather than whether stele rubbings or past masters' ink works should be modelled on. Acknowledged patriarchs of the Stele School are Deng Shiru, most accomplished in the seal and regular scripts, and Yi Bingshou, an expert in the clerical script. Deng's familiarity with Northern steles is manifested in the archaistic and unpretentious marriage of the clerical with the regular script in his Couplet of 37-character Lines (Plate 141), whereas Yi's delicacy robed in archaistic simplicity and breakthroughs in character structuring and brush methods are in plain sight in his Pentasyllabic Couplet in clerical script (Plate 144). There were also the Stele School calligraphers who had gone astray by mechanically mimicking the carving effects of angularity and ruggedness in Northern steles at the expense of brush methods. Oblivious of the original ideals of the Stele School, some even went to the extreme of insisting on faithfulness to the incision and erosion marks in their pursuit for a "bronze-and-stone flavor." In an attempt to free themselves from the impasse, He Shaoji and Wu Changshi gained recognition for respectively the running-regular and seal scripts by delving into the pre-Qin and Sui-Tang traditions. Wu has been lauded for his bronze-and-stone flavor resulting from welding painting, calligraphy, and seal carving into one. Indeed, hardiness is achieved when a brush is wielded like a rod. Still, the demerits remain. The artistic expression made possible by the application of various brush methods is obliterated. It had to wait until the mushrooming of museums and the popularization of photocopying in the late Qing that the calligraphic perversion finally withered and died.

Also leaving their marks on the history of Chinese calligraphy are traditionalists like Lin Zexu, Guo Shangxian, and Wang Renkan. Although dismissed for belonging in the Chancellery School, they should not be neglected on account of their artistic accomplishment. Lin's Manuscript in running script (Plate 146), for instance, strikes with its confident and effortless reinterpretation of Ouyang Xun's style.

The above serves as a brief introduction to the art of Chinese calligraphy with reference to the present volume on model-calligraphies.

The Jin, Tang, and
The Five Dynasties Periods

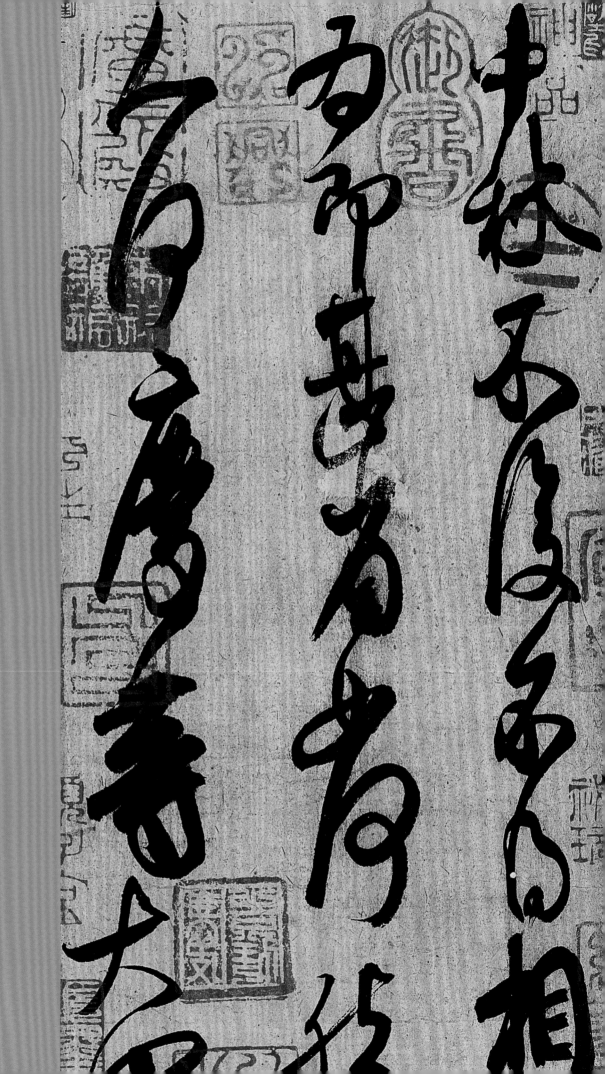

1

Letter on Recovery
— by —
Lu Ji
— of —
the Jin Dynasty
Ancient cursive script

Ink on paper
Height 23.7 cm Width 20.6 cm

Lu Ji (261–303), a native of Wujun (present-day Suzhou) whose grandfather was the Eastern Wu illustrious general Lu Xun, was an acclaimed litterateur of the Western Jin. Serving as Administrator of Pingyuan and Commander-in-chief of Hebei at various times, he was defeated and killed during the Rebellion of the Eight Princes.

This is a letter from Lu Ji to a friend with tidings about He Xun, Wu Ziyang and Xia Borong. It is titled after the reference to the unlikely recovery of the frail He Xun at the beginning of the calligraphy. Despite the absence of signature, the reputed authorship has been adopted ever since the piece was first entered in the *Catalogue of Paintings in the Imperial Xuanhe Collection* (*Xuanhe Huapu*) under Lu Ji's works in draft-cursive script. The title slip inscribed by the Song Emperor Huizong Zhao Ji further supports the attribution.

Written with a worn-out brush and largely unhalted in rendering, the archaic draft-cursive script is vastly different from its later version. Stylistically more akin to the cursorily written clerical script from the Han and Jin periods, the form may more appropriately be called cursive-clerical script. In terms of material, the hemp paper used also points to more or less the same period. Boasting unquestionable provenance since the Song Dynasty, the work has been widely acknowledged as the earliest surviving example of a calligraphic work in ink.

To the right of the text is a title slip, probably contemporary with the work, reading "Calligraphy by Lu Ji, Administrator of Pingyuan and a native of Wujun in the Jin Dynasty." Another title slip, on the front separator, is inscribed by Emperor Huizong to read "Lu Ji's *Letter on Recovery*" while the colophon paper contains colophons by Dong Qichang from the Ming Dynasty and Pu wei, Fu Zengxiang, and Zhao Chunnian from the modern era.

Collector seals: *Yin Hao* (two characters illegible); Song: Emperor Huizong's double-dragon seal, *Xuanhe*, *Zhenghe*, and *Zhenghe*; Ming: seals of Han Shineng and his son Han Fengxi, and Zhang Chou; Qing: seals of Liang Qingbiao, An Qi, Yongxing, Zaizhi, and Yixin; Modern: Pu Ru, Fu Zengxiang, and Zhang Boju.

Literature: *History of Calligraphy* (*Shu Shi*), *Catalogue of Paintings in the Imperial Xuanhe Collection*, *Zhan Jingfeng's Personal Viewing Notes* (*Dongtu Xuanlan*), *The Qinghe Boat of Painting and Calligraphy* (*Qinghe Shuhua Fang*), *Journal on Authentic Masterpieces* (*Zhengji Rilu*), *Records of Paintings and Calligraphies* (*Shuhua Ji*), *Collected Notes on Paintings and Calligraphies of the Shigu Hall* (*Shigutang Shuhua Huikao*), *Spectacles Viewed in a Lifetime* (*Pingsheng Zhuangguan*), *Inspiring Views* (*Daguan Lu*), and *Fortuitous Encounters with Ink* (*Moyuan Huiguan*).

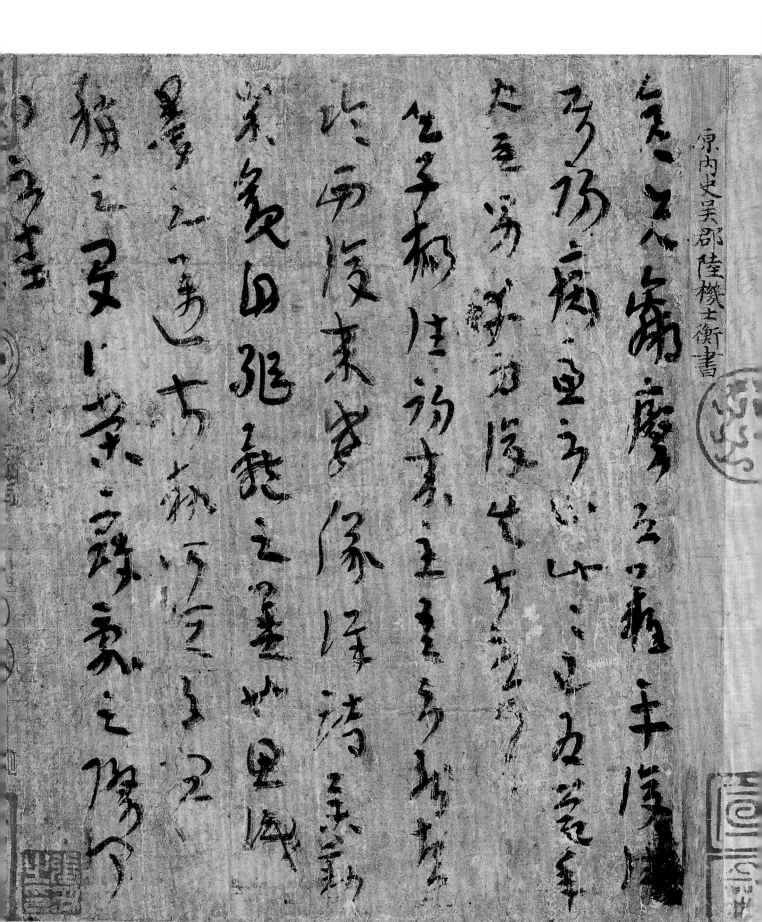

右平原真蹟有藏宗縹字及宣和
此璽蓋右軍以前元常以後惟存
此為希代寶余所篋藏在辛
和春特為庶吉士韓宗伯方為館
師故時小將魏名蹟惡弟甲乙以此為
嚴情世善葊摹者予利鴻堂帖不
後能收之耳
　　　甲辰亥平月翊蓍其昌識

昔王僧虔論書云陸機吳士也無以較其多少庾肩
吾書品列機於中之下而惜其以弘才掩迹唐李嗣
真書品後則置之下之首謂其楷帶古風觀
彼諸家之論意士衡遺蹟自六朝以來傳世絕罕
故無以評定其甲乙耶惟宣和書譜載御府所藏
二軸一為行書想帖一為章草即平服帖也今堂
想帖久已無傳惟此帖如魯靈光殿巋然獨存二
千年來孤行天壞間此洵為之奇珍非僅墨林之
瑰寶也董玄宰謂右軍以前元常以後惟謹數行為
希代寶至教言少宣和書譜言平服帖作作晉武帝
初年前右軍蘭亭燕集叙大約百有餘歲其當在晉
屬最古云今人得右軍書數行已動色相告矜為星
鳳劂此帖為晉和開山第一祖墨乎哉此六寅軍諸第此帖自宣
和御府著錄後紙存徽宗泥金籤題六字相傳為宣
和御府所題

謹以錫晉名臣誌古權且深惜諸跋伏生使秀古者無所謂
乃補書諡晉諸題於後惲寶鑑定時宣統再戊夏日
　　諡晉齋記平復帖
　　陸機平復帖一卷在
壽康宮陳設乾隆丁酉大事後
　　　　　　　　　　恭親王溥傳識

識紙似似蠹蘭造年深頗渝徹墨色有綠意筆力堅
勁倔強如萬歲枯藤與閣帖晉人書不類昔人謂
士衡善章草與索靖幼安出師頌齊名陳眉公謂其
書乃得索靖筆法圓渾如太素玄酒
者今細衡之乃不盡然惟論其筆法似有麓村所記謂此帖大非章
草運筆猶存篆法似為得之矣余不工書而嗜
古成癖間有前賢名翰恆思目玩手摩亦窺尋其
旨趣不意垂老之年忽觀此神明之品歡喜讚
歎心懌神怡串載以來閱置危城西隱王城
懷為之漢釋素雅擅清裁大隱王城
古懼獨契宗元劄蹟精鑑靡遺卜居城西與余衝
宇相望頻歲過從賞奇析異晃晃今者鴻
寶來投蔚然為法書之弁冕墨緣清福非偶
然從此攜持永離水火蟲魚之厄使昔賢精睍長存
於尺幅之中與日月山河而並壽寧非幸歟
物護持永離水火蟲魚之厄使昔賢精睍長存
歲在戊寅正月下澣江安傳增湘識

平復真書北隋元常以後右軍前
慈寶宗殿春秋閱祥手翬縣十四年
　　諡晉齋記書詩
　　古一記二詩共二百八十一字　溥傳年記

晉陸機平復帖墨蹟

此帖本末沅井同年之跋言之詳矣顧尚有軼聞可補為
翁文恭恭記辛巳十月初十於蘭陶翁得見陸平原平復帖
手跡墨筆沈古筆法全是秦籀不如先管制勒且不見
宗高宗題籤董香光籤成親王公府
時母太妃所手授故蘭此籤後傳至治貝勒其府
元今蘇恭王邸以賿蘭孫相國文恭而言如平原巳為光
緒七年是在李文心齋矣何巳又歸恭邸詢之文心長公
子符曾侍郎知帖始歸此帖也
伯駒屬為記此不使後人讀文恭日記者有軼聞也雌
韶諡晉齋詩帖為孝聖憲皇后遺賜而文恭言分府
時母大妃手授則傳聞之誤當為訂正戊寅九月苕雪題
　　椿年識於北京漢魏五碑之館　時年七十有一

高宗為徽宗之誤

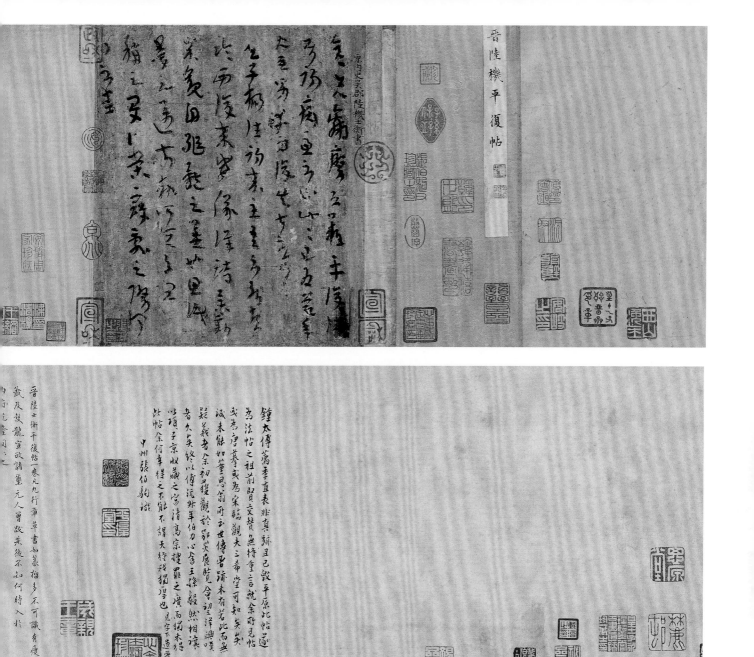

2

Preface to the Orchid
Pavilion Gathering
(copy by Feng Chengsu of
the Tang Dynasty)
—— by ——
Wang Xizhi
—— of ——
the Jin Dynasty

Running script

Ink on paper

Height 24.5 cm Width 69.9 cm
Qing court collection

Wang Xizhi (321–379), a native of Linyi, Langya (in present-day Shandong), served as General of the Right and Administrator of Kuaiji and has often been referred to by his post title as Wang the Right General. As the most accomplished calligrapher throughout the history of China, he has been exalted as the Sage of Calligraphy. His new Wei-Jin regular script marks the evolution of the clerical script into the regular and of the ancient cursive script into the modern. Feng Chengsu (617–672) was an official copyist of the Institute for the Advancement of Literature (Hongwen Guan) during the reign of the Tang emperor Taizong.

On the third day of the third month in the ninth year of the Yonghe reign (353) in the Eastern Jin, Wang Xizhi gathered with Xie An, Sun Chuo, and others at the Orchid Pavilion in observance of the *xiuxi* custom. Poems composed by each and everyone present at the gathering were collected together with a preface written by Wang Xizhi. In the preface, Wang laments the ephemerality of blessings and the transcience of mortal existence. Legend has it that the original calligraphy was buried with Emperor Taizong in the Zhao Mausoleum. The present specimen was ascertained by Guo Tianxi of the Yuan and Xiang Yuanbian of the Ming to be a tracing copy by Feng Chengsu and hence the attribution ever since. It is also known as the Shenlong Version in view of the Tang emperor Zhongzong's seal "*shenlong*" that is left in part at the beginning of the scroll.

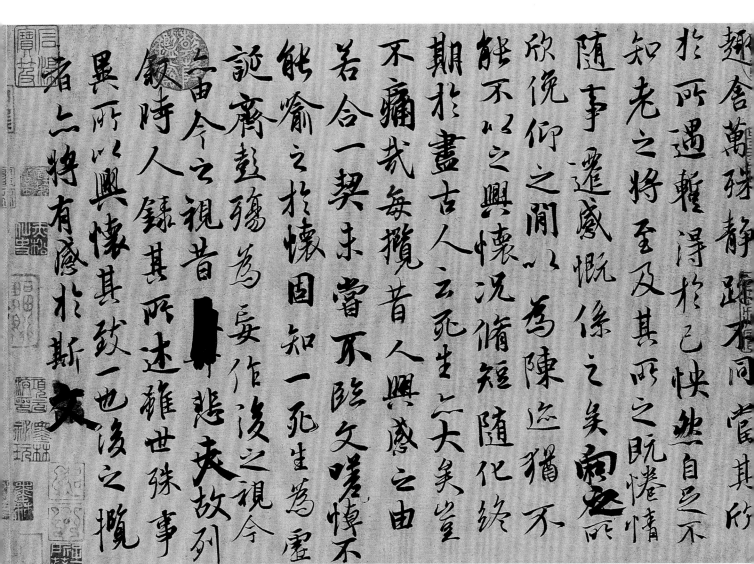

Painstakingly yet deftly traced, the calligraphy is written in increasingly well-spaced columns and mutually complementing characters, exhibiting Wang Xizhi's invigorating diversity and captivating elegance. With the movement of the brush and variation in ink gradation readily perceivable, the present specimen has been considered to be the best tracing copy of the lost masterpiece.

The work is identified as "Tang Copy of the *Preface to the Orchid Pavilion Gathering*" in the front separator. Emperor Qianlong is the inscriber of "the Jin-Tang images of the mind" in the frontispiece and the title slip reading "Third of the Eight Pillars of the *Orchid Pavilion Preface*." To the left of the calligraphy are 24 colophons and viewer inscriptions by Xu Jiang, Wang Anli, Li Zhiyi, and Qiu Boyu of the Song, Zhao Mengfu, Guo Tianxi, Xianyu Shu, Deng Wenyuan, Wu Yanhui, and Wang Shoucheng of the Yuan, and Li Tingxiang, Xiang Yuanbian, and Wen Jia of the Ming. Of these, only those by Guo Tianxi, Xianyu Shu, Deng Wenyuan, Li Tingxiang, Wen Jia, and Xiang Yuanbian are in situ. The rest have been transferred from elsewhere.

Collector seals (numbering more than 180): *Shenlong, Shaoxing, Zhao*, and *Wuxing*; Ming: seals of Emperor Hongwu, Wang Ji, and Xiang Yuanbian; Qing: seals of Chen Ding, Ji Yuyong, and Emperor Qianlong.

Literature: *Coral Nets: Records of Calligraphies (Shanhu Wang Shu Lu), Records of Paintings and Calligraphies, Collected Notes on Paintings and Calligraphies of the Shigu Hall, Spectacles Viewed in a Lifetime, Inspiring Views, Shiqu Notes (Shiqu Suibi)*, and *Shiqu Catalogue of Imperial Collection of Painting and Calligraphy: Series Two (Shiqu Baoji Xubian)*.

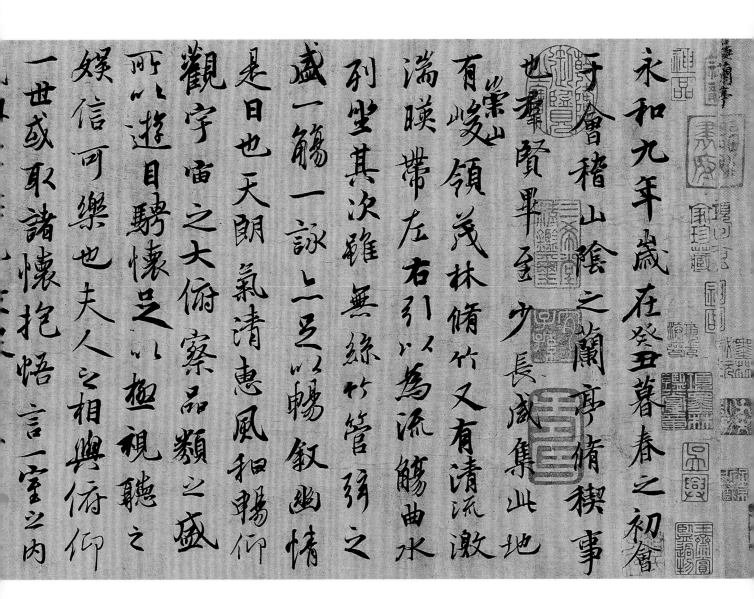

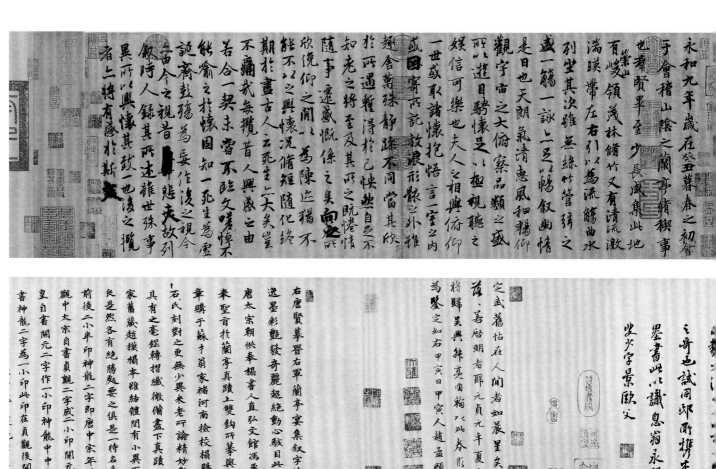

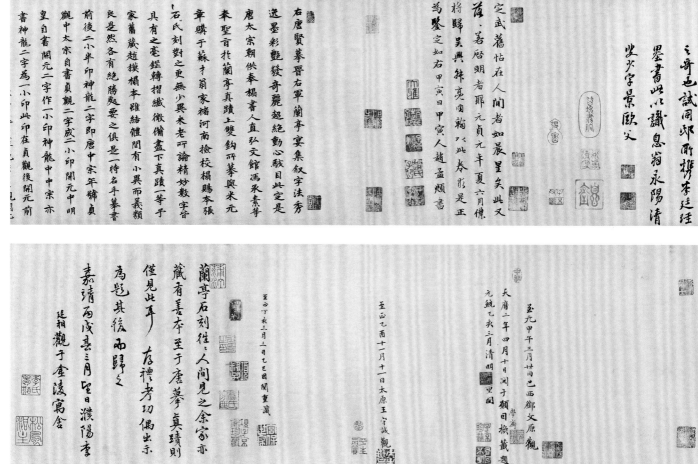

晉唐心印

本乃嘗詩題袖唐時皆依己之石漢寫袰又是倦振而
不乃今看承素卷也看真雖惜已買海欣氣乘聯孫羽郵
設郵懸似秋人用舊題袂卷韻
壬辰暮春月中澣衲題

長樂許將照寧丙辰
益冬開封府西齋閱

臨川王安禮黃慶基
同閱元豐庚申閏
月十日

朱光裔李之儀觀
元豐五年三月二十七日

李祉王景通同觀
王景脩張太寧同觀

元豐四年孟春十日
又同張保清馮澤
繼觀文安王景脩題
仇伯玉朱光庭石蒼舒觀
元豐六年四月廿八日

甲午禊日靜空集賢官房

替爲古世沿共視大寫亂年

君家搨帖許甲乙和璧陪珠價相
斂神龍負觀苦未遂趙莒馮湯摁
名迹主人熊魚兩黃愛彼短馮湯摁
有湩三百廿有七字、龍蛇怒騰擲
吾聞神龍之初黃庭樂毅真迄人力
嗟予到手眼生暉肯毅存焉豈人力
慈此帖消唐萬無一有餘不乏貴相通
古帖消唐萬無一有餘不乏貴相通
欲抱奇書求博易
鮮于樞題

金城郭天錫祐之平生真賞

二月甲午重裝于錢塘廿泉坊居快雪齋
壬子日易政贊曰
神龍天子文皇孫寶章小璽餘半痕驚罷
離：舞泰雲龍驚蕩：跳天門明光宮中
泰曦溫玉案卷舒娛至尊六百餘年今幸
存小臣寧致此璵璠

是御府印書者張彥遠名畫記唐貞觀開元
書印及晉宋至唐公卿貴戚之家私印二詳載
獨不載此印蓋猶搜訪未盡也予觀唐印橫闌
亭兹衆皆無唐代印跋未若此帖印宛然真
述入昭陵橢本中擇其絕肖者似之內府兹本
畫是餘宵不賜皇太子諸王中宗是文皇帝孫
內殿所秘信爲寂善本宜切近真也至元癸巳
藏于楊左輪都尉家傳是尚方資送物是年

爲懇其後兩歸之
嘉靖丙戌春三月望日濮陽李
廷相觀于金陵寓舍

墨林項元汴真賞

唐摹蘭亭眞蹟今凡三本其一在宣興吳氏獨孤
諸名公跋語車馬之見存見今
世不傳好事者不可不知亦藏吳氏一觀也見中
傳世獨此本神龍印二印可寶
褚世南三印神龍本也高宗御
印今只右此本也跋語非一墨

3

Letter on Planting Pine Trees

— by —

Wang Xianzhi

— of —

the Jin Dynasty

Running script

Ink on paper

Height 22.8 cm Width 22.3 cm
Qing court collection

Wang Xianzhi (344–386), a native of Linyi, Langya, was Wang Xizhi's seventh son. The highest official positions he held included General Who Establishes Might (General of Jianwei), Prefect of Wuxing and Secretariat Director. Proficient in various scripts especially the running-cursive, he has been mentioned in one breath with his father Wang Xizhi as the Two Wangs.

With four characters worn off, the specimen is the fragment left of a letter about further planting 800 pine trees for dyke reinforcement and landscaping.

Although a copy, the rendering is after all done with a hard-hair brush, allowing the best approximation of the Jin master's flowing grace.

Collector seals: Southern Song: *Shaoxing*, *Neifu shu yin*, and *jixia qingwan zhi yin*; Ming: seals of Wen Zhengming; Qing: seals of Cao Rong.

Literature: *Catalogue of Paintings in the Imperial Xuanhe Collection*, *Records of Southern Song Chancelleries* (*Zhongxing Guange Lu*), *Collected Works of Dong Qichang* (*Rongtai Ji*), *Notes from the Summer of the Gengzi Year* (*Gengzi Xiaoxia Ji*), and *Fortuitous Encounters with Ink*.

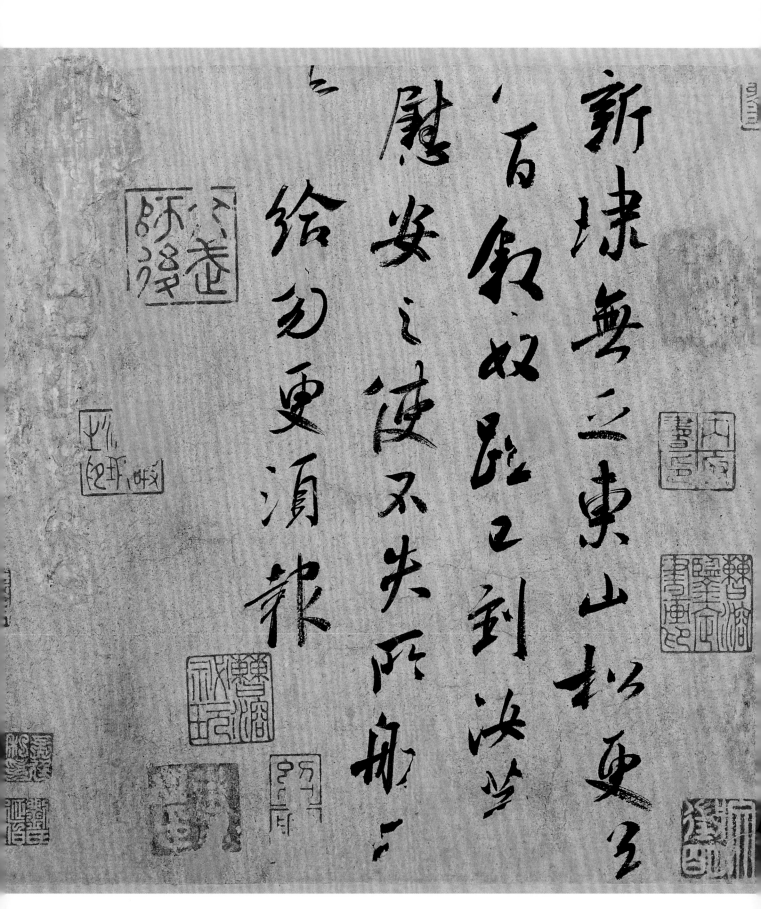

新埭無二東山松更了

百數奴既已到汝等

慰安之使不失所船二

給勿更須報

4

Mid-Autumn Letter
— by —
Wang Xianzhi
— of —
the Jin Dynasty

Running script

Ink on paper

Height 27 cm Width 11.9 cm
Qing court collection

This is the Song calligrapher Mi Fu's incomplete copy of Wang Xianzhi's *The Twelfth Month* with a number of characters dropped, resulting in a total of just 22 characters in the copy compared with 32 in the original. The Qing emperor Qianlong loved it so much that he called it together with Wang Xizhi's *Timely Clearing after Snow* and Wang Xun's *Letter to Boyuan* as the Three Rarities and deposited them in the Hall of Three Rarities (Sanxitang).

The fluid movement, unsparing ink and unimpeded execution are Mi Fu's own, however. Writing with a "*sanzhuo*" brush on bamboo paper came into fashion not until the Song Dynasty and therefore has nothing to do with Wang Xianzhi either.

The frontispiece carries two characters reading "most precious" and a passage inscribed in running script by Emperor Qianlong, who is also the inscriber of the title slip reading "*Mid-Autumn Letter* by Wang Xianzhi of the Jin." At the end of the scroll are colophons by Dong Qichang and Xiang Yuanbian of the Ming and Emperor Qianlong of the Qing. Inserted between colophons are two paintings, one by Emperor Qianlong and the other by Ding Guanpeng.

Collector seals: Song: *Xuanhe, yushu, Shaoxing, Hongwen zhi yin, Xianzhi Zhuren,* and *Guangrendian*; Ming: seals of Xiang Yuanbian and Wu Ting; Qing: seals of Emperors Qianlong and Jiaqing; Modern: seals of Guo Baochang.

Literature: *Catalogue of Paintings in the Imperial Xuanhe Collection, The Qinghe Boat of Painting and Calligraphy, Seen and Heard in Qinghe (Qinghe Jianwen Biao), In the Qinghe Private Chest (Qinghe Miqie Biao), Coral Nets: Calligraphy Inscriptions (Shanhu Wang Shuba), Spectacles Viewed in a Lifetime, Collected Notes on Paintings and Calligraphies of the Shigu Hall, Inspiring Views,* and *Shiqu Catalogue of Imperial Collection of Painting and Calligraphy: Series One (Shiqu Baoji Chubian).*

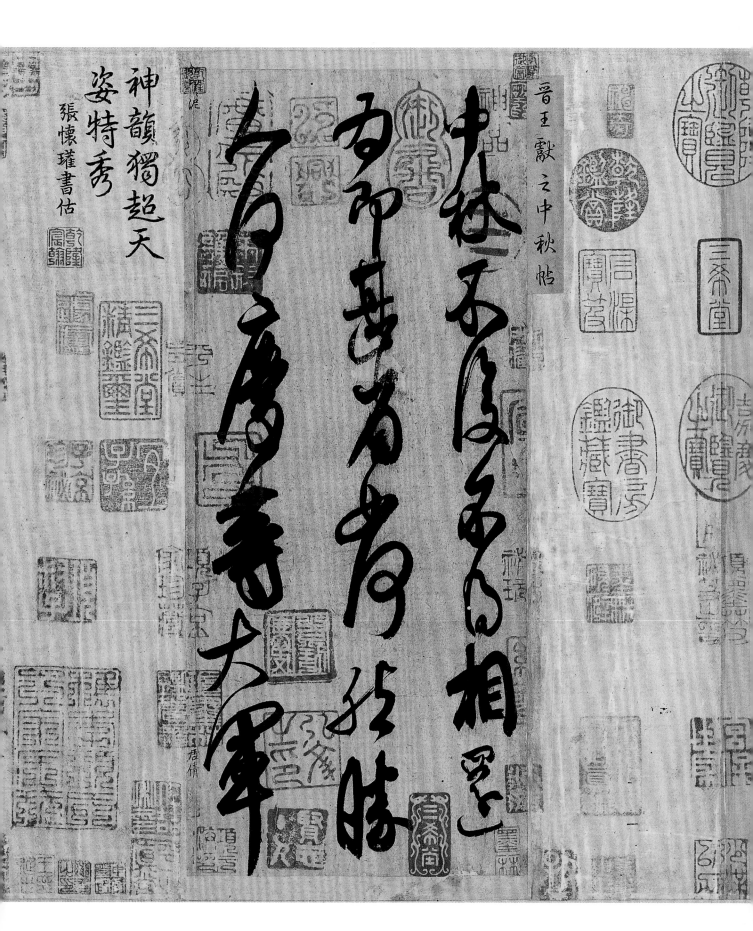

晉王獻之中秋帖

神韻獨超天
姿特秀
張懷瓘書估

29

Letter to Boyuan

by

Wang Xun

of

the Jin Dynasty

Running script

Ink on paper

Height 25.1 cm Width 17.2 cm
Qing court collection

Wang Xun (349–400), a native of Linyi, Langya, was Wang Dao's grandson and Wang Xizhi's distant nephew. Ennobled as Marquis of Dongting, he was the holder of such positions as Bulwark-general of the State, Governor of the State of Wu, Vice Director of the Department of State Affairs, and Director of the Department of State Affairs. His achievement in literature and the running-cursive script has earned him the epithet of the Sage of the Cursive Script in the *Catalogue of Paintings in the Imperial Xuanhe Collection*.

This letter is the only signed specimen of all extant Wei-Jin masterpieces and the only authentic one among the Three Rarities in the Qing imperial collection.

Vigorous, refined, and free of affectations, the calligraphy embodies heavy tinges of the clerical script, attesting to the evolution of the clerical script into the regular that was taking place in the Eastern Jin and typifying the style of the period.

Emperor Qianlong is the inscriber of the four-character inscription in running script, meaning "Charms of Eastern Jin," and the title slip "*Letter to Boyuan* by Wang Xun of the Jin." To the left of the calligraphy are colophons by Dong Qichang and Wang Kentang of the Ming and Emperor Qianlong and Shen Deqian of the Qing, together with a painting by Dong Bangda, who was also from the Qing.

Collector seals: seals of the Qing emperors Qianlong, Jiaqing, and Xuantong, *Guo shi Zhizhai miji zhi yin*, *Fanyang Guo shi zhencang shuhua* and *Guo Baochang yin*.

Literature: *Catalogue of Paintings in the Imperial Xuanhe Collection*, *Notes from the Zen Painting Studio (Huachanshi Suibi)*, *Spectacles Viewed in a Lifetime*, *Fortuitous Encounters with Ink*, *Collected Notes on Paintings and Calligraphies of the Shigu Hall*, and *Shiqu Catalogue of Imperial Collection of Painting and Calligraphy: Series One*.

珣頓首頓首伯遠勝業情

期群從之寶自以羸患

志在優遊始獲此出意

不剋申分別如昨永為

遠隔嶺嶠不相瞻臨

古遠

晉賢真跡惟

尚有存者然米南宮時

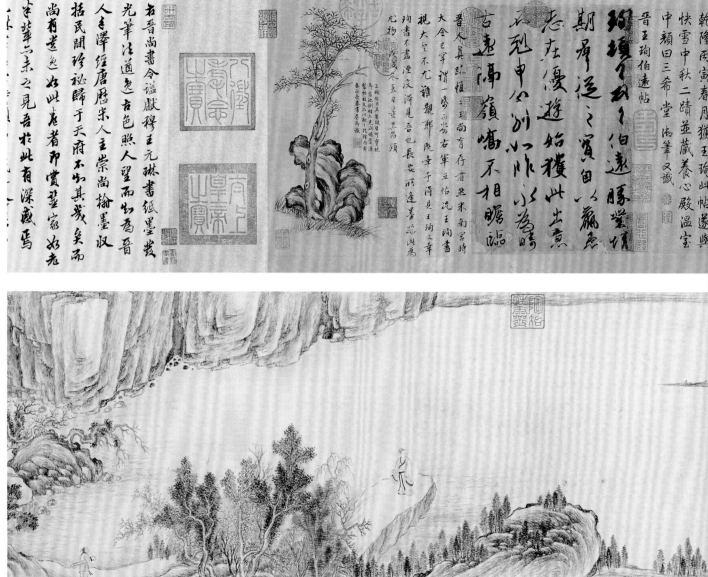

江左風華

唐人真蹟已不可多得況晉人邪
內府兩藏右軍快雪帖大令中秋
帖皆希世之至今又見王旬中屬

家學世范　學重奇傳
宣和書譜

尚有逸……如此卷者即賞鑒家如吾……老
本華六宋之見吾於此有深藏焉
元琳書名當時頗為市珉所擠故為之
語曰法渡非不惟僧弥爾難為兄弟……
小字伯珉小字……此帖之遠……近世
王穉登山人……乃……
謂是正老十二月王彰寫吳新宇中
秘出不留賞信宿書八歸之
延陵王肯堂

三希堂歌
江左風流數王氏司遠渡江後多聞人義秋父

工既以王氏三帖貯三希堂
詔臣遠繪為圖又以此伯遠一
命補其空臣謹按札中有走左
札卷屁餘紙……
優遊及遠陳嶺幡語……
沸情景在林下藏得之致
偏念希世奇瑜屢得附名
其後臂策之榮寔瑜踰……
臣董邦達謹畫敬記

6

Eulogy on Dispatching the Troops

— by —

Anonymous

— of —

the Sui Dynasty

Hand Scroll, draft-cursive script

Ink on paper

Height 21.2 cm Width 29.1 cm
Qing court collection

Composed by Shi Cen of the Eastern Han, the tetrasyllabic verse eulogizes an Eastern Han expedition led by Deng Zhi against the Qiang people. Textually slightly discrepant with the version adopted in *The Zhaoming Anthology of Literature* (*Zhaoming Wenxuan*), this specimen was ascertained by Mi Youren to be written by a Sui worthy, implying that the calligraphy is meritorious despite the anonymity.

Skilfully structured and executed, the draft-cursive script is more untainted than Lu Ji's *Letter on Recovery*, more normalized than the cursive script in Jin bamboo slips, more akin to the regular-running and modern cursive scripts than Huang Xiang's *A Primer*, and more archaic than the cursive script of the Tang Dynasty. Stylistically, this rare gem in the draft-cursive script relates itself to the Sui monk-calligrapher Zhiyong's *Thousand-Character Essay* in cursive script.

The two-character inscription reading "Jin Ink" in seal script in the frontispiece corresponds with the period style of the Yuan Dynasty. The Song imperial seals including Gaozong's *jiuwu zhi zun* and the signature mark *wu* are all faked. At the end of the scroll are colophons by Mi Youren of the Song, and an anonymous inscriber and Zhang Dashan of the Yuan.

Collector seals: seal of the Tang princess Taiping (in Sanskrit), Wang Ya's *yongcun zhenmi*, *Neifu Mishu zhi yin*, *lidai yongbao*, *Jianshuhua boshi yin*, *Langya Wang Jingmei shi shoucang tushu*, and seals of An Qi and Qing emperors Qianlong, Jiaqing, and Xuantong.

Literature: *Fleeting Delights for the Eyes* (*Yunyan Guoyan Lu*), *Subsequent Manuscripts by Wang Shizhen* (*Yanzhou Shanren Gao Xugao*), *Zhan Jingfeng's Personal Viewing Notes*, *Records of Paintings and Calligraphies*, *Inspiring Views*, *Fortuitous Encounters with Ink*, *Shiqu Catalogue of Imperial Collection of Painting and Calligraphy: Series Two*, and *Shiqu Notes*.

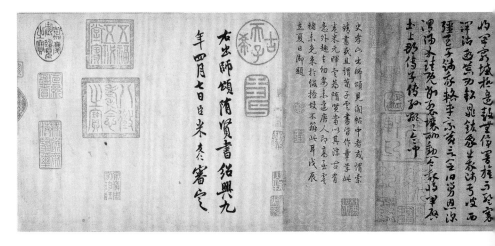

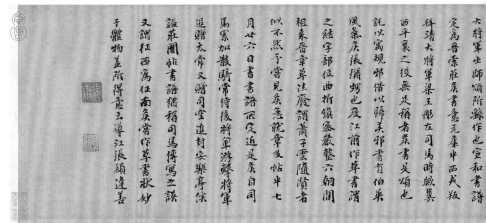

Zhang Han

by

Ouyang Xun

of

the Tang Dynasty

Regular-running script

Ink on paper

Height 25.1 cm　Width 31.7 cm

Qing court collection

Ouyang Xun (557–641), a native of Linxiang, Tanzhou (present-day Linxiang, Hunan), successively served the Southern Dynasties, Sui, and Tang courts as Director of the Court of the Watches and Academician of the Institute for the Advancement of Literature. Ranked among the four leading calligraphers of the early Tang, he was most accomplished in the regular and running scripts. His elongated characters are atypically and stringently structured, amalgamating the Two Wangs' gracefulness with the robustness of Northern steles. So individual is the style that it has been specially named after the calligrapher.

The text tells the story about Zhang Han's resignation from the civil service on the pretext of homesickness to evade calamities, which is also documented in *The Book of Jin* (*Jinshu*) and *A New Account of Tales of the World* (*Shishuo Xinyu*).

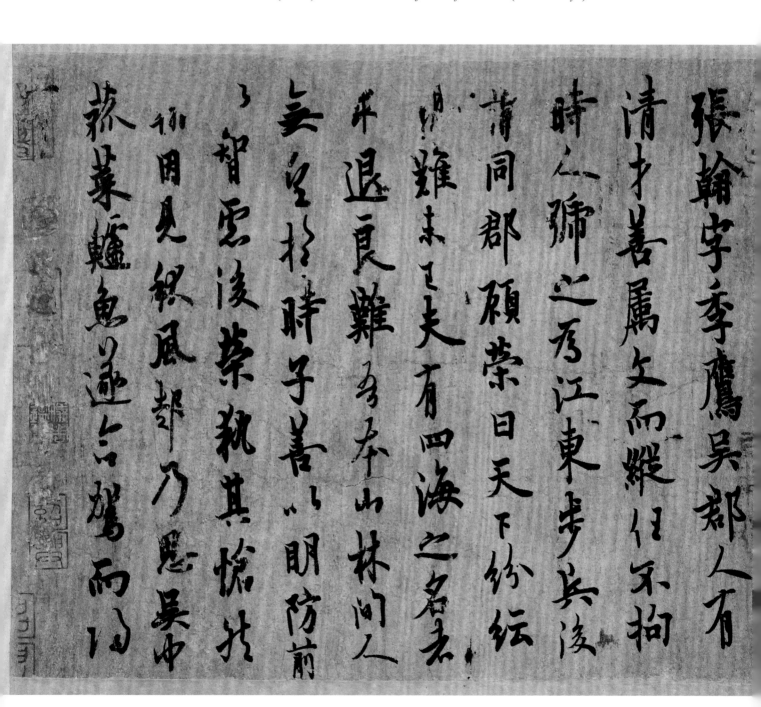

This tracing copy manifests Ouyang Xun's hallmarks in the elongated characters, vigorous brushwork, idiosyncratic treatment, and borrowings from Wang Xizhi.

Opposite to the calligraphy is an unsigned inscription in slender gold script, probably by the Song emperor Huizong in his early years.

Collector seals: *Shaoxing, Yizhou jiancang, Chaoxian ren*, and *An Qi zhi yin*. Qing imperial seal marks and inscriptions by Emperor Qianlong have been scraped off.

Literature: *Catalogue of Paintings in the Imperial Xuanhe Collection, A Mounter's Random Notes (Zhuang Yu Ou Ji), Collected Notes on Paintings and Calligraphies of the Shigu Hall, Inspiring Views, Fortuitous Encounters with Ink*, and *Model-calligraphies of the Hall of Three Rarities (Sanxitang Fatie)*.

Bu Shang

— by —

Ouyang Xun

— of —

the Tang Dynasty

Regular-running script

Ink on paper

Height 25.2 cm Width 16.5 cm

Qing court collection

Bearing some discrepancies from the version in *Collection of Literature Arranged by Categories* (*Yiwen Leiju*), the enlightening text is an excerpt from *Amplification of the Book of Documents* (*Shangshu Dazhuan*) in which Bu Shang discusses the significance of studying the *Book of Documents* (Shangshu). Bushang, also named Zixia, a native of the state of Wei in the Spring and Autumn period, was one of Confucius' disciples.

This unsigned tracing copy is unmistakably after the style of Ouyang Xun and is even more elaborately and dexterously made than *Zhang Han* is.

Collector seals: (two characters illegible) *zhi yin*, *An*, and *Yizhou jianshang*.

Literature: *Catalogue of Paintings in the Imperial Xuanhe Collection*, *A Mounter's Random Notes*, *Collected Notes on Paintings and Calligraphies of the Shigu Hall*, *Inspiring Views* and *Fortuitous Encounters with Ink*.

閒讀書畢見孔、李
二何者作書商日事、
論素略、如日月之代明、雖
雖如象辰之錯行、借所商所
於夫子、脂志之於弟敢忘
也

9

Samantapāsādikā

—— by ——

Guo Quan

—— of ——

the Tang Dynasty

Hand Scroll, regular script

Ink on paper

Height 22.6 cm Width 468.8 cm
Qing court collection

Guo Quan (dates unknown) was a sutra copyist during the reign of the Tang emperor Taizong. His calligraphy resembles Yu Shinan and Chu Suiliang in style. Consistent in brushwork, neat in structure, and well-versed in brush methods, the specimen shows admirable eradication of the formulaic tendencies that were common among Six Dynasties sutra copyists.

Samantapāsādikā is one of the five major commentaries on the *Vinaya Piṭaka* in the Theravadan Buddhist tradition. The scroll begins with the title "*Samantapāsādikā*" and is signed at the end with "Written by Guo Quan on the tenth day in the 12th month of the 22nd year of the Zhenguan reign (649)." This is followed by a list of proofreaders, mounters, and supervisors, providing clues to the production process. Considering the involvement of prominent figures like Zhao Mo and Yan Liben, the sutra copy may have been an imperial undertaking for gaining merit.

The specimen was in the Southern Song and Qing imperial collections. A total of nine colophons and viewer inscriptions by Zhao Mengfu, Ni Zan, Xing Tong, Dong Qichang, and others can be found on the colophon paper.

Collector seals: *Shaoxing, Jixidian bao, Zhaojun Su, Jiahe Wu Zhong yin, Yan shi jiacang, Shi Degui yin, Chen shi zizisunsun yongbao zhi, Hua Xia, Wu Shifang yin, Yunjian Wang Hongxu jianding yin* and Qing imperial seals.

Literature: *Zhan Jingfeng's Personal Viewing Notes* and *Pearl Forest in the Secret Hall: Series Two* (*Midian Zhulin: Xupian*).

想比丘或緣餘事行来相觸非故觸如想无

罪不知者若女人作男子裝梳比丘不知

者无罪不受者若眾多女人共捉比丘不受

樂无罪眾初末制貳顛狂心亂无罪苐二僧

伽婆尸沙廣說竟

令次随結磨觸貳從身心起二受樂不苦樂

是名二受念母者以念故觸母身突吉羅女

姊妹亦如是何以故女是出家人怨家若

母沒溺水中不得以手㧞取若有智慧比丘





犯夢有四種一者四大不和二者先見三者
天人四者想夢問曰云何四大不和若夢見
四大不和夢者眠時夢見山崩或飛騰虚空
或見虎狼師子賊逐此是四大不和夢若
女夜夢見而夢者或晝日見或四大不和夢
人現善夢見而夢者令人得善惡想天
現惡夢真實想夢者現善夢者慮不實天人
有善知識天人前身若夢見山者想夢也或
有惡知識天人亦想夢法師曰四大不和夢
佛誦經戒布施種種功德此是想夢也若
此夢夢中能識不為想也答曰亦不眠亦不
譬者言眠見夢者於阿毘曇有達若言覽見夢
見欲事與眠律有達問曰有何達夢中无罪
事无人得脱罪又律中說唯除夢中无罪若
如此者夢見赤白青黄色此是无記何以故如
眠備多羅夢即盧也答曰不虚何以故如彌
若尒者應受果報若夢中人夢如彌
眠中說佛吉大王世聞人夢如彌
心業羸弱故不能感果是故律中說雅除
夢中殘者故不受果報何以故夢如
尸沙者殘也問曰云何僧伽婆尸沙僧伽
已得罪樂欲清淨往到僧所僧與波利婆
法中僧伽婆尸沙者何僧也答曰初
有善者僧伽婆尸沙若僧也答曰以
眠是故有夢問曰夢善耶為无記耶答曰以
法師曰但取義味不須究其文字此罪僧
能治非一二三人故名僧伽婆尸沙若得故
出精罪應知方便時想應知方便者我令出

中段（右起）

故得突吉羅罪若至境界得波羅夷罪若根
已貪綱滑不入戒罪竟境界得僧伽婆
尸沙罪是名欲樂綱樂者或内綱或外綱内
者我以手試為强為輕因綱故精出不犯若
有出心貪樂得罪是名内綱外綱者俱
綱故得僧伽婆尸沙綱若綱綱樂出精俱
抱之精出者无罪若綱綱樂或癃或疾蟲綱
得罪癃者或抱或摩綱細滑精出而敷視得
心綱女身或抱或摩綱精出犯罪若男根起以
僧得僧伽婆尸沙罪或見女根起而敷視得
樂者若比丘根起因勢動出犯罪若見
樂得餘罪若坐欲心起因動腰得僧伽婆尸
沙罪是名坐樂問曰靜寞得僧伽婆尸沙女
根古何為曰黑為瘦作如是語精出
與女人於靜寞坐共語者與女人於靜寞汝
出罪因瘑惡語得僧伽婆尸沙罪若語有
或以香華檳榔更相往還綱極香美我令綱
何以故香華檳榔皆從林出故名折林若
女人若綱家起念故或母或姉妹以手澽或
還檳越家以念故或母或姉妹以手澽或
抱精出不犯因綱故得突吉羅罪若摩澽
此大德令我比丘開此已欲起精出不犯若
因便故此罪又因不出得偷蘭遮罪法師
曰是名十一二此比尼師善觀諸病授藥病
輕若重言輕者如律本所治者若无罪若
如是作善聲如醫師善觀諸病隨病授藥病
者得愈醫師得賞故此不净者如為初心
樂出而不弄不動若精出有罪除夢中者若
出心无罪有出心有罪若精出不净何以
與女人共作婬事或夢共抱其眠如是欲法

下段（右起）

著衣突吉羅比丘以繩縛女人衣突吉羅若
丘以衣達縛衆多女牽去偷蘭遮中央女不
一一僧伽婆尸沙中央女不著偷蘭遮比
尸沙若衆多女聚在一處若摣根計女多少
人二僧伽婆尸沙若根衆多女聚在一處
作畜生想突吉羅二女者如是為初若根二
想突吉羅男子作人女想作畜生想偷蘭
偷蘭遮黄門疑突吉羅男子作黄門作黄門
伽婆尸沙人女作人女想偷蘭遮人女想僧
蘭遮人女作黄門想偷蘭遮人女想僧
若衣穿著肉僧伽婆尸沙若障翳路根偷蘭
僧伽婆尸沙若根置女人去一由旬不動
手得一僧伽婆尸沙若置更根隨得隨偷蘭
者還離其身根將著女人去一由旬不動
作不置得一僧伽婆尸沙人女者就其所盜
為不置得一僧伽婆尸沙一日僧伽婆尸沙
根多少一一僧伽婆尸沙悲僧伽婆尸沙
亦如是伍綱者從頭而嗅隨至頭
根者置根乃至一伍綱者從兩至脚底
以一手摩綱乃至一手得從兩至脚隨
根置更根隨得隨偷蘭遮根置隨

尒時世尊遊舍衛城尒時者為聲聞弟子結
戒時非世間時也遊者有四何謂為四一者
行二者住三者坐四者卧以此四法是名遊
辟如世人言王出遊若到戲處或行住坐卧
佛遊舍衛城復如是若到舍衛又名多有何謂
有道士居住此地住古有王見此地好就道
士乞為立國以道名号為舍衛也昔
昔有轉輪王更相代謝心住此城多有王故
号為舍衛此云多有亦復如是舍衛又名多有
有諸國珍寶及雜異物皆来歸聚此國故名多有

含衛甚微妙　觀者无厭足
豐饒多珍寶　猶如帝釋宮
心音樂聲　音中喚飲食

迦留陀夷者是比丘名也欲意熾盛者為欲火
所燒故顏色憔悴身體損瘦法師曰次苐文
句易可解耳不湏廣說若有難慶我今當說
亂意睡眠者以不定慧心此睡眠也若此睡
眠先念其時其時當起如傭作人若至其
某當起若某當起如是眠亦應知時月至其
諸比丘若汝洗浴竟欲眠當念我當念初
㸦於十善法中一一随心所念而眠此
㸦比丘不作是念而眠者故是念弄出
不淨除夢中者是故法師曰律本說唯除夢
與夢俱出何以夢若如律本中說佛
業不制意業是以夢中无罪故弄出
吉諸比丘汝當作如是說弃罪故出精

能治非一二三人故名僧伽婆尸沙若得故
出精罪應知方便時想應知方便者我今出
內色欲出外色俱出內外虛空中動如是方
便故名方便出起時有五種一者欲起時二
者大便起三者小便四者風動五者蟲觸是
名五種若欲出男根便強堪用過此時不
起病者如是亦如是復有十句初內色為初
者如是二者初內色與外色為初亦有十二
律本中說戶孔為初赤无內色外色自動故得罪
蟲者蟲身有毛若觸痒而起生天或作裁若
作藥或布施或祠祀或試或以生天或作裁
種者作藥如是者皆悲得罪故出精而不出不得罪
解若僧伽婆尸沙罪若者故出精離本慶
得自添出非故出者亦无罪法師曰次句易
解若比丘得罪往至毗尼師所毗尼師次苐
問我言勑勿覆藏我如醫師病者
而可責言師无驗而假言脚痛醫師誤藥病亦不差
即先勑勿覆藏先黠脚痛設藥是故汝可一一
向我說若重結重若輕結輕若
一欲十一方便問曰何謂為十一欲苦曰一
者樂二者正出樂三者巳出樂四者欲樂五
者纜樂六者癢樂七者樂八者坐樂九者
語樂十者見樂十一者折林也樂八者坐樂
若比丘欲心時起樂欲故出精出精得僧
伽婆尸沙若非故出者亦无罪故出精得僧
比丘心想而眠先作方便以脚夾或以手握
根作想而眠夜夢精出得僧伽婆尸沙罪若
欲起觀不淨心觀之心清无垢而
眠若夢精出樂出而减之心清无垢而
比丘眠而夢精出者是名樂出而覺而名
眠精不樂作欲事出而正出自念言
出无罪若匠出而動者得罪若正出自念言
勿汙衣席不樂出而以手捉塞將出以
外洗无

出心无罪有出心有罪除夢中者若比丘夢
與女人共作姓事共抱其眠如是法
以手捉往至洗慶不犯若根有瘡病以油塗
之或種種藥磨不樂精出兩際夾犯罪若
次苐汝自當知若精出无罪若匠出而覺有智
慧比丘若眠夢慎莫動善若精出无罪若
此比丘眠夢出无罪匠出而覺如人精
出无罪稟初未制戒不犯苐一僧伽婆尸沙
說竟
尒時佛住舍衛國祇樹給孤獨園精舍法師
曰我今當知於阿蘭若有難解
者若我前巳解此磨觸若有難若阿蘭
震所以非真阿蘭震所以作非真在給孤
獨園精舍後林中故名阿蘭若此比丘房四
面周圓精舍中住震善莊嚴者其中巧妙種種
莊飾治欲謀人不思善法一徧開一
窻餘震當開若開此窻開餘窻此震復開如
是語巳婆羅門尼自念言此婆羅門意欲樂
出家應覆藏而發露者所以發露者欲遮婆
羅門出家心故何震高德作如是惡事欲高德
者姓貴德高亦言大富貴姓女者有夫女人
或无夫女或无子女姓亂慶心者心變欲入身
如夜又鬼人心故黑赤如老象溺泥不能自
或姓貴德高亦言大富貴姓女者有夫女人
著亦如其兒身猶溫未燥如此始生若亦何
時生也其兒身猶溫未燥如此始生身亦何
况長大根本為初磨觸細滑此是惡行也是
故律本中說若捉手法師曰今當廣說手者是
名為手踝者踝淺无難若觸苦苦之處至爪亦

樂无罪眾初未制是顛狂心亂无罪是第二僧
伽婆尸沙廣說竟
今次隨結磨鬬武從身心是二受藥不苦樂
是名二受念母者以念鬬母身突突女
姊妹亦如是何以故女人是出家人怨家若
母溺水中不得以手撈取若得有智慧比丘
以船接取若无竹木繩杖接取若得母捉袈裟
母怖畏多罪僧接亦得至岸母捉袈裟
繩杖脱袈裟裟而已若至岸母捉袈裟
巳比丘以相牽袈裟裟一切无常令巳得
巳比丘向母言檀越莫畏一切无常令巳得以
活何足追怖若母因此溺勢遂死比丘得以
手捉纜縷无罪不得棄擲若母於泥井中沒
亦如是女人所用衣服一切不得捉若突
吉羅唯除布施得取若寶若人布施隨賣用一切殺
不得捉若捉突吉羅若人布施隨賣用一切殺
得捉若捉突吉羅阿此十種寶
車輦馬珂珊瑚唐珀金銀瑠璃阿此十種寶
是真實作堂比丘欲說法得上坐住无罪悉
若比丘往戰鬬處見此是褰掃器伏先打壞
然後拾取若得楷破作權用一切樂用
一切器伏與眾僧不得賣雖末成者得捉若
人施得未成器猶是朴得捉若人布施者
得隨意賣夜又尼句者乃至他化自在天夫
人亦不得捉若捉偷蘭遮法郵欲弟父句
易可辭耳

守律共見律堂
為秋崖設教
前集贖待制馮
子振奉
皇姊大長公主命題

東海倪瓚觀

國詮書法頗精嚴
卷末題衙識老閣
善見誰能依釋武
平生書律歌相无
　　　　趙巖

國詮書是爾時尊宗粹教
奉戴俱命善書者即趙模
閣志本臨書高甸觀帝鄭
重此李真李唐一大文敕也
敢言公版中亦用三公為證墨
氣氛可擬拾卷膽小能大足
簡中偈語均可寶耳
奉佛弟子潾南郡佩謹書

士顧寬堂再見之法傳入
新安汪宗孝手三十年
姑收之筐筥觀其行華
結撰皆褚家所敢望也以
宗以後書家所敢望也以
趙文敏正書校之當有
古今之隔讀者不昧斯
　語　葑里圖跋時年八十

天啓甲子仲春之月董宗伯訪余
雛翠山房出此善見律相示東時余
方與宗伯和會靈飛紅未暇及也崇
禎戊辰宗伯乃以此律來易靈飛經
以去余徒以此律有之吾家仲因不
意仲因文以之提質廋庫也至午十月余
從都門還續向頂庫贖回計終始所
費已叁百余矣憶三十年間真陰實撲
指不勝屈兩此律仍歸吾篋陶神物
原有呵護不以物聚于所好也後之
人善寶之
　丙申閏五月櫟社老人識

著衣突吉羅比丘以繩縛女人衣突吉羅若
女人次革坐膝膝相著比丘捉著上頭第一
女僧伽婆尸沙餘女突吉羅若合捉衣第一
女偷蘭遮第二女突吉羅第三女以下第一
若磨觸女人廯厚爪相著偷蘭遮若女人細薄衣
毛出磨觸僧伽婆尸沙僧床隨毛著一突吉
多罪如赤身坐臥衆僧床隨毛著一偷蘭遮
相著毛毛相繫為得一罪為得衆偷蘭遮何以故無
覺觸故法師曰以繩相繫得一罪為得衆羅此女不染一偷蘭遮不得多羅今說往昔
羅漢偈

震想又觸欲　真實無孤裝如律本中說
擾者女人也想者是女想欲者磨觸細滑欲觸　重罪汝當知
者知觸女人身具如此事得僧伽婆尸沙餘
者偷蘭遮若有欲心觸磨觸女身得僧伽婆尸沙
沙若無心觸突吉羅女以青衣覆身
而眼比丘欲心誤得女人身悲突吉
眠比丘欲心觸磨衣得女人身悲突
吉羅若女人共比丘一麠坐女不婬欲心
沙次至掩句者無女想以手掩女人身悲突
吉羅觸磨觸比丘有欲心動身僧伽婆尸沙
來磨觸僧伽婆尸沙動身僧伽婆尸沙
洗法師曰如是次第黃門男子畜生罪有輕
重汝自當知若女人掩比丘比丘以欲心受
不動突吉羅若女或打栖比丘比丘以
欲心喜受突吉羅比丘以形想欲心或
橫目或動身動手動足種種想形相變心
悲突吉羅比丘以欲心動身僧伽婆尸沙
身不動突吉羅若比丘有欲心
重汝自當知若女人羊
少力故者臨行姪時比丘覺方便求走得脫無
所作者不故者臨行姪時比丘覺方便求走得脫
罪不故者臨行姪時比丘竟方便求走得脫無
推盪牽挽今解得脫一切不犯若女人羊
種種飲食相觸無罪無想者比丘於女人無

僧後讀律不守律

余十年前於吳中獲此卷蓋
貞觀間團搨書有褚以陸徐風
後有署銜趙模搨立本皆在
焉皇慶二年歸之蘭谷請善
藏之次年四月廿九日子昂書

易可解耳

奉佛弟子濟南郡侯信謹書

貞觀廿一年十二月十四日圀詮寫
用大麻紙七張二分
淨住寺沙門道意初校
會昌寺沙門法倫再校
古兩府錄事參軍事趙模監
門下坊主事臣馮紹智監
左武衛倉曹參軍事靈守勤監
銀青光祿大夫行祕令臣閻立本總監

崇禎丁丑秋日觀于
羽琌樓悶初

趙榮祿家藏唐人國詮奉敕手
書善見律一卷而稱其書法有
褚薛徐家風以歸蘭谷命善藏
之其鄭重若此況後有御史署
銜兩時趙模搨立本皆與之同事
蓋太宗營敕虞褚書經搨帖至
今傳於世則國與褚薛端云驚名
可知也余舊藏蘭亭褚模廛
去歲生國詮搨後有藕來二五
題識評其書法當在庭海上
之上觀此卷信不誣矣　董善賓

龍江徐霖敬題

Shangyang Terrace

— by —

Li Bai

— of —

the Tang Dynasty

Running-cursive script

Ink on paper

Height 28.5 cm Width 38.1 cm

Qing court collection

Li Bai (701–762), whose ancestry originated from Chengji, Longxi (present-day Qin'an, Gansu), and resettled in Suyab (in present-day Kyrgyzstan), a garrison of the Anxi Protectorate during the Tang Dynasty, was a great poet meriting the honorific of the Immortal Poet. Also adept in calligraphy, he led a vagrant life, relishing wine and poetry. His appointment as Academician in Attendance since the first year of Emperor Xuanzong's Tianbao reign (742) was curtailed by slander, resulting in his banishment out of the capital. The genius eventually died of illness.

The calligraphy is a self-composed tetrasyllabic quatrain signed as "Li Bai at the Shangyangtai. The 18th day." This only surviving masterpiece by the Immortal Poet overwhelms with its unrestrained and unsubtle execution. The open brush is allowed to show even at the end of strokes that continue on to the next, half visible and half suggested.

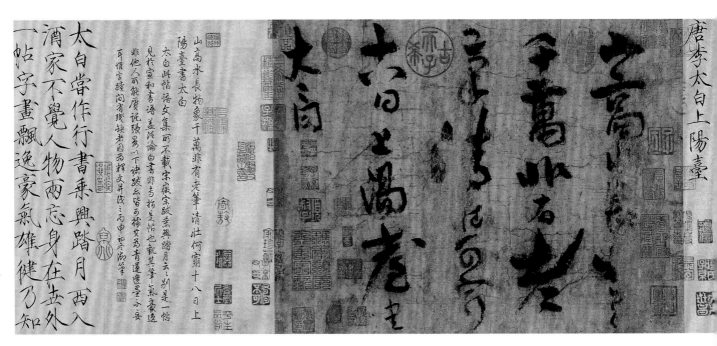

The frontispiece is inscribed in regular script with four characters by the Qing emperor Qianlong to read "Li Bai's untrammelled calligraphy." Next to the top right of the calligraphy is a title slip inscribed in slender gold script by the Song emperor Huizong reading "*Shangyang Terrace* by Li Bai of the Tang" To the left of the calligraphy are colophons and viewer inscriptions by Emperor Huizong of the Song, Zhang Yan, Du Ben, Ouyang Xuan, Wang Yuqing, Wei Su, and Zou Lu of the Yuan, and Emperor Qianlong of the Qing.

Collector seals: *Zigu*, *Yizhai*, *Qiuhe tushu*, *Zhang Yan siyin* and *Ouyang Xuan yin*; Ming: seals of Xiang Yuanbian; Qing: seals of Liang Qingbiao and An Qi, and imperial seals; Modern: seals of Zhang Boju.

Literature: *Fortuitous Encounters with Ink*, *Wu's Records of Painting and Calligraphy* (*Wu Shi Shuhua Ji*), *Spectacles Viewed in a Lifetime*, *Shiqu Catalogue of Imperial Collection of Painting and Calligraphy: Series One*.

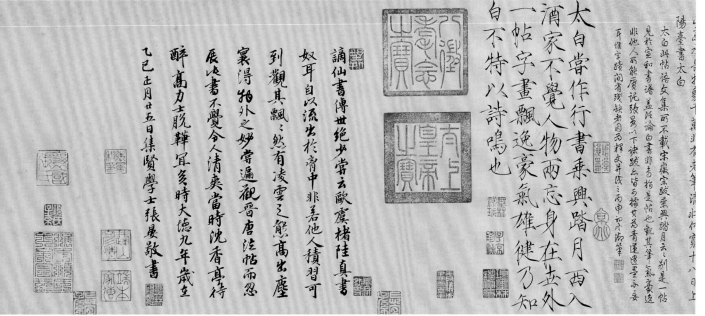

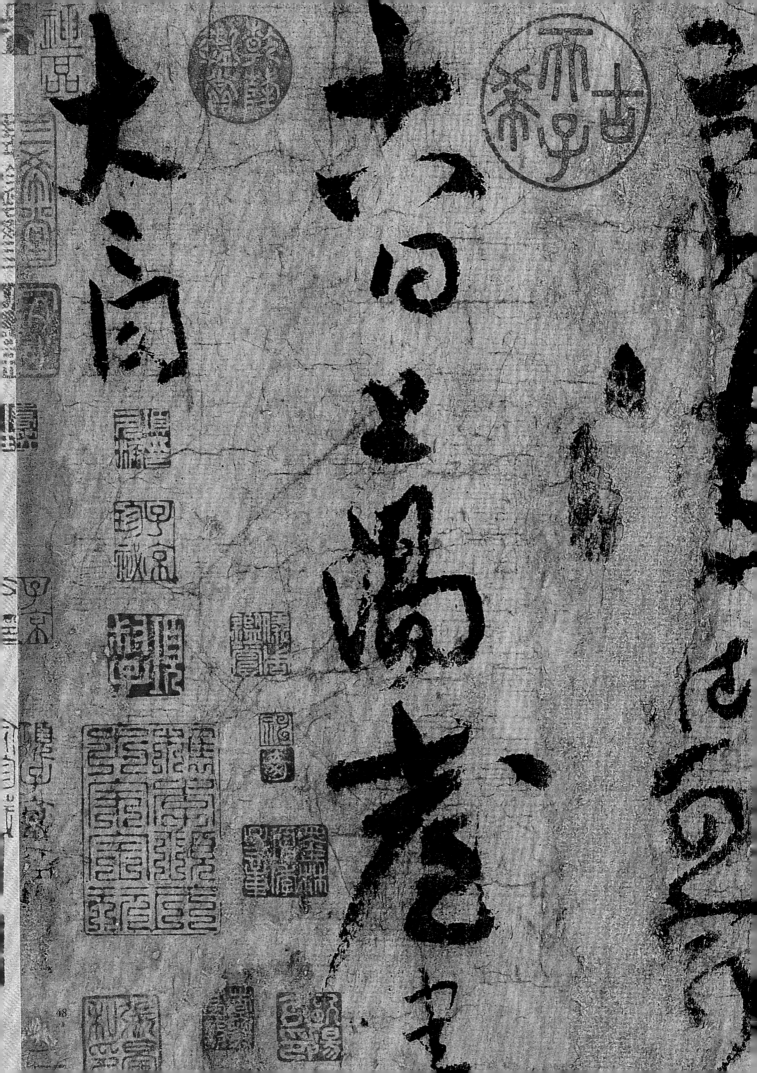

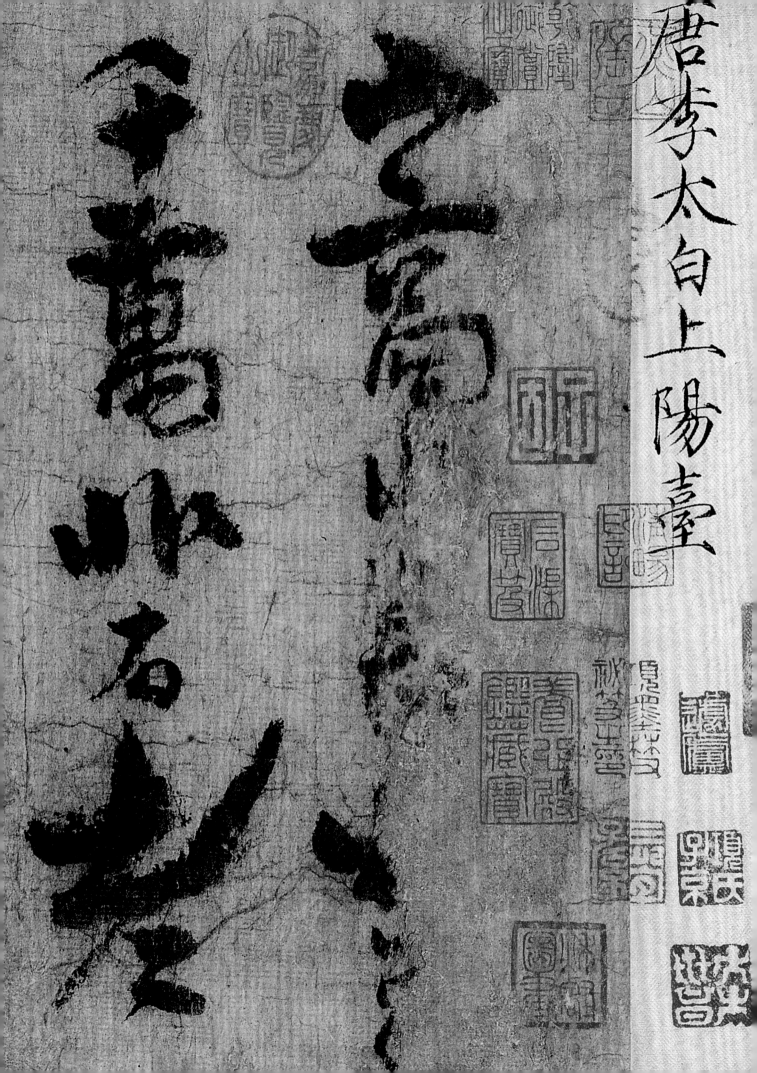

11

Collaborative Chain Poetry of the Zhushantang

by

Yan Zhenqing

of

the Tang Dynasty

Album of 15 leaves, regular script

Ink on silk

Each leaf: Height 28.2 cm Width 13.7 cm

Yan Zhenqing (708–784), a native of Donglin, Langya, came from a family of scholars, the most preeminent of whom being his fifth-generation grandfather Yan Zhitui from the Northern Qi and his great-grandfather Yan Shigu from the early Tang. Ranking as high as Minister of Personnel and Grand Preceptor of the Heir Apparent, he was ennobled as Duke of Lu. The expert on the regular and cursive scripts was indebted to Chu Suiliang and Zhang Xu. Ushering in a style known as the Yan Style, he wrote with vigour and weightiness.

In the third month in the ninth year of the Dali reign (774) at a banquet at Pan Shu's Zhushantang, a collaborative chain poem allegedly calligraphed by Yan Zhenqing was composed with two lines each contributed by Yan Zhenqing and other guests including Li E, Lu Yu, Monk Jiaoran, Lu Shixiu, and Wei Jie. The calligraphy begins with acknowledging the calligrapher to be Yan Zhenqing and ends with the date.

The original mounting should have been in the form of a single sheet, which was subsequently cut up to fit into an album. With the artwork very much resembling a patchwork as it is, there is no overall composition to speak of. Furthermore, imitation is suspected from the unvarying horizontal and vertical strokes. The two-column colophon by Mi Youren at the Southern Song emperor Gaozong's decree indicates that the calligraphy was in the Song imperial collection and should date no later than the emperor's Shaoxing reign (1131–1162).

On the mounting border to the right is an inscription in regular script reading "Yan Zhenqing's *Collaborative Chain Poetry of the Zhushantang*: top top grade." The colophon section contains three colophons by Mi Youren of the Song, and Yao Nai and Tie Bao of the Qing.

Collector seals: *Shaoxing*, *yufu zhi yin*, and *Jixi jingzhi*; Ming: seals of Wang Shimao; Qing: seals of Liang Qingbiao and An Qi; Modern: seals of Ye Gongchuo and Zhang Heng.

Literature: *Zhan Jingfeng's Personal Viewing Notes*, *Spectacles Viewed in a Lifetime*, *Collected Notes on Paintings and Calligraphies of the Shigu Hall*, and *Fortuitous Encounters with Ink*.

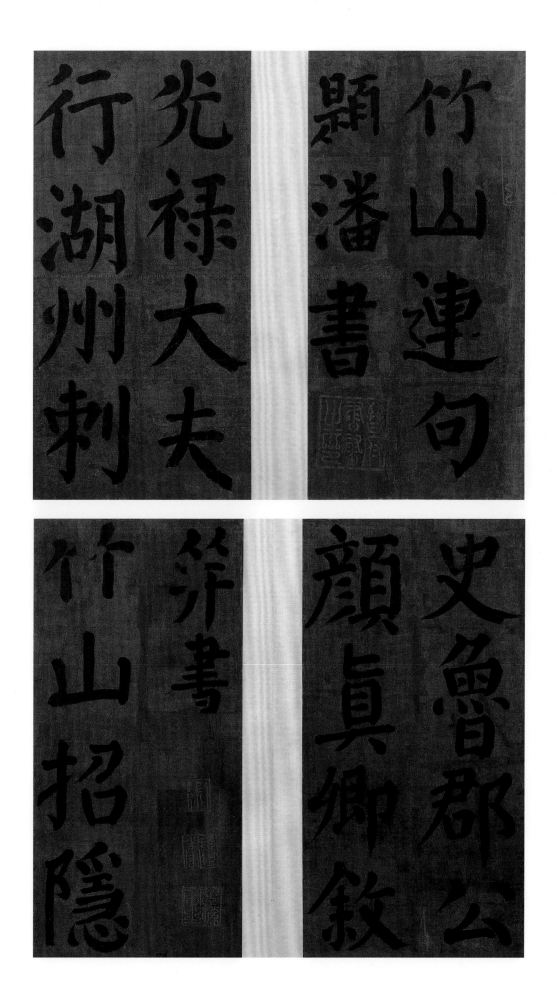

竹山連句

題潘書

史魯郡公

顏真卿敘

光祿大夫

行湖州刺

竹山招隱

笋書

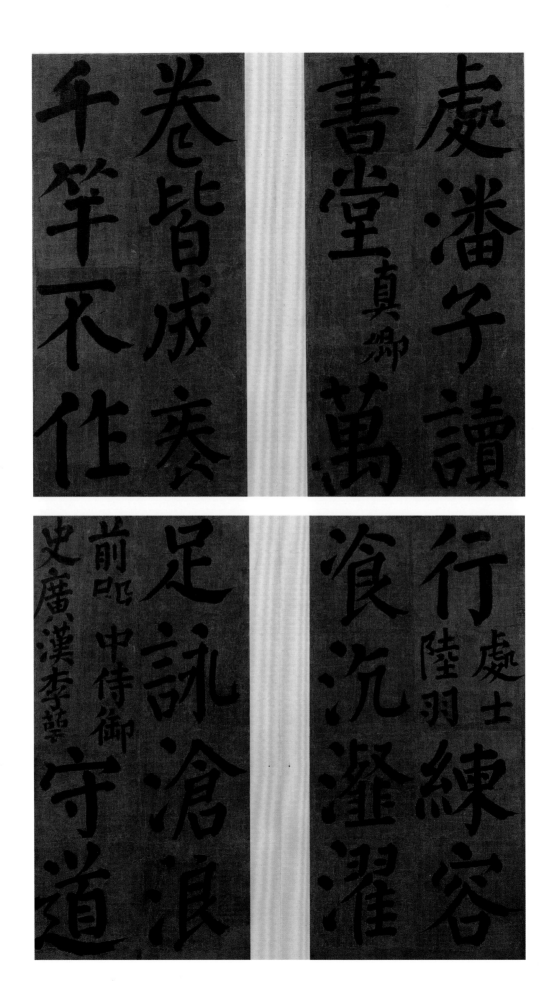

心自樂下
帷名益彰

發勝河陽
推官會稽
康造　文策

前梁縣尉
河□木裴備　風來
似人秋興花

曉雲祈接
琴春日長

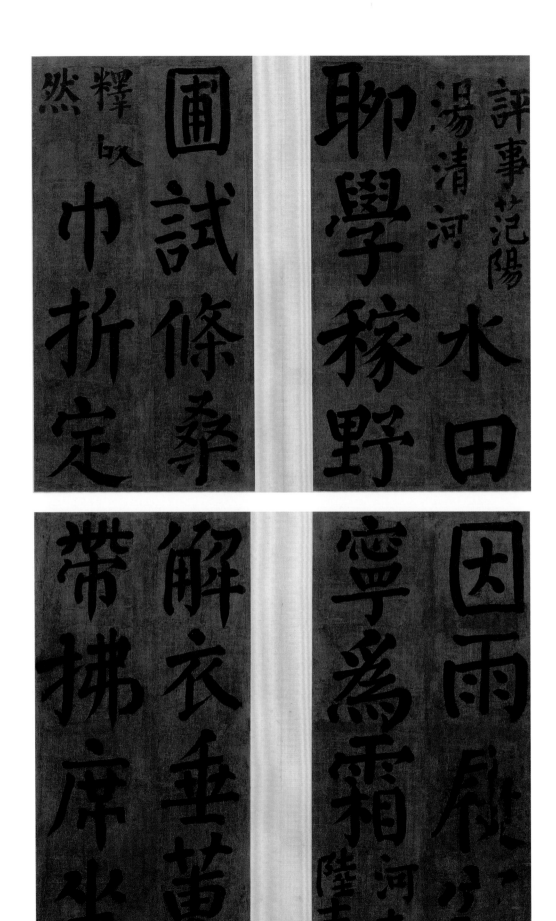

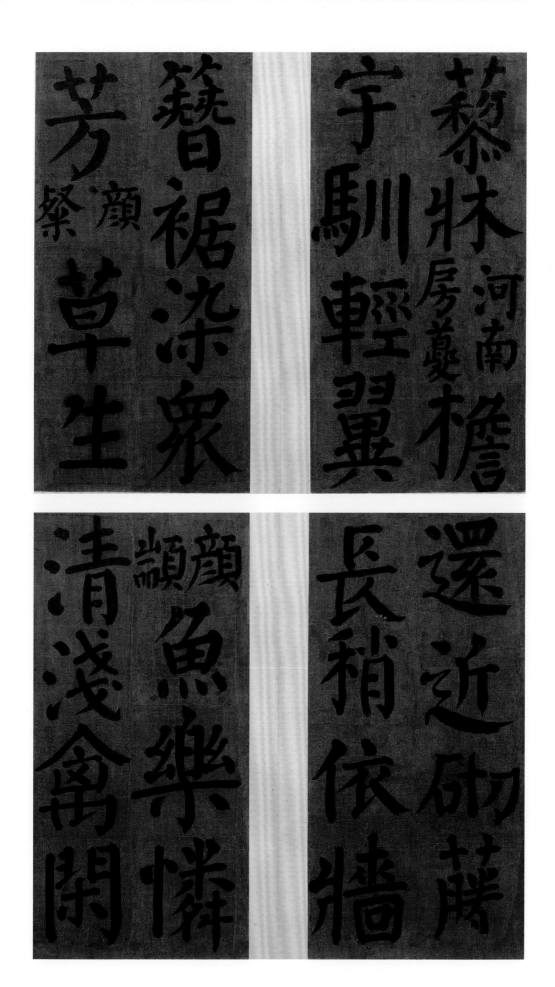

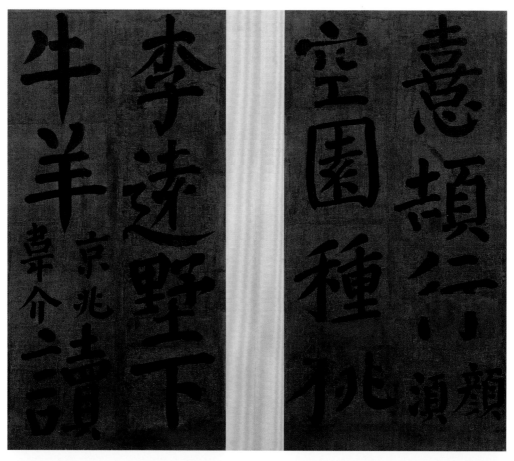

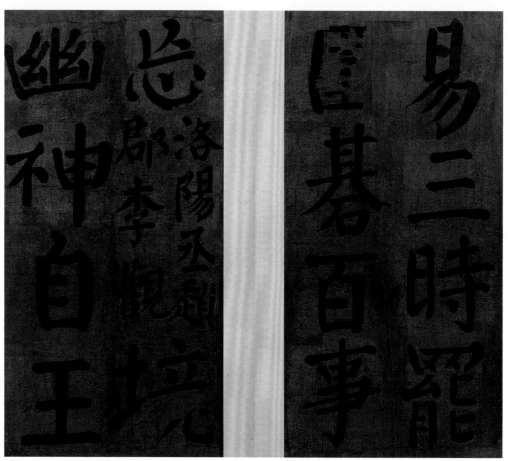

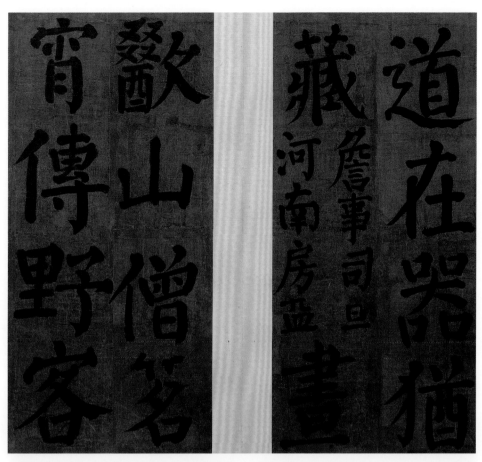

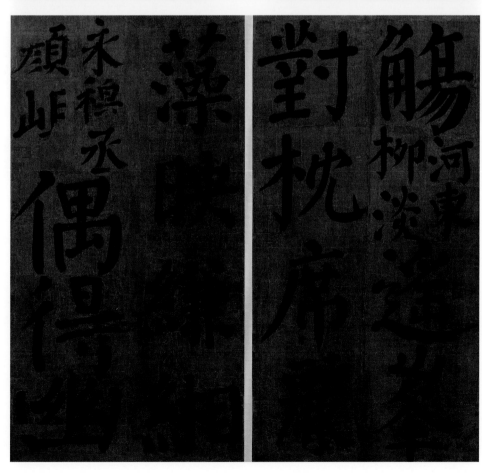

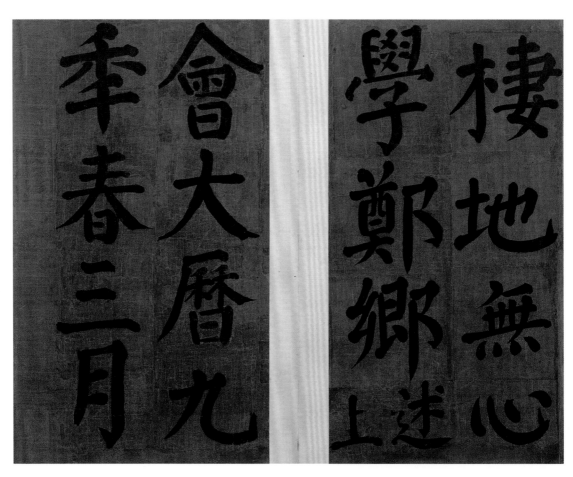

棲地無心

學鄭鄉述

上

會大曆九

季春二月

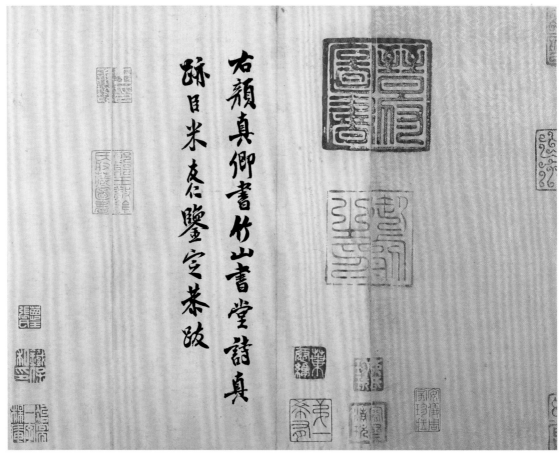

右顏真卿書竹山書堂詩真

跡目米友仁鑒定茶跋

58

顏魯公竹山連句詩舊魯公集所未載在四
庫館時攄梁蕉林相國秋碧堂帖所摹補
入集內然未見元蹟也今於
冶亭先生處睹此墨本昻蕉林所用以入石者
也其前有叙蓋斷損僅存七字袤者連綴於
其首又內穿字下半斜出小字內蓓事司直河
南房蓋直蓋二字皆本損而袤者盞之遂以
直為旦梁摹因之觀此知皆裱工之失非其本
然也　嘉慶丁卯十二月朔桐城姚□□觀因題

此卅叢在潁韻伯所攄之得之葉玉邨然無印章
可證北郡嚴肆每喜此室藏物為標楬不盡可信
故自鐵冶亭家轉歸何人殆不可考韻伯去世兩藏星
散此卅歸滙業銀行又轉價貨以與陳君崑亭閱
數載陳君攜之來滬余回為作緣歸　蕙玉余韋重寶
之得所輒紀其可述者如石魯公墨迹傳世有數　蕙玉博
雅好古精于鑒別不減景林江村虹月之光將益輝于浙水
可勝羨蘇此卅清代以前流傳有緒惜題識皆失去暇
當詳考為蕙玉輯錄之以成完璧焉
中葉民國三十五年六月　遐菴葉恭綽志

12

Poem to Zhang Haohao
— by —
Du Mu
— of —
the Tang Dynasty

Hand Scroll, running script

Ink on paper

Height 28.1 cm Width 161 cm
Qing court collection

Du Mu (803–852), a native of Wannian, Jingzhao (present-day Xi'an, Shaanxi), was the historian Du You's grandson. He was qualified as *jinshi* in the second year of the Tang emperor Wenzong's Dahe reign (828) and was appointed to offices like Left Rectifier of Omissions, Senior Compiler of the Historiography Institute, and Vice Director of the Catering Bureau. Literally gifted and honoured as Du the Junior for distinguishing from the great Tang poet Du Fu, he has been most noted for his poignant poetry. His calligraphy is described in the *Catalogue of Paintings in the Imperial Xuanhe Collection* to be as powerful as his literary works.

Included in *Collected Works of Du Mu* (*Fanchuan Ji*), the poem was composed in the ninth year of the Dahe reign (835), slightly predating the calligraphy and somewhat discrepant from the carved version of the literary collection. In the poem, the life of Zhang Haohao, a talented and beautiful song girl, is sympathetically recounted from her blissful encounter with the senior official Shen Chuanshi to her being left to fend for herself by selling wine upon his death.

The spontaneous calligraphy is rich in ink gradations with occasional flying-whites in a medley of running, cursive, and regular scripts. With no other examples extant, this poetic manuscript by Du Mu is of immense value both literally and historically.

The title slip reading "Du Mu's *Poem to Zhang Haohao*" in the front separator is inscribed in slender gold script by the Song emperor Huizong and impressed with his imperial round double-dragon seal. Mounting is in the celebrated Xuanhe format. The colophon paper is filled by seven colophons by various Yuan, Ming, and Qing masters but most are transfers from elsewhere. There is also *A Man-poem on Yangzhou* by Zhang Boju from the modern period.

Collector seals: *Hongwen zhi yin*, *Xuanhe*, *Xuanhe*, *Zhenghe*, *Zhenghe*, *neifu tushu zhi yin*, and *Qiuhe tushu*; Ming: seals of Zhang Xiaosi and Xiang Yuanbian; Qing: seals of Song Luo, Nian Gengyao, Liang Qingbiao, and Emperors Qianlong, Jiaqing and Xuantong; Modern: Zhang Boju.

Literature: *Catalogue of Paintings in the Imperial Xuanhe Collection*, *A Supplementary Record of Paintings and Calligraphies in Yuesheng's Collection* (*Yuesheng suo Cang Shuhua Bielu*), *Seen and Heard in Qinghe*, *Coral Nets: Calligraphy Inscriptions*, *Spectacles Viewed in a Lifetime*, *Collected Notes on Paintings and Calligraphies of the Shigu Hall*, *Inspiring Views*, *Paintings and Calligraphies Seen in the Wu-Yue Area* (*Wu-Yue suojian Shuhua Lu*), and *Shiqu Catalogue of Imperial Collection of Painting and Calligraphy: Series One*.

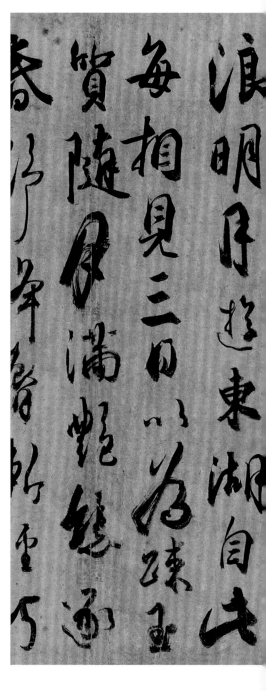

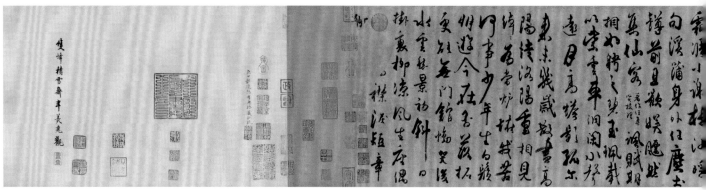

顧四座，始訝未踟躕。吳娃起引贊，低佃映長裾。雙鬟可高下，纔過青羅襦。盼盼乍垂袖，一聲雛鳳呼。繁弦迸關紐，塞管引圓蘆。眾音不能逐，裊裊穿雲衢。主公再三歎，謂之天下殊。贈之天馬錦，副以

張好好詩并序　牧大和三年，佐故吏部沈公江西幕。好好年十三，始以善歌舞來樂籍中。後一歲，公移鎮宣城，復置好好於宣城籍中。後二歲，為沈著作述師以雙鬟納之。又二歲，余於洛陽東城重睹好好，感舊傷懷，故題詩贈之。

君為豫章姝，十三才有餘。翠茁鳳生尾，丹臉蓮含跗。高閣倚天半，章江聯碧虛。此地試君唱，特使華筵鋪。主公顧四座，始訝未踟躕。吳娃起引贊，低佃映長裾。雙鬟可高下，纔過青羅襦。盼盼乍垂袖，一聲雛鳳呼。繁弦迸關紐，塞管引圓蘆。眾音不能逐，裊裊穿雲衢。主公再三歎，謂之天下殊。贈之天馬錦，副以水犀梳。龍沙看秋浪，明月遊東湖。自此每相見，三日以為疏。玉質隨月滿，豔態逐

13

Praising the Profundity of the Lotus Sutra

by

Anonymous

of

the Tang Dynasty

Hand Scroll, cursive script

Ink on paper

Height 28.4 cm Width 373.2 cm

Totally ten volumes, *Praising the Profundity of the Lotus Sutra* was authored by the Tang Buddhist priest Xuanzang's disciple Monk Ci'en (632–682). It provides an account of the origins of the *Lotus Sutra*, its teachings, categorization of sutras, and interpretation of the scriptures.

With the beginning and ending sections missing, this sutra copy on ruled paper is rare for being written in the cursive script. Crisp and full in body, the script is definitely the Two Wangs' small cursive, dovetailing with the period style of the script.

Collector seals: *Luo Zhenyu yin, Luo Shuyan, Kang Sheng kanguo,* and *Mengyi Caotang.*

14

Letter on Summer Heat

— by —

Yang Ningshi

— of —

the Five Dynasties

Cursive script

Ink on paper

Height 23.8 cm Width 33 cm
Qing court collection

Yang Ningshi (873–954), a native of Huayin, Shaanxi, successively served the five courts of Liang, Tang, Jin, Han, and Zhou, rising as high as Junior Preceptor of the Heir Apparent. He was often addressed by his official title and was also called Yang the Lunatic for his unruly behaviour.

Equally unruly and unpredictable is his calligraphy, which is emulative of Ouyang Xun and Yan Zhenqing. According to *Catalogue of Paintings in the Imperial Xuanhe Collection*, Yang excelled particularly in the wild cursive script, the robustness of which rivals Yan Zhenqing's running-cursive script, making him a calligraphic leader of his time.

Identifying himself at the beginning of the letter, Yang conveys good wishes to a monk by presenting him with a drink for respiting the summer heat.

Availing of the brush methods of the Tang calligraphers Yan Zhenqing and Liu Gongquan, the calligraphy is invigorated with a strong individuality, the style of which is vastly different from Yang's regular or running script, attesting to the great diversity at the calligrapher's command.

The colophon paper contains colophons by Wang Qinruo of the Song, Xianyu Shu and Zhao Mengfu of the Yuan, and Zhang Zhao of the Qing together with a transcription by the Qing emperor Qianlong.

Collector seals: *Xianzhitang yin, Zhao Mengfu yin, Qiao shi,* and *Chuncaotang tushu yin*; Ming: seals of Xiang Yuanbian; Qing: seals of Cao Rong and *Nalan Chengde, and imperial seals. A number of other seals from antiquity are illegible.*

Literature: *Coral Nets: Calligraphy Inscriptions, Wu's Records of Painting and Calligraphy, Spectacles Viewed in a Lifetime, Collected Notes on Paintings and Calligraphies of the Shigu Hall,* and *Shiqu Catalogue of Imperial Collection of Painting and Calligraphy: Series One.*

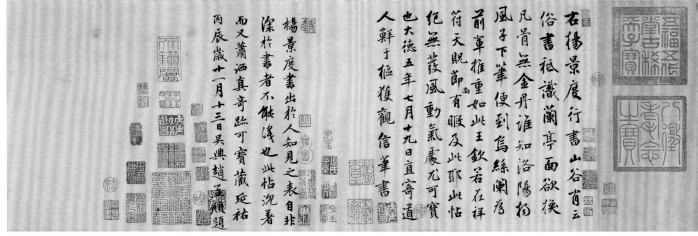

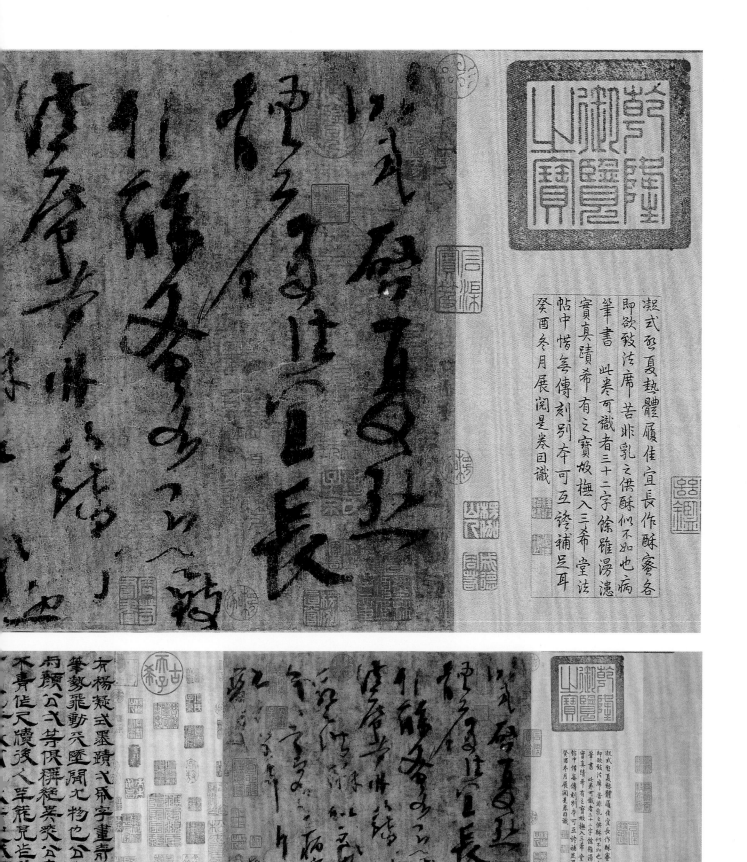

15

Regimen for Attaining Divine Immortality

by

Yang Ningshi

of

the Five Dynasties

Cursive script

Ink on paper

Height 27 cm Width 21.2 cm

Qing court collection

Dating from the antiquity and in the form of a mnemonic ditty, *Regimen for Attaining Divine Immortality* is a Chinese medical prescription for wellness. Seemingly cursory without the slightest forethought, the calligraphy is littered with flying-whites amidst alternating light and dark tones. Maintaining proper balance despite the tilted structuring, the characters and columns are comfortably spaced out. Building on the tradition of Tang calligraphy, Yang has successfully forged a daringly innovative style that endears with its obliteration of contrived craftiness. The signature comes with the date of "late 12th month in the first year of the Qianyou reign (948)." Qianyou was the reign title of the Later Han emperor Gaozu, or Liu Zhiyuan.

The colophon paper features colophos by Mi Youren of the Song, Shang Ting of the Yuan, and Zhang Xiaosi of the Qing. There is also an anonymous transcription in five columns. Immediately to the bottom right of the calligraphy is a single character denoting a serial number under Xiang Yuanbian's system.

Collector seals: *Shaoxing, xishi cang, neifu shu yin, Yuesheng, Yuzhai qingwan, zhenshang tushu, Deyoulintang, Zhao Mengfu yin*, and *Songxuezhai*; Ming: seals of Yang Shiqi, Chen Daofu, and Xiang Yuanbian; Qing: seals of Zhang Xiaosi and Chen Ding and imperial seals.

Literature: *Corals Harvested with Iron Nets* (*Tiewang Shanhu*), *Intended Meanings* (*Yuyi Pian*), *The Qinghe Boat of Painting and Calligraphy*, *Collected Notes on Paintings and Calligraphies of the Shigu Hall*, *Spectacles Viewed in a Lifetime*, *Inspiring Views*, *Shiqu Catalogue of Imperial Collection of Painting and Calligraphy: Series Three* (*Shiqu Baoji: Sanbian*), and *Xiqing Notes* (*Xiqing Zhaji*).

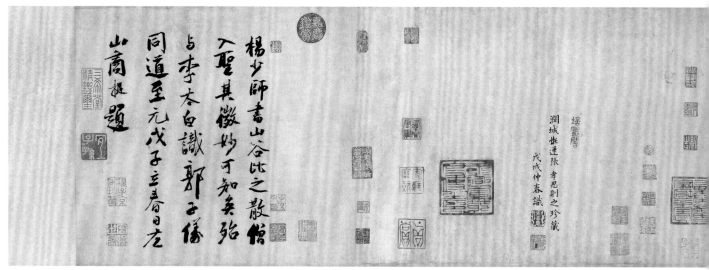

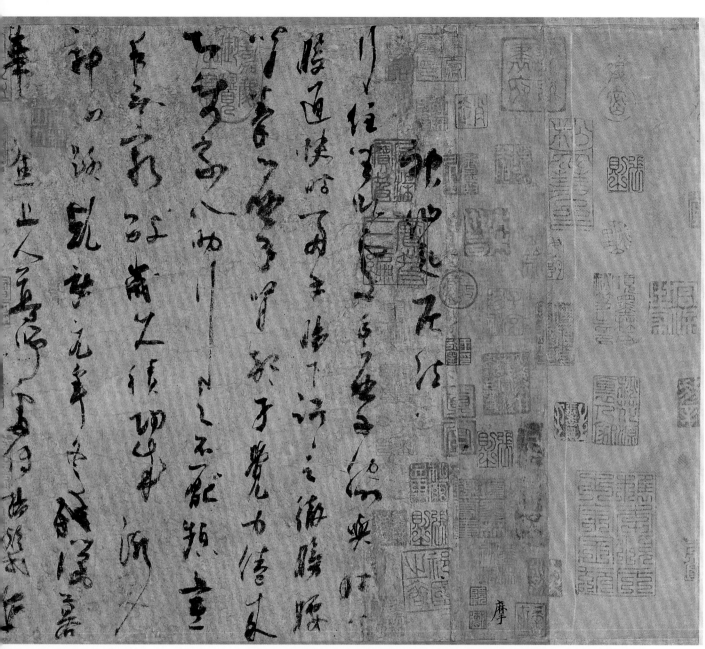

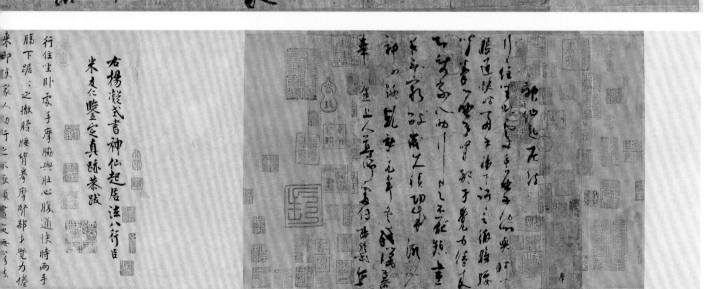

The Song Dynasty

收張僧繇天王皆

薛稷題跋閱二物為

老可元立取浮又

16

Letter to a Fellow Qualifier

— by —

Li Jianzhong

— of —

the Song Dynasty

Running script

Ink on paper

Height 33 cm Width 51 cm

Li Jianzhong (945–1013), a native of Luoyang (in present-day Henan), was once Censorate of Xijing (i.e. Luoyang) and hence has also been referred to by his official title in short. Mainly influenced by Ouyang Xun, Yan Zhenqing, and Yang Nishi, the renowned calligrapher from the early Northern Song played a significant role in the development of calligraphic art in the transitional years between the Tang and the Song.

A rare extant work by the calligrapher, this letter to a friend who qualified with him as *jinshi* in the same year contains a reference to Xijing, or the Western Capital. It can thus be inferred that the letter was written when he was Censorate of Xijing, a position he occupied since the Jingde reign (1004–1007) until his death early in the Dazhongxiangfu reign (1008–1016). Originally enclosed with the letter is the calligrapher's poem entitled *Reminiscing Xiangnan* (*Huai Xiangnan Shi*), most probably inspired by his memories of the Western Capital.

Li's characteristic simple and yet enchanting style is manifested in the ingenious marriage between Yan Zhenqing's plumpness and Ouyang Xun's elongation to embody artistry in crudity.

Collector seals: *Dongshan*, *wuyang*, and seals of Xiang Yuanbian.

Literature: *Coral Nets: Calligraphy Inscriptions, Collected Notes on Paintings and Calligraphies of the Shigu Hall, Yu's Records of Painting and Calligraphy Inscriptions: Series Two* (*Yu Shi Xu Shuhua Tiba Ji*), *Spectacles Viewed in a Lifetime*, and *Inspiring Views*.

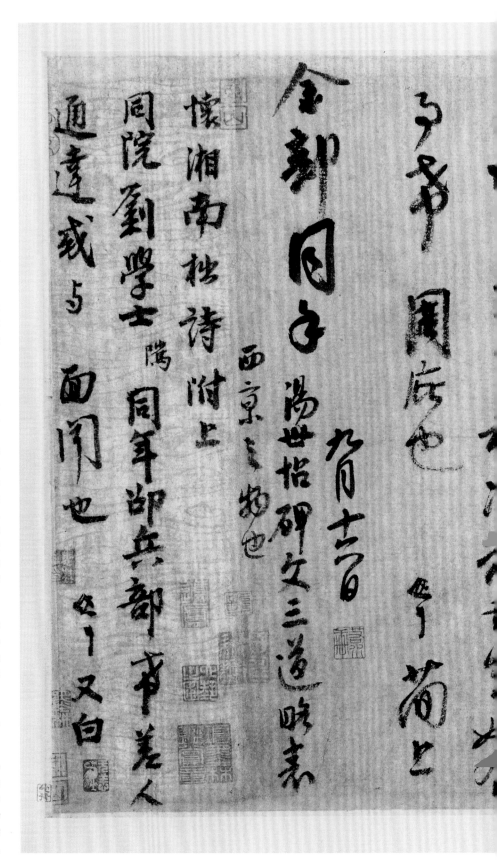

金部員外載喜拔

風遲慰　私抱殊未

豁竢心豁来晨

卻軍竹遠遠蒙

示喻氣備老懷惟冀

保愛也甚之不脉情暌

見女夫家仲讓秀委并書二晚

歡曲逵遠

17

Self-composed Poems

by

Lin Bu

of

the Song Dynasty

Hand Scroll, running script

Ink on paper

Height 32 cm Width 302.6 cm
Qing court collection

Lin Bu (967–1028), a native of Qiantang (present-day Hangzhou), was an unambitious man who loved antiquities more than pursuing any official career. Having widely travelled in the Jiang-Huai area and being gifted in poetry, literature, painting, and calligraphy, Lin decided to take up seclusion on the island of Gushan in the West Lake of Hangzhou. His devotion to plum trees and cranes can be glimpsed from his being described as having plum trees for wives and cranes for children.

The five poems mounted into the present scroll were composed when the calligrapher was leading a reclusive life on Gushan. The calligraphy is signed by the artist to read "Lin Bu at Beizhai, Gushan, in the fifth month when the emperor has just ascended the throne." In other words, the scroll was written in the first year of the Song emperor Renzong's Tiansheng reign (1023).

Lin's affinities with Li Jianzhong's handsomeness can be seen in the lean form, emphatic brushwork, exposed brush-tip, and sharp turns and corners that evoke an ethereal placidity.

To the left of Lin's calligraphy is an undated heptasyllabic verse by Su Shi, possibly written between the fourth and fifth year of the Yuanyou reign (1089–1090) when he was Prefect of Hangzhou. Charmingly written with the brush tip concealed, it is one of the rare masterpieces by the Song artist-litterateur. The juxtaposition of calligraphic works by two prominent figures in history makes the scroll a jewel of jewels.

The colophon paper further contains four heptasyllabic verses adopting the same rhymes as Su's and a colophon by Emperor Qianlong. Other inscribers include Wang Shizhen and Wang Shimao of the Ming and Wang Hongxu and Dong Gao of the Qing.

Collector seals: *Jiyang wenfu, Yunjian Wang Hongxu jianding yin, Baojinshanfang, Yilaotang zhencang yin* and Qing imperial seals.

Literature: *Catalogue of Paintings in the Imperial Xuanhe Collection, Coral Nets: Calligraphy Inscriptions, Zhan Jingfeng's Personal Viewing Notes, Spectacles Viewed in a Lifetime, Wu's Records of Painting and Calligraphy, A Sequel to Fortuitous Encounters with Ink (Moyuan Huiguan Xubian), Collected Notes on Paintings and Calligraphies of the Shigu Hall, Gao Shiqi's Summer Notes (Jiangcun Xiaoxia Lu), Inspiring Views, Shiqu Notes,* and *Shiqu Catalogue of Imperial Collection of Painting and Calligraphy: Series Two.*

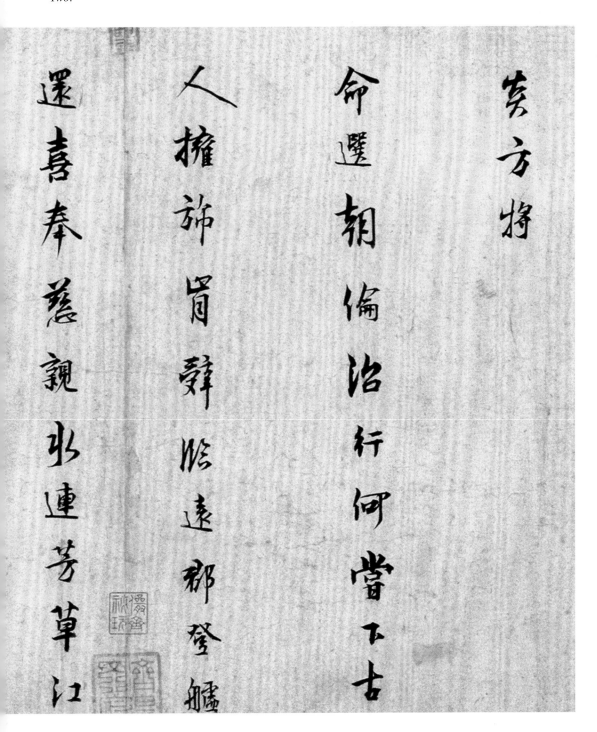

林表秋山白鳥飛 山中幽
發世還締誼家峯口人煙
曉唑見漁舟之歸
隶方將
遺史穀前典封川
命遷朝偏治行何當下古
人擁旆旨辭於遠郡登艫
還喜奉慈親水連芳草江
南地煙隔寒梅嶺上春芳
遇中逢信歸鴈慰懷饒
与發音塵
春日齋中偶成

寺蹊鐘勳晚寒

鬱葦蕊乾樓閣藏城

日看遠不堆載　　重斜

湾一運何人到中林畫

片山萬水遠睛雪浚瀄

孤山雪中寫照

虜可煩長聽隱居風

甚渙詩一面入手凉生珠自

編松等蓬寧山中萬浮

并詩為遺之次来韻

制詰李舍人以松扇二柄

書和靖林處士詩後　蘇軾

祇亭樂素甸　　書後原韻漸筆

絕和吟空謝已人曲兩貿社南祭

孤山北齋手書林逋記

皇上蹬寶位歲夏五月

好事之意耳時

數章少塞

為索病中援筆勉書

惠顧昵語未我且以批詩

殿直丁君自沂適閩賦毎

臥病春風時後動齋症

長社驚歸蕎畫海棠人

空階重疊上垣衣白畫初

世言林和靖字不如詩不如人然觀
此卷□自瘦勁有法杜裏詩陽云書貴瘦
硬方通神宣先生謂耶世人貴耳若無坡
翁詩此卷寄至以重價售者第籍長乙去
先生時代無我為長歌題其卷後推重
玉此奇韋國當以坡詢給主誼使主平合作竟
忽其本耶若藉書則又是其主平合作竟
謂君陵多幸誠兹
郑玉此蹬書于壽常齋中　丁亥春覆宝

史稱林逋力學好古佶廬西湖之孤山
二十年足不及城市真宗聞其名賜粟

康子春春月漸題四用蘇軾韻

永到西湖十五載物景民情在心曲重来惜景
赤珠前孤覺驚害異前絲乗間試步孤山陰一
泓碧水浸梅樹護墨門千秋地下安珠燭樂飢
絕俗依然梅樹護墨門千秋地下安珠燭樂飢
樂道趣有保女年城市不及呈向題三詩和蘇
韻真跡不厭辭和蟹肉緒沼二礼竹疊冷更識沈
作先我録携来卷冊相印瑩朗那藉招隱曲
古歌粹山生鄙夾長生學服蓄

乙酉春月漸起三用軾韻

金籍刀書狀標曲陡踐錦貿古色綵毫逕
遺蹟乃驚人味句蘇和兩珠玉世間書卷
堂不彩半屬僧為半荏佩通清坡健此聯
孫煥覺肌光屋樂鴉揺末印燒澄轉神三
度虜吟玄末見論怡早匹氣廣腑說偶不
磁燒桔肉兩甸出虜縱展珠致一佰高風有
史稱佳湖山雲綱芳踪吳代固時通熱出
祥謂兩甸真法靴後人常接詞前竹祠中

18

Letter on Departure and Letter on Border Duties

———— by ————

Fan Zhongyan

———— of ————

the Song Dynasty

Running script

Ink on paper

Height 31 cm Width 39 cm
Height 32 cm Width 39 cm
Qing court collection

Fan Zhongyan (989–1052), a native of Wuxian, Suzhou (present-day Suzhou, Jiangsu), was qualified as *jinshi* and rose through the ranks to hold offices such as Assistant Administrator and Auxiliary Academician of the Dragon Diagram Hall (Longtuge). The Northern Song courtier has been best remembered for his defence of the empire against aggressions from the Western Xia, his sweeping reforms, and his contributions to scholarship and literature.

The two letters featured are collectively known as *Two Letters in Regular-running Script*. *Letter on Departure* is addressed to Jingshan and was written before the Qingli reign (1041–1048) when Fan was at a low point in his career. Dated the tenth day of the third month, *Letter on Border Duties* is addressed to Fu Yan, who was Bureau Director of the Ministry of Justice and Prefect of Suzhou early in the Qingli reign. The border duties mentioned in the letter probably refers to the war with Zhao Yuanhao of the Western Xia. It follows that the letter should have been written in the third year of the Qingli reign (1043).

Austere and squarish in strict abidance by rules and principles, the calligraphy is often said to be a reflection of the calligrapher's upright character.

Collector seals: *Wujun Zhang Qing*, *Zhongjun fu*, *Dongshan Wang shi chuanjia zhi baoqing*, *Zhenshu*, *Sikang*, *Zhaoyin Jiang shi*, and seals of the Qing emperors Qianlong, Jiaqing, and Xuantong.

Literature: *Shiqu Notes* and *Shiqu Catalogue of Imperial Collection of Painting and Calligraphy: Series Two*.

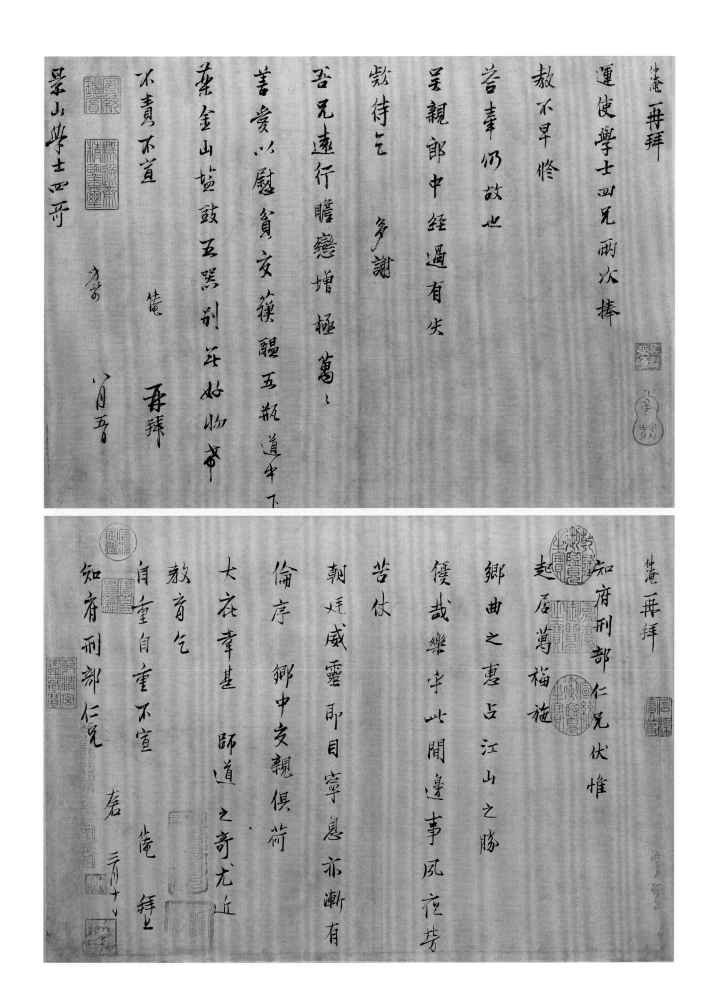

冲菴一再拜
運使學士四兄兩次捧
教不早修
荅辜仍故也
呈親郎中經過有失
款待乞　多謝
吾兄遠行瞻戀增極萬々
善愛以慰貧交藉醞五瓶道中下
葉金山塩豉五器別无好物幸
不責不宣
冀山學士四哥
再拜

冲菴一再拜
知府刑部仁兄伏惟
起居萬福施
鄉曲之惠占江山之勝
優哉樂宇此間邊事風庖芳
荅伏
朝廷威靈即目寧息亦漸有
倫序　鄉中支親俱荷
大在幸甚　師道之奇尤近
教育乞
自重自重不宣
知府刑部仁覽
春　三月十
菴　拜上

19
Three Letters
— by —
Wen Yanbo
— of —
the Song Dynasty

Hand Scroll, running-cursive script

Ink on paper

Height 43.6 cm Width 223 cm

Wen Yanbo (1006–1097), a native of Jiexiu, Fenzhou (in present-day Shanxi), was a high-ranking official who successively served four emperors of the Northern Song for five decades. He was also a poet, essayist, and calligrapher.

Of the three letters, the first bears a reference to Zhao Xie, who was Edict Attendant of the Hall of Heavenly Manifestations (Tianzhangge) during the Song emperor Shenzong's reign. The second comprises no more than three columns. The third discusses the volume of water in River Luo and the operation of water mills, which are also chronicled in *History of the Song: Records of Waterways* (*Song Shi: Hequ Zhi*). By inference, the letter should have been written after the third year of the Yuanfeng reign (1080) in the Northern Song when Wen was reinstated as Assistant Prefect of Henan.

As far as the calligraphy is concerned, the first letter is thrifty, the second unimpeded, and the third casual, demonstrating personal creativity while grounded in the Jin-Tang tradition.

To the left of the calligraphies are colophons by Mi Youren and Xiang Shui of the Song and Yongxing, or Prince Cheng, and Mianyi of the Qing.

Collector seals: *Ronglin jushi, Xu shi, Fuyu daoren Xu Xiaomo Zhongmoukuozhai wenji zhi yin, Xiaomo, Qin shi, baoyin xianyi, Jia Sidao tushu zisun yongbaozhi, Qiuhe zhenwan, Chang, Yuesheng, shengji, Guanguzhai jianshang shuhua ji, Jiangbiao Huang Lin, meizhi*, and seals of Yongxing, Yihui, Wanyan Jingxian, and Ye Gongchuo.

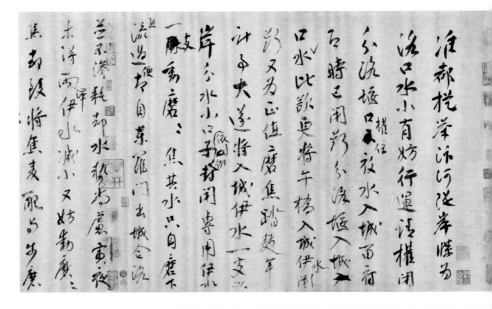

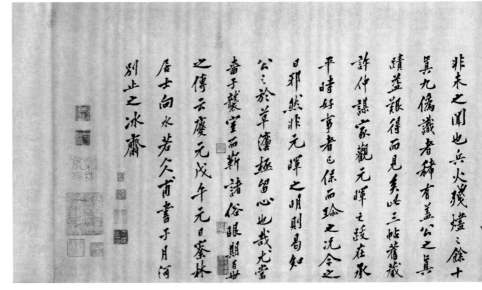

Literature: *Notes from the Summer of the Xinchou Year* (*Xinchou Xiaoxia Ji*) and *List of Paintings and Calligraphies in the Sanyu Hall* (*Sanyutang Shuhua Mu*).

78

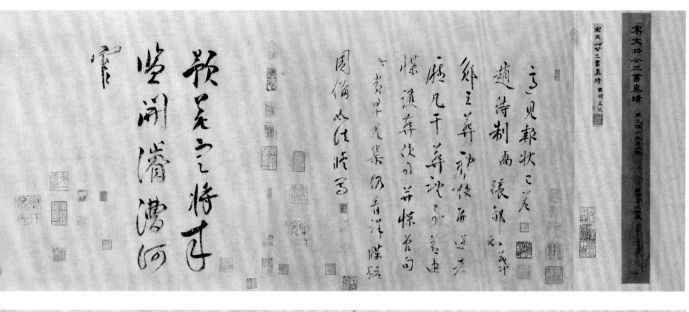

宋文忠公三書真蹟

20

Letter on Moxibustion
by
Ouyang Xiu
of
the Song Dynasty

Running script

Ink on paper

Height 25 cm Width 18 cm

Ouyang Xiu (1007–1072), a native of Jishui, Luling (in present-day Jiangxi), was a Northern Song official, historian, and litterateur who ranked among the Eight Men of Letters of the Tang and Song Dynasties. The practitioner of calligraphy was also a founder of bronze-and-stone studies (Epigraphy) in the Song Dynasty.

The letter was addressed to the sender's student Jiao Qianzhi, asking after him. In the letter, the addressee is addressed by his official title as Director of the Imperial University, a post that he held around the first year of the Jiayou reign (1056).

Exemplifying the calligrapher's late style, the calligraphy enchants with a finesse informed by aesthetics of the Tang Dynasty.

The colophons to the left of the calligraphy are inscribed by Li Dongyang of the Ming and Weng Fanggang of the Qing.

Collector seals: *Wujun Zhang Qing*, *Zhongjun fu*, *Shichang*, and seals of An Qi and Jiang Deliang.

Literature: *Fortuitous Encounters with Ink*.

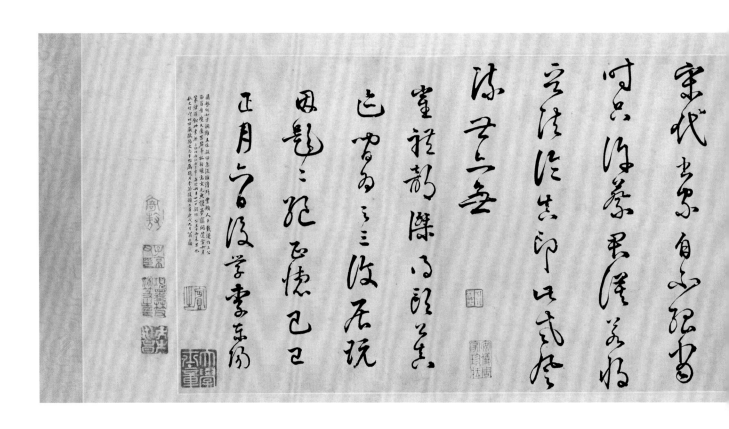

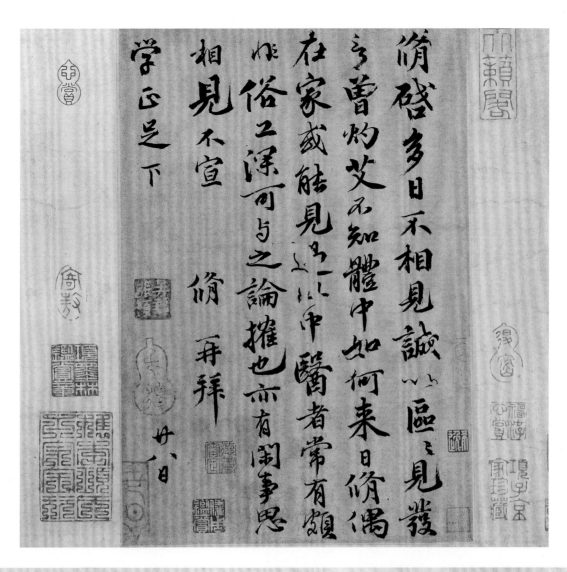

修啓多日不相見誠以區區見發
言曾灼艾不知體中如何來日修偶
在家或能見子以申醫者常有閑事思
俗工深可與之論攉也亦有閑事思
相見不宣　　　修　再拜
學正足下　　　　　　廿八日

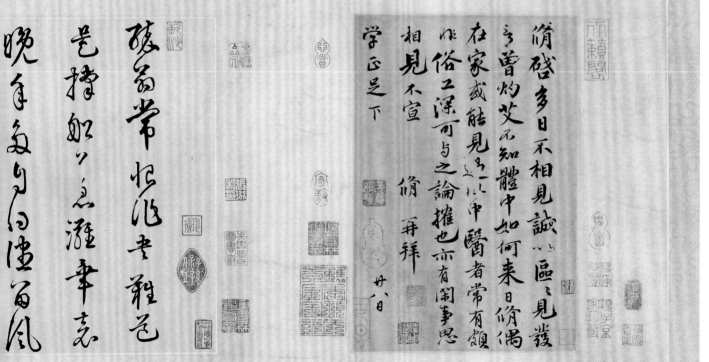

晚年多自得于此風
老撐舟以名灘車去
張卽常好泝峽舟雜卷

21

Self-composed Poems
— by —
Cai Xiang
— of —
the Song Dynasty

Hand Scroll, running script

Ink on paper

Height 28.2 cm Width 221.2 cm
Qing court collection

Cai Xiang (1012–1067), a native of Xianyou, Xinghua (present-day Fuzhou, Fujian), lived in the Northern Song and was an acclaimed calligrapher and an official posted to various places following his qualification as *jinshi*. The knowledgeable and sophisticated calligrapher is distinguishable for his poise and unobtrusive beauty that justifies his place among the Four Masters of the Song together with Su Shi, Huang Tingjian, and Mi Fu.

Extracted from the poet's manuscripts, the calligraphy features 11 self-composed poems that have either pentasyllablic or heptasyllabic lines. It is learned from the content that the poems were composed when the poet was on his way to Bianjing upon discharge from his post as Transport Commissioner of Fujian. The time should have been around the third year of the Huangyou reign (1051).

Thanks to the calligrapher's contentment with a successful career and the psychological relaxation with writing one's own compositions, the calligraphy exudes an unforced and spontaneous charm and grows even better past the first half. Quintessential of Cai's mature style in his middle age, it attracted the remark of "This piece rivals the ancients in style" underneath the third poem. It is revealed in the Song scholar Yang Shi's colophon that the remark was made by the calligrapher's good friend Ouyang Xiu.

The colophons to the left of the calligraphy are inscribed by Cai Shen, Yang Shi, Zhang Zhengmin, Jiang Can, and Xiang Shui of the Song, Zhang Yu and Zhang Shu of the Yuan, Chen Pu, Kuaiweng of Kuangshan and Hu Cuizhong of the Ming, Wang Wenzhi of the Qing, and Zhu Wenjun of the modern era.

Collector seals: *Jia Sidao tushu zizisunsun yongbaozhi, Jia Sidao yin, Sidao, Chang, Yuesheng, Ronglin Xiang Shui, Wuyue Wang tushu, Guan Yanzhi yin,* and seals of Liang Qingbiao and the Qing emperor Jiaqing.

Literature: *Coral Nets: Calligraphy Inscriptions, Wu's Records of Painting and Calligraphy, Spectacles Viewed in a Lifetime, Shiqu Catalogue of Imperial Collection of Painting and Calligraphy: Series Three, A Sequel to Xuanxue Studio Records of Paintings and Calligraphies Viewed (Xuanxuezhai Shuhua Yumu Xuji),* and *Notes from the Summer of the Renyin Year (Renyin Xiaoxia Lu).*

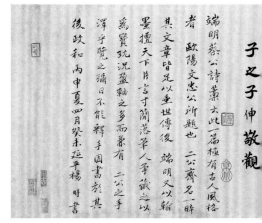

22

Letter of Thanks
(leaf five of an album of poems)

by

Cai Xiang

of

the Song Dynasty

Regular-running script

Ink on paper

Height 22.7 cm Width 16.5 cm

Qing court collection

In the letter, the addressee Li Duanyuan is addressed as Defender-in-chief, which was then a proper title for high-ranking military officials. Li was therefore likely to be serving as Military Commissioner of Wukang following his prefectship in Xiangzhou early in the Zhiping reign (1064–1068). Soon afterwards, Li was transferred back to the capital city to fill an unimportant position on his own application. There he was close with Cai, who was Hanlin Academician acting as Finance Commissioner. The letter should have been written around this time since Cai was posted to Hangzhou in the second year of the Zhiping reign (1065).

Dating from the calligrapher's late years, the calligraphy is enhanced with a touch of scrupulousness and reservation when compared with the fluid and rounded style of his mid years. Personal identity and artistic virtuosity stand strikingly out in this masterpiece.

Collector seals: *Xiang Du*, *Yizhou jianshang*, and *xinshang*.

Literature: *The Qinghe Boat of Painting and Calligraphy (Qinghe Shuhua Fang)*, *Journal on Authentic Masterpieces*, *Yu's Records of Painting and Calligraphy Inscriptions: Series Two*, *Coral Nets: Calligraphy Inscriptions*, *Wu's Records of Painting and Calligraphy*, *Collected Notes on Paintings and Calligraphies of the Shigu Hall*, *Spectacles Viewed in a Lifetime*, *Inspiring Views*, *A Mounter's Random Notes*, *Fortuitous Encounters with Ink*, and *Shiqu Catalogue of Imperial Collection of Painting and Calligraphy: Series Three*.

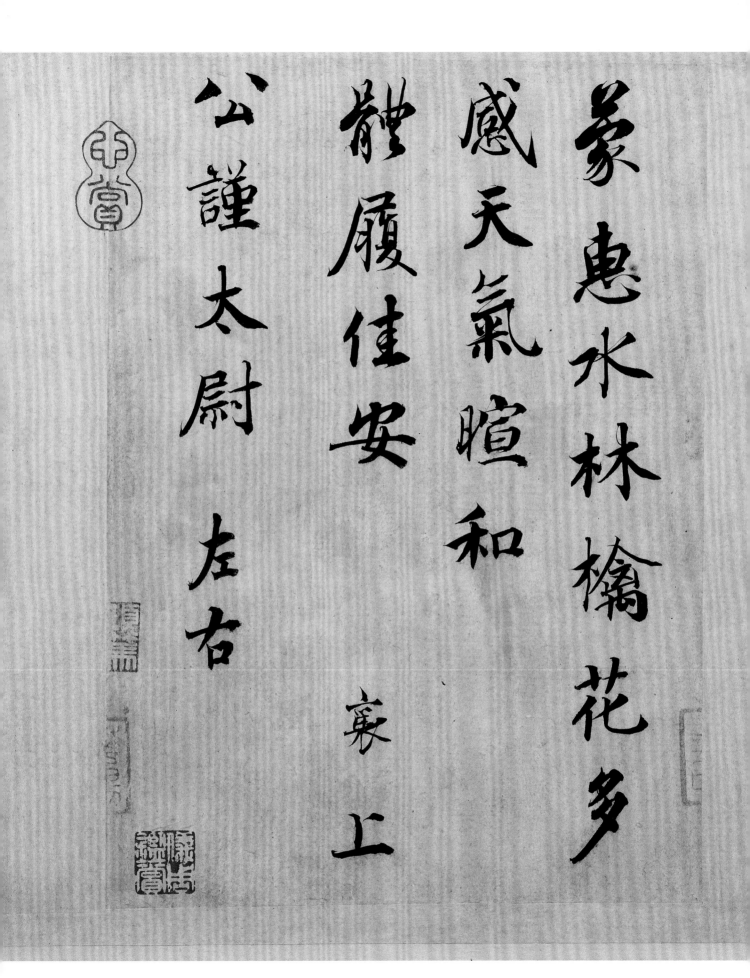

蒙惠水林檎花多
感天氣暄和
體履佳安
公謹太尉　左右
　　　　襄上

23

Letter on a Sweltering Day

———— by ————

Fu Yaoyu

———— of ————

the Song Dynasty

Regular-running script

Ink on paper

Height 26.3 cm Width 17.3 cm

Fu Yaoyu (1024–1091), a native of Jiyuan, Mengzhou (in present-day Shandong), was so intelligent that he was able to write essays when he was just ten and to qualify as *jinshi* before he turned 20. This good friend of Su Shi's was once Investigating Censor but was posted out of the capital for dissenting from Wang Anshi. Subsequently, he was recalled and made Minister of Personnel, Reader-in-waiting, and Vice Director of the Secretariat.

This only surviving calligraphic work by the calligrapher is a letter for sending regards to a friend. The characteristics defining the calligraphy of the early Song are readily detectable in the proportioned structuring and the unambiguous brush methods.

Collector seals: *Jiang Deliang jiancang yin*, *Nanyunzhai*, *Lianqiao Cheng Xun jianshang shuhua zhi zhang*, and *Huang shiyizi Cheng Qinwang Yijinzhai tushu yin*.

Literature: *Impressions of Paintings and Calligraphies* (*Shuhua Jianying*).

燾再拜氣候蒸燠伏惟

台候萬福来日

瞻奉崇詳盡

燾恐悚

Letter Seeking Advice
— by —
Lü Dafang
— of —
the Song Dynasty
Regular-running script

Ink on paper
Height 27.4 cm Width 44.5 cm

Lü Dafang (1027–1097), a native of Lantian, Jingzhaofu (present-day Lantian, Shaanxi), was a book collector and scholar from the Northern Song. Qualified as *jinshi*, he rose through the ranks to become Left Vice Director of the Department of State Affairs and Vice Director in the Chancellery, and was ennobled as duke. He was subsequently demoted for his involvement in factional strifes during Emperor Zhezong's Yuanyou reign (1086–1094).

Addressed to Zhang Jie, the letter is a rare calligraphic specimen by the calligrapher. Holding positions including Transport Commissioner of Chengdu and Supply Commissioner of the Jiang-Huai Region at various times, Zhang was Prefect of Qingzhou (in the vicinity of present-day Qingyang, Gansu) in the administration region of Shaanxi in the early years of the Yuanyou reign. The letter should have been written around this time by inferrence from the content.

Quintessential of Lü's late style, the calligraphy closely resembles that of Cai Xiang in the solid tenacious strokes and the well-controlled structuring and composition but is wanting when it comes to vibrancy.

Collector seals: *renren yishi zhi jia*, *Li shi tushu zhi yin*, and seals of Xiang Yuanbian, Jiang Deliang, and Wang Nanping.

Literature: *Records of Paintings and Calligraphies* and *Fortuitous Encounters with Ink*.

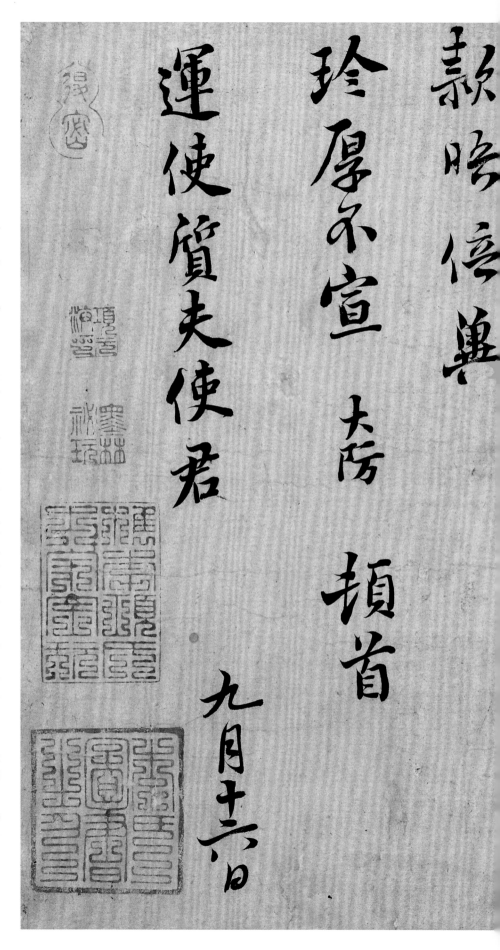

夫颐坐辱

示問欣承

臨部以還

動止佳福陝於諸道為剷剩

害之形有不可遠害者必煩

精思而後辦末緣

25

Letter on Sojourning in the North

by

Jiang Zhiqi

of

the Song Dynasty

Running script

Ink on paper

Height 25.5 cm Width 38.2 cm

Jiang Zhiqi (1031–1104), a native of Yixing, Changzhou (in present-day Jiangsu), joined the civil service by qualifying as *jinshi* through examinations and filled positions like Investigating Censor, Palace Censor, Hanlin Academician, and Administrator of the Bureau of Military Affairs. As an official, he was noted for his capability but was ridiculed for defaming Ouyang Xiu.

Expressing concern for the addressee's ailment, accommodation, and diet, the letter should have been addressed to Sima Guang, the preeminent historian of the Northern Song, as suggested by the salutation. By the same token, it should have been written in the early years of Emperor Shenzong's reign when Sima Guang was compiling the *Comprehensive Mirror in Aid of Governance (Zizhi Tongjian)* on imperial decree in his position as Academician Reader-in-waiting of the Hanlin Academy.

Somewhat similar to Cai Xiang in style, the calligraphy is a respectable work of art.

Collector seals: *Qingsenge shuhua yin, Heyuan Lang shi*, and seals of Xiang Yuanbian.

Literature: *Collected Notes on Paintings and Calligraphies of the Shigu Hall* and *Spectacles Viewed in a Lifetime*.

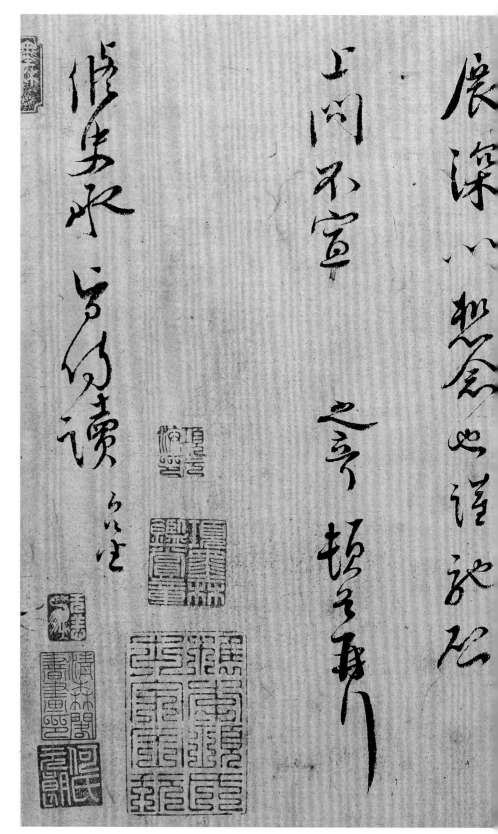

之至损音啓及朝伏惟

台候萬福比審少留方廿甚

熱又房室陝窄寔良

不易處之聞

小苦痔疾更乞

調餙食将息爲佳久闊不

91

26

Letter on Tomb Matters

by

Su Shi

of

the Song Dynasty

Running script

Ink on paper

Height 29.2 cm Width 45.2 cm

Qing court collection

Su Shi (1037–1101), a native of Meishan, Meizhou (in present-day Sichuan), was qualified as *jinshi* in the second year of the Jiayou reign (1057). The frustrations he suffered in his official career have been more than compensated by the indelible marks he has left in China's history of literature, painting, and calligraphy. Deservedly, he has been exalted as one of the Eight Men of Letters of the Tang and Song. As for his calligraphy, placed over and above his contemporaries by Huang Tingjian, he exerted gigantic influence on posterity with his profound learning and inspiring calligraphic theories.

The letter was written to entrust the management of two tombs to a Buddhist abbot, who was Su Shi's townsman. The date is given to be the 18th day of the eighth month in the closing inscription, and the year, as established by inscribers of the colophons, was sometime during the Xining reign (1068–1077) when Su Shi was resident in the capital city.

The delicate brushwork and charming forms correspond with the "captivating allure" attributed in literature to the calligrapher's early style.

The frontispiece contains a portrait of Su Shi painted in the Ming and a portrait eulogy by Monk Miaosheng whereas the colophon paper colophons by Zhao Mengfu of the Yuan and Wen Zhengming and Wang Zhideng of the Ming.

Collector seals: *Shangqiu Song Luo shending zhenji* and *Wujiang Zhang Quan Dezai tushu.*

Literature: *Spectacles Viewed in a Lifetime*, *A Mounter's Random Notes* and *Catalogue of Paintings and Calligraphies in the Shengjing Imperial Collection* (*Shengjing Gugong Shuhua Lu*).

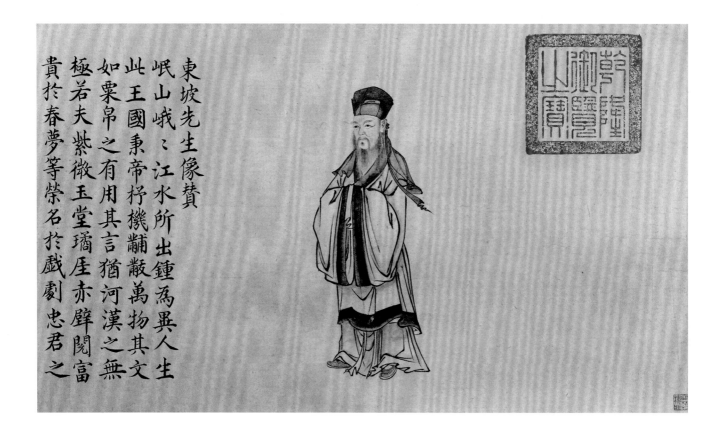

軾啓久別思念不忘遠想

獅中佳勝

法眷多無恙

佛閣必已成就

應師仍在思濛住院如何瞻望

梵備不易數年念經度得幾人徒弟

示及

石頭橋 塯頭寺靈墳瑩必煩

照管程六小心吾惟頻与提舉星要

此久未蜀中一郡歸吾相見末間惟

佳愛々不宣

軾手啓上

治平史院主徐大師二大士　侍者

八月十八日

石二帖以東坡早年真迹與其

鄉僧惟治平二大士帖趙文敏以為早年真迹按

難与暮年同論情文勁至

稍可想見矣是世間墨寶

孟煩

右蘇文忠公與鄉僧治平二大士帖趙文敏以為早年真迹按
公嘉祐元年舉進士六年辛丑舉制遷為鳳翔僉判越四年治平辛
巳名判登聞鼓院尋丁憂還蜀至熙寧二平乙酉始舉科遂出判杭州州書六月十六日發中有非人請郡之語當是熙寧居京師
時作孟二治平中雖嘗居京熙乙巳冬還朝而老泉以明年丙午四年辛卒中
間即熙六月矣其時資淺不應為鄉故庼歲出入顏九泉無疑是公孚三十
有四年矣公書少學徐季海姿媚而喜晚歲入顏九泉所藏石湖嘗住石湖
駴與此帖如出兩人矣此帖故為二帖元季為吳僧聲九泉原李北海故特健勁渾
治後此帖轉徙也斯而吳帖一自逆留寺中且刻以傳而寒非吳中治平也九泉
既浚此帖轉徙也斯而失其一吾友張東道世家石湖之上謂是山中故實
以厚直購而藏之偶余疏其大略如此嘉靖癸十一月四日文徵明跋

藕文忠書法出自王僧虔仰希江郢小鄉帖誰謂不由晉
轍哉此書之远全貌僧慶正文待詔所去少年作也老
始爛漫縱橫若二手矣此三帖而失其一自張武已然

玄津先生每以示余相共歡賞先生下世後獨瞻復
以相示不勝人琴之感擕擕寶此不翔赤刀銀匱矣

辛卯蠟月二日王釋馨敬書

Letter for a Rendezvous and Condolence Letter to Chen Zao

by

Su Shi

of

the Song Dynasty

Running script

Ink on paper

Height 30.2 cm Width 48.8 cm
Height 29.5 cm Width 45.1 cm
Qing court collection

Dated the second day of the first month, the first letter relates to an upcoming rendezvous in Huangzhou with Chen Zao and Li Chang at the end of the month, which corroborates with what is recorded in *Collected Works of Su Shi (Dongpo Ji)*. By inference from the content, the letter should have been written in the fourth year of the Yuanfeng reign (1081) in the Northern Song during Su's office as Deputy Magistrate of Huangzhou. The second of the two letters conveys condolences to Chen Zao, who was bereaved of his elder brother Chen Bocheng. Judging from the style, the two letters now mounted as one were written within a short interval of time.

Although personal in nature, the letters afford fine calligraphic specimens from the calligrapher's transition from his early to his mid-year style. Each of the strokes is precisely delineated in the unaffected and vigorous masterpiece.

To the left of the calligraphy is a colophon by Dong Qichang of the Ming.

Collector seals: *yufu shu yin*, *yufu baohui*, *Kang* (one character illegible) *houyi*, *Wu Jianshu shi*, and seals of Xiang Yuanbian and An Qi.

Literature: *Fortuitous Encounters with Ink* and *Inspiring Views*.

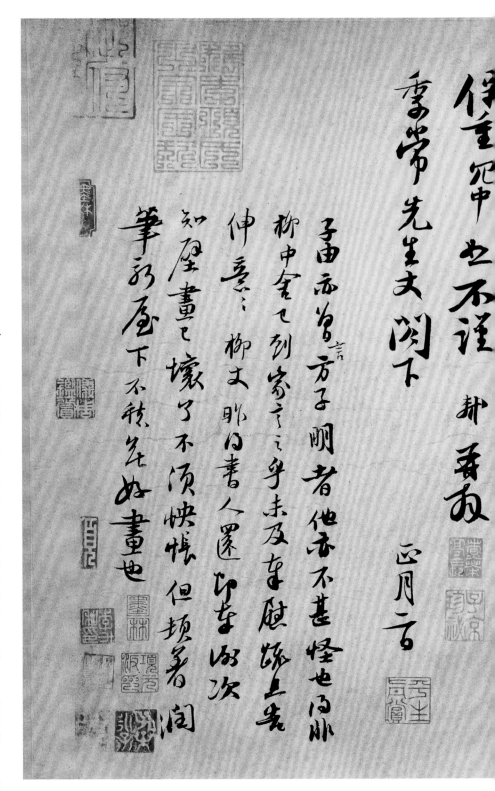

軾啟　新歲未獲
展慶　祝頌無窮　稍晴
起居何如　軾舊來
入城　昨日得
公擇書過上元乃行計
月末間到此
公亦以此時来　必有
起造必有涯　何日果可
窃計上元起造尚未
畢工軾亦自不出無緣至陰夜遊也沙枋
畫一軸且夕附
陳隆船去次今先附挟書
子曾有此中有一鑄銅匜敬借
兩恨建州木茶臼子並椎試令依樣造看者兼
適有閩中人便故令看過因生遂頁一剂也

不皇惟万々

賓懷毋忽都言也不下 戰再拜

知花日舉挂不能一哭甚

靈悅貴千万々酒一撺告るー

爵元鑒用々

東坡真跡余所見凡率一所千卷皆宋

人双鉤廓填坡書本濃既経填墨

益不免墨豬之論唯此二帖則杜老所

謂頷史九重真龍出一洗万古凡馬空也

董其昌觀

96

軾啓人來得

書不意

伯誠遽至於此哀愕不已

宏才令德百未一報而止於是耶

季常篤於兄弟而於

伯誠尤相知照想閔之無復生意某不

上念

門戶付囑之重下思

三子皆未成立任

情所至不自知返則朋友之愛蓋未可量

伏惟深照死生聚散之常理悟愛哀

之無益釋然自勉以就

遠業軾蒙

遠照之厚及此不肖之言也某頓首再拜

28

Letter after a Long Absence

by

Li Zhiyi

of

the Song Dynasty

Running script

Ink on paper

Height 28.3 cm Width 35.8 cm

Li Zhiyi (?–1117), a native of Wudi, Cangzhou (in present-day Shandong), was qualified as *jinshi* during the Yuanfeng reign (1078–1085). He once worked in the private secretariat of his teacher Su Shi, who was then Prefect of Dingzhou. The official positions that Li held include Junior Compiler in the Bureau of Military Affairs and Assistant Prefect of Yuanzhou. Literally and poetically talented, he was an expert writer of letters.

Meant for catching up with a friend, the letter exemplifies Li's calligraphic style that consists in emphatic strokes and compact characters that are compressed especially in the upper half.

Collector seals: *Song Luo shending, Songzhou, Deliang, Wang Xun zhi yin, Huang shiyizi Cheng Qinwang Yijinzhai tushu yin, Lianqiao jianshang*, and *Lianqiao ceng guan*.

Literature: *Impressions of Paintings and Calligraphies.*

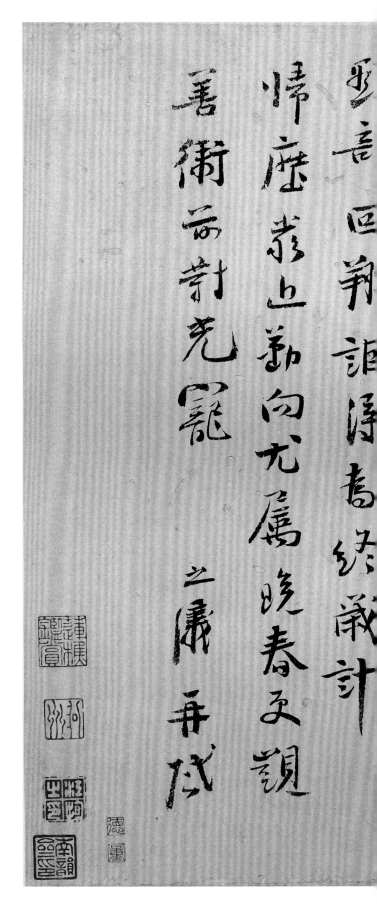

儀再拜感自汗隈
眺迄遷後累年一曾於書海上不辱
報句之不敢嗣音而
雋德相求之際或未在
素黙故役投漏謂得逺

右又不維藝其味可知

29

Monk Wenyi's Sayings

— by —

Huang Tingjian

— of —

the Song Dynasty

Hand Scroll, cursive script

Ink on paper

Height 33 cm Width 729 cm

Qing court collection

Huang Tingjian (1045–1105), a native of Fenning, Hongzhou (present-day Xiushui, Jiangxi), was a leading Northern Song poet who has been mentioned in one breath with Su Shi. Together with three other fellow students who have studied under Su Shi, he ranks among the Four Scholars of the Su School. In recognition of his calligraphic achievement, he has also been exalted as one of the Four Masters of the Song.

Signed and impressed with a calligrapher seal (*Shangu Daoren*), the text was copied from the Buddhist sayings of Wenyi, a Five Dynasties monk from Jinling (present-day Nanjing), for presentation to the calligrapher's friend Li Rendao, who was a native of Zitong, Sichuan, and resident in Jiangjin (in present-day Chongqing). Considering that the calligrapher was posted to Rongzhou (in the vicinity of present-day Yibin, Sichuan) upon demotion during the Yuanfu reign (1098–1100) when he composed poems in response to Li's, it is probable that the present specimen was written around this time.

This quintessential masterpiece from the calligrapher's late years emulates Monk Huaisu's wild cursive script. As if dancing off the paper and driven by an unstoppable momentum, the calligraphy is impeccably sophisticated in brushwork, character structuring, and overall composition.

To the left of the calligraphy are colophons by Wu Kuan of the Ming and Liang Qingbiao of the Qing.

Collector seals: *neifu shu yin, Shaoxing, Yuesheng, Chang, Wei Su siyin, zhenwan, zhenshang, Hua Xia, Li Shen siyin, Zhenbai, Zhou Yuanliang jieguan yiguo*, seals of Sun Chengze and Wang Hongxu, and Qing imperial seals.

Literature: *Intended Meanings, Records of Paintings and Calligraphies of the Qianshan Hall (Qianshantang Shuhua Ji), Annotations of the Zhenshang Studio (Zhenshangzhai Fuzhu), The Qinghe Boat of Painting and Calligraphy, Notes from the Summer of the Gengzi Year, Collected Notes on Paintings and Calligraphies of the Shigu Hall*, and *Shiqu Catalogue of Imperial Collection of Painting and Calligraphy: Series One.*

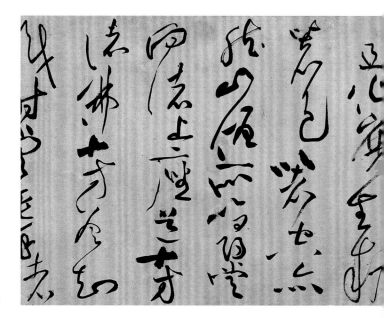

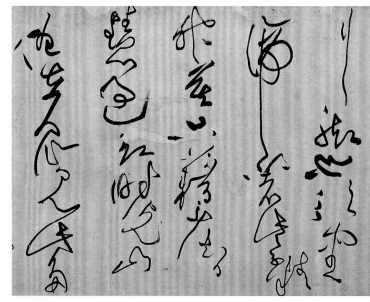

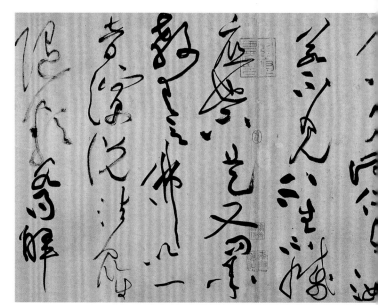

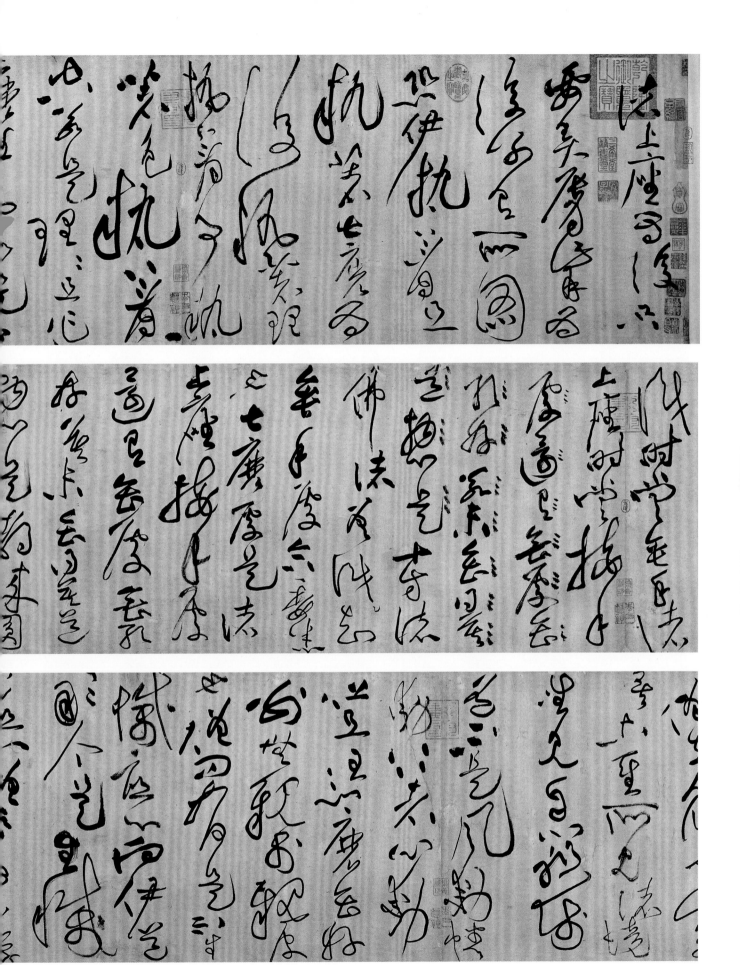

山谷老人書

河北梁清標書

山谷老人書

昔東坡見山谷草書壁旁
釋疑錢穆父獨惜少為未
見懷素真迹後山谷見
自叙帖書遂頓異
不當此卷臨時是嘗見
耶抑或未見耶職方以
深於書者藏此不能辨
之吳寬題

Poem to Helan Xian
by Du Fu

by

Huang Tingjian

of

the Song Dynasty

Album Leaf, cursive script

Ink on paper

Height 34.7 cm Width 69.6 cm

Qing court collection

The calligraphy owes its text to a pentasyllabic poem composed by Du Fu for Helan Xian. Rounded in contours and connected between characters, the calligraphy seems to have been executed in a perfect rapture without any hesitation. Mutually accentuating, the dynamism is starkly contrasted by the poem's sedatory title in regular-running script at the end. The mastery is not at all discounted by the brevity of the piece.

Collector seals: *neifu shu yin, Jia shi, Dianli Jicha Si yin, guilai yin,* and *xizhi.*

Literature: *Records of Paintings and Calligraphies, Spectacles Viewed in a Lifetime,* and *Shiqu Catalogue of Imperial Collection of Painting and Calligraphy: Series One.*

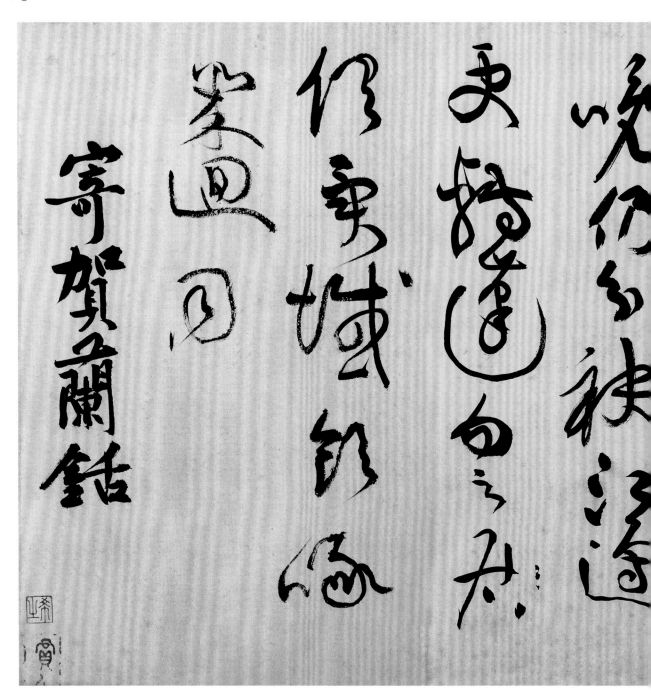

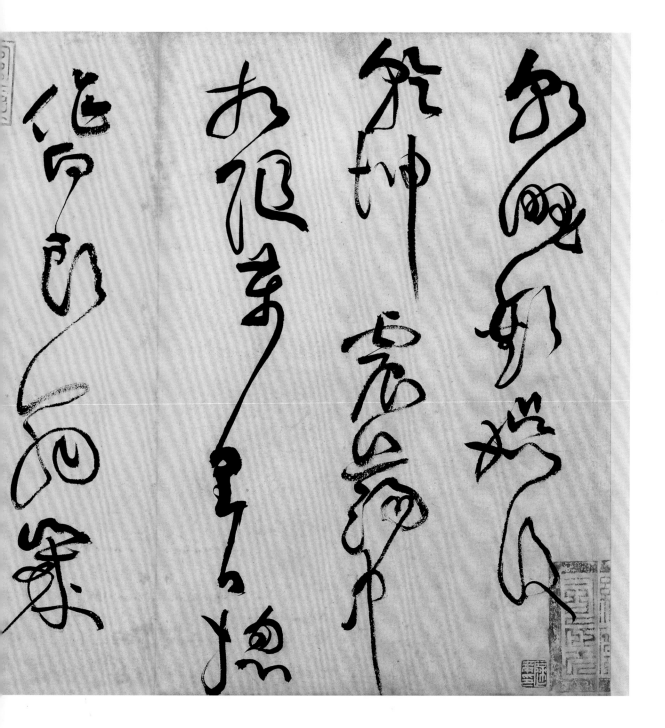

31

Letter Returning Good Wishes

by

Wang Yansou

of

the Song Dynasty

Regular-running script

Ink on paper

Height 26 cm Width 38 cm

Qing court collection

Wang Yansou (1044–1094) was a native of Qingping, Daming (present-day Linqin, Shandong). Having qualified as *zhuangyuan*, or the top *jinshi*, in the imperial examination, he served the court as Auxiliary Academician of the Bureau of Military Affairs, Notary of the Bureau of Military Affairs, and Academician of the Duanming Hall at various times.

This is a social letter ordinarily exchanged between colleagues and hence the brevity. For the same reason, the calligraphy is as ceremonial as the language. To emphasize the sender's respectfulness, the letter is signed and impressed with a signature seal (*Yansou*).

To be selected as the top candidate in civil examinations, Wang must have been an expert in writing in the Chancellery style. As expected, the character structuring is formal. Yet the calligraphy is not at all dull and stale owing to the adroit manipulation of the brush, imbuing the work with nobility and refinement.

Collector seals: *Pujiang jingbiao xiaoyi Zheng shi*, *Zhang Liu*, *Qianlong yulan zhi bao*, and *Baoji chongbian*.

Literature: *Wu's Records of Painting and Calligraphy*, *Shiqu Catalogue of Imperial Collection of Painting and Calligraphy: Series Two*, *Model-calligraphies of the Hall of Three Rarities*, and *Extant Manuscripts by Song Masters (Songxian Yihan)*.

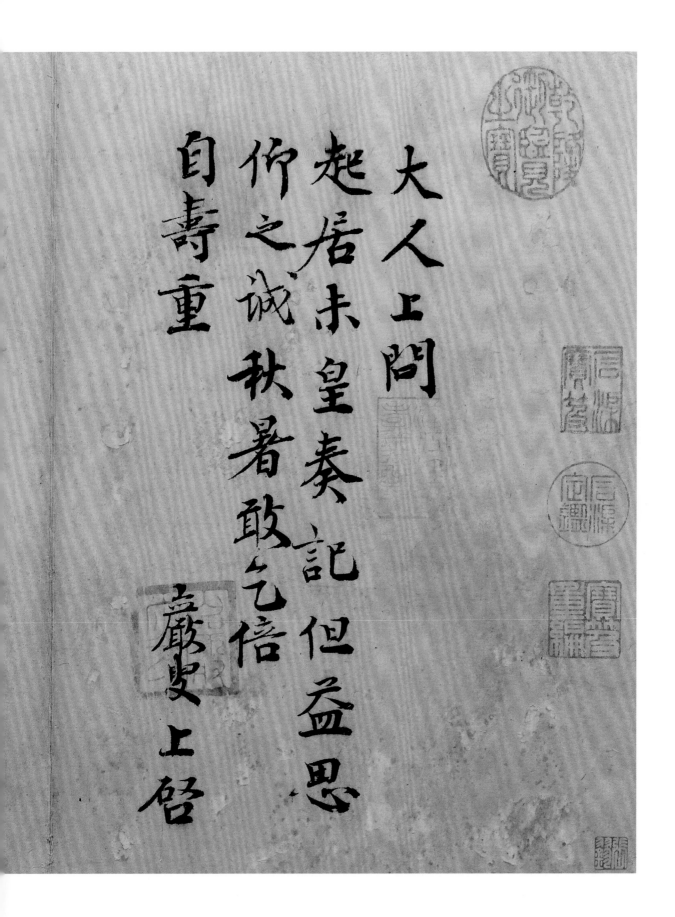

大人上問
起居未皇奏記但益思
仰之誠秋暑敢乞倍
自壽重

嚴史上啟

32

Self-composed Poems

— by —

Wang Shen

— of —

the Song Dynasty

Hand Scroll, running-cursive script

Ink on paper

Height 31.3 cm Width 271.9 cm
Qing court collection

Wang Shen (ca.1048–ca.1104), a native of Taiyuan, Shanxi, became Commandant-escort on marrying Emperor Yingzong's daughter but was demoted on various occasions for being a member of the Yuanyou faction. The famed Northern Song painter was a close friend of Su Shi's, and the two often engaged in literary exchanges. A zealous collector and connoisseur, he wrote his calligraphy in such a unique style that it has been difficult to pinpoint the origins of his art. A theory is that it resulted from his transformation of Yan Zhenqing and Liu Gongquan with exaggeration.

The scroll consists of three sections. The first is a narrative about the calligrapher's boat trip on the West Lake with friends in order to make the best of his disrupted journey to Qingying. The second are poems composed onboard the boat and the third is a *ci*-poem. The date of the poems should be sometime in the early Yuanyou reign when the calligrapher was posted to Yingchangfu (present-day Xuchang, Henan) upon demotion. As for the *ci*-poem, the reference to returning after banishment helps date it to after his reinstatement in the capital of Bianjing.

Despite the woefulness and dejection expressed, the poems are written very livelily without the slightest hesitation. The cohesive character structuring, the emphatic horizontal strokes, and the exposed brush tip all contribute to Wang's identity.

To the right of the calligraphy is an inscription by Kang Youwei reading, "This treasure has long been housed in a museum in Paris, France. It broke my heart when I saw it in Paris, and I composed a poem to vent my feelings. Youwei." To the left are colophons by Emperor Qianlong and a copy of Cao Rong's colophon by Peng Yuanrui.

Collector seals: *Shaoxing*, *neifu shu yin*, *Juqu Waishi*, *Xianke*, *Shigutang shuhua*, *Lingzhi*, *Bian Lingzhi jianding*, and seals of Emperor Qianlong and Wanyan Jingxian.

Literature: *Collected Notes on Paintings and Calligraphies of the Shigu Hall*, *A Sequel to Fortuitous Encounters with Ink*, *Shiqu Catalogue of Imperial Collection of Painting and Calligraphy: Series Two*, *Painting and Calligraphy Records of the Zhuangtao Pavilion (Zhuangtaoge Shuhua Lu)*, and *List of Paintings and Calligraphies in the Sanyu Hall*.

余尝年思移清颍
蓮幕許昌尚迟小泊
向西湖之別館未我
一月常与　韓公
范景仁泛舟宿使之
頗岂专圉流離之
恨也　韓公凄愴漫
厚風度高絶圉已

住辞甕句須刻而
城尖臾莫不蕞孚也
此衙
相迎就除增明
憂学士以宠之因
鬼方今進任者
成如老而更犯
之未之以厚风浴
耳

梯臺倒剪芙蓉沼楊
巾垂、風、爤前無
牧青鈿小似去囿未無限
好流溢歸來到了心
情少坐到黃香人情、
更應添浮朱頜若

古標志花

余舊不飲酒近年輙徙飲
古多酢中所土平

玄溶跋夫始之謬者正之
六既渙邀明白矣知其諜
更加緣飾則其謬不滋甚
乎幾徐題識更正仍存偽
跋以見考訂之由命彭元瑞
書溶跋於後

壬子孟夏溥識

此卷舊傳雙井書眠其執筆迴不相肖公
平生無移潁上留許昌事集中亦無此絕
句而楷尾蝶戀花詞入草堂選余心儗王
晉卿蹟不敢遽謂然也出家藏韓持國南
陽集考之白雪青蓮之句為和王都尉詩
蜀公用玉臺故實的、可證余自喜老眼
生花猶堪懸定古人墨派也晉卿繪事為
時兩重不以書名山谷曾以番人錦囊致
諸然其去國羇栖自云能飲託意信陵至
推眼蜀公大能忠君愛國蓋親受省山陶
鑄一洗膏梁風習超詣乃爾即使未譜八
法猶當以人重況豪落之氣躍、行墨間
者乎先生幸珍惜勿河漢余言康熙庚申
九月望前一日橋李曹溶

勅補錄

臣彭元瑞奉

韓公詩曰法歌
樏白雪态差淳
青蓮徒就西楼
月禹如事停而
蜀公云懀乘霄
潺飢勘說淋泥
蓮可惜玉壺霉
莘開、貳年
盖公不亲辭民
枷有是句六可
一关也

王詵自書詩詞筆勢豪健
宋紙精潔雏無名颖爲真
蹟室疑下永譽書畫彙考
載元趙蕭明王洪陳繼儒
三跋皆以爲黃庭堅作我
朝曹溶始摽草堂詩徐及
韓維南陽集定爲詵蹟詵
集不傳而溶能旁引曲證
可謂典確不知何時乃易
比蘇軾蔡襄黃庭堅三跋
卷語襄集答此跋襄以英
考軾跋見本集非專題是
宗元豐三年庚申軾謫黃
宗治平二年乙巳卒玉神
州詵始坐累謫均州後十
五年庭堅集亦答此跋且
阮有跋安湜復稱爲庭堅

33

Poems on the Tiao Stream

by

Mi Fu

of

the Song Dynasty

Hand Scroll, running script

Ink on paper

Height 30.3 cm Width 189.5 cm

Qing court collection

Mi Fu (1051–1107), whose ancestors in Xiangyang (present-day Xiangfan, Hubei) hailed from Taiyuan, Shanxi, made Runzhou (present-day Zhenjiang, Jiangsu) his home in his late years. During the reign of the Song emperor Huizong, he served the court as Vice Director of the Ministry of Rites and Erudite of Painting and Calligraphy. Noted also for his connoisseurship and painting, he was eclectic in his choice of models to arrive at a pristine style in calligraphy that is diverse in brush methods and quaintly sloping in character structuring. Belonging in the group called Four Masters of the Song, he has been considered to be on a par with Cai Xiang, Su Shi, and Huang Tingjian.

The six poems that make up the scroll were composed in the third year of the Yuanyou reign (1088) when Mi visited the Tiao Stream while sojourning in Wuxi in late spring and early summer. Come the eighth month, they were calligraphed as a farewell gift to friends prior to his departure for Huzhou. Having been smuggled out of the Puppet Manchurian Palace in Changchun, the scroll is damaged completely in six characters, partly in two, and slightly in three. The frontispiece inscribed in seal script by Li Dongyang and the inscription by Xiang Yuanbian are now missing. Recovered in 1963, the scroll has been remounted, and the missing or torn characters replaced by tracing.

Quintessential of the calligrapher's mid-year style which has been described as "emitting an aura comparable to swirling clouds and mists," the calligraphy is striking in its confidence and robustness in a composition where diffusion alternates with concentration.

Inscribers on the colophon paper include Mi Youren of the Song and Li Dongyang of the Ming.

Collector seals: *Hesidian yin, Shaoxing, Baiji yinzhang, Xianyu, Lu You,* (one character illegible) *shi* (one character illegible) *shou zhenwan, Xichu wangsun, Shiqi zhi yin, Yang shi jiacang, Quanqing zhenshang, Quanqing,* and seals of Xiang Yuanbian, Liang Qingbiao, and Qing emperors Qianlong, Jiaqing, and Xuantong. There is also a serial number under Xiang Yuanbian's system.

Literature: *Coral Nets: Calligraphy Inscriptions, Wu's Records of Painting and Calligraphy, Collected Notes on Paintings and Calligraphies of the Shigu Hall, Yu's Records of Painting and Calligraphy Inscriptions: Series Two, Spectacles Viewed in a Lifetime, Inspiring Views,* and *Shiqu Catalogue of Imperial Collection of Painting and Calligraphy: Series One.*

※ 本頁為行草書法作品影像，字跡為草書，辨識困難，以下為盡力釋讀。

通貨非理性批病覺養心切
小圓能留客青冥不厭
鴻秋帆尋賀老載酒
過江東
仕倦成流苦遊頻慣轉
蓬熟來隨意住涼至逐
東入境親珠集他鄉
彼此同暖承革食飽但覺
愧梁鴻
旅食緣交難浮家為興
束句留荆水話襟向下
峯開過荆如尋戴遊梁
定賦枚漁歌堪盡畫又
有魯公陪
密友得春折紅薇過夏
榮園枝殊自得顧我若舍
青漫有蘭隨色寧無石

松來元章濤翰居紹興
以磨思放圓昌壬子友仁
題之没轉先生蕭墓果

村陸先生檢詰放篋重
加裝飾物之群曉圓
自為孤我先生方探點
陸之榜振匜君蒲之
二十士賴以名卻後于余
老為美識之章母以乙
事觀之主貽筆而子二月
十二日長沙學素陽題

将之苕溪戲作呈
諸友
襄陽漫仕黻

松竹留因夏溪山去為
秋久賀白雪詠更慶宵
菱謳繪來鑑唯榮
團金橘滿洲水宮無限
景載與謝公遊
半歲依舊竹三時看好
花懶傾惠泉酒點盡
墅源茶主席多同好群
舉伴不辭朝未遣還
簡使起故巢覽茗
諸友載酒不辭而余以
彥明約置膳

密友篤春拆紅薇過夏
榮團枝殊自得顧我若舍
情漫有蘭隨色寧無石
對聲初懷暇二月依
廂滿郎行
元祐戊辰八月八日作

秋兌元章詩翰有紹興
乃唐興鏺園曰軍友仁
題卷後轉先邕蕭�êñ
亓亭名氏義也元章去
歡精姌而友仁而亦象
陳子子思美與善慶耽
後公盤閒之中澶去慶
嵩南汜潛如宋氏去江

34

Elegy to Empress Dowager Xiang

— by —

Mi Fu

— of —

the Song Dynasty

Leaves, small regular script

Ink on paper

Height 30.2 cm Width 22.7 cm (leaf one),
and 22.3 cm (leaf two)

An avid calligrapher, Mi Fu has been called a "treasury of archaic characters" for his assimilation of a horde of past masters and was unsurpassed in the Song Dynasty in artistry, diversity, and vigour. Empress Dowager Xiang was Emperor Shenzong's empress, and the title was bestowed on her when their son Zhezong succeeded as emperor. She passed away in the first year of the Jianzhongjingguo reign (1101) at the age of 56.

Drafted by some other officials as specified in the closing inscription, the elegy was calligraphed and signed by Mi Fu upon the Empress Dowager's decease.

Dating from the calligrapher's late years, the regular script is tinged with peculiarities of the running script. Vigorous in brushwork and compact in character structuring, the calligraphy has shed the uniformity of the Tang regular script. Although the majority of his

extant examples are in running-cursive script, Mi in fact believed it is the regular script that showcases calligraphy in its entirety.

Colophons to the calligraphy are inscribed by Dong Qichang and Huang Daozhou of the Ming and Sun Shenxing, Zhu Yifan, Yang Shoujing, and Li Baoxun of the Qing.

Collector seals: *Xiang Zijing yin*, *Hongxu*, *Xu Weiren yin*, and *Fei Nianci*.

Literature: *Attachment to Antiquity (Nigu Lu)*, *The Qinghe Boat of Painting and Calligraphy*, *In the Qinghe Private Chest*, *Coral Nets: Calligraphy Inscriptions*, *Spectacles Viewed in a Lifetime*, and *Collected Notes on Paintings and Calligraphies of the Shigu Hall*.

35

Letter Painted with a Coral

by

Mi Fu

—— of ——

the Song Dynasty

Running script

Ink on paper

Height 26.6 cm Width 47.1 cm

In the letter about the items in his collection, Mi mentions two artists. One of them is Zhang Sengyou, a Southern Dynasties painter noted for his Buddhist and Daoist images such as the "Heavenly King"; and the other, Xue Ji, was an early Tang calligrapher. The name Jingwen, or presumably Xie Jingwen in full, refers to a contemporary who was acting minister posted as prefect and is therefore referred to by the title "*jiexiang*" in the poem. He was likely to be the collector of the painting *Seeking Advice on Rites* and the coral brush rest. An alternative proposition is that "*jiexiang*" actually implies a member of the current imperial family.

Although vehement and capricious, the calligraphy follows established rules and principles. The painting of a coral brush rest as illustration is a stroke of ingenuity and provides posterity with a solitary example of the calligrapher in another genre.

Inscribers of the colophons include Mi Youren of the Song, Guo Tianxi, Shi Guangyuan, and Ji Zongyuan of the Yuan, Xie Zaizhu, and Jiao Yuanpu of the Ming, and Yongxing of the Qing.

Collector seals: *neifu shu yin*, *daya*, *wenyan sanmei*, seals of Liang Qingbiao, Wang Hongxu, An Qi, and Yongxing of the Qing, *Nanyunzhai yin*, *Dingfu zhencang*, *Zeng Cunding di Xingyouhengtang*, *Zeng Cun Xingyouhengtang*, *Xingyouhengtang shending zhenji*, and *Jiean jianshang*.

Literature: *Fleeting Delights for the Eyes*, *Inspiring Views*, *Fortuitous Encounters with Ink*, and *Painting and Calligraphy Records of the Zhuangtao Pavilion*.

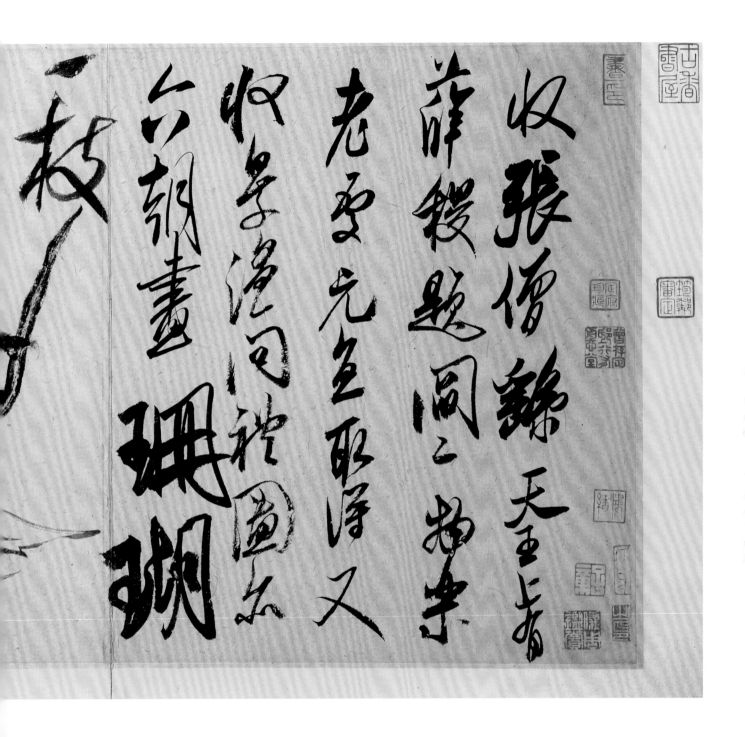

收張僧繇天王古
薛稷題閻立本畫
老叟元宗取浮丘
收呈滉句飲圖亦
六朝畫珊瑚
一枝

Letter Conveying Good Wishes

Mi Youren (1074–1153) was Mi Fu's eldest son and a privileged exponent of his father's calligraphic legacy so much so that father and son have gone down in history as Mi the Senior and Mi the Junior. He served the court as Vice Minister of War and Auxiliary Academician in the Hall for the Diffusion of Literature (Fuwenge) in the early Southern Song before entrusted by Emperor Gaozong with authentication of paintings and calligraphies in the imperial collection.

Also named Zhi Xing Tie, the letter was written by Mi Youren. Possibly with certain characters cut off, the letter is not entirely comprehensible.

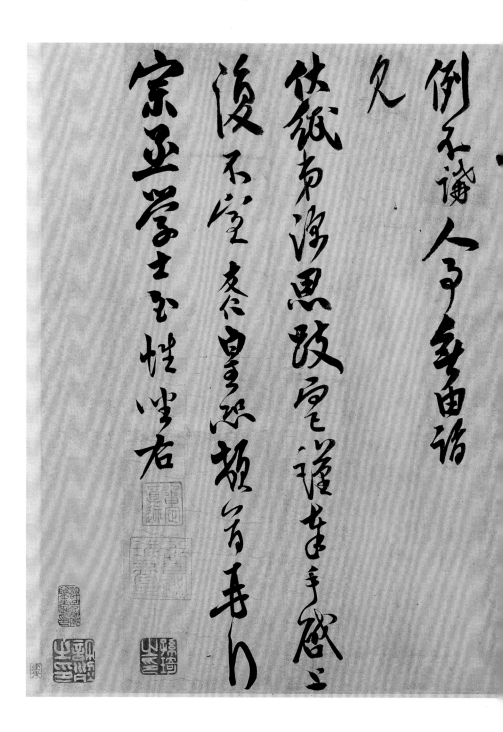

Although indistinguishable from Mi Fu's style in character structuring and brush methods, the son's calligraphy appears to be rather reserved and lacks the father's unrestrained ethos. In a way, this testifies to the fact that imitation, however assiduous, can never completely suppress idiosyncrasies even if the legacy is passed on from father to son.

The colophon is inscribed by He Guangqian of the Yuan.

Collector seals: *shending zhenji*, *Guo shi miwan zhi yin*, *Hanmolin shuhua zhang*, and *Sun Qi zhi yin*.

Literature: *Collected Notes on Paintings and Calligraphies of the Shigu Hall* and *Inspiring Views*.

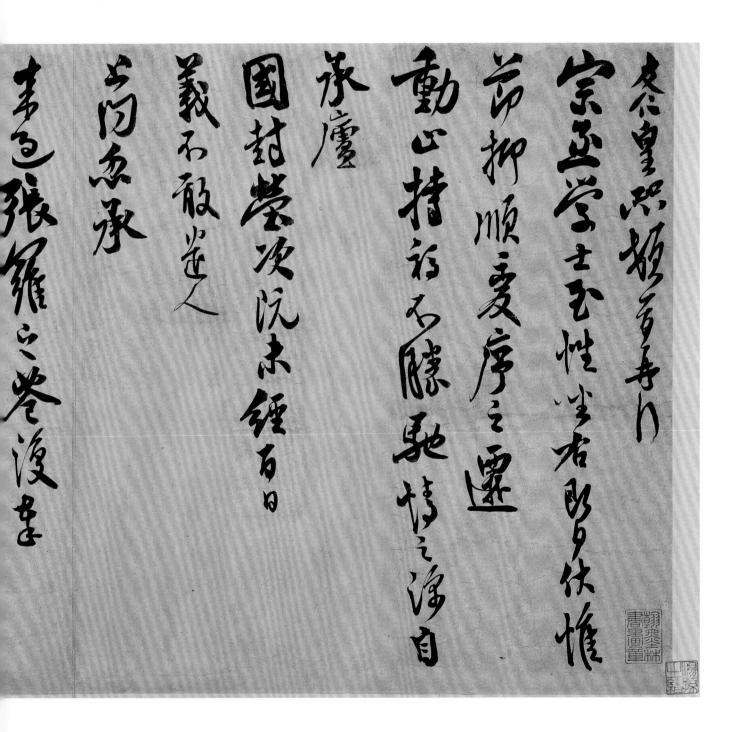

Letter to Zhao Lingrang

— by —

Xue Shaopeng

— of —

the Song Dynasty

Cursive script

Ink on paper

Height 21.5 cm Width 34.8 cm

Xue Shaopeng (dates unknown), a native of Chang'an (present-day Xi'an, Shaanxi), was Senior Compiler of Hanlin Academy and Transport Intendant in the Zitong Circuit in the early years of Emperor Huizong's reign. The calligrapher had a passion for collecting and appreciating antiquities and was mentioned in one breath with his bosom friend Mi Fu.

Impressed with a large seal (*Qingmige shu*), the letter is addressed to Zhao Lingrang, the Song emperor Taizu's fifth-generation grandson, asking to view two inksticks made by Li Chengyan and Zhang Yu, who were celebrated artisans from the Five Dynasties period. Xue further promised that he was willing to offer Zhao a calligraphic work by Wang Xizhi in exchange if the two works were intact and authentic. The specimen is therefore also a valuable raw material for studying collecting activities among the Northern Song elites.

Entrenched in the Two Wangs tradition, the calligraphy is characterized by its practised manipulation of the brush. Its subtlety and archaistic flavour also set it apart from the expressiveness that defines Northern Song calligraphy.

Collector seals: *Shaoxing*, *Zhenyuan*, and *Xu Zixian jianding yin*.

Literature: *Intended Meanings, Corals Harvested with Iron Nets, Wu's Records of Painting and Calligraphy, Collected Notes on Paintings and Calligraphies of the Shigu Hall, Spectacles Viewed in a Lifetime,* and *Calligraphies by Song Masters (Songren Shuhan).*

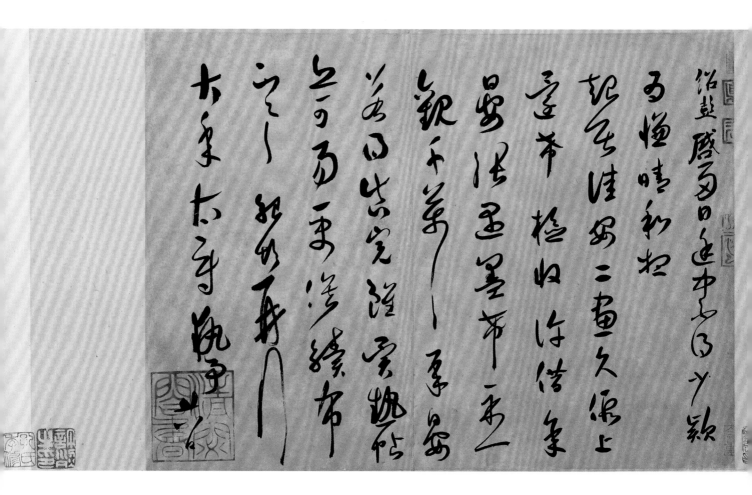

38

Letter of Early Summer
— by —
Wang Sheng
— of —
the Song Dynasty
Running script

Ink on paper

Height 32.2 cm Width 38.1 cm

Wang Sheng (1076–?), a native of Bian (present-day Kaifeng, Henan), presented Emperor Huizong with his own calligraphy and successfully solicited a scribe position at court. Some of his extant works are dated as late as the 19th year of the Shaoxing reign (1149) in the Southern Song.

Unflustered and spontaneous, this letter of greetings to a friend has captured Mi Fu's essences. In addition to the running script seen here, the calligrapher's cursive script has also been held in high regard for approximating Zhang Xu's style, enticing the ill-intentioned to pass off his works, with signatures cut off, as Tang masters'.

Collector seals: *Zhenhuitang ji*, *Song Luo shending*, *Huang shiyizi Cheng Qinwang Yijinzhai tushu yin*, *Nanyunzhai yin*, *Lianqiao jianshang*, and *Jiang Xun zhi yin*.

Literature: *Impressions of Paintings and Calligraphies*, *Authentic Calligraphies in the Collection of the Haishan Xianguan (Haishan Xianguan Cang Zhentie)*, and *Calligraphies by Song Masters (Songren Shuhan)*.

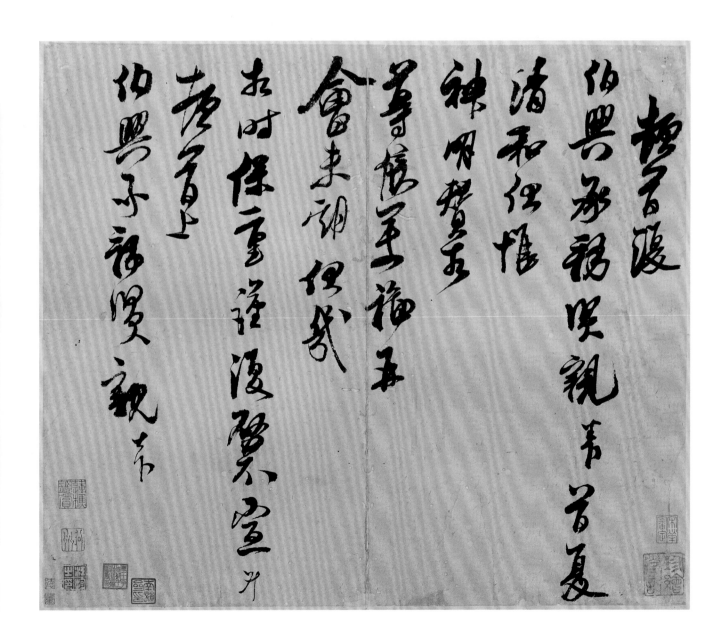

Letter of Wuyuan

by

Zheng Wangzhi

of

the Song Dynasty

Leaf, running script

Ink on paper

Height 34.3 cm Width 47 cm

Zheng Wangzhi (1078–1161) was a native of Pengcheng (present-day Xuzhou, Jiangsu) resident in Shangrao. Qualifying as *jinshi* in the fifth year of the Chongning reign (1106), he rose through the ranks to become Vice Minister of Personnel and retired as Auxiliary Academician of the Huiyou Pavilion (Huiyouge) in the seventh year of the Shaoxing reign (1137).

Addressed to Zeng Hongfu, a good friend of Zheng's, the letter is the only extant specimen by the calligrapher. The merits of the calligraphy are especially conspicuous in the robustness and refinement made possible by perfect control of the brush, while the structuring and brush methods are borrowed from Su Shi and Mi Fu.

Collector seals: *Xu Zixian jianding yin* and *Ji Xiu bogu*.

Literature: *Calligraphies by Song Masters*.

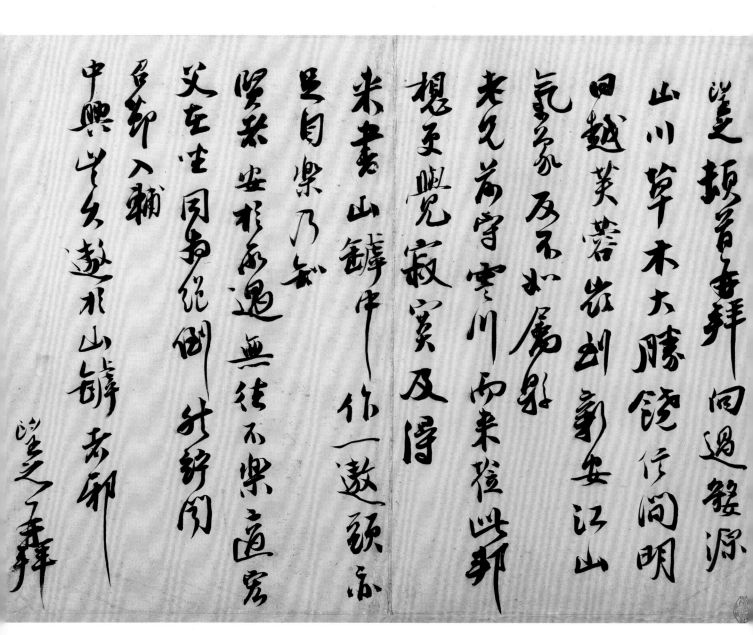

40

Poem on the Leap Mid-Autumn Moon

— by —

Zhao Ji

— of —

the Song Dynasty

regular script

Ink on paper

Height 35 cm Width 44.5 cm
Qing court collection

Zhao Ji (1082–1135), or the Song emperor Huizong (r. 1100–1126), was Emperor Shenzong's 11th son and Emperor Zhezong's younger brother. He succeeded to the throne in the third year of the Yuanfu reign (1100) and abdicated in favour of his son, the future Emperor Qinzong, in early 1126 when the empire was threatened by Jin Jurchen troops advancing from the north. In 1127, the father and the son were taken as hostages and never released when the capital Bianjing fell to Jin hands in an incident called Jingkang Humiliation in Chinese history. Gifted in calligraphy as much as painting, the emperor modelled on Huang Tingjian at first and Xue Ji later. More importantly, he was the inventor of the slender gold script that is characterized by its ornamentally attenuated strokes.

The calligraphy owes its text to a heptasyllabic octave that the Emperor composed in the fourth year of the Daguan reign (1110). In that leap year by the Chinese lunar calendar, there were two Mid-Autumn Festivals for admiring the extraordinarily full moon twice in a row. Elated at the rare opportunity, Zhao celebrated by composing the present poem. In calligraphing it subsequently, he blended the beauty of nature, literature, and calligraphy into one. The work is impressed with two seals of the Emperor, with "*yushu*," or "by the emperor," in the upper right and "*Xuanhedian bao*," or "treasure of the Xuanhe Palace," in the upper left.

Collector seals: *Song Luo shending* and *Jiaqing yulan zhi bao*.

Literature: *A Mounter's Random Notes* and *Shiqu Catalogue of Imperial Collection of Painting and Calligraphy: Series One*.

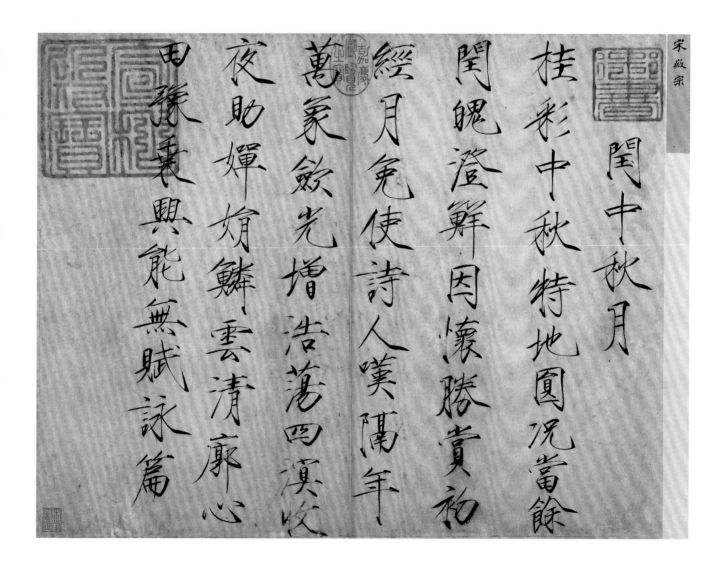

Letter of Thanks
— by —
Zhu Shengfei
— of —
the Song Dynasty
Regular-running script

Ink on paper
Height 28.7 cm Width 28.6 cm

Zhu Shengfei (1082–1144), a native of Caizhou (present-day Ru'nan, Henan), was qualified as *jinshi* in the second year of the Chongning reign (1103). In the wake of the Jingkang Humiliation, he joined others in persuading Zhao Gou to take over the throne and later emerged as a prominent official of the early Southern Song, occupying important positions such as Right Vice Director of the Department of State Affairs doubling up as Administrator of the Bureau of Military Affairs. In supporting launching campaigns to the north to recover lost territories, he found himself at odds with Qin Hui and was forced to stay away from the court on excuse of ill health.

By inference from the content, the letter should have been written in the calligrapher's late years during his self-imposed abstention.

In emulation of Su Shi, the calligraphy is handsomely sparse and casual, leaving the calligrapher's gloom to the viewer's imagination.

Collector seals: seven seals belonging to Xiang Yuanbian including *Xiang Yuanbian yin* in addition to *Shiqi zhi yin* and *Yang shi jiacang*.

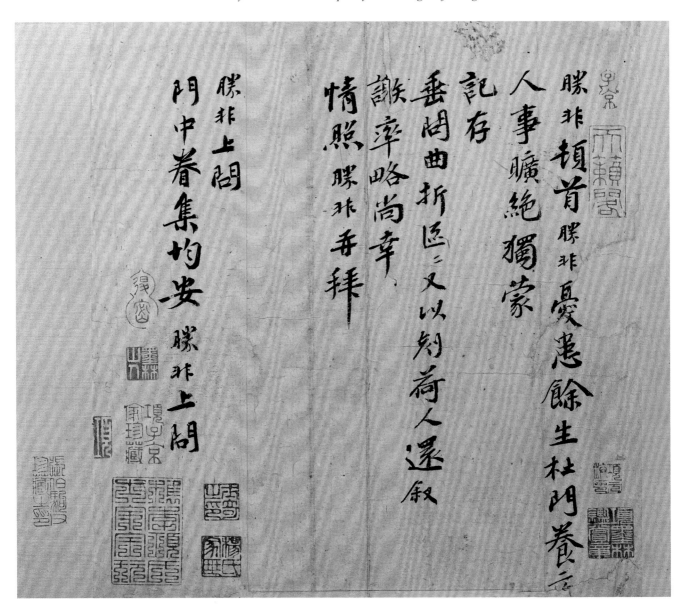

42

Letter of Thanks
— by —
Han Shizhong
— of —
the Song Dynasty

Regular-running script

Ink on paper

Height 29.7 cm Width 37.7 cm

Han Shizhong (1089–1151), a native of Yan'an (present-day Yan'an, Shaanxi), joined the army at the age of 18. His valiant leadership in the resistance against Jin Jurchen invasions in the early Southern Song won him glorification as one of the Four Generals of the Dynastic Revival. In the 11th year of the Shaoxing reign (1141), he was demilitarized and compensated with the office of Military Affairs Commissioner and ennoblement as duke, which was posthumously elevated to Qi Wang, Zhongwu, by Emperor Xiaozong.

Han mentions in the letter that he has donated all his personal properties to the government, a deed that is documented in *History of the Song* (*Song Shi*). His noble character and patriotism are admirable till the end of time.

The general's cultivation is reflected in the calligraphy, which is firm and poised with Su Shi's classic attributes.

Collector seals: *wuyang* and *Xu Zixian jianding yin*.

Literature: *Collected Notes on Paintings and Calligraphies of the Shigu Hall* and *Calligraphies by Song Masters* (Songren Shuhan).

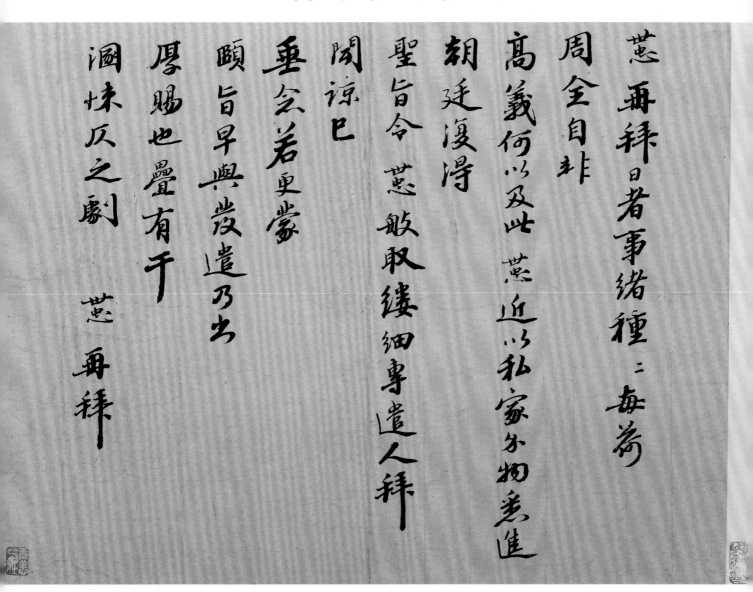

43

Letter with Greetings for Autumn

— by —

Liu Guangshi

— of —

the Song Dynasty

Running script

Ink on paper

Height 33.5 cm Width 43.2 cm

Qing court collection

Liu Guangshi (1089–1142), a native of Baoanjun (present-day Zhidan, Shaanxi), joined his father Liu Yanqing, an illustrious general, in suppressing the Fang La Rebellion. He was known together with Yue Fei, Han Shizhong, and Zhang Jun as the Four Generals of the Dynastic Revival for his gallant military service to the empire against Jin Jurchen attacks. He was discharged of his military duties in the seventh year of the Shaoxing reign (1137) and was posthumously ennobled as Wang by Emperor Ningzong.

The letter is addressed to a prefect. To show respect, a new column is started whenever reference is made to the addressee or anything associating with the emperor. Thus, there are sometimes just a few characters in a column and hence the rather unusual composition.

As was common among officials at the time, the influence of Su Shi is again strongly felt in the present specimen with its somewhat squat forms and substantial strokes.

Collector seals: *Zhanguntang, Zhongche, Yuan Zhongche yin*, and *Nanchang Yuan shi jiacang zhenwan zisun yongbao*.

Literature: *Wu's Records of Painting and Calligraphy, Collected Notes on Paintings and Calligraphies of the Shigu Hall*, and *Shiqu Catalogue of Imperial Collection of Painting and Calligraphy: Series Two*.

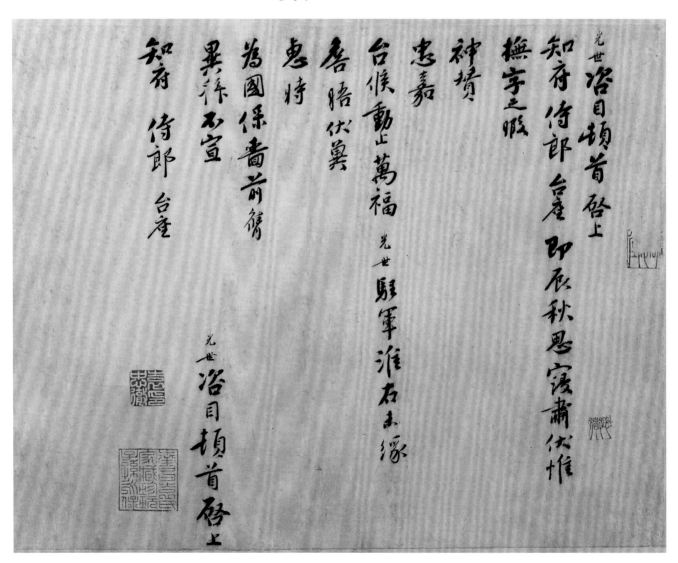

44

Letter on a Bandit
— by —
Zhang Jun
— of —
the Song Dynasty

Running script

Ink on paper

Height 31.5 cm Width 38.2 cm

Zhang Jun (1097–1164), a native of Mianzhu, Hanzhou (present-day Sichuan), was Right Vice Director of the Department of State Affairs and Administrator of the Bureau of Military Affairs during the Shaoxing reign (1131–1162) after qualifying as *jinshi* in the eighth year of the Zhenghe reign (1118). In Chinese history, he has been acclaimed for his role in the resistance against the Jin Jurchens. He was, however, removed from office owing to his serious conflicts with Qin Hui, and his reinstatement had to wait until the latter's death.

Dated the third year of the Shaoxing reign (1133), the letter is addressed to the legendary general Yue Fei, who had just quelled the rebels in Qianzhou (present-day Ganzhou, Jiangxi). The reference to the event makes the letter an important piece of historical material.

Featuring a relatively compact character structuring, the calligraphy carries hints of Su Shi's style.

Collector seals: *Shen Zhou baowan*, *Wu Shen shi Youzhuzhuang tushu*, *Li Junshi jianding*, *Zuili Li shi Hemengxuan zhencang ji*, *wuyang*, and *Xu Zixian jianding yin*.

Literature: *Intended Meanings*, *The Qinghe Boat of Painting and Calligraphy*, *Collected Notes on Paintings and Calligraphies of the Shigu Hall*, *Spectacles Viewed in a Lifetime*, and *Calligraphies by Song Masters*.

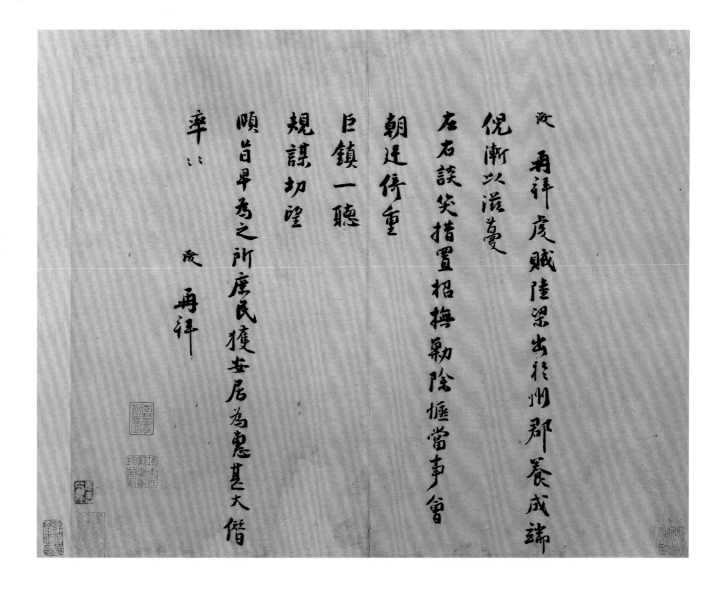

Latter Fu-rhapsody on the Red Cliff

by

Zhao Gou

of

the Song Dynasty

Hand Scroll, cursive script

Ink on silk

Height 29.5 cm Width 143 cm (painting inclusive)

Qing court collection

Zhao Gou (1107–1187) was the Song emperor Huizong's ninth son who succeeded the throne as Emperor Gaozong (r. 1127–1162) when Emperors Huizong and Qinzong were abducted to the north by Jin forces. With the capital relocated first to Yingtianfu, Nanjing (present-day Shangqiu, Henan), and then Lin'an (present-day Hangzhou, Zhejiang), the Song regime was reinstored and has come to be known as the Southern Song in history. In the 32nd year of the Shaoxing reign (1162), he abdicated in favour of Emperor Xiaozong. Like his father Zhao Ji, he was artistically gifted, excelling in the regular, running and cursive scripts.

Mounted as a single scroll with a painting of the same title by the Southern Song Academy painter Ma Hezhi, the calligraphy owes its text to Su Shi's literary classic the *Latter Fu-rhapsody on the Red Cliff* (*Hou Chibi Fu*). Judging from the round dragon seal and the seal reading "*Taishang Huangdi zhi bao*," or "treasure of the Emperor Emeritus," it should have been written after the calligrapher's abdication.

Tallying the perception that the calligrapher was fascinated with Huang Tingjian and Mi Fu in his early years and with Wang Xizhi and Wang Xianzhi in his late ones, the effortless and sophisticated calligraphy echoes the Two Wangs without effacing its own personality.

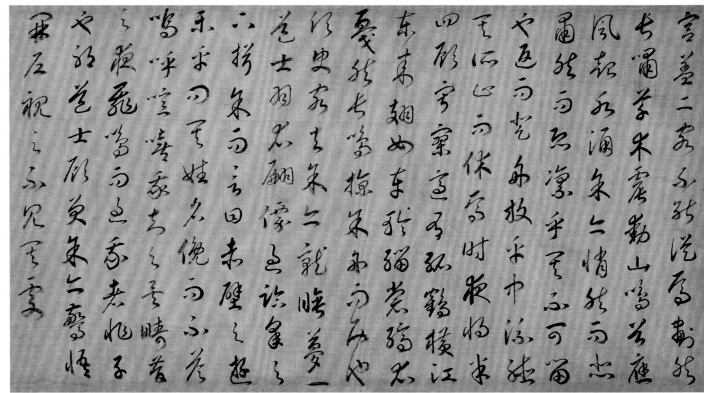

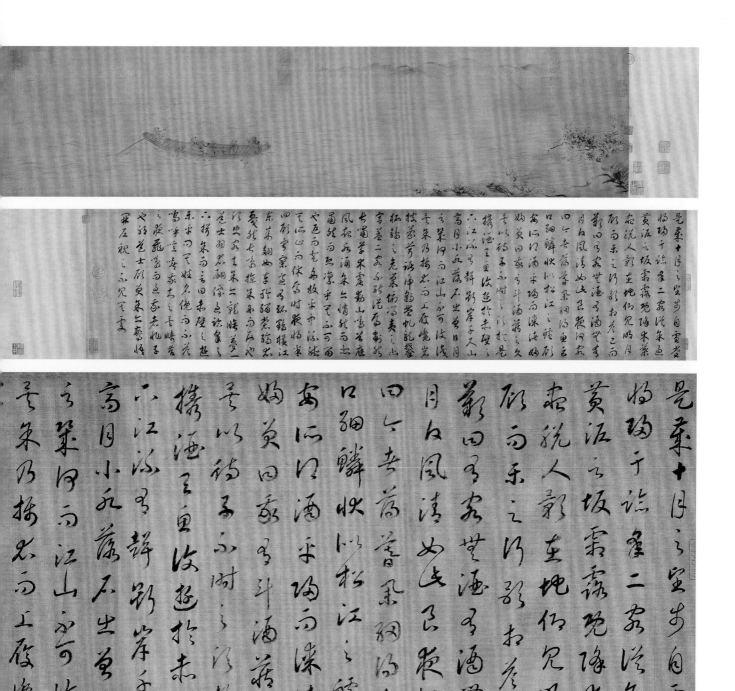

46
Letter to Zhang Tao

by

Liu Cen

of

the Song Dynasty

Running-cursive script

Ink on paper
Height 31.3 cm Width 52.5 cm

Liu Cen (dates unknown), a native of Wuxing (present-day Huzhou, Zhejiang), was qualified as *jinshi* in the sixth year of the Xuanhe reign (1124) and was once dispatched to the Liao as envoy. His confrontation with Qin Hui ended in his dismissal during the Shaoxing reign (1131–1162) but was reinstated and eventually promoted to become Vice Minister of Revenue after Qin's death.

Dating from the calligrapher's late years, the calligraphy is facilely written with no pretensions, a testimony to the cultivation of the average literatus.

Collector seals: *Lianqiao jianshang, Jiang Xun zhi yin, Deliang, Nanyunzhai yin,* and *Huang shiyizi Cheng Qinwang Yijinzhai tushu yin.*

Literature: *Impressions of Paintings and Calligraphies* and *Calligraphies by Song Masters.*

太夕拾引
以不乃意四句生石津南清深危告告多至延一性
真石坦好生書中國遂不世方
郎書居若詩汗罷专专善倦好之言
石作何如 春珍比遊由三空城堪書叶沉丁程天史却小長庆
以生書
晋何怕岁刂以口当叮谁命专心
川主書
以共为未我为手悄与专口夕俟卹孜专好美专
拙毫岩南し耘主迩め民两两形
任乜図
去专二田水障廈
为揭行生岁金め
以辭有阮石专助雲情专倦名未乐
任专交谷一

Letter Soliciting a Jade Ruler

——— by ———

Wu Yue

——— of ———

the Song Dynasty

Running script

Ink on paper

Height 25.2 cm Width 45.4 cm

Wu Yue (dates unknown), a native of Qiantang (present-day Hangzhou, Zhejiang), once served the court as Secretarial Court Gentleman of the Interior. His accomplishment among Southern Song calligraphers warrants eulogization by Emperor Gaozong in his *On Calligraphy* (*Hanmo Zhi*). In addition to his proficiency in various scripts, he created the "gossamer style," by which characters with delicate gossamer-like strokes in the cursive script are attractively written with the tip of the brush in a continuous interconnected string.

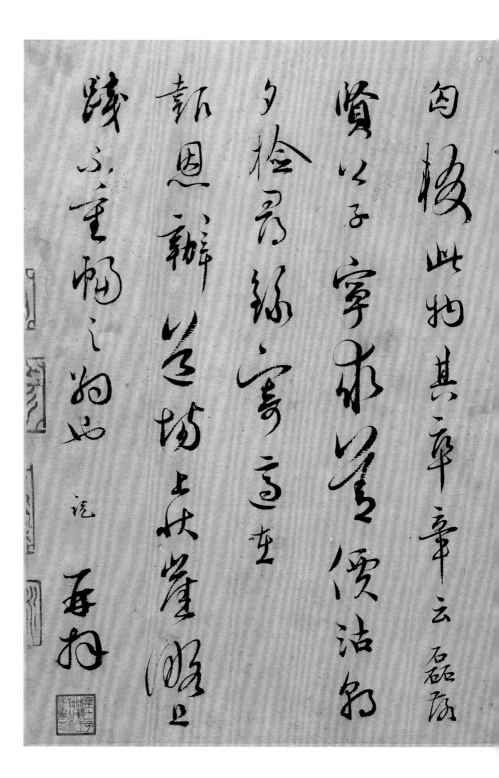

In the letter, Wu asks a friend to make available a jade ruler that would make a tasteful adornment in his studio, providing posterity with an instance of literati pursuits. The calligraphy is fluid and elegant, doing full justice to the Two Wangs tradition that the calligrapher espoused.

Collector seals: six illegible fragmented seals, *Jiang Deliang jiancang yin*, and *Huang shiyizi Cheng Qinwang Yijinzhai tushu yin.*

Literature: *A Mounter's Random Notes.*

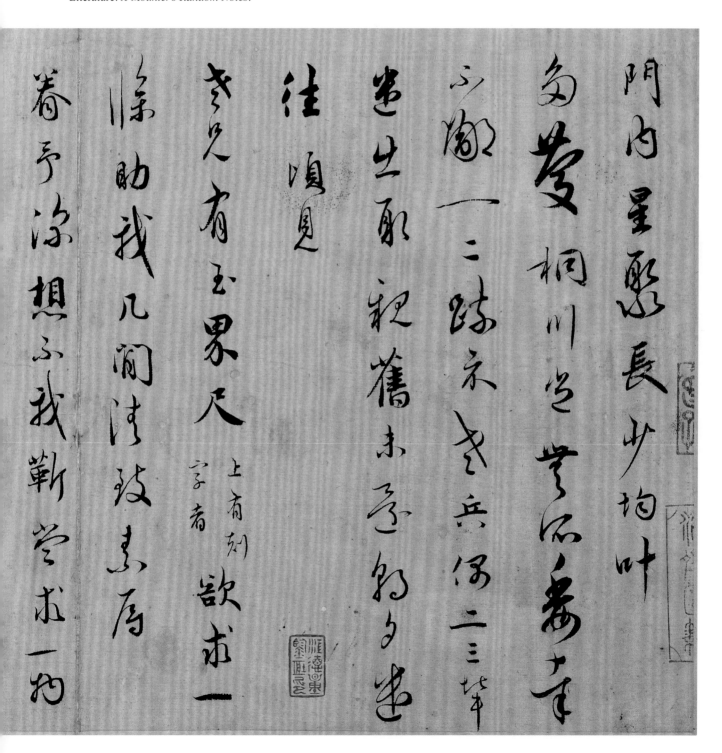

48

Reminiscences of Chengdu

by
Lu You

of
the Song Dynasty

Hand Scroll, running-cursive script

Ink on paper

Height 34.6 cm Width 82.4 cm
Qing court collection

Lu You (1125–1210), a native of Shanyin, Yuezhou (present-day Shaoxing, Zhejiang), rose through the ranks to become Edict Attendant of the Baozhang Pavilion (Baozhangge). The patriotic poet of the Southern Song was also an adept calligrapher with a distinctive style despite his professed emulation of Zhang Xu of the Tang for the cursive script and Yang Ningshi of the Five Dynasties for the running.

At the recipient's behest, the present heptasyllabic verse in the ancient style, entitled after the same piece collected in *Poetic Works from Jiannan* (*Jiannan Shigao*), was selected for the text. Preceding the calligraphy by several years, the poem, composed in the fifth year of the Chunxi reign (1178) for banishing the solitude and listlessness of an unambitious life back home, reminisces the more colourful days when the calligrapher was Assistant Administration Commissioner of Chengdu when he was around 50.

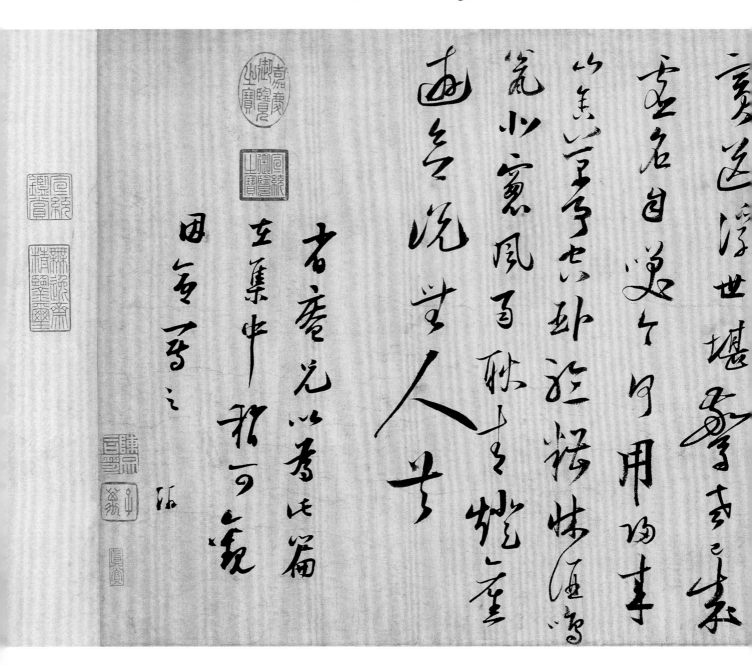

Refreshingly original, the calligraphy befits the calligrapher's reputation.

To the left of the calligraphy are colophons inscribed by Chen Yi, Xie Duo, Cheng Minzheng, Wang Ao, Zhou Jing, Yang Xunji, and Shen Zhou of the Ming.

Collector seals: *Yuanbo, zhenshang, Shangqiu Song Luo shending zhenji, Chen Zonghou yin, Ziwan, Qianlong yulan zhi bao, Jiaqing yulan zhi bao,* and *Xuantong yulan zhi bao.*

Literature: *A Mounter's Random Notes* and *Shiqu Catalogue of Imperial Collection of Painting and Calligraphy: Series One.*

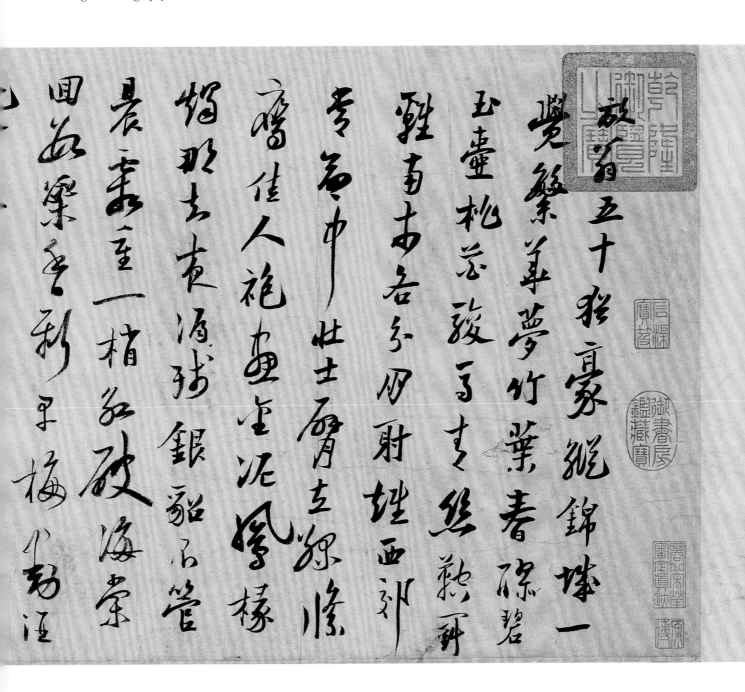

49

Letter to Fan's sister-in-law
— by —
Fan Chengda
— of —
the Song Dynasty

Running script

Ink on paper
Height 31.8 cm Width 42.4 cm

Fan Chengda (1126–1193), a native of Wuxian, Suzhou (present-day Suzhou, Jiangsu), was qualified as *jinshi* in the 24th year of the Shaoxing reign (1154). He retired to his hometown Shihu in his old age after having served as envoy to the Jin and Assistant Administrator in his career as an official. Fan was also an esteemed man of letter, ranking with Yang Wanli, Lu You, and You Mao as the Four Poets of the Dynastic Revival.

Devoid of floridity and flushed with initimacy, the letter was written to ask after his sister-in-law and other members in his extended family.

Fluid and vigorous although not without a measure of subtlety, the calligraphy is a gem among calligraphies in the form of letters.

Collector seals: *Jiean shuhua*, *Zuili Li shi Hemengxuan zhencang ji*, *yunyan guoyan*, *Xiang Dushou yin*, *Xiang Zichang fu jianding*, *wuyang*, and *Xu Zixian jianding yin*.

Literature: *Collected Notes on Paintings and Calligraphies of the Shigu Hall*, *Spectacles Viewed in a Lifetime*, and *Calligraphies by Song Masters*.

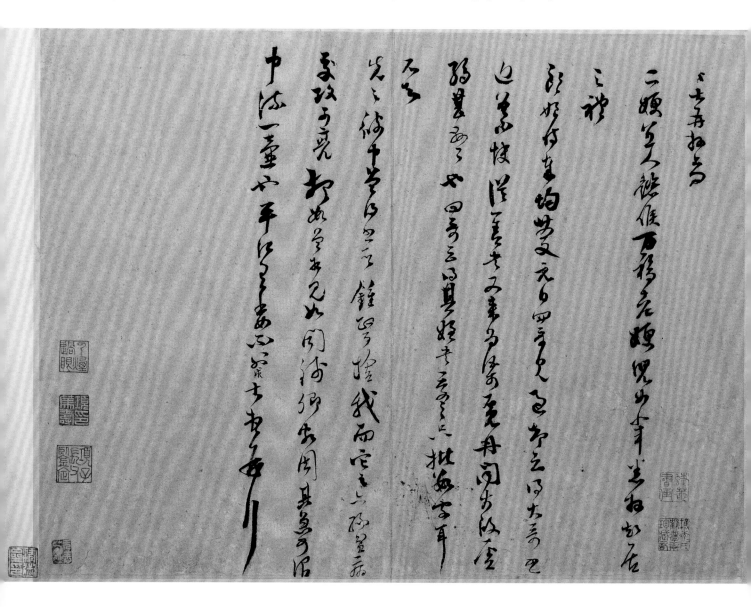

50

Letter of Thanks
— by —
Zhang Xiaoxiang
— of —
the Song Dynasty
Leaf, running script

Ink on paper

Height 31.3 cm Width 45.9 cm

Zhang Xiaoxiang (1132–1170), a native of Wujiang, Hezhou (present-day Hexian, Anhui), held various positions including Editorial Director and Secretariat Drafter following his qualification as *zhuangyuan*, or the top *jinshi*, in civil examinations, in the 24th year of the Shaoxing reign (1154). In history, he has been lauded for petitioning the emperor in support of the condemned Yue Fei at the risk of his life. He served the court until his retirement in the fifth year of the Qiandao reign (1169). Adopting an unrestrained style reminiscent of Su Shi's, he has been celebrated for his *ci*-poetry and exalted as a leader in Southern Song literature.

The letter was written to express gratitude to a friend who came to visit him despite the summer heat.

As can be expected of a talented man of letters, the calligraphy is appealing with its handsome characters, lively rendition, and radiating aura.

Collector seals: *Qingrongzhai, wuyang, Xiang Zijing jia zhencang*, and *Xu Zixian jianding yin*.

Literature: *Collected Notes on Paintings and Calligraphies of the Shigu Hall* and *Calligraphies by Song Masters*.

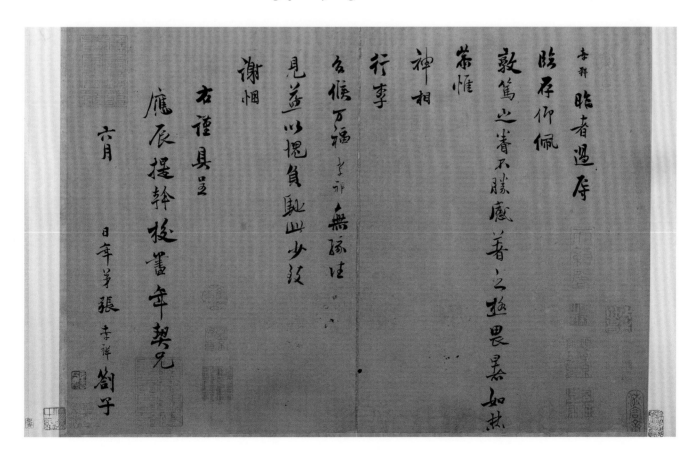

51

Letter referring to Yuegu

——— by ———

Wu Ju

——— of ———

the Song Dynasty

Running script

Ink on paper

Height 22.5 cm Width 48.7 cm

Qing court collection

Wu Ju (dates unknown), a Southern Song native of Bianliang (present-day Kaifeng, Henan), was a nephew of Empress Wu, Emperor Gaozong's empress consort, and therefore a prince. Unambitious politically, he adopted copying ancient calligraphic masterpieces as a favourite routine, nurturing himself to become an esteemed calligrapher of his time.

The reference to "Yuegu" in the letter likely denotes Han Tuozhou, a powerful courtier at the time, by the name of his studio Yuegu Hall. By inference from the content, Wu probably wrote it towards the end of the Chunxi reign (1174–1189), when he was posted to Xiangyang.

Whether in character structuring or brush methods, the calligraphy is remarkably similar to Mi Fu's. No wonder the Qing collector An Qi remarks that he assumed the masterpiece to be a Mi Fu at first glance and only realized his mistake when he got to read the signature.

Collector seals: seals belonging to An Qi including *An Qi zhi yin*.

Literature: *Spectacles Viewed in a Lifetime, Inspiring Views, Fortuitous Encounters with Ink, Model-calligraphies of the Hall of Three Rarities*, and *A Magnificent Collection of Model-calligraphies (Fashu Daguan)*.

比苦丶附書謀兄在下旬可到遄
中收十月三日手筆并詩深以為
慰亦嘗之卷襄州之行非所懼也
不謂以常式辭免就隆政令辭
難進牽何以白文不黑　閱古之意
幼令必當密論矣十九日入泉西界
盡割安撫司職事廿日方浮陽暑
劇乎且具辭免且在鄧州境上何
復回隆若省劇更遲數日則
日到襄陽卻之襄次二百餘里
江陵亦然歲晚官裏無處迳不

52

Poetic Responses on Southern Sights

by

Zhu Xi

of

the Song Dynasty

Hand Scroll, running script

Ink on paper

Height 31.5 cm Width 275.5 cm

Qing court collection

Zhu Xi (1130–1200), a native of Wuyuan, Huizhou (present-day Wuyuan, Jiangxi), resident in Jianyang (in present-day Fujian), was a preeminent Neo-Confucian from the Song Dynasty. He joined the civil service through qualification by civil examinations as *jinshi* in the 18th year of the Shaoxing reign (1148) and was Edict Attendant of the Huanzhang Hall (Huanzhangge) during the reign of Emperor Guangzong (r. 1190–1194). The prolific writer was posthumously honoured and provided with a secondary shrine at the Temple of Confucius.

In the eighth month of the Qiandao reign (1167), Zhu visited his friend Zhang Shi in Tanzhou (present-day Changsha, Hunan). Besides engaging in scholarly discussions, the pair visited sights in the south of the city, which inspired composition of quite some poems and poetic responses. As specified at the beginning of the scroll, the responses in the form of 20 pentasyllabic quatrains have accorded the present calligraphy with its text. The work is signed and impressed with a signature seal (*Zhu Xi zhi yin*).

Derivative of Zhong You's style, the calligraphy is marked by its slim structuring, substantial strokes, and facile execution, being a style of its own.

Collector seals: *Xie Zaihang, Sima Lanting shangjian, Sun Chengze yin, Wang Yan zhi yin, Jiaqing yulan zhi bao,* and *Xuantong yulan zhi bao.*

Literature: *Zhu's Corals Harvested with Iron Nets (Zhi Shi Tiewang Shanhu), Records of Paintings and Calligraphies of the Qianshan Hall, Notes from the Summer of the Gengzi Year, Collected Notes on Paintings and Calligraphies of the Shigu Hall,* and *Shiqu Catalogue of Imperial Collection of Painting and Calligraphy: Series Three.*

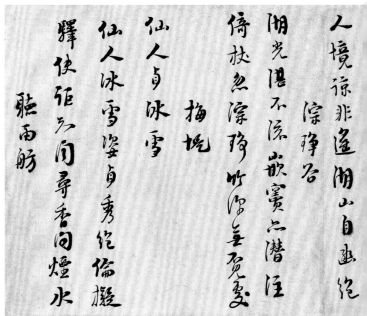

元晦夫子手蹟

奉旨

對夫人城南之作

仙湖

詩筒連畫卷坐看復月吟
想象南湖水秋來數許深

東渚

小山幽桂藂歲莫靄佳色
花底間庭波秋風嫋川起

詠歸橋

瀯瀯平橋水朱欄跨水橋
舞雩千載事歷歷在今朝

船齋

麗澤堂

堂後林陰密堂前湖水深
後湖湜趣難忘觀闕心

孝經堂陵溪港水雲深

尔漁洲

不遇至趣首深東賣墮淩

沙江來芙蓉十及心至歡

濯清亭

興吳照例景上下起空明

月色三秋白湖光四面平

月榭

法華初出水堤樹六成り

柳塢

羅王津與薰風拂面涼

吟

淙琤忽霽開為吳展回眺

西山雲霧深徒倚一舒嘯

卷雲亭

臨臥竹下梁瀨彼澗中石

莫舘遠寒聲秋空勤澄碧

石瀨

先生湖海姿蒙養乄自閟
銘坐仰先覺點畫存吾察

翠軒

誅舟傳畫架容乄污輪眠
夢彼蓬寶扁寒聲勤一川

聽雨舫

湖平秋水碧桂棹木蘭舟
一曲菱歌晚䂓兔邪卜隔

南阜

高丘復層觀何卜去岭漼

一日長空畫寒江列莫峯

晦翁此帖極神俊
弘治
拜觀於友人沈揮特賜所
後學司馬里

Letter of Yanling

— by —

Zhang Shi

— of —

the Song Dynasty

Running script

Ink on paper

Height 33.3 cm Width 60 cm

Zhang Shi (1133–1180), a native of Mianzhu, Hanzhou (present-day Mianzhu, Sichuan), was the acclaimed general Zhang Jun's eldest son. The esteemed Neo-Confucian was Senior Compiler of Hanlin Academy during the reign of the Southern Song emperor Xiaozong (1163–1189).

Addressed to Han Yuanji, the letter was written in the first month of the eighth year of the Qiandao reign (1172) with a reference to the addressee's son-in-law Lü Zuqian. Yanling was an ancient name for the vicinity of the Fuchun mountains in Tonglu, Zhejiang, and soared in fame ever since the Eastern Han literatus Yan Guang took up seclusion there. The

list of post titles, namely Right Gentleman for Rendering Service, Acting Probationary Left Vice Director of the Department of State Affairs, and Expositor-in-waiting, preceding the calligrapher's signature are congruous with the information provided in *History of the Song*.

The compact forms and wiry strokes make for distinctive features in the present specimen.

54

Condolence Letter to Liu Tun

—— by ——
Lü Zuqian

—— of ——
the Song Dynasty

Running script

Ink on paper
Height 30 cm Width 18.8 cm

Lü Zuqian (1137–1181), a native of Shouzhou (in present-day Anhui), rose through the ranks to become Editorial Director and Junior Compiler in the Historiography Academy after qualifying through various means. Together with Zhu Xi and Zhang Shi, the preeminent Southern Song Neo-Confucian has been known in history as the Three Sages of the Southeast.

The letter was written to convey condolences to Liu Tun, who was mourning a recent bereavement. Liu Tun, a native of Chengdu, once served as Senior Compiler of Jiying Hall (Jiyingdian). He is referred to in the letter by the title of "prefect," providing an illuminating clue that the calligraphy was written in the seventh year of the Chunxi reign (1180) when he was transferred to assume prefectship in Tanzhou shortly after his posting to Jiangling in the first month of the same year, and then he passed away in the year after.

There is a suggestion of sloppiness in the primarily low and broad characters. Yet the value of this only surviving specimen by the scholar is not discounted since he has been revered more for his learning than his calligraphy.

Colophons to the calligraphy are inscribed by Sun Chengze and Zhang Dunren of the Qing.

Collector seals: *Zhongyuan* and *zhi yin*. One signature mark.

55

Inscriptions to Xu Xuan's Calligraphy

— by —

Lou Yue

— of —

the Song Dynasty

Running script

Ink on paper

Height 26.7 cm Width 78.3 cm

Qing court collection

Lou Yue (1137–1213), a man of letters from Yinxian, Mingzhou (present-day Ningbo, Zhejiang), was qualified as *jinshi* in the first year of the Longxing reign (1163). Unwilling to associate himself with Han Tuozhou, he abstained from court for 13 years and only made himself available when Han was executed. The position he held include Secretariat Drafter, Hanlin Academician, Minister of the Personnel, Administrator of the Bureau of Military Affairs, and Assistant Administrator.

The text is afforded by the calligrapher's inscriptions to Xu Xuan's *A Fu-poem on the Shrine of King Xiang Yu* (*Xiangwang Ting Fu*). Xu Xuan was a leading litterateur active in the Southern Tang and the Song who excelled in the small seal script. In the inscriptions, he is referred to by an abbreviated form of his post title Policy Adviser. Another name that comes up is Wang Kui, who was qualified as *jinshi* during the Qiandao reign. He was Chief Minister of the Court of Imperial Sacrifices in the early years of the Jiading reign (1208–1224) and marked the high point of his career with the office of Minister of the Personnel. Separately impressed with calligrapher seals (*Yue* and *Gongkuizhai*), the first of the two inscriptions is dated the first year of the Shaoxi reign (1190) whereas the second the third year of the Jiading reign (1210).

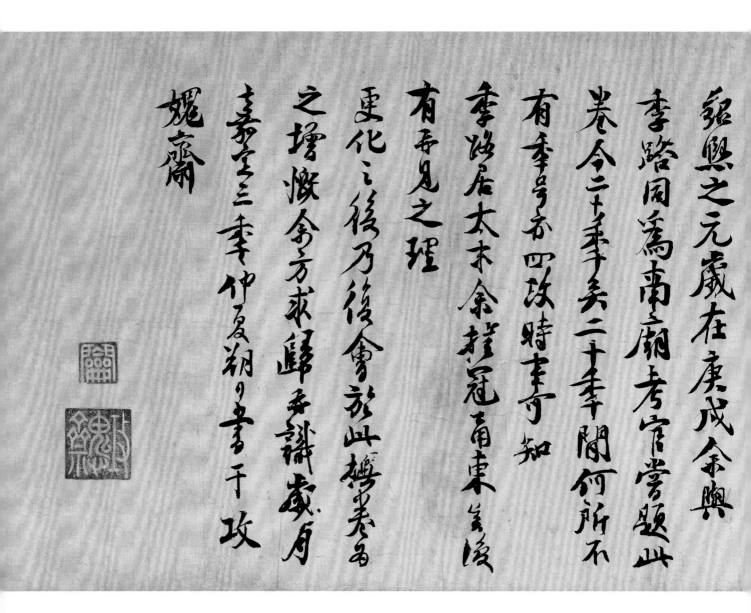

The accomplishment of the calligrapher is evinced by the anecdote that he was asked by Emperor Gaozong, who was a great admirer of his, to write a plaque for the Imperial University to mark its completion. In the present specimen, the broad structuring and the cursory brushwork especially in the dots and turns typify the Song disdain for established rules.

Literature: *Wu's Records of Painting and Calligraphy*, *Spectacles Viewed in a Lifetime*, *Fortuitous Encounters with Ink*, *Shiqu Catalogue of Imperial Collection of Painting and Calligraphy: Series Two*, and *Shiqu Notes*.

舊見岸老筆談載騎省蠨圖

之說近有敷原王季中彥良實

襄敏諸孫余及見其莫年嘗問

古人篆字眞蹟何以黑燥筆季中

笑曰罕有問及此者蓋古人力在腕

石畫用筆力令人以筆爲力或燄筆

使禿而用之移筆則墨曰燥矣今觀

此軸信然子孫非石甘匹工惜其自壞家

法反以端直姿媚僞一時後進競敷

三古意頹畫但可爲知者道乐绍

56

Letter of Absence from
the Capital

by

Xin Qiji

of

the Song Dynasty

Regular-running script

Ink on paper

Height 33.5 cm Width 21.5 cm

Xin Qiji (1140–1207) was a native of Licheng, Jinan (present-day Jinan, Shandong). When the empire was invaded by the Jin Jurchens, he led a volunteer corps to wage a resistance war. After the war, he was recruited into the civil service and became the holder of such positions as Vice Minister of the Court of Judicial Review, Senior Compiler of Jiying Hall, Prefect of Fuzhou, Military Commissioner of Fujian, Officer in the Dragon Diagram Hall, Prefect of Jiangling, and Recipient of Edicts in the Bureau of Military Affairs. In Chinese literature, he was a leading exponent of the Unrestrained School of *ci*-poetry of the Song Dynasty.

The references in the *zhazi*-letter correlate with Xin's suppression of the tea bandit Lai Wenzheng when he was Judicial Commissioner of Jiangxi. As chronicled in *History of the Song*, he was subsequently rewarded with a promotion as Senior Compiler of Hanlin Academy in the second year of the Chunxi reign (1175), which is congruous with the post title that precedes the signature. In other words, the calligraphy should have been written in the tenth month of that year.

This only surviving calligraphy by Xin Qiji faintly evokes the legacy of Su Shi and Huang Tingjian in its flowing grace and strict abidance by the rules. There is a total absence of self-indulgence despite the spontaneity.

Collector seals: *Yang shi jiacang*, *Yuansuzhai*, *Songxuezhai*, *Lin yin*, *Haiyin jushi*, *Huang Lin meizhi*, *Xiubo*, Xiang Yuanbian's seals, *Huang shiyizi Cheng Qinwang Yijinzhai tushu yin*, *Nanyunzhai yin*, *Lianqiao Cheng Xun jianshang shuhua yin*, and *Lianqiao cengguan*.

Literature: *Notes from the Liuyan Studio (III)* (*Liuyanzhai Sanbi*) and *Impressions of Paintings and Calligraphies*.

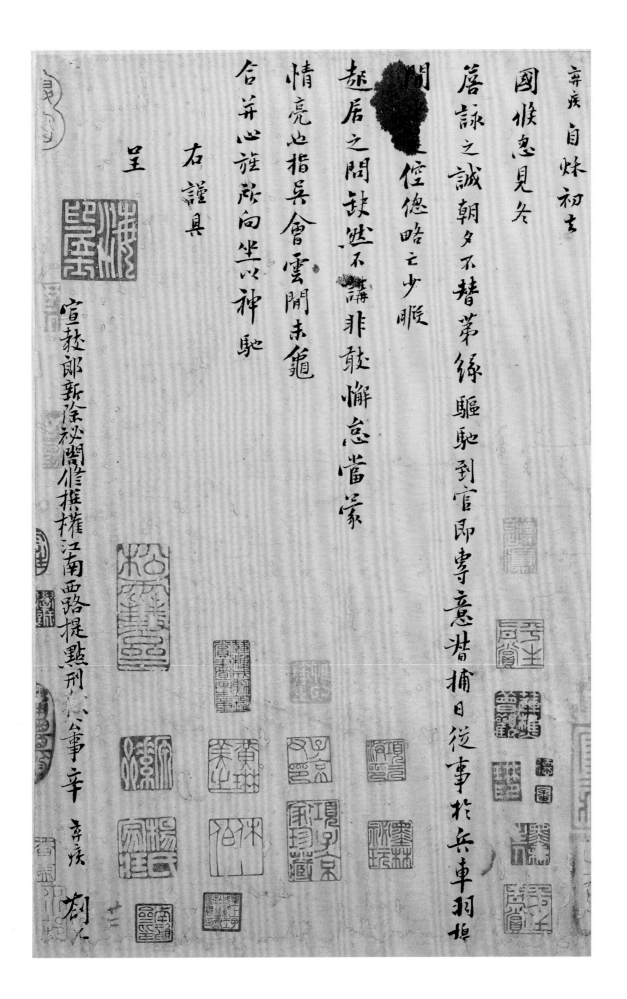

辛疾　自媿初上

國候忽見冬

居詠之誠朝夕不替葉綠驅馳到官即專意措捕日從事於兵車羽檄

閒　　　徑憃略之少暇

趨居之間缺然不講非敢懈怠當蒙

情亮此指呉會雲開未龜

合幷此旌毀向坐以神馳

　　右謹具

　　　呈

宣教郎新除秘閣修撰權江南西路提點刑獄公事　辛棄疾　劄子

Letter of the Leap Twelfth Month

by

Qiao Xingjian

of

the Song Dynasty

Running script

Ink on paper

Height 32.1 cm Width 42.5 cm

Qiao Xingjian (1156–1241), a native of Dongyang, Wuzhou (present-day Dongyang, Zhejiang), was Lü Zuqian's student and a prominent courtier in the Southern Song. A *jinshi* qualified in the fourth year of the Song emperor Guangzong's Shaoxi reign (1193), he was the holder of positions such as Assistant Administrator, Administrator of the Bureau of Military Affairs, Junior Grand Councillor, Senior Grand Councilor, Military Commissioner of Baoning, and Custodian of the Temple of Sweet Spring and was ennobled as duke during the reign of Emperor Lizong (1225–1264).

The signature "Yijian" in the letter has been tampered with and the post title preceding it cut off in an attempt to impersonate Song Yijian of the Northern Song. Researches inspired by the reference to the leap twelfth month has established the year to be the fourth year of the Jiaxi reign (1240), which is further supported by the fact that Qiao was feeble in

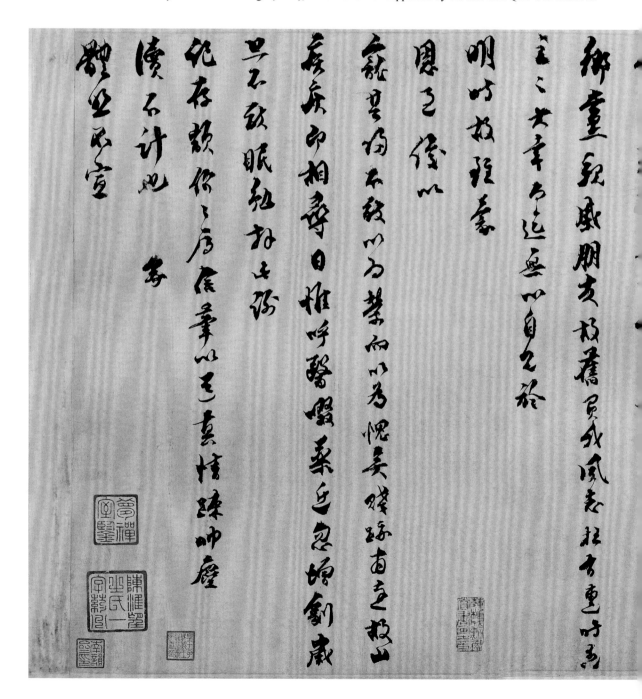

his old age as complained in the letter. This is Qiao Xingjian's calligraphy in his late years, with its obvious Qu-Tang touch, it has a free style governed by rules and principles.

Collector seals: Lianqiao jianshang, *Huang shiyizi Cheng Qinwang Yijinzhai tushu yin, Lianqiao Cheng Xun jianshang shuhua zhi zhang, Nanyunzhai yin, Mengchanshi jian,* and *Chen Huai Wangzhi shi yizi Yaozhou.*

Literature: *Spectacles Viewed in a Lifetime* and *Impressions of Paintings and Calligraphies.*

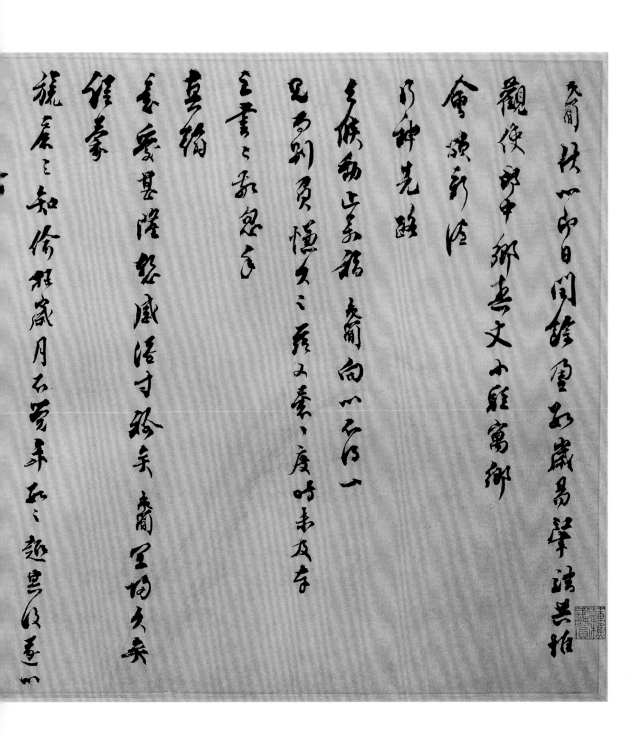

58

Condolence Letter to Zhao Fan and Zhao Kui

— by —

Wei Liaoweng

— of —

the Song Dynasty

Leaves, cursive script

Ink on paper

Leaf one: Height 36.2 cm Width 47.8 cm
Leaf two: Height 36.2 cm Width 51.8 cm

Wei Liaoweng (1178–1237), a native of Pujiang, Qiongzhou (in present-day Sichuan), was a Southern Song philosopher and a man of letters. Having joined the civil service as jinshi in the fifth year of the Qingyuan reign (1199), he was made Notary of the Bureau of Military Affairs, Prefect of Fuzhou, and Military Commissioner of Fujian at various times.

References to post titles have offered clues for establishing the identities of the relevant individuals, including the addressees Zhao Fan and Zhao Kui as well as their father Zhao Fang, who was Zhang Shi's student and whose departure occasioned the letter. Zhao Fang was Changping secretary director and conveyance officer, prison officer, later became Jinghu Zhizhishi and Shang Yang's official. By further matching the addressees' post titles with the account given in History of the Song: Biography Zhao Fan (Song Shi: Zhao Fan Zhuan), the date of the letter can be assumed to be the 14th year of the Jiading reign (1221). The family is described in the letter as meritorious because of their valour in defending the empire against Jin invasions.

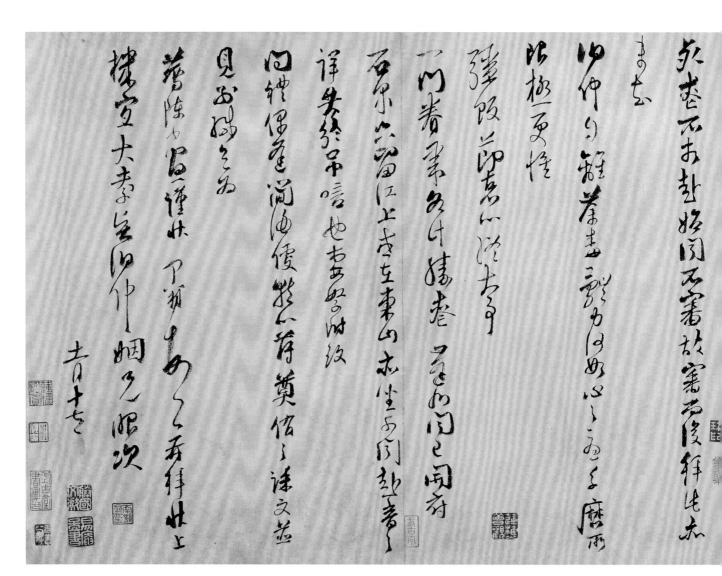

Freely shifting between the running and cursive scripts, the unhalted calligraphy exhibits attributes of Yan Zhenqing's running script in the visible exertion of pressure.

Inscriptions by Prince Cheng and Cheng Xun are found on the mounting.

Collector seals: *Zhenyuan, Lin yin, wuyang, Bian Lingzhi jianding, Shigutang shuhua yin, shengguo wenxian, Yi'an tushu, Shigutang, An shi Yizhou shuhua zhi zhang, Chaoliao, Guannei Hou yin, Jiang Deliang jiancang yin,* and *Jiang Qiushi.*

Literature: *Wu's Records of Painting and Calligraphy, Collected Notes on Paintings and Calligraphies of the Shigu Hall, Fortuitous Encounters with Ink,* and *Impressions of Paintings and Calligraphies.*

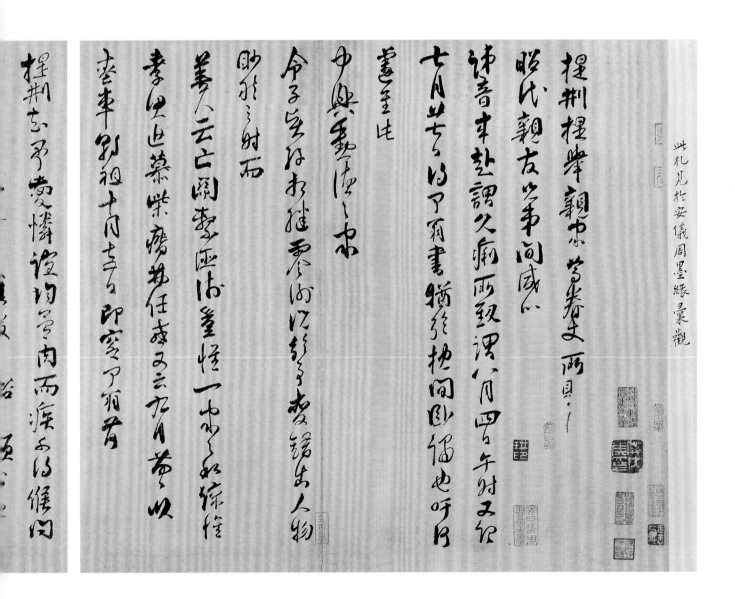

59

A *zhazi*-letter

— by —

Yue Ke

— of —

the Song Dynasty

Regular script

Ink on paper

Height 30.3 cm Width 49.5 cm

Yue Ke (1183–1243), a native of Tangyin, Xiangzhou (in present-day Henan), was Yue Fei's grandson and an official occupying such positions as Vice Minister of the Ministry of Revenue and Academician of the Baomo Pavilion (Baomoge). He was a connoisseur-collector as well as a calligrapher.

The letter is called "*zhazi*," a genre of official correspondence that came into being during the Northern Song for communicating with superiors or for giving orders to subordinates. By the Southern Song, it was sometimes used for private correspondence if the matter was important. Normally written in the regular or running script, it was to be properly signed at the end with the sender's post titles fully listed out. With the closing inscription reading "A *zhazi*-letter from Yue Ke, Grand Master for Court Audiences, Acting Vice Minister of Revenue, and Overseer-general of Zhexi, Jiangdong, and Huaidong," the present specimen provides a standard example and is fittingly matched with the formality suggested by the neat calligraphy.

Collector seals: *Yuexuelou zhuren liusun Zhaoyun siyin* and others.

阿　揆序且夏庚伏蘊隆仙惟

權郡簽判通直榮攝郡符

神所欲介

台候動止萬福　阿　比者草率上狀旋蒙

巽咨慰懌号已宇文兄試牒重荷

垂應寒士三年之期一試之地得失升沉之所

繫自匪

惠念何以有此感怍殆不容聲亟此叙

謝末究怳惕尚湏嗣記時間故幾

居高

召擢之寵

間

60

Ode to the Twin Pines Painting

— by —

Zhang Jizhi

— of —

the Song Dynasty

Hand Scroll, regular script

Ink on paper

Height 33.8 cm Width 1,196 cm

Qing court collection

Zhang Jizhi (1186–1266), a native of Hezhou (present-day Hezhou, Anhui), marked the height of his official career with the office of Assistant Director of the Court of the National Granaries and was granted the title Auxiliary in the Imperial Archives. Espousing the Tang tradition, the reputable calligrapher had an enormous influence on his peers with his meticulous character structuring and unconventional brush methods.

The calligraphy owes its text to Du Fu's heptasyllabic verse *A Playful Ode to Wei Yan's Twin Pines Painting* that pays homage to the marvellous masterpiece. Wei Yan was a proficient painter of the pine and was unmatched except by his contemporary Bi Hong during the late Sui and early Tang periods. Impressed with three calligrapher seals (*Zhang*, *Zhang shi*, and *Jizhi*) at the end, the calligraphy is signed to read "By Zhang Jizhi at the age of 72." The year should therefore be the fifth year of the Baoyou reign (1257) in the Southern Song.

Tinged with features from the running script, the sophisticated yet unabashed calligraphy overwhelms with its intrepid structuring and diverse stroke treatment.

To the left of the calligraphy is a painting of ancient cypresses fraudulently ascribed to Su Shi, and to the right, colophons by Chen Xin and Xia Yanliang of the Ming.

Literature: *Intended Meanings* and *Shiqu Catalogue of Imperial Collection of Painting and Calligraphy: Series One*.

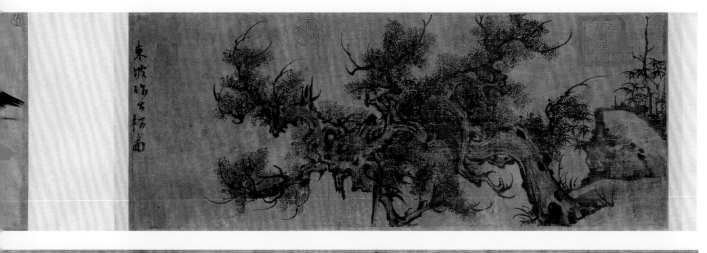

雨垂　松根　胡僧　憩寂　賓尾　眉皓

王　前洛　韋俠　數相　見我　有一　匹好

凌亂　諸公　放筆　為直　輪郎　張　之七

中　書　饒載　醉

城翁為宋朝名臣樓寮乃盖世君士人間
得其片紙隻字若雘璧全東俞庭
器先生攜藏此卷相苗松翰誠為合
璧寶希世之玩也庭茲以予言石惜之
又有能辮之者　當
洪武壬戌花朝前二日後學陳　識

坡僧文章功頌流傳後人不愍背而藍閣之英後
能倍以墨歲全顏此畫拔籵乃無端石跋先破
奇格如賀中之璧書開天下其子真学免後後
主秋閣以能書閒天下其子真学免後後見金人
書人金國三字故九　上貽印之劉以此圖山有人
不出一月栗駿達得得見嬴安使此圖亂初山
先挍辭不易之幸垛藏之
癸未夏四月七日東明夏慶良遐之于绣鋅寧申

高白杉龍孔入
枝摧骨寄黑太

襄脚露右偏住首
松業雙肩袒著無

令段錦不重束
拂巳繡減之綃

峯龍雲雨時歲十
興舞槐連積寓二

61

Inscription of the Studio of Contentment

— by —

Ge Changgeng

— of —

the Song Dynasty

Hand Scroll, cursive script

Ink on paper

Height 32.5 cm Width 81.5 cm
Qing court collection

Ge Changgeng (1194–1229), renamed Bai Yuchan upon adoption by the Bai family, was born in Qiongzhou (in present-day Hainan) and raised in Minqing (in present-day Fujian). The theorist on inner alchemy was one of the five patriarchs of the Daoist Golden Elixir Sect. During the Jiading reign (1208–1224), he was summoned to court and was granted the abbotship of the Palace of the Great One (Taiyigong) together with the title of the Perfected of Purple Clarity. The voracious reader was also a man of letters, painter, and calligrapher especially in the cursive, seal, and clerical scripts.

In this inscription written for his friend Zhou Yunchang, Ge accounts for the naming of the studio as "Contentment" and elaborates the importance of such a state of mind. The given date of "the *bingxu* year of the Baoqing reign" corresponds to the second year of the reign, or 1226.

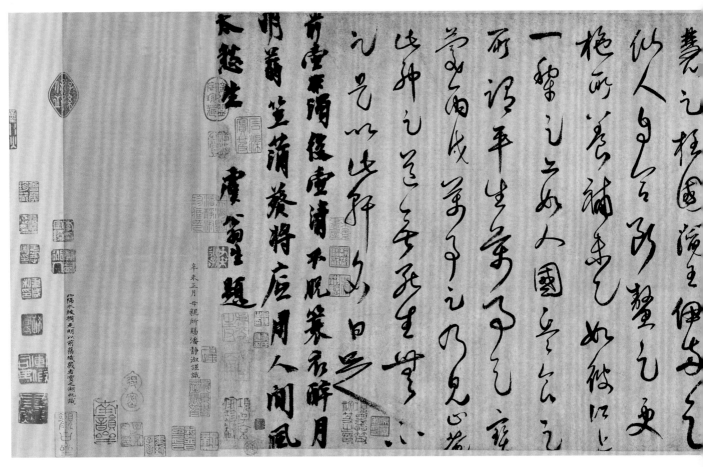

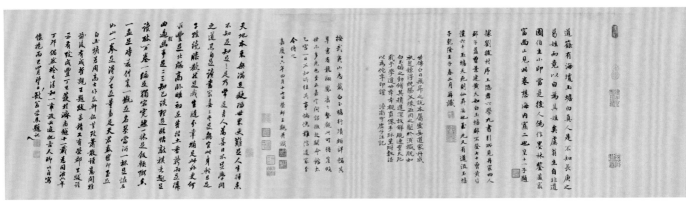

In this rare masterpiece evocative of the Jin masters, the calligraphy is crisp and vigorous with interconnected characters in a form that has been described as "dragons and phoenixes in flight."

To the left of the calligraphy are colophons inscribed by Yu Ji of the Yuan, Xiang Yuanbian of the Ming, Yongxing, Shouxuzi, Mianyi, and Chongen of the Qing, and Wu Hufan and Pan Jingshu of the modern era.

Collector seals: seals of Xiang Yuanbian, Geng Jiazuo, An Qi, Emperor Qianlong, Yongxing, Yihui, and Wu Hufan.

Literature: *Spectacles Viewed in a Lifetime* and *Fortuitous Encounters with Ink.*

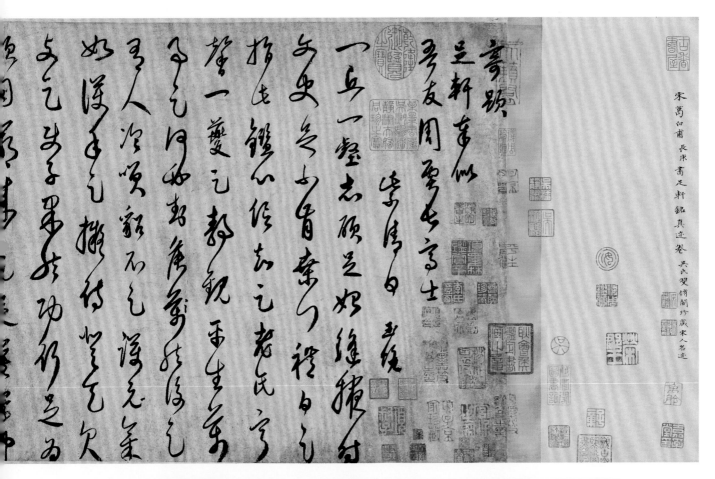

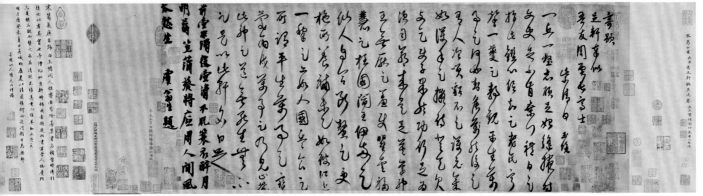

62

Self-composed Poems

by

Zhao Mengjian

of

the Song Dynasty

Hand Scroll, running script

Ink on paper

Height 35.8 cm Width 675.6 cm

Zhao Mengjian (1199–1264) was a descendant of the Song imperial family. He was qualified as *jinshi* in the second year of the Baoqing reign (1226), leading to his appointment as Grand Master for Closing Court and Prefect of Yanzhou before retiring to Haiyan, Zhejiang. His excellence in calligraphy and painting especially those of narcissus, plum blossoms, and bamboo in the outline style has been well documented.

In the scroll, references are made to Zhao Lingrang and Zhao Lingsong, who were both esteemed painters among descendants of the Song imperial family. The date "the first year of the Kaiqing reign" given in the closing inscription corresponds to the year 1259.

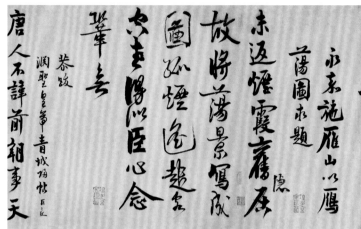

Quintessential of the calligrapher's late style, the calligraphy betrays influences by Huang Tingjian in the robust and untethered execution, while the slender form, compact structure and slanting inclination have their origins in Mi Fu.

The narcissus painting to the right of the calligraphy is a fake by a past master. To the left are viewer inscriptions by Zhang Shen of the Yuan, Du Mu of the Ming, and Chen Baochen of the Qing.

Collector seals: seals of Xiang Yuanbian, *Wu Yuanhui Liquan, Wu shi Liquan pingsheng zhenshang, Liuhu, Luo Liuhu jia zhencang, Pan Jian'an tushu yin, Yanling xinshang,* and *Duanxi He Shu zi Yuanyu hao Qu'an guoyan jingji jinshi shuhua yinji.*

Literature: *Notes from the Summer of the Renyin Year (Renyin Xiaoxia Lu).*

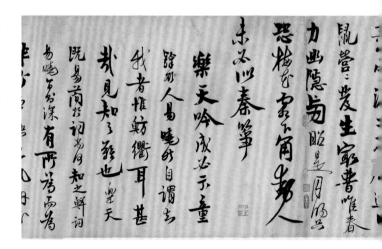

63

Letter to Bao Hui

— by —

Wen Tianxiang

— of —

the Song Dynasty

Hand Scroll, running script

Ink on paper

Height 39.2 cm Width 149.9 cm

Wen Tianxiang (1236–1283), a native of Luling, Jizhou (present-day Ji'an, Jiangxi), joined the civil service after qualification as *zhuangyuan*, or the top *jinshi*, through civil examinations but was dismissed for dissenting from power-wielding eunuchs and courtiers. He was summoned to render his service to the empire when it was on the brink of disintegration, rising to positions such as Junior Grand Councilor, Military Affairs Commissioner, and Junior Guardian. Ennobled as marquis, he was staunch in his resistance against the Mongolian invaders and was killed for refusing to defect upon capture.

The letter in the *zhazi*-genre was written in the first year of the Xianchun reign (1265) to congratulate Bao Hui on his appointment as Minister of Justice and Notary of the Bureau of Military Affairs as well as ennoblement as marquis. The discussion on current affairs also makes the letter an important material for historical researches.

Crisp and archaistically enchanting, the calligraphy is a rare extant masterpiece by Wen Tianxiang.

The colophons are inscribed by Li Shimian of the Ming, Yongxing, Mianyi, Li Duanfen, and Zhu Yifan of the Qing.

Collector seals: seals of Xiang Yuanbian, Bian Yongyu, An Qi, Yongxing, Yihui, and Mianyi.

Literature: *Coral Nets: Calligraphy Inscriptions, Collected Notes on Paintings and Calligraphies of the Shigu Hall, Yu's Records of Painting and Calligraphy Inscriptions: Series Two, Spectacles Viewed in a Lifetime*, and *Fortuitous Encounters with Ink*.

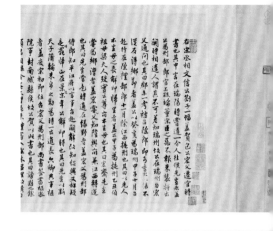

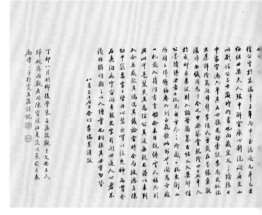

廬陵尚書宏齋先生 ... 至瑞陽郡當以一介人往候

先生盤所

先生錫之書

天祥皇恐書呈三窗之中

廬陵尚書宏齋先生 ... 至瑞陽郡當以一介人往候

先生盤所

先生錫之書

The Yuan Dynasty

非推惟□不任思容少以宣

荔枝譜曰謝可以撞過習之令即

梅花潭四折氣

偏是書

64

Against Luxurious Ease
by
Xiao Ju
of
the Yuan Dynasty

Hand Scroll, clerical script

Ink on paper

Height 27.4 cm Width 60.3 cm

Qing court collection

Xiao Ju (1241–1318), a native of Fengyuanlu (present-day Xi'an, Shaanxi), served the court as Right Adviser to the Heir Apparent. Revered as the unsurpassed scholar of his time, he was knowledgeable in astronomy, geography, calendrics, and mathematics. Although he is not documented in histories, his writings are collected in *Steles from All Corners of the Earth* (*Huanyu Fang Bei Lu*) and the present specimen is the only one of his calligraphy.

Signed and impressed with a calligrapher seal (*Xiao shi Weidou fu*), the calligraphy owes its text to *Book of Documents: Against Luxurious Ease* (*Shangshu: Wuyi Pian*), which advises rulers against decadence and complacency. The given date of "the *xinchou* year of the Dade reign" corresponds to the fifth year of the reign, or the year 1301. Mounted as one with the present specimen are calligraphies of the same text by Yang Heng in seal script and by Zhao Mengfu in regular script.

Although professed to be in the Han clerical script, the dignified and scrupulous calligraphy is in fact inspired by the clerical script that was fully developed by the Han-Wei period as exemplified by *The Xiping Stone Classics* or *Memorial for Accepting the Abdicated Throne*. In addition, resemblances to Tang masters' clerical script reveal themselves in the stability and uniformity.

The present specimen is uninscribed, whereas Zhao Mengfu's calligraphy carries a poem inscribed by Jie Xisi of the Yuan and a colophon by Nian Gengyao of the Qing.

Collector seals: *Zhiya, Renzhe siyin, Zhugu waishi, Ziyunxuan, qiankun qingqi, miao wuyi jia, taigu wushang, Caonan Chen Weigong zhai Jinchuntang shuhua yin, Yunjiao, Pingchang, Yiwu zhi yin, Hetong, Chen, Xishan Shengxue, pingsheng zhenshang, buqu jiang yin*, and seals of the Qing emperor Qianlong.

65

Poem on *Stopping by the Zhao Mausoleum* by Du Fu

— by —

Xianyu Shu

— of —

the Yuan Dynasty

Hand Scroll, running script

Ink on paper

Height 32 cm Width 342 cm

Qing court collection

Xianyu Shu (1246–1301), a native of Yuyang (in the vicinity of present-day Jixian, Hebei), served the court as Retainer for Militia, Clerk of the State Finance Commission, and Archivist of the Court of Imperial Sacrifices at various times. Modelling on the Tang masters, the renowned calligrapher excelled in the running script and ranked with Zhao Mengfu in the Yuan Dynasty for championing calligraphic reforms through returning to the past.

Signed and impressed with five calligrapher seals (*Xianyu, Baiji yinzhang, Jizi zhi yi, Hulin Yinli,* and *Zhongshan houren*), the calligraphy owes its text to the pentasyllabic poem *Stopping by the Zhao Mausoleum* composed by the iconic Tang poet Du Fu in memory of the Tang emperor Taizong, who was laid to rest in the Zhao Mausoleum.

Exemplary of the calligrapher's large characters in running script, the calligraphy is sparse in structure and unimpeded in execution, perfectly matching the calligrapher's termperament.

The colophons are inscribed by Wang Yi and Song Lian of the Ming.

Collector seals. *Si, qingjing, Jiaolin Yuli shi tushu, guan qi daitie, Taishi shi, Song Jinglian shi, Wang Yi zhi yin*, and seals of the Qing emperors Qianlong, Jiaqing, and Xuantong. The five sheets that form the scroll are impressed with Liang Qingbiao's seal *Hebei Tangcun* across the margins.

Literature: *Spectacles Viewed in a Lifetime, Shiqu Catalogue of Imperial Collection of Painting and Calligraphy: Series One*, and *The Palace's Catalogue of Lost Paintings and Calligraphies* (*Gugong Yiyi Shuhua Mu*).

Letter to Lu Hou
— by —
Cheng Jufu
— of —
the Yuan Dynasty

Running script

Ink on paper
Height 18.8 cm　Width 59.8 cm

Cheng Jufu (1249–1318), a native of Jingshan, Yingzhou (in present-day Hubei), went by this courtesy name of his instead of his original name because of naming taboo of the late Yuan emperor Wuzong. Literarily proficient, he served the Yuan court for four successive reigns since that of Emperor Shizu and rose to the ranks of Provisioner of the Hanlin Academy and Hanlin Academy Recipient of Edicts, making tremendous contributions to the Sinification of the Yuan rulers.

During his office as Surveillance Commissioner in the Minhai Circuit of Fujian, the calligrapher wrote this letter to congratulate his friend Lu Hou on his promotion, voicing his expectations for him and apologizing for the late response because of a funeral. Lu Hou, a native of Jiangyin (in present-day Jiangsu), was once Surveillance Commissioner of Zhexi.

Typifying the style of the literati, this only surviving work by the calligrapher is vaguely reminiscent of Su Shi in the brisk brushwork, slightly squat structuring, and the splightly execution.

Collector seals: *cengjing woyan ji woyou* and *Xiaoshuhuafang miwan*.

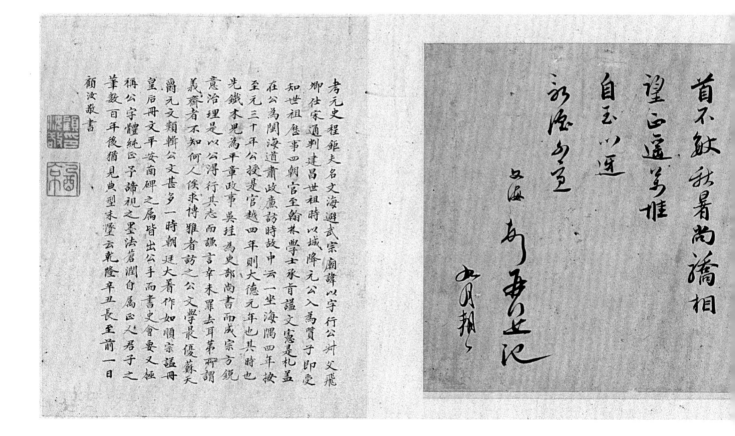

真書深佩
薄雲之誼未笑孫羅家㯢
函、奔母未䢍蘗只楠申
洞過閔江東
賀正既則開
拂天之誨又
上貢金春矢宋教業訪諭
巳錦孟
相里高畠士風不振
義齋真為勁氣漫劈
䎃野吾堂不孤為為檀華
新深當在道
賀 一坐海沙四年韋亮
去而歸曑浩括趣紫山俟代
義齋以此及我困

67

Letter to Lu Hou

— by —

Xu Yan

— of —

the Yuan Dynasty

Running script

Ink on paper

Height 17 cm Width 52.4 cm

Xu Yan (ca. 1220–1301) was a native of Dongping (in present-day Shandong), whose literary flair led to his appointment as Director of the Branch Secretariat of Shaanxi Province on Wang Pan's recommendation. He was Surveillance Commissioner of Zhexi in the 31st year of the Zhiyuan reign (1294) and became Hanlin Academy Recipient of Edicts in the second year of the Dade reign (1298).

Mounted in the same scroll with Cheng Jufu's *Letter to Lu Hou* (Plate 66), the letter is likewise addressed to Lu Hou. In it, the sender, who has already assumed the office of Surveillance Commissioner of Zhexi, refreshes memories of their mutual past, speaks highly of the addressee's integrity and looks forward to their upcoming meeting.

In this only surviving example by Xu Yan, the absence of interconnected characters and the splightly dynamism bespeak derivation from Yan Zhenqing.

Colophons to the calligraphy are inscribed by Gu Rujing and others of the Qing.

Collector seals: *Xunmian zhi yi* and *Xiaoshuhuafang shending*.

炎頓首拜後
同知 相公 羲齋先生
日者
車從過錢塘無以
相餞轂反承
薤牘備極豐腆不
勝感激
閣下前在浙西凡郡
凜凜甚而寶史而敬畏
我輩繼之實不及也
近聞
上臺新選有江東廉副
之除始知
朝廷公議固在如寅之

庚寅歲武贈余楊君謙郎二泉諸先生尺牘
一卷，端題曰明人墨蹟余諦視之中間有
兩札紙渝墨糊書法逼雅砥礪非勝國時物頫
以筈他左驗又題籖之第之於心而已
早丑仲冬偶讀元史史考諸他書乃得審定
為程文憲徐文獻兩公手札十數年之疑惑
一旦以釋而又釋此希世之寶烏可知也因
念此兩札浮沈世間不知歷幾何歲月而今
乃入余手不當一日三摩挲焉尖此有斁乎
存其間耶方付裝池後為記此

先生歟弟三刌乃知羲齋字方謐文獻嘗為浙西
廬訪司合之札中羲齋前在浙西及我輩繼之
二語當是羲齋先曾為是官而先生其適在分司
也弟余司公署今在蘇州府志不載何時遷至杭州令
玩先生車從過錢塘云更秦以輟耕錄所紀知公
署之邊實自先生始其在至元中無考績書之以補
志乘之缺焉汝敬又書

68

Inscription to a Painting of Cao Zhi by Zhou Wenju

by

Zhao Mengfu

of

the Yuan Dynasty

Small regular script

Ink on paper

Height 27.9 cm Width 33.3 cm

Qing court collection

Zhao Mengfu (1254–1322), a native of Wuxing (present-day Huzhou, Zhejiang), was the Song emperor Taizu's 11th-generation-grandson and held offices including Hanlin Academy Recipient of Edicts and Grand Master for Glorious Happiness during the Yuan Dynasty. Versatile in the arts and unsurpassed in the Yuan as a calligrapher especially in the regular and running scripts, he has come to define the artistic achievement of the Dynasty as a whole. In the history of Chinese calligraphy, he has been exalted with Ouyang Xun, Yan Zhenqing, and Liu Gongquan, all of whom were from the Tang Dynasty, as the Four Masters of the Regular Script.

The calligraphy was originally written as an inscription to the Five Dynasties painter Zhou Wenju's painting, now lost, likely to be of Cao Zhi, who was a man of letters from the Three Kingdoms period. While confident about the identity of the figure, the inscriber finds the painting's title baffling. Signed and impressed with the calligrapher's signature seal (*Zhao shi Zi'ang*), the inscription is dated "the 14th day of the second month in the eighth year of the Dade reign (1304)."

Despite the brevity, the robust inscription is nothing short of a masterpiece from the calligrapher's mid years with its disciplined structuring and refined strokes that are accentuated by its intrinsic strength and extrinsic ethos.

To the left of the calligraphy are viewer inscriptions by Li Ti and Zhang Shen of the Yuan.

Collector seals: Ming: Xiang Yuanbian; Qing: Wang Yan and Emperor Qianlong.

Literature: *Shiqu Catalogue of Imperial Collection of Painting and Calligraphy: Series One*.

右周文矩子建採神圖曾入紹興內府前
有紹興題識印款傳彩溫潤人物古雅
信為一種珍玩子建舍曹民並其人但未
詳採神為何義當必有說以俟知者
大德八年春二月十四日吳興趙孟頫子昂

69

Fu-rhapsody on the Nymph of the Luo River

— by —

Zhao Mengfu

— of —

the Yuan Dynasty

Hand Scroll, running script

Ink on paper

Height 29 cm Width 220.9 cm
Qing court collection

Written by Cao Zhi, a man of letters from the Three Kingdoms period, *Fu-rhapsody on the Nymph of the Luo River* is a florid and poignant account of the writer's fantastical romantic encounter with the nymph. Overflowing with sorrows over a love that is never meant to be, the literary masterpiece has inspired many Chinese works of art, with as many as six or seven extant specimens produced by Zhao Mengfu alone. Undated, the calligraphy is signed and impressed with a signature seal (*Zhao shi Ziang*).

Arguably one of the best from the calligrapher's late years, the calligraphy stands out with its elegantly proportioned characters and lithe sophistication. The running script is in part interspersed with the structuring and brushwork of the regular script.

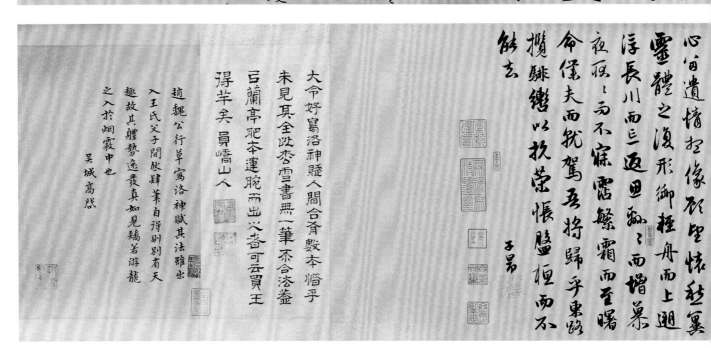

The front separator contains an inscription of two columns by Wang Duo whereas the colophon paper colophons by Li Ti of the Yuan, Gao Qi of the Ming, and Wang Duo and Cao Rong of the Qing.

Collector seals (numbering 37): *Shigutang shuhua*, *Bian Lingzhi jianding*, and seals of the Qing emperors Qianlong, Jiaqing, and Xuantong.

Literature: *Collected Notes on Paintings and Calligraphies of the Shigu Hall* and *Shiqu Catalogue of Imperial Collection of Painting and Calligraphy*.

洛神賦　并序

黃初三年　余朝京師　還濟洛川　古人有言斯水之神　名曰宓妃　感宗玉對楚王說神女之事　遂作斯賦　其詞曰

余從京域　言歸東藩　背伊闕　越轘轅　經通谷　陵景山　日既西傾　車殆馬煩　爾乃稅駕乎蘅皋　秣駟乎芝田　容與乎陽林　流眄乎洛川　於是精移神駭　忽焉思散　俯則未察　仰以殊觀　睹一麗人　于巖之畔　乃援御者而告之曰　爾有覿於彼者乎　彼何人斯　若此之艷也　御者對曰　臣聞河洛之神　名曰宓妃　則君王之所見也　無乃是乎　其狀若何　臣願聞之

余告之曰　其形也　翩若驚鴻　婉若游龍　榮曜秋菊　華茂春松　髣髴兮若輕雲之蔽月　飄飄兮若流風之迴雪　遠而望之　皎若太陽升朝霞　迫而察之　灼若芙蕖出淥波　穠纖得衷　修短合度　肩若削成　腰如約素　延頸秀項　皓質呈露　芳澤無加　鉛華弗御　雲髻峨峨　修眉聯娟　丹唇外朗　皓齒內鮮　明眸善睞　靨輔承權　瑰姿艷逸　儀靜體閑　柔情綽態　媚於語言　奇服曠世　骨像應圖　披羅衣之璀粲兮　珥瑤碧之華琚　戴金翠之首飾　綴明珠以耀軀　踐遠遊之文履　曳霧綃之輕裾　微幽蘭之芳藹兮　步踟躕於山隅　於是忽焉縱體　以遨以嬉　左倚采旄　右蔭桂旗　攘皓腕於神滸兮　采湍瀨之玄芝　余情悅其淑美兮　心振蕩而不怡　無良媒以接歡兮　託微波而通辭　願誠素之先達兮　解玉佩以要之　嗟佳人之信脩　羌習禮而明詩　抗瓊珶以和予兮　指潛淵而為期　執眷眷之款實兮　懼斯靈之我欺　感交甫之棄言兮　悵猶豫而狐疑　收和顏而靜志兮　申禮防以自持

70

Stele of Danba

— by —

Zhao Mengfu

— of —

the Yuan Dynasty

Hand Scroll, regular script

Ink on paper

Height 33.6 cm Width 166 cm

Both the text and the calligraphy of the stele inscription were written by Zhao Mengfu in honour of the Tibetan Buddhist lama Danba (1230–1303). The cleric was bestowed with the title of Teacher to the Emperor by the Yuan emperor Shizu in the seventh year of the Zhiyuan reign (1270) and posthumously with another more elaborate honorific in the first year of Emperor Renzong's Huangqing reign (1312). Dated "the third year of the Yanyou reign (1316)," this is the second stele inscription that Emperor Renzong decreed from Zhao.

Apart from modelling on the Two Wangs for the running-cursive script and on Tang masters for stele inscriptions, Zhao freely availed himself of the merits of Chu Suiliang, Yan Zhenqing, Xu Hao, Zhang Congshen, Su Lingzhi, and especially Liu Gongquan and Li Yong. Yet, he was able to walk out of their shadows to create his own style, which has been known in history as the Zhao Style. In the present example, which is exemplary among Zhao's stele insciptions, the calligraphy is dignified and disciplined as prescribed by the solemnity of the purpose. There is, however, vibrancy in propriety and beauty in solidity.

Inscribers of the colophons include Yang Xian, Li Hongyi, Pan Zuyin, and Wang Ning of the Qing.

Collector seals: *diyi xiyou* and seals of Tan Jing from the modern era.

Literature: *Han Shinan's Model-calligraphies Tabulated (Nanyang Fashu Biao)*, *Zhan Jingfeng's Personal Viewing Notes*, *Collected Notes on Paintings and Calligraphies of the Shigu Hall*, *Notes from the Summer of the Renyin Year*, and *List of Paintings and Calligraphies in the Sanyu Hall*.

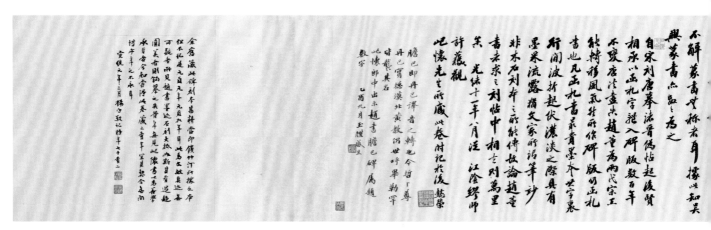

大元敕賜龍興寺大覺普慈廣照無上帝師之碑

大元敕賜龍興寺大
覺普慈廣照無上帝
師之碑
集賢學士資德大
夫臣趙孟頫奉
勅撰并書篆
皇帝即位之元年有
詔金剛上師膽
巴謚大覺普慈廣
照無上帝師勅
臣孟頫為文并書刻
石大都

祖伐河東
取其銅像以鑄錢宋太宗為
焚時契丹入鎮州縱火焚人火周人
寺建於大悲菩薩像五代
于委禮不隨世紀有金興龍
下至諸王將相貴人
今皇帝皇太后皆從受戒法
晉王及
武宗皇帝

臧人天歸敬
然流聞自是德業隆
詞伽剌持戒甚嚴晝
法建立道場行祕密呪
之祚師始於五臺山
西番帝師之事屬
乃道要顯密兩融
至中國
聖師之昆弟帝師告歸

師在上都彌陀院八
至此皆驗大德七年
大元年東宮既建為
舊邸田五十頃賜寺之
為常住業師之所言
聖德有受命之符以至
果飯之費皆福香華
聖躬受無量福度我私
靈雕護我
無有已時用名集神
法蓮華經勅相代妙
海等繼今可日講衆妙
主其寺復令僧曰
今皇帝為大切德主
徽仁裕聖皇太后奉
奏書

無量義身
佛住婆婆世界演說
三
退轉十方諸如來一
師從無始劫學道不
之頌曰
無如師者臣孟頫為
上謹嚴具智慧神通
皇元一統天下西番
獲舍利無數寶光
殞涅槃現五色寶光

人興起山門即為梵

論縣是深入法海博
采標的至元七年與
衆寶無照獨立三界示
帝師巴思八俱

句徐鉉以後歷宋元明三朝紘篆
書者止趙吳興一人即此顥可見
嘉定錢唐事言曾見吳興篆書

71

Letter Accompanying
Gifts

— by —
Guan Daosheng

— of —
the Yuan Dynasty
Leaf, running script

Ink on paper
Height 26.9 cm Width 53.3 cm
Qing court collection

Guan Daosheng (1262–1319), a native of Wuxing (present-day Huzhou, Zhejiang), was Zhao Mengfu's wife and was ennobled as Lady of the State of Wei. She was accomplished in painting the plum blossom, orchid, and bamboo in a style that was influenced by her husband. She was also an adept calligrapher but many of her extant works were actually ghostwritten by Zhao Mengfu.

Ghostwritten by Zhao Mengfu for his wife, the present letter accompanies a gift of sweetmeats, fish, and candles to an aunt and her family. It is signed as "Daosheng" and dated "the 20th day of the ninth month."

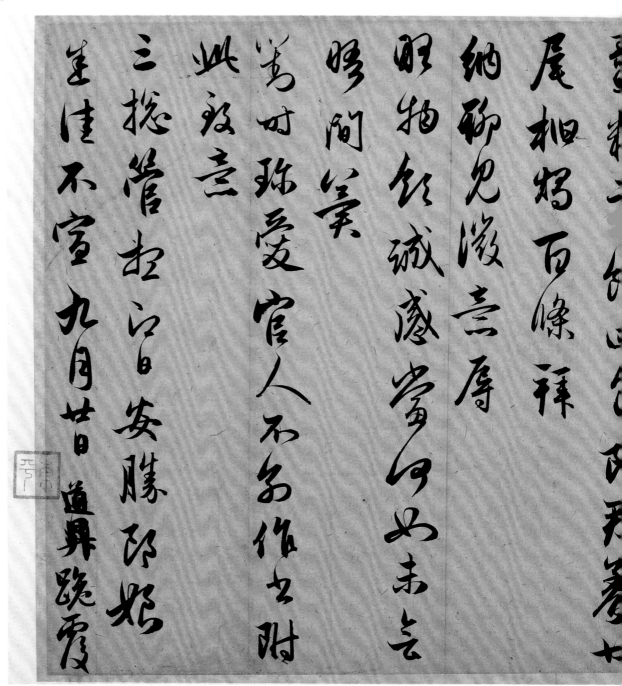

Consisting of elongated characters, the calligraphy is robust, effortless, and charming, making it a masterpiece from Zhao's mid-fifties. By a slip of the brush, Zhao put down his own name in the signature and wrote over it as "Daosheng" in correction. The correction is conspicuous nonetheless.

Collector seals: seals of the Qing emperor Xuantong and Li Zhaoheng.

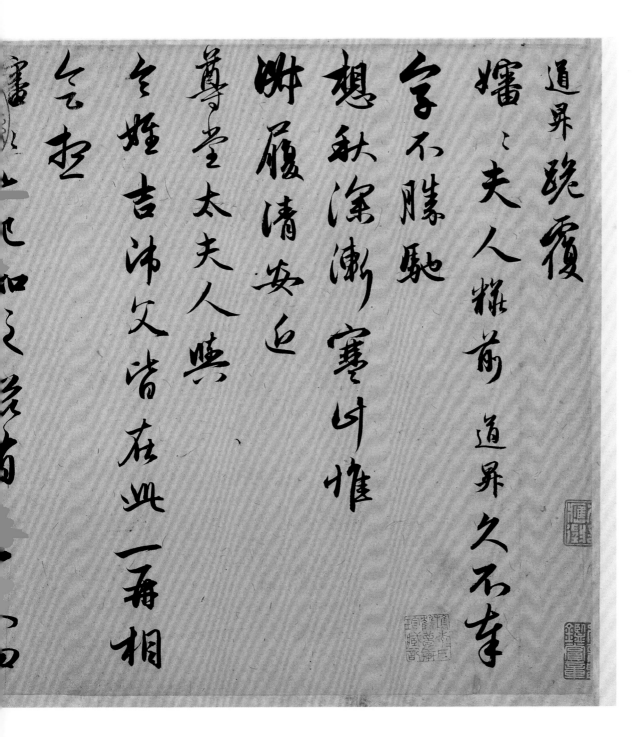

A Gift to a Brush Maker

by

Li Ti

of

the Yuan Dynasty

Album leaf, running script

Ink on paper

Height 32.7 cm Width 17.5 cm

Li Ti (dates unknown), a native of Taiyuan, Hedong (present-day Taiyuan, Shanxi), served the court as Academician Reader-in-waiting of the Academy of Scholarly Worthies (Jixianyuan), Commander of Linjiang Circuit, and Salt Distribution Commissioner at various times. A man of letters and a connoisseur, he excelled in painting particularly ink bamboos and calligraphy written in the Jin style. It is said that his mastery of the past masters, with a refreshing charm of his own, is inferior to neither Zhao Mengfu nor Xianyu Shu.

The calligraphy is mounted with works by Xianyu Shu, Guan Bao, Du Shixue, and Zhao Su in a single album for presentation to a brushmaker named Fan. In his calligraphy, Li Ti advises Fan not to compromise artisanship for profit if his craft is to attain perfection.

Fluid, refined, and robust, the calligraphy testifies to Li's admiration for Wang Xizhi. Attention is also paid to projecting the gentility of the Jin tradition besides emphasizing implicit strength and explicit composure. The literati ethos impregnated evokes that of Zhao Mengfu.

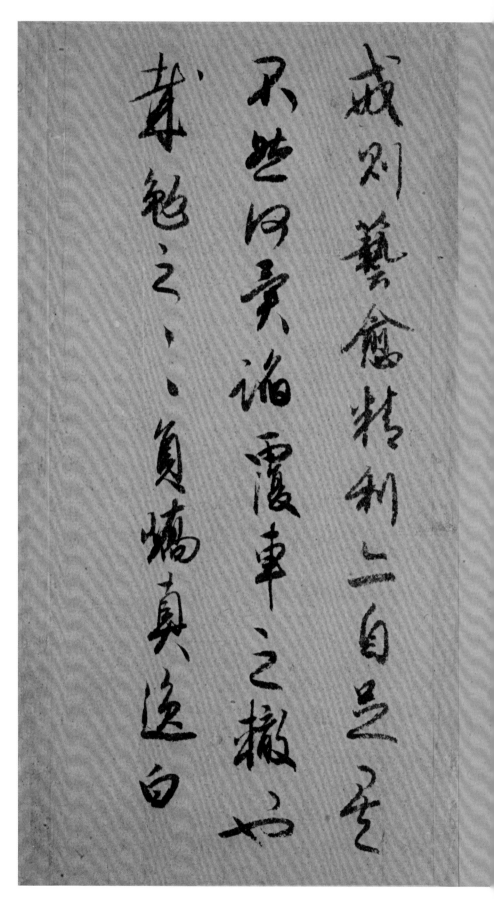

餘不范君用製筆精妙
諸公稱賞歲至余收何言
但君用常織伯梅以云劇事
馮三人趙利敗藝之語為

李倜字士弘河東太原人號員嶠真逸官至集賢

竹讀學士以好書名天下稍眠以取晉右軍縱筆擬

為之以擬晉顏至齋趙橫字茂原歸月摽曾題

楊竹西草亭圖卷士言長古一首絕佳官至杜在

元時書名不甚題而以筆政不佝至名一代以會

所尚幾於家靈珠和人第壓以困學翁至松雪為

開閒混在之功為不小也 有花朝後五日苦翁周書再後

擦名彼以移尚有李息齋趙文敏鄧善之

三跛不名月時稅去可惜如趙至鄧也名日

藏密多狗真意修有此譜一乙有題詩庵

莪京邯中不名尚存怪漁陽書此藏此

一頃善在當日陳傳已少天壓十珠珠示曷

遼得者无宜孫重

李夏月五日苦煩晏賠劉閑也自逸 苦翁揮汗

宣城諸蔦氏自晉時以筆名至唐

宋程松柳陳議兩用蘇玉局所稱巧是也

元時業此不一家即少顥門之業觀困學名

兩稱可見京法苦之年以胡仝溪童元

宗莹尚弱裘笔豪家膽材二佳丽遍吴

魏陵瀚毫不易寄此筆入者覚佳竟

不可得于書故拟又以為一佳筆供驅馳

宜生一搁笔即如骄生馬在旅途中以

一技之微二可以觀世運展困学筆及元

諸以贈苍筆工册為慨焉久之

同治四年乙丑季夏月望後雨日燈心室試郵席

庄筆書此

苌首再後

因学先生此書輒率府作尤极超渾入妙以壽之

弟三敢覚不工也世外莽家不是莽毅哲玉之世

其滕可覩見当日人才之盛松雪首工予别藏十

餘種当真讀之陸佳者善之先生予之藏其自

書詩叢卷雖失此兩跋尚不古悦惜之

光绪二年丙子季春月十日燈心自菴再後

計高工該时又十二年予六十有三矣自菴予六十歳

以後作書憑此觯齐記之

73

A Primer

— by —

Deng Wenyuan

— of —

the Yuan Dynasty

Hand Scroll, draft-cursive script

Ink on paper

Height 23.3 cm Width 368.7 cm
Qing court collection

Deng Wenyuan (1258–1328), a native of Mianzhou (present-day Mianyang, Sichuan), held such official positions as Senior Compiler of the Hanlin Academy, Supervisor of Confucian Schools in Jiangsu and Zhejiang, Surveillance Commissioner of Zhexi Circuit, Auxiliary Academician of the Academy of Scholarly Worthies, and Chancellor of the Imperial University at various times. He was a calligrapher proficient in the regular, running, cursive and especially the draft-cursive scripts and has been considered to be on a par with Zhao Mengfu and Xianyu Shu.

Written by Shi You in the Western Han, the widely circulated *A Primer* is a child's very first reader with names, honorifics, and items in everyday life assembled in a rhymed verse. It is learned from the closing inscription that the date is "the tenth day of the third month in the third year of the Dade reign (1299)," the recipient is Li Xi, a native of Yutian (present-day Hetian, Xinjiang), who once served as Assistant Prefect of Wujun, and the place is the Qingshou Temple in Beijing that was demolished in the 1950s. The calligraphy is signed and impressed with three calligrapher seals (*Deng Wenyuan yin, Baxi Deng shi Shanzhi,* and *Sulüzhai*).

Imitation of the Han draft-cursive script is evident in the sinuous and scrupulous brushwork. Yet the preferences at the time were such that the archaistic tenor of the ancient script is supplanted by the calligrapher's own masterly interpretation.

The frontispiece is inscribed to read "Sage of the Curisve Script" by the Qing emperor Qianlong whereas the colophon paper by Shi Yan, Yang Weizhen, and Zhang Yu of the Yuan and Yu Quan, Yuan Hua, Monk Daoyan, and Chen Qian of the Ming. At the very end of the scroll is a painting of pines, cypresses, and bamboos amongst rocks by Dong Bangda of the Qing.

Collector seals: *Yuan Hua siyin, Jiang Shaoshu yin, Eryou,* and seals of Xiang Yuanbian and the Qing emperors Qianlong and Xuantong.

Literature: *Collected Notes on Paintings and Calligraphies of the Shigu Hall, Coral Nets: Calligraphy Inscriptions, Spectacles Viewed in a Lifetime,* and *Inspiring Views.*

草 聖

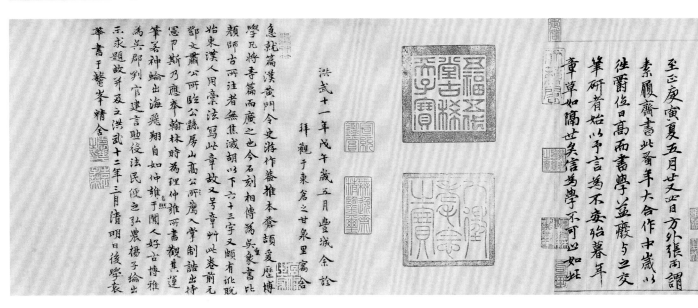

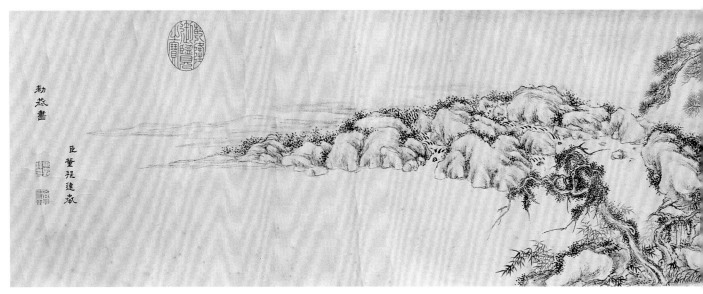

74

Poems on Eulogy to Boyi

— by —

Deng Wenyuan

— of —

the Yuan Dynasty

Running script

Ink on paper

Height 32.7 cm Width 40.9 cm

Deng Wenyuan's calligraphy attracted comments from his contemporaries Yu Ji and Zhang Yu. Yu regarded him to be a leader along with Xianyu Shu and Zhao Mengfu among calligraphers of the Dade (1297–1307) and Yanyou (1314–1320) reigns. Zhang, however, was disappointed that Deng became less devoted to calligraphy as he rose in rank since his mid years and that the draft-cursive script from his late years compared less favourably with his earlier works.

Signed and impressed with two signature seals (*Deng Wenyuan yin* and *Baxi Deng shi Shanzhi*), the calligraphy is made up of two pentasyllabic poems that originally served as a colophon to *Eulogy to Boyi* written by Fan Zhongyan of the Song. It alludes to how the calligraphy was recovered by Fan's descendants after the calligraphy and Deng's colophon had been lost for years.

In line with the period style of the Yuan Dynasty, the calligraphy is vibrant and spontaneous but not without paying conscious heed to rules and principles.

Collector seals: *bao xian*, *shilushi sun*, *Zhenyuan*, and seals of Zhang Heng and Pan Hou.

Literature: Ming: *Corals Harvested with Iron Nets*; Qing: *Inspiring Views*.

先慈吾師表斯文古鼎
銘義形扣馬諫善朦擾
戴經坡事嶽皇祐鄉
初謁仲丁登堂覩遺墨
山雨颯英靈
心田無與遠手澤慶年
殊誰購山陰彥真還合
於爾朱身誰名不了

75

Letter to Qian Liangyou

— by —

Gong Su

— of —

the Yuan Dynasty

Album leaf, running script

Ink on paper

Height 28 cm Width 38.4 cm

Gong Su (1266–1331), a native of Gaoyou resident in Pingjiang (present-day Wuxian, Jiangsu), worked in Xu Wanpi's private secretariat before serving as director of the academies Hejing and Xuedao and Deputy Supervisor of Confucian Schools in Zhejiang. He has been noted for his literature and calligraphy.

In the letter, references are made to the addresser's son-in law Wu Yan, who was a scholar on the seal script, and the addressee's son Qian Kui. *A Treatise on the Lychee* (*Lizhi Pu*), written by Cai Xiang of the Song Dynasty, should have been a rubbing since it is unlikely that the original would be given to the addressee's grandson as said in the letter. By inference from the honorific used in respect of the addressee, the letter was probably written during the Zhida reign (1308–1311) when Qian Liangyou was Instructor in the Wu County.

This calligraphy from the calligrapher's mid years is characterized by its brisk and unhalted manipulation of the brush. There is no doubt that the calligrapher is in perfect control of writing with the tip of the brush despite the vigour and swiftness. The unpretentious flavour is indebted to the Jin tradition.

Collector seals: *Tianlaige, An Yizhou jia zhencang, Lianqiao jianshang, Tan shi Ouzhai shuhua zhi zhang*, and *He Zizhang shending yin*. There are two serial numbers under Xiang Yuanbian's system.

Literature: *Fortuitous Encounters with Ink* and *List of Paintings and Calligraphies in the Sanyu Hall*.

錢□事擇履

翼之教授足下　　客亳州　龍□潇承封

瑞記事擇履

翼之教授足下小□□□□東□

手帖□□尉□□

□□見□如□

□讀序父□□云□□□□□

□□□□□□住思□少閒□□應

命非□□調也

□枝□□□□小孫習之　□郎□

76

Letter Preceding a Gathering

— by —

Yuan Jue

— of —

the Yuan Dynasty

Album leaf, running script

Ink on paper

Height 28.3 cm Width 38.9 cm

Yuan Jue (1266–1327), a native of Yinxian (present-day Ningbo, Zhejiang), was director of the Lize Academy before serving the court as Junior Compiler in the Historiography Academy, Auxiliary Academician in the Hanlin Academy, Academician Expositor-in-waiting, Drafter, and Chief Compiler of Dynastic History at various times. He was the calligrapher of many official publications and commemorative steles.

The letter is a personal exchange between friends and is expectedly uncontrived and unimpeded. Calligraphic laws are conformed to nonetheless. Vestiges of Mi Fu's unrestrained tilt are noticeable in the turns produced with precise pressing of the brush.

Collector seals: *An Yizhou jia zhencang*, *Lianqiao jianshang*, *jing xian*, *Tan shi Ouzhai shuhua zhi zhang*, and *Zhao Shuyan*.

Literature: *Fortuitous Encounters with Ink* and *List of Paintings and Calligraphies in the Sanyu Hall*.

栖比者終日獲接

雅譚維即搆句且可假書之

諸延閉

風帆趣潮将侶逢出毛

言敍是不果芸審

珮音琅出方持驚高詠

覿吾吉水逐覺

77

Colophon to Zhao Mengfu's Poems by Tao Qian

by

Yu Ji

of

the Yuan Dynasty

Album leaf, clerical script

Ink on paper

Height 33.2 cm Width 55.8 cm

Yu Ji (1272–1348) was a native of Renshou (in present-day Sichuan) settled in Chongren, Linchuan (in present-day Jiangxi), after the demise of the Song Dynasty. Holding positions such as Confucian School Head in Dadulu and Court Calligrapher and Academician of the Hall of Literature (Kuizhangge), he was charged with the compilation of *Encyclopedia of Statecraft* (*Jingshi Dadian*). Knowledgeable and literally talented, he commanded quite a reputation and has been known together with Liu Guan, Huang Jin, and Jie Xisi as the Four Masters of Confucian Studies and with Jie Xisi, Fan Peng and Yang Zai as the Four Poets of the Yuan.

Juxtaposed with Zhao Mengfu's *Poems by Tao Qian* on the same leaf, the colophon showers praises onto Zhao's calligraphy, compliementing the calligrapher to be unsurpassed in the Yuan Dynasty.

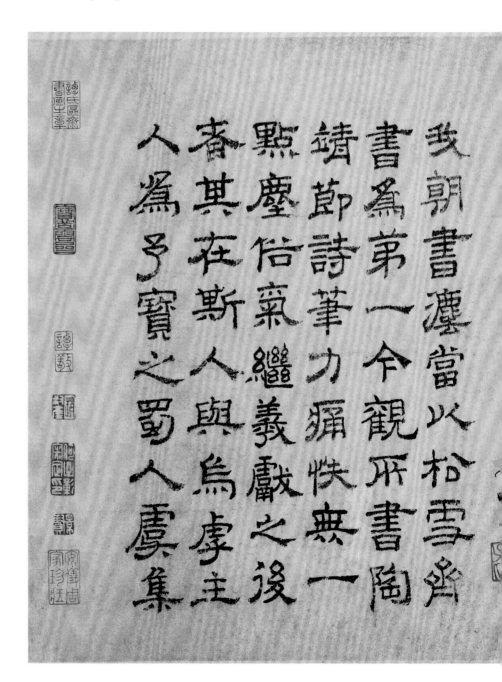

Yuan calligraphers in the clerical script were mainly inspired by the Wei-Jin and Tang masters and prioritized faithfulness to the past. In the present specimen, there is indeed a profound understanding of ancient brush methods and spirit resonance. By integrating rounded and angular brushstrokes for the sake of diversity, Yu has succeeded in enlivening the austerity of the Han-Wei tradition with vibrancy, meriting the accolade in *An Essential History of Calligraphy* (*Shushi Huiyao*) to be unrivaled in the ancient clerical script among his contemporaries.

Collector seals: *cang zhi daqian*, *Pusun, Zhao Shuyan, Lianqiao jianshang, Tan shi Ouzhai shuhua zhi zhang, Tan Jing, He Zizhang shending yin, jing xian*, and *An Yizhou jia zhencang*.

78

Poem of *Four Bird Calls* by Liang Dong

— by —

Guo Bi

— of —

the Yuan Dynasty

Hand Scroll, running script

Ink on paper

Height 30.5 cm Width 112.4 cm

Qing court collection

Guo Bi (1280–1335), a native of Dantu (present-day Dantu, Jiangsu), served as Local School Instructor in Zhenjiang Circuit, Master of the Pojiang Academy in Raozhou Circuit, and Confucian School Head in Wujiang Sub-prefecture of Pingjiang Circuit at various times. He also excelled in painting and calligraphy.

The calligraphy owes its text to Liang Dong's poem *Four Bird Calls*. The poet Liang Dong was qualified as *jinshi* during the Southern Song reign of Xianchun (1265–1274). When the Song empire was destroyed, he followed his younger brother and went up to Mount Mao to seek enlightenment in Daoism. As exemplified by the poem here, bird calls or bird songs have been personified for making observations on life in ancient Chinese poetry. Signed and impressed with a signature seal (*Guo Bi Tianxi*), the calligraphy is dated "the fifth year of the Yuan emperor Renzong's Yanyou reign (1318)" and is specified to have been inscribed as a colophon to the poet's work, which was then in the family's collection.

Well balanced and elegantly formed, the calligraphy calls to mind the style of Zhao Mengfu in character structuring and brush methods.

Collector seals: *Shigutang shuhua, xianke, An Qi zhi yin, An shi Yizhou shuhua zhi zhang, Chaoxian ren, Xuantong jianshang,* and *Wuyizhai jingjian xi.*

四禽言

脫却布袴貧家僅有

一尺布寒機剪盡無

可裁可人不来廉叔

度脫却布袴

不如歸去錦官宫破

迷春樹天津橋上三

兩辭叫破中原無夏

住不如歸去

提葫蘆今年酒賤頻、

沽衆人皆孫我名醉

哀哉誰問醒三閭提

79

Heart Sutra

— by —

Wu Zhen

— of —

the Yuan Dynasty

Hand Scroll, cursive script

Ink on paper

Height 29.3 cm Width 203 cm

Wu Zhen (1280–1354), a native of Jiaxing, Zhejiang, studied Confucian, Buddhist, and Daoist classics in his early years and, instead of entering officialdom, earned his living as a diviner by shuttling between Hangzhou and Jiaxing. He excelled in literature, painting, and calligraphy. He was so accomplished in painting that he has been known collectively with Huang Gongwang, Ni Zan, and Wang Meng as the Four Masters of the Yuan. As for calligraphy, he sought emulation of Monk Huaisu and Yang Nishi and was most adept in the cursive script. Unfortunately, specimens are rare other than in the form of painting inscriptions.

Impressed with two calligrapher seals (*Meihua'an* and *Jiaxing Wu Zhen Zhonggui shuhua ji*), this copy of the *Heart Sutra* comes from the calligrapher's late years with the date specified as "the sixth year of the Zhiyuan reign (1340)."

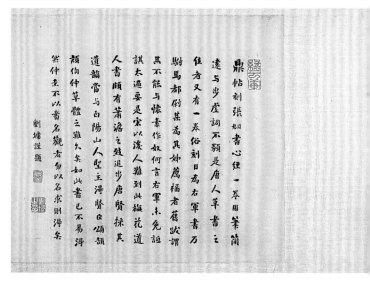

In the calligraphy, diversity is striking whether in the structuring of the strokes, the inclination of the forms, or the tonal value of the ink. Perceivable in the mind rather than by the eyes, the momentum sustains from one character to the next, imbuing the work with a flush of energy. Although it has been said that Wu Zhen's models were Zhang Xu and Monk Huaisu, indebtedness to Yang Ningshi and Huang Tingjian is also not to be dismissed. Clearly, the calligrapher has succeeded in stepping out of the shadows of these masters to forge an identity that is defined by its elegance and spontaneity.

Colophons to the calligraphy are inscribed by Liu Yong, Yongxing, and Yang Shoujing of the Qing.

Collector seals: *Qian Yue suo cang, Zhou Jiaqian Sijie shi ceng guan, moyi, Boya shi, Shaohu guoyan,* and *Yijinzhai yin.*

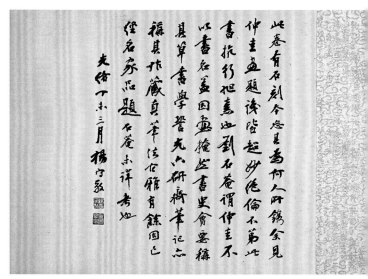

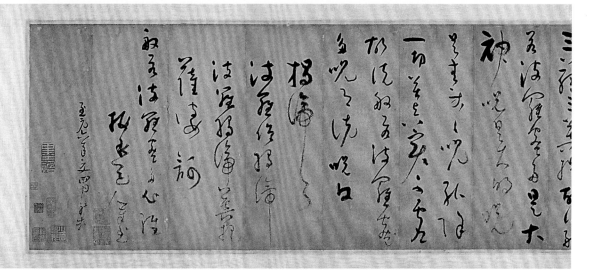

男仲圭草書心經

仲圭人品甚高與盛子
昭同鄉時皆責盛畫
而輕仲圭之曰瓚垂垂當
有知余者自製生壙兩
題之蓋於死生之途有
達觀矣此參與去兩
傳竹譜中草法不頹
饒有旭素之致于兒
松雪隨侶繳繞之讚
也
　　　皇十一子題

遺翰當与白陽山人聖主得賢臣公部
顏伯仲草體之難久矣如此書已不易得
然仲圭不以書名觀者多以名求則得矣
劉墉謹題

205

80

Poem of Thanks for Tangerines

———— by ————

Zhang Yu

———— of ————

the Yuan Dynasty

Running script

Ink on paper

Height 26.5 cm Width 29.4 cm

Zhang Yu (1283–1350), a native of Qiantang (present-day Hangzhou, Zhejiang), left home to become a Daoist cleric in his 20s. When he was young, he received calligraphic instructions directly from Zhao Mengfu and studied under Yu Ji to become a learned and eloquent scholar. His shared similar views with Mi Fu, whose character he very much admired. As for the arts, he was an adept in literature and painting and excelled in calligraphy in the Jin-Tang tradition.

Signed and impressed with a signature seal (*Juqu Waishi*), the calligraphy consists of two heptasyllabic quatrains composed by Zhang to thank Monk Yuanjing of the Lingyin Temple in Hangzhou for his gift of tangerines.

The calligraphy is a hybrid of Zhao Mengfu's placidity and Li Yong's vigour and is most meritorious for its disciplined spontaneity.

Collector seals: *An Yizhou jia zhencang*, *Lianqiao jianshang*, *jing xian*, and *Tan Jing*.

次韻謝
天鏡上人送柑

肚能緊束三條篾 千亦親栽兩顆
黎尚憶黄甘三百顆 好山多在洞
庭西

塵中誰識羅公遠 一嗅黄甘辨（香）三
輕不似枇杷金彈子 已供遊俠打
嗁鶯

81

The Banished Dragon
— by —
Kangli Naonao
— of —
the Yuan Dynasty
Hand Scroll, cursive script

Ink on paper
Height 28.8 cm Width 137.9 cm
Qing court collection

Kangli Naonao (1295–1345) was a Semu from the Kangli tribe (descendants of the ancient Gaoche people in Kipchak Khanate, in present-day Kazakhstan) but was well exposed to Han culture and well versed in Chinese classics. The positions he held at court include Assistant Director of the Palace Library, Auxiliary Academician of the Academy of Scholarly Worthies, Grand Academician of the Hall of Literature, Hanlin Academician Recipient of Edicts, Drafter, and Participant in the Classics Colloquium. He attained accomplishment in calligraphy through modelling on Yu Shinan for the regular script, and Zhong You and Wang Xizhi for the running and cursive, emerging as a leading calligrapher from among the ethnic minorities of the Yuan Dynasty. For a time, the northerner was considered worthy enough to rival Zhao Mengfu in the south.

Impressed with a signature seal (*Kangli Zishan*) for presentation to a friend who was an assistant prefect, the calligraphy owes its text to the fable *The Banished Dragon* (*Zhelong Shuo*) written by Liu Zongyuan of the Tang Dynasty.

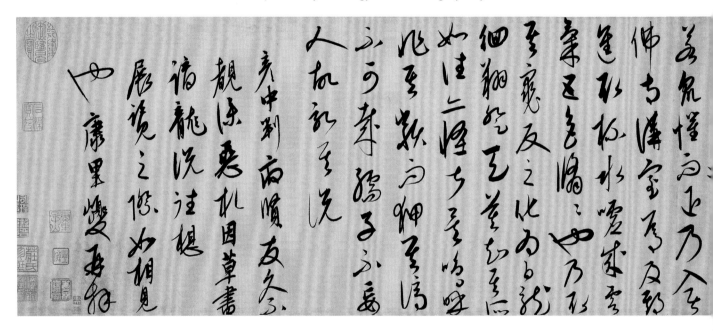

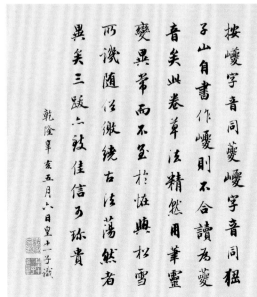

The calligraphy is a swift rendition with the centre-tip of the brush. The strokes are lithe, the brush methods sophisticated, and the aura ethereal. It is of interest to note that the form of the character "dragon" has been popularly adopted by later generations.

The title slip is inscribed by Yongxing of the Qing, whereas the colophons by Zhou Boqi, Ang Ji, and Qu Zhi of the Yuan and Yongxing of the Qing.

Collector seals: *Jiaolin jianding*, *An Yizhou jia zhencang*, and seals of the Qing emperor Qianlong.

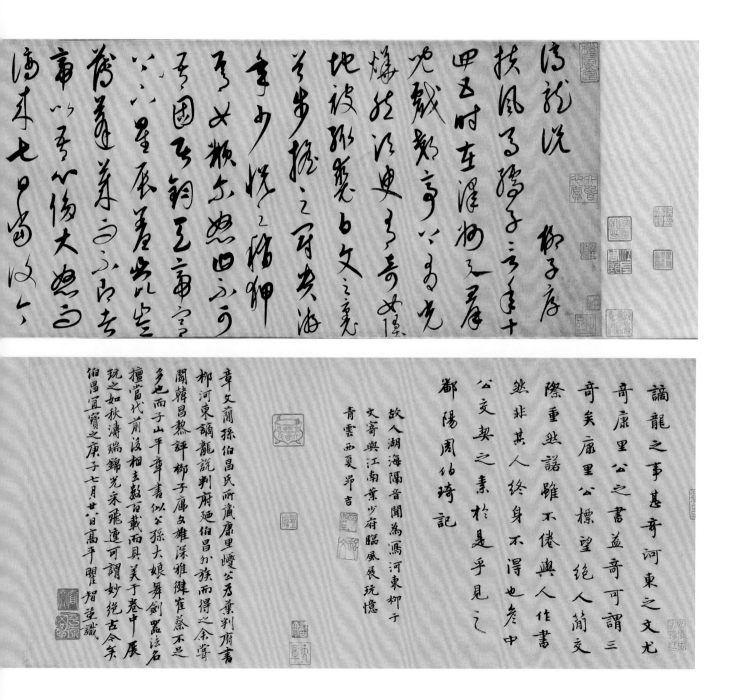

82

Letter to Zhang Demao

— by —

Huang Jin

— of —

the Yuan Dynasty

Running script

Ink on paper

Height 30 cm Width 36.5 cm

Qing court collection

Huang Jin (1277–1357), a native of Yiwu, Wuzhou (in present-day Zhejiang), was qualified as *jinshi* in the second year of the Yanyou reign (1315) and served as Deputy Governor of Ninghai County, Provisioner of the Hanlin Academy, Erudite of the Imperial University, Supervisor of Confucian Schools in Jiangsu and Zhejiang, Auxiliary Academician in the Hanlin Academy, and Academician Expositor-in-waiting at various times. He was held in high esteem for his literature by his peers.

Zhang Demao, the addressee of the letter, was an intimate friend of the calligrapher's and a ghostwriter for Zhao Mengfu. By inference from the content, the letter should have been written while the calligrapher was in Ninghai, suggesting the date to be the second year of the Yanyou reign (1315). In other words, this is an example from his early years.

Residual influences by Southern Song masters are discernible from the elongated forms that are quaint and robust. Mostly seen in inscriptions, Huang's calligraphic style seems to be anything but consistent. The enigma is solved by *Begin the Plentiful* (*Shifeng Gao*), which says Huang had all his manuscripts faired by his students.

Collector seals: *Feng ren Ji shi* and *Yeyuan zhenshang*.

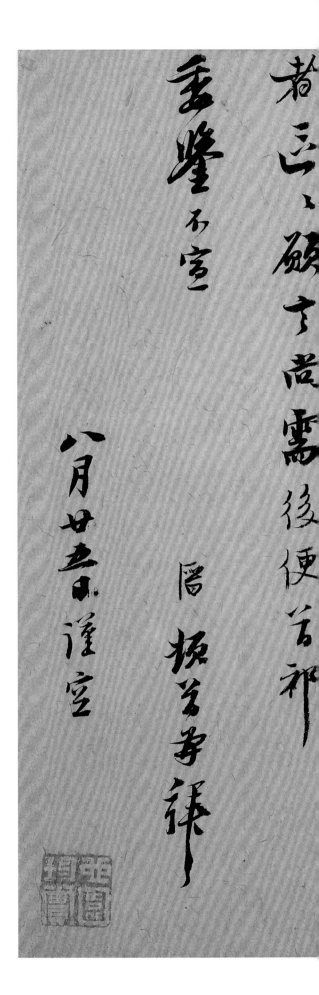

唇頓首再拜

徒撼處正捉筆尊繄之長生書

唇 六月

十一日菇

苕祗賊事東西驅役去邑中僅旬日不

咋暮歸自鄴境今早又出鄰埫田

適值陳兄行倉粹掌楮聊伸

啟居歕甚愧不勝且妾一物可備虛函

83

Inscription for Hall of the Spring Sun

— by —

Ouyang Xuan

— of —

the Yuan Dynasty

Hand Scroll, regular script

Ink on paper

Height 29 cm Width 102.9 cm
Qing court collection

Ouyang Xuan (1283–1357), a resident of Liuyang, Hunan, who hailed from Luling (present-day Ji'an, Jiangxi), was qualified as *jinshi* in the second year of the Yanyou reign (1315) and was promoted to positions such as Hanlin Academy Recipient of Edicts and Chancellor of the Directorate of Education. He excelled in literature and calligraphy, the latter of which was modelled on Su Shi.

The inscription was written and calligraphed to commemorate the hall that Wang Boshan specially built for his mother, lauding the son for his filial piety and the mother for her virtuousness. The name of the hall is an allusion to the Tang poet Meng Jiao's well-known poem that analogizes motherly love to the warm sun in spring. Impressed with a signature seal (*Jijun Ouyang Xuan yin*), the inscription is signed with the date given to be "the eighth month in the *jimao* year of the Zhiyuan reign," which corresponds to the fifth year of the reign, or 1339.

In emulation of Su Shi but not without originality, the calligraphy impresses with its poised structuring and meticulous attention to the exertion of pressure to produce the desired turns and folds.

The colophon paper contains poems inscribed by Zhang Zhu, Wu Dang, Gong Shidao, and Cheng Yi in relation to Wang's dutifulness as a son.

Collector seals: *An Qi zhi yin* and seals of Emperors Qianlong, Jiaqing, and Xuantong.

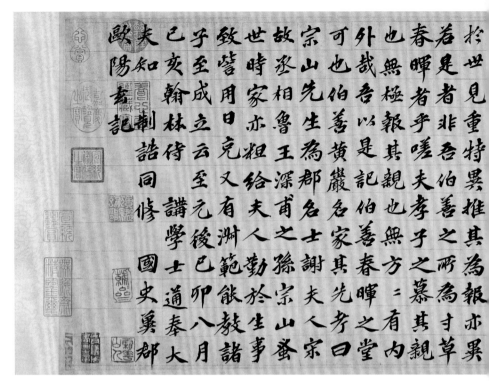

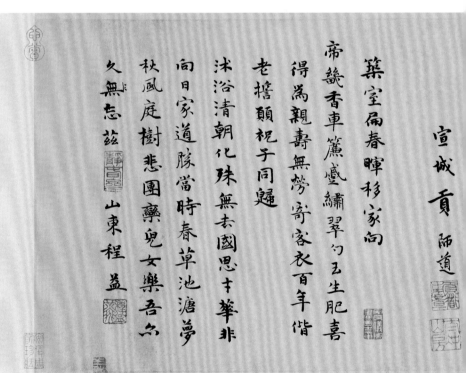

春暉堂記

黃巖王君伯善寄跡老氏法中　泛特進吳上卿侍祠京師泰　定丙寅奉吳上卿　命代祀江南諸名山事竣告歸養　母未幾上卿力挽之復來乃迎　母俱至得屋順承門之西曰而　泊之暄涼適宜溫凊有所母婆　居歲五十年行年七十有二笑　京師珍臞輴湊順承懋遷鱗次　伯善賣藥闤闠之中以有餘之　詧左右耶甘旨如攜母益安裕　奉親之堂曰春暉謁余浩其　夫春暉之義始吳君養名草　心報得三春暉之句則以謂草　順適無病待制吳曰春暉　化工之於百物生之而已爾壹　受之初心斯以草言　望報者栽特百物各以其所賦　之以著也蓋菖也以報今以神百穀也　以養人百藥也以療人其微者　蕢也亦著也菖菖以報生也　可為夢笈橋爾雅雜離騷劉之　也名不見於詩爾則以代陶尾其為　世用亦博矣芝蘭也生於山林

早歲移天已自嗟白頭今日　到京華不辭織履日方進會　見隨官似大家反哺烏聲時　繞對忘憂萱草鎮朝花鄉來　王謝汸風在宜与詞臣作傳

　誇　　河東張翥

王謝流風故國傳縈縈苦節更　耦賢承家未墜　詩書澤衍舍猶　存伏臘田曉鏡丹鉛塵漠漠寒　窗機杼月娟娟　春暉堂外慈烏　樹移在城南尺五天

　　　臨川吳當

繁華流水去滋滋富貴如雲　氣未降謝相有孫鸞影隻　王郎浔子鳳毛雙壺鶬上　壽城南定機杼鷺秋月夜

Preface to Shen Guorui's Collection of Poetry

— by —

Yang Weizhen

— of —

the Yuan Dynasty

Hand Scroll, running script

Ink on paper

Height 29.7 cm Width 77.8 cm

Yang Weizhen (1296–1370), a native of Shanyin (present-day Shaoxing, Zhejiang), was qualified as *jinshi* in the fourth year of the Taiding reign (1327) of the Yuan Dynasty and was promoted to positions such as Governor of Tiantai County and Supervisor of Confucian Schools in Jiangxi. Into the Ming Dynasty, he was summoned by the new court to Nanjing to work on ritual and music compilations. The forthright man was a man of many talents. His poetry was so extraordinary that he became the archetype of a style named after him besides being a leading poet with a large following in the late Yuan. Dynamic and forceful, his calligraphy is no less unique.

Included in *Collection of Yang Weizhen's Works* (*Dongweizi Wenji*), the text was written as a preface to Shen Guorui's *Collection of Yuefu-poems* (*Yuefu Shiji*) and gives a general evaluation of *yuefu*-poetry and its poets from the Yuan Dynasty. Shen, in particular, is highly approved of for rivaling the Song poets for his rhetoric and sincerity. Dated "the *gengzi* year of the Yuan emperor Shundi's Zhizheng reign (1360)," the calligraphy is impressed with a number of caligrapher seals (*Kuaiji Yang Weizhen*, *Kuaiji Yang shi Lianfu*, *Baoyi Laoren*, *Dongweizi*, and *qingbai chuanjia*).

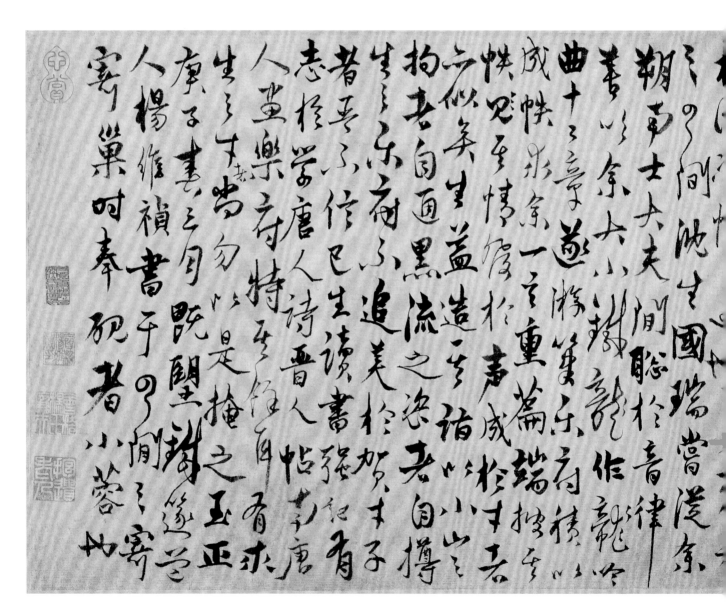

The distinctive calligraphy is robust and diverse, with the ink freely applied in largely varied tones.

Collector seals: *An shi Yizhou shuhua zhi zhang* and *Heng Jiuxian jia zhencang*.

Literature: *Notes from the Summer of the Renyin Year*.

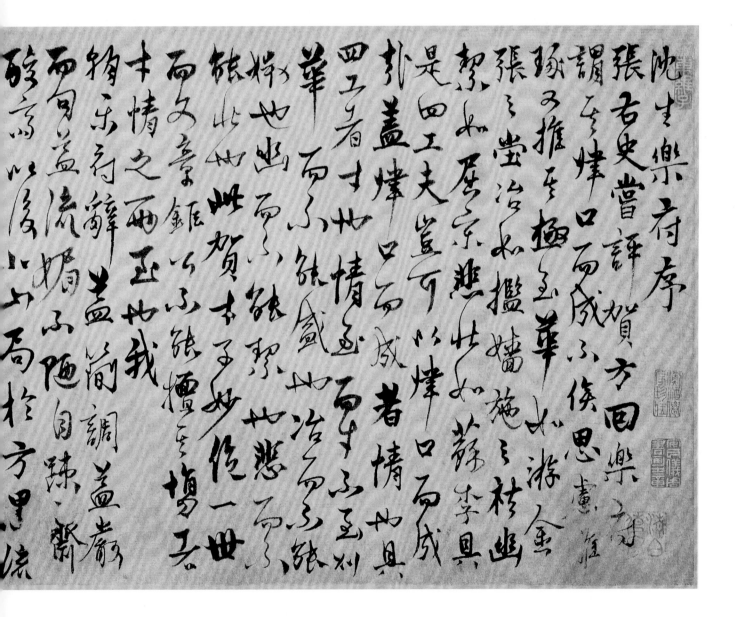

85

Inscription for a Humble Dwelling

by

Tai Buhua

of

the Yuan Dynasty

Hand Scroll, seal script

Ink on paper

Height 36.9 cm Width 113.5 cm

Tai Buhua (Taibuqa, 1304–1352), a member of the Mongol tribe of the Bayaut, was a native of Taizhou (present-day Linhai, Zhejiang). He was qualified as *jinshi* in the first year of the Yuan emperor Yingzong's Zhizhi reign (1321) and rose through the ranks to occupy such positions as Senior Compiler of the Hall of Worthies (Jixiandian) and Vice Minister of Rites. Excelling in the seal, clerical, and regular scripts, he derived his seal script from Xu Xuan and Zhang You and succeeded in forging his own identity.

The calligraphy owes its text to *Inscription for a Humble Dwelling* (*Loushi Ming*), a classic literary piece written by Liu Yuxi of the Tang Dynasty. It is signed and dated "the 28th day of the first month in the sixth year of the Zhizheng reign (1346)."

This only surviving seal-script specimen by the calligrapher is distinguishable by the wiry obtuse brushwork, the sparse structuring, and the neat elegant style.

Both the front and the back separators are inscribed by Luo Tianchi of the Qing Dynasty.

Collector seals: *An Qi zhi yin*, *Chaoxian ren*, *Peichang baocang*, and *Mutou Laozi*.

元人白野蕙菩篆書陋室銘　希世名迹

潘德畬方伯借刻於海山仙館帖中　羅天池記

陋室銘

山不在高有仙
則名水不在深
有龍則靈斯是
陋室惟吾德馨
苔痕上階綠艸
色人簾青談笑
有鴻儒往

86

Poem of the Studio of Blandness

by

Ni Zan

of

the Yuan Dynasty

Hanging Scroll, regular-running script

Ink on paper

Height 64 cm Width 27 cm

Ni Zan (1301–1374), a native of Wuxi (in present-day Jiangsu), came from an affluent family. In his mid years, he gave away all his fortune and set off for extensive travels. Passionate for antiquities and collecting, he was also literally and artistically gifted and was popularly known as one of the Four Masters of the Yuan for his painting. His calligraphy was first inspired by the ancient clerical script and then informed by Ouyang Xun and Chu Suiliang.

As indicated in the closing inscription, the text is a poem composed for Zi'an and is now written for Zongdao, a friend. The poem tells of the calligrapher's solitary life in the company of just clouds and birds.

According to Ni himself, he declined requests for steles owing to his inadequacy in writing large characters, making this only surviving specimen all the more precious. Borrowing from the clerical script, the running-cursive script seen here is underlined by discipline and regularity in the rendering of the strokes, character structuring, and overall composition.

Collector seals: *Runzhou Dai Zhi zi Peizhi jiancang shuhua zhang.*

欲寓新詩塵滿九味我迂言淡如水自雪淡之何
從來伴我孤吟北窗裏酒味甘濃易變酸此
情對面九疑山白雪且結無情友明月幽
禽与德還
八月廿日過宗道雲樓樓命余賦子安淡室詩
目賦是日躇陽生涼山光滿九殊有幽興也墳

Copy of the Dingwu Version of the *Orchid Pavilion Gathering Preface*

— by —

Yu He

— of —

the Yuan Dynasty

Hand Scroll, running script

Ink on paper

Height 26.7 cm Width 83.7 cm

Yu He (1307–1382), a native of Tongjiang (present-day Tonglu, Zhejiang) resident in Hangzhou, preferred a life of seclusion to officialdom. Steeped in the Jin and Tang masters through copying, he excelled in all the scripts. In his early years, he had the opportunity to observe Zhao Mengfu at work when he studied calligraphy under the great master. His running-cursive script resembles his teacher so closely that his works, with signatures and addressees tampered with, have been passed off as Zhao's.

The *Dingwu Version of the Orchid Pavilion Gathering Preface* adopted for the present copy has been said to be a stone carving of the Tang calligrapher Ouyang Xun's copy. It is named after Dingwujun, or Dingzhou (present-day Dingxian, Hebei), where the carving was discovered in the Northern Song. Next to the calligraphy is a poem in draft-cursive script that Yu professes to be a playful attempt using the same rhymes in Zhang Yu's poetic inscription to Gao Kegong's painting. Impressed with three calligrapher seals (*Yu He*, *Zizhisheng*, and *tejianyao*), the calligraphy ends in a signature that reads, "Copied by Yu He at the Kang Garden in Huanggang. The 13th day of the fourth month in the *gengzi* year,

知老之將至及其所之既惓情
隨事遷感慨係之矣向之所
欣俛仰之間以為陳迹猶不
能不以之興懷況脩短隨化終
期於盡古人云死生亦大矣豈
不痛哉每攬昔人興感之由
若合一契未嘗不臨文嗟悼不
能喻之於懷固知一死生為虛
誕齊彭殤為妄作後之視今
六由今之視昔
敘時人錄其所述雖世殊事
異所以興懷其致一也後之攬
者亦將有感於斯文

or the 20th year of the Zhizheng reign (1360)," suggesting that it was written when the calligrapher was in Huanggang, Hubei, to flee wars. The frontispiece is impressed with two seals (*Qingyin* and *Jingxue*).

Yu copied the present piece with the utmost care, neglecting neither the folds nor the connectives between strokes, thus leaving posterity with the best ever copy of the *Preface to the Orchid Pavilion Gathering*. By contrast, the poem in draft-cursive script is liberal and spontaneous in execution.

The title slips to the right of the calligraphy are inscribed in regular script by Wang Shu and Wang Wenzhi, whereas the colophons to the left by Chen Jiru of the Ming, and Wang Shu, Shunfu Jushi, Wang Wenzhi, Wu Yun, and Fei Nianci of the Qing.

Collector seals: *Xiang Zijing jia zhencang, Gu Zishan miqie yin, Cheng Zhenyi zhencang yin, Wu Zhen, Xuzhou,* and *Wu Ting.*

Literature: *Records of Paintings and Calligraphies of the Lodge of Passing Clouds* (*Guoyunlou Shuhua Ji*).

異所以興懷其致一也後之攬
者亦將有感於斯文

晉永和九年歲在癸丑暮春之初會
于會稽山陰之蘭亭脩禊事也...
于黃岡之康園

握其幛以止不蹈襲已...
伯生之瀟宕伯幾之沈著
伯雨之古厚丹邱之峻刻
芝此書純以健攀擅場又
肯是集賢未到之境乂業
出諸家之外軌謂元代書
家不出集賢願運我定武
蘭亭甚好不臻而健攀之
中含孕風神乃其正龍門
脈此卷紫芝自題曰特健
藥蓋深有會於定武之健
攀者學書者由此必筆寧

紫芝筆舞洞精諸巻通動似興
誌藝善唯率寞武不顧典鴻波此盾
也此惟吳周生寶藏之 陳洪綬為

俞紫芝蘭亭帖題跋於元翔硯齋...

俞武禊帖

永和九年歲在癸丑暮春之初
于會稽山陰之蘭亭脩禊事
也群賢畢至少長咸集此地
有峻領茂林脩竹又有清流激
湍暎帶左右引以為流觴曲水
列坐其次雖無絲竹管弦之
盛一觴一詠亦足以暢敘幽情
是日也天朗氣清惠風和暢仰
觀宇宙之大俯察品類之盛
所以遊目騁懷足以極視聽之
娛信可樂也夫人之相與俯仰
一世或取諸懷抱悟言一室之內
或因寄所託放浪形骸之外雖
趣舍萬殊靜躁不同當其欣
於所遇暫得於己快然自足不
知老之將至及其所之既惓情
隨事遷感慨係之矣向之所
欣俛仰之間以為陳迹猶不
能不以之興懷況脩短隨化終
期於盡古人云死生亦大矣
不痛哉每攬昔人興感之由
若合一契未嘗不臨文嗟悼不
能喻之於懷固知一死生為虛

特健藥

康熙五十有五年歲在丙申秋七月既望良常王澍
若林從孫編脩文子借觀十日乃還

紫芝臨晚蘭亭合有數本真欲突過趙集賢
門徑法力勝而筆無橫逸趙則每多自運故法
意不純此非可勉強就此帖公歘謂與褚登善其
泰定武大屬話柄定式之名何昉祇國歐格專立
門戶而褚令自有家法堂惟不屑旁參抑且夢
想不到不意通人落此語病猶見盧舟方跋一卷
謂滕出緜本上彼係生紙此係宋紙故圓渾如志
彼帖雖佳仍未晚趙家筆徑耳合觀識此

　　西河順甫居士附跋

余少時見元人書輒以為
俱是趙集賢一派筆卒四十
優始知元代諸家皆自立
門戶不相蹈襲一顧忽焉齒

元代書家莫不宗法趙襲或近真遊近精
紙財又皇進一懷不屑寫人臞公富最著有
鮮于伯機鄧善之柯敬仲均孤雄視書壇英
人三揚兼善田鄧此帖之重獨多折閱門惟此派
波此脩夢楷經脩宿俞子中生精晚少時惟祝見然
運筆文注弱言標形神畢肖好車者必望中是此跋
書每因趙款漢鑒善品董祗佑祺又若兆中諸英
益均工形軌渡諸情宕怕佑注大各此其先萬里渡
萬雖卯已西仙居仍宗佑之惺生佑兩王子均失
此卷形寫武禊帖而仍宗法緜恒生佑參華攷
持平論美楷文消若祗紫芝自題曰特健藥盡澤青宗
初芝嚴龍者崔舉者全樓武手余如楮武手山師府
　　　　　　　　　　　　題曰特健藥盡澤青宗

舉者學書者由此必筆寧
非巨海之津梁也載是卷
舊為吳門繆氏所收七歸
休寧武硯齋汪氏邨舍
蓋得而見之云
嘉慶元年午節後五日丹
徒王文治記
　　由緜入汪其價值三百金
　　當時已有石刻拓本矣佳

88

Self-composed Poem
—— by ——
Shao Hengzhen
—— of ——
the Yuan Dynasty

Running script

Ink on paper

Height 24.5 cm Width 58.9 cm

Shao Hengzhen (1309–1401), whose ancestry originated from Yanling (in present-day Zhejiang), lived in Huating (present-day Songjiang, Shanghai). Serving as Assistant Instructor in Confucian Schools in Songjiang, he was well versed in the Confucian classics and histories and was accomplished in literature and calligraphy.

The text is a heptasyllabic quatrain composed to rhyme with a poem by Yang Weizhen. It is dated "the *guimao* year of the Zhizheng reign (1363)" and impressed with three calligrapher seals (*Mu Shao Hengzhen, Shao shi Furu,* and *Qingxi Yeshi*). Since it is documented that the calligrapher was posted in Wumen between the *jihai* year and the *yisi* year of the Zhizheng reign (1359–1365), the calligraphy may have been written during that period.

The calligraphy is uninhibited and shows borrowings from Su Shi and Zhao Mengfu.

Collector seals: *Molin miwan, Beiping Sun shi, Guxiang Shuwu,* and *Hengyong siyin.*

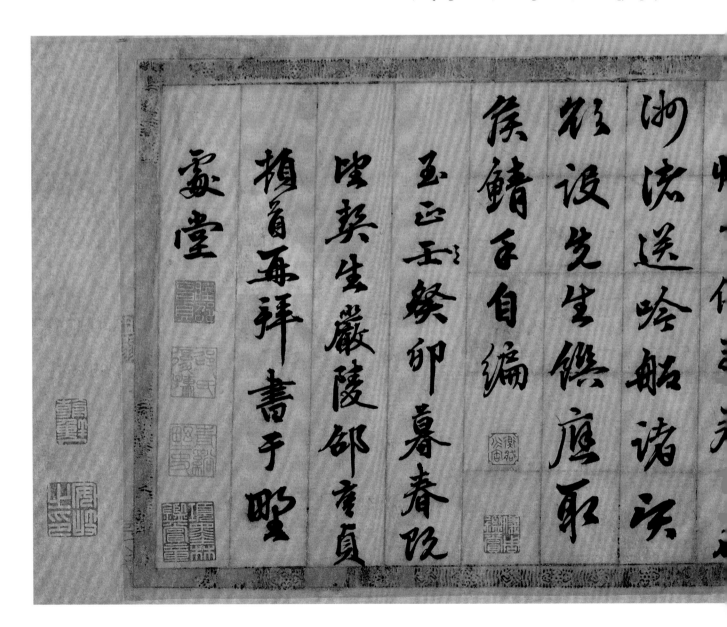

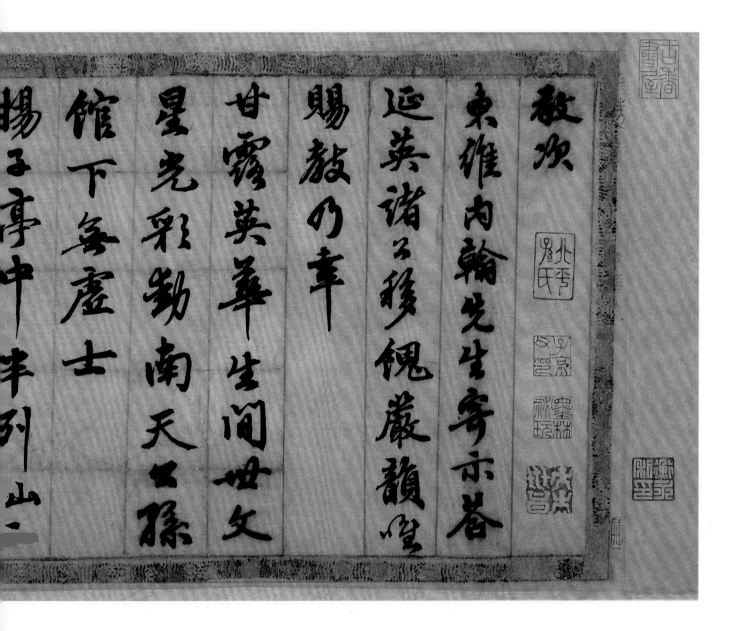

敎坎

東維內翰先生寄示荅

延英諸公移餽巖韻唯

賜敎の章

甘露英華生間母父

星光彩勤南天孫

館下參盧士

揚子亭中半列山二

225

89

Letter to Yuan Tai

by

Chen Ji

of

the Yuan Dynasty

Leaf, running script

Ink on paper

Height 38 cm Width 42.5 cm

Qing court collection

Chen Ji (1314–1370), a native of Linhai (present-day Taizhou, Zhejiang), was Huang Jin's student. He occupied the position of Examining Editor in the Classics Colloquium during the Zhizheng reign and became an advisor to Zhang Shicheng, a rebel leader, in late Yuan. In the early years of the succeeding Ming Dynasty, he was summoned to compilie a history of the Yuan Dynasty and retired when the project was completed. The zealous seeker of knowledge has been noted for his literature and calligraphy.

In the letter, Chen thanks Yuan Tai for a calligraphy by Zhao Mengfu and promises help with a real estate matter. Yuan Tai, Yuan Yi's second son, was head of a prefectural school and an accomplished poet and essayist.

Dating from Chen's middle age, the calligraphy is fluent and dignified.

Collector seals: *zhenshang*, *Banqian*, *Jiang Xia shi tushu ji*, *Dongping*, *Qianlong jianshang*, *Xuantong jianshang*, and *Wuyizhai jingjian xi*.

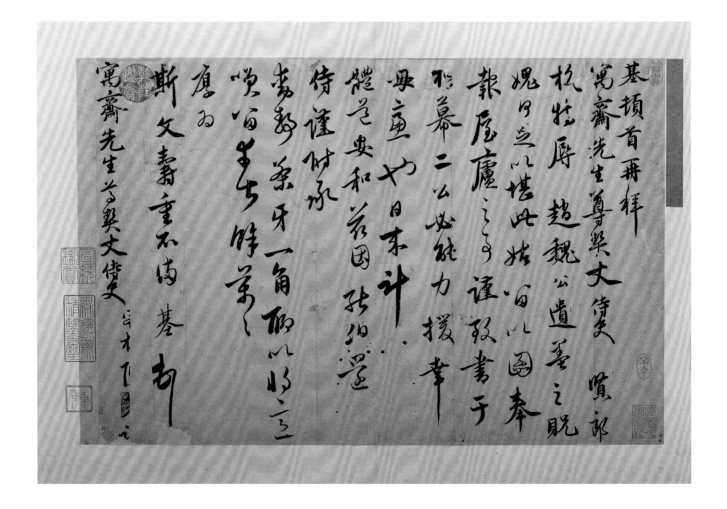

90

Letter with Poems to Chen Zhi

— by —

Shen You

— of —

the Yuan Dynasty

Regular script

Ink on paper

Height 27 cm Width 40.5 cm

Shen You (dates unknown), a native of Wu (present-day Suzhou, Jiangsu), was born into affluences, thus dispensing him with the need to pursue a career as an official. He excelled in literature and owed his handsome calligraphy to Ouyang Xun.

The letter includes five poems composed when the calligrapher was tipsy. Contemporary men of letters and calligraphers such as Chen Ji, Zheng Yuanyou, and Qian Kui, are mentioned, offering glimpses into the social life centring around poetry and wine that was led by literati of the Suzhou and Hangzhou areas towards the end of the Yuan Dynasty.

Shen's small regular script mainly allures with its delicacy. Relaxed and restrained, the present specimen displays apt complementariness in every stroke.

Collector seals: *Beiping Sun shi*, *Lianqiao jianshang*, *jing xian*, *Zizhang zhenwan*, *Zhang Yuan siyin*, and seals of Xiang Yuanbian, An Qi, and Tan Jing.

Literature: *Corals Harvested with Iron Nets*, *Collected Notes on Paintings and Calligraphies of the Shigu Hall*, *Spectacles Viewed in a Lifetime*, *Fortuitous Encounters with Ink*, and *List of Paintings and Calligraphies in the Sanyu Hall*.

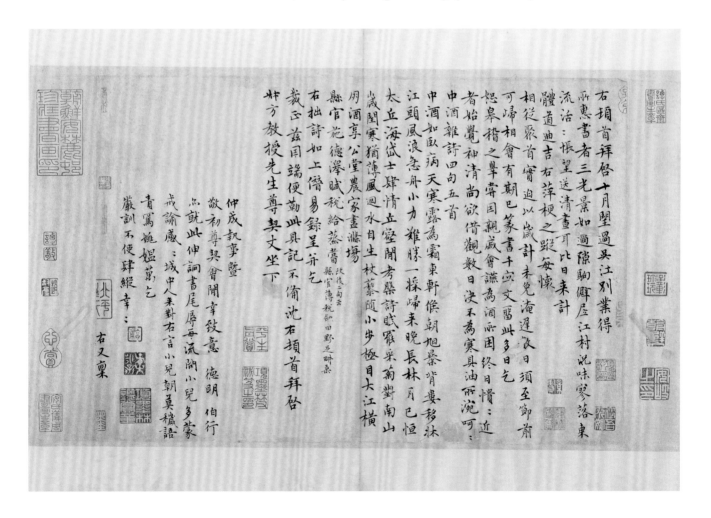

91

Poem on the Tiao Stream

— by —

Lu Juren

— of —

the Yuan Dynasty

Hand Scroll, cursive script

Ink on paper

Height 28.2 cm Width 130.7 cm

Qing court collection

Lu Juren (dates unknown), a native of Huating (present-day Songjiang, Shanghai), was a teacher all his life. The calligraphic adept excelled in poetry and often engaged in poetic exchanges with Yang Weizhen and Qian Weishan. The three of them were buried in the same tomb called Tomb of the Three Lofty Men on the eastern slope of Mount Qian.

In the heptasyllabic verse, the Tiao Stream inspires a eulogy to the brush maker Lu Wenjun and his durable and impeccable brushes. Lu was a native of Wuxing (present-day Huzhou, Zhejiang). For his family, brush making was an occupation that had garnered them generations of fame from far and wide. The date given in the Jupiterian calendar corresponds to the fourth year of the Hongwu reign, or 1371.

A masterpiece from the calligrapher's late years, the calligraphy is etherally elegant and is reminiscent of Zhang Xu, Monk Huaisu, and Sun Guoting.

Another masterpiece is found in the colophon paper, namely a poem to rhyme with Lu's inscribed in regular script by Zhang Shu of the Yuan Dynasty. There is also a colophon by Chen Pu and a poem by Yuan Kai, both also dating from the Yuan.

Collector seals: *Tianlaige*, *Lingzhi qingwan*, *Guxiang Shuwu*, and seals of Emperors Qianlong and Xuantong. There is also a serial number under Xiang Yuanbian's system.

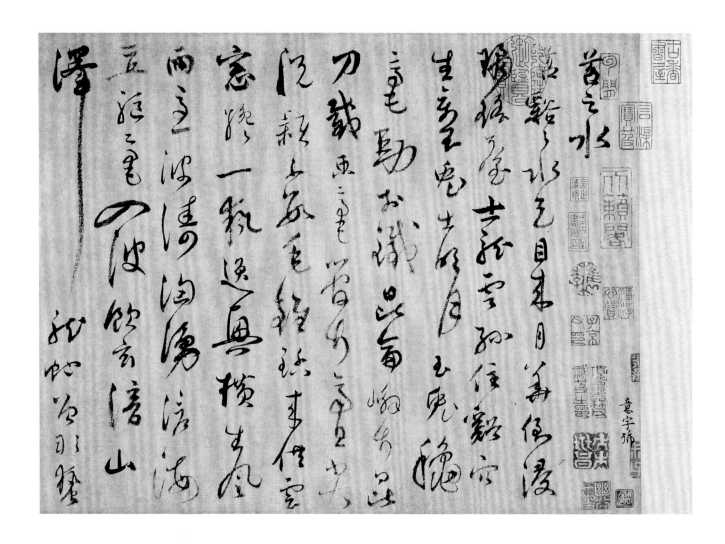

92

Letter to Zhang Shen

by

Rao Jie

of

the Yuan Dynasty

Running-cursive script

Ink on paper

Height 28.4 cm Width 32.9 cm

Rao Jie (dates unknown), a native of Linchuan (in present-day Jiangxi), rose through the ranks from Provisioner of the Hanlin Academy and Assistant Censor-in-chief of Zhexi to become Assistant Administrator of the Branch Secretariat of Huainan towards the end of the Yuan Dynasty. Subsequently, he was recruited to fill that same position by Zhang Shicheng, who had declared himself king with Suzhou as his capital. When the regime was conquered, Rao was captured and taken to Nanjing where he was executed. Easy-going, he had a wide circle of friends. Regarding talents, he was an adept in poetry and calligraphy.

Zhang Shen, the addressee of the letter, also worked for Zhang Shicheng towards the end of the Yuan Dynasty. From the matters discussed, including recommendation for the addressee's younger brother and bringing up the matter with members of the private secretariat, it is apparent that the sender and the addressee were close colleagues in Zhang Shicheng's court.

The calligraphy is unaffected in overall composition, sparse in character structuring, and diverse in stroke thickness. Although influences by Xianyu Shu are visible, the calligrapher's personal style is not at all stifled.

Collector seals: *Tianlaige, Xiang Tingmo yin, Yizhou jianshang, Lianqiao jianshang, Zhao Shuyan, Tan shi Ouzhai shuhua zhi zhang*, and *jing xian*.

Literature: *Fortuitous Encounters with Ink* and *List of Paintings and Calligraphies in the Sanyu Hall*.

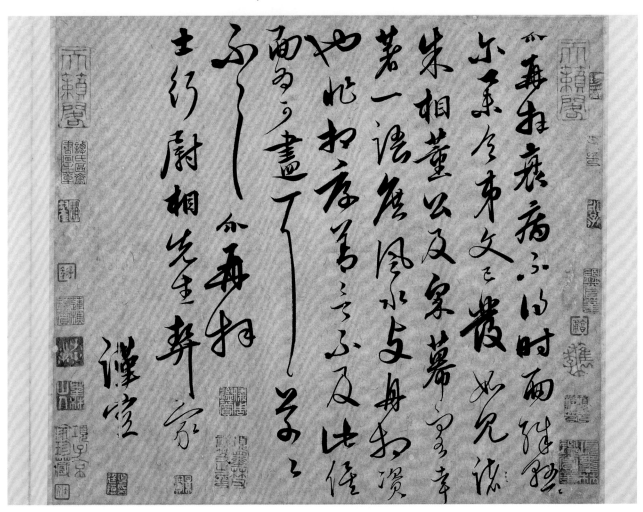

93

Inscriptional Gifts to Mo Weixian

— by —

Qiu Yuan and others

— of —

the Yuan Dynasty

Hand Scroll of five sections

Ink on paper

Section one: Height 30 cm Width 61.3 cm
Section two: Height 34 cm Width 59.4 cm
Section three: Height 35.6 cm Width 84.3 cm
Section four: Height 31.3 cm Width 31.4 cm
Section five: Height 24.6 cm Width 23.3 cm
Qing court collection

Mo Weixian (dates unknown), a native of Qiantang (present-day Hangzhou, Zhejiang), built the West Lake Hermitage on a mountain overlooking the West Lake for gathering with his literary friends. The present scroll consists of writings by Bai Ting, Zhang Zhu, Qiu Yuan, Zhang Yu, and Sang Weiqing for congratulating their poetic friend on this new property of his. The frontispiece carries an inscription in seal script by Zhou Boqi, reading "West Lake Hermitage" and a painting of the retreat by a Ming painter.

Section one: Bai Ting's *Draft Inscription for Mo Weixian's Painting of the West Lake* in running script. Bai Ting (1248–1328), a native of Qiantang (present-day Hangzhou, Zhejiang), had a penchant for literature and was learned in Confucian classics and histories. As for calligraphy, he was steeped in Mi Fu's style. The calligraphy in the present specimen is marked by fluidity and spontaneity, favouring robustness and simplicity over precision in execution. Based on its style, it should be completed in his late years.

Section two: Zhang Zhu's *On Manuscripts of the West Lake* in regular script, dated the third year of the Taiding reign (1326). Zhang Zhu (1287–1368), a native of Jinning (in present-day Yunnan), studied poetry under Qiu Yuan in his early years. As an official, he was the holder of positions such as Junior Compiler in the Hanlin and Historiography Academy and Hanlin Academician Recipient of

Edicts. The calligraphy in the specimen is indebted to Ouyang Xun for its neatness. The pronounced corners give it a solid and stable character.

Section three: Qiu Yuan's *Introduction to Mo Weixian's Poetry* in running-cursive script, dated the *dingmao* year of the Taiding reign (1327). Qiu Yuan (1247–1326), a native of Qiantang (present-day Hangzhou, Zhejiang), was regarded as a poet worthy enough to be mentioned in the same breath with Bai Ting in the Zhejiang area. He modelled on Ouyang Xun for the regular script and was especially skilled in the running and cursive scripts. In his late years, he switched to Monk Zhiyong and Yan Zhenqing for inspiration and attained broadness and roundedness in his style. Peppered with nuances of the regular, running, and cursive scripts, the present specimen is defined by an untainted flowing grace with a sparse structuring, unsparing ink, and unambiguous strokes. Without doubt, this is a masterpiece from the calligrapher's late years.

Section four: Zhang Yu's colophon in regular-running script. At once robust and captivating, the specimen manifests the calligrapher's indebtedness to first Zhao Mengfu and later the Tang masters.

Section five: Sang Weiqing's two poems in running script. Sang Weiqing (dates unknown) was an excellent calligrapher judging from the assured rendition in the present specimen.

Collector seals: Ming: *Mu Linting zhang*; Qing: seals of Emperors Qianlong and Jiaqing.

Literature: *Shiqu Catalogue of Imperial Collection of Painting and Calligraphy: Series Two.*

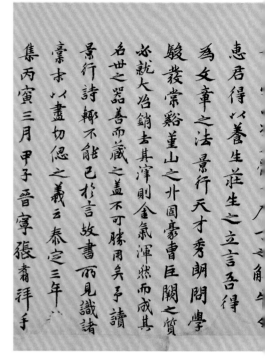

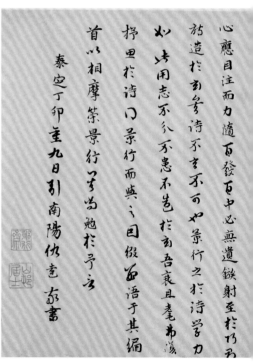

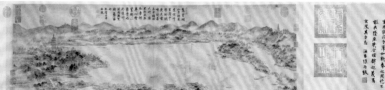

擬題

莫景行西湖宮景畫

廷頫畫

達人風浮煙靄趣羅屋西川
背城往伊誰筆看縮地注盡
卷湖山入尊俎勢如翠浪灨
天起一線縱橫妄影路儼宮
佛祠阿閣晴暗看朱樓出煙
樹畫船百尺小推蠶頁克汀鷗
與沙鷗南山北山相娟嫵郤是枚
藥買到霄自秀水影夢重坡
晴光照光翠西字幾回閑戶成臥
趙不屈連朝陽風雨人生百年
炊一腕雙度將迎鐵爐多歲
寒只合觀畫圖不作宣明面相碩

書西湖豪

詩看古今體其氣格聲熱若上
而實同一律二不可分而亦不可強同
於其不可分不可同二則

名世之器善而藏之蓋不可勝用矣予讀
景行詩輒不能已於言故書所見識諸
豪末以盡切恩之義云泰定三年
集丙寅三月甲子晉寧張肴祥手

莫景行詩引

京行早逸予遊其天資明敏為學之進勢
翩若鷹隼之習泉心之達即浸澄不可禦
喜為詩氣實而思銳一字一句必研煉
不為年詩已成編予嘗斷取律詩自唐以前
不論上之為李杜韋柳下之為姚賈許劉不
專一體而多成一體以傳於前後世惟
才力不至圓有高下大小之殊若乎不敢
多可以二言本論於往體張來體馳六
之以藝為馳張弛之宜則為公言為射夫
富豈嚴率規率的而發為乎公言為
之二亦其壹於的方未之多也於有古體濟乎
今體律聲有不同而律苦牙不同一於此則得久

94

Eulogies on Southern City's Past

— by —

Naixian

— of —

the Yuan Dynasty

Hand Scroll, regular-running script

Ink on paper

Height 23.5 cm Width 156.6 cm

Qing court collection

Naixian (1309–after 1364) was a Qarluq from the Western Regions (descended from the Tiele peoples who lived west of the Altai Mountains). On their migration to the east, the tribe settled first in Nanyang, Henan, and then in Ningbo, Zhejiang. Rising as high as Junior Compiler of the Hanlin Academy in rank, Naixian was noted for his literature.

Dated the eighth month in the 11th year of the Zhizheng reign (1351), the text consists of 16 pentasyllabic verses composed when the calligrapher was visiting the Southern City of Dadu (present-day Beijing) with friends. The themes are inspired by sights such as temples, pavilions, and gardens in and around the city. The calligraphy begins with a self-composed preface listing out the companions for the visit.

Vigorous in rendition and sparse in structuring, the neat and pretty calligraphy is strewn with vestiges of masters such as Zhao Mengfu, Zhang Yu, and Ni Zan.

Collector seals: *Yiyuan cangzhen, Xueye, Jiaozhongtang cang, Shidao, Wang Yuji, Furong Shanfang,* and seals of the Qing emperors Qianlong, Jiaqing, and Xuantong.

Literature: *Shiqu Catalogue of Imperial Collection of Painting* and *Calligraphy* and *Model-calligraphies of the Hall of Three Rarities.*

南城詠古

至正十一季龍八月既望太史宇文公太
常危公偕蒦人梁虞士九思臨川黃君毅
士四卿道士王虛齋新進士朱夢炎与余
凡七人聯轡出遊燕城覽故宮之遺蹟凡其
城中塔廟樓觀臺榭園亭莫不歷個
瞻眺拭其殘碑斷柱為之二讀其廢
興而論之余七人者呂為人生出處聚散
不可常也解后一日之樂有足惜者豈
獸感歎既陳蹟而已哉各賦詩一有六首以記
其事庶来者有所徵焉河朔外史廻賢
易之

黃金臺

落日燕城下高臺草蔚秋千金何足惜一
士固難來滄海誰青眼空山畫白頭還
憐易河水今古只東流

臺在大悲閣東南
院臺坊内

憫忠閣

高閣秋天迴金仙寶路齋青山排闥現紫
氣隔城迷朱栱浮雲溫琱檐落照低回懷
百戰士惆悵立層梯

唐太宗憫征遼士

臺殿青真外團海月凉陰廣
秉燭燒霓裳銅雀晨霞眩金盤夕露
瀼人不復迈慈灾海生桑
即金之望月臺

長春宮

嬴驂彌秋日迢遞謁琳宮松子花亂落豁
流板閹通樓臺非下土環珮憶高風草昧
媾難日神仙第一功

城南天尺五祇對孤園甲第王侯玄精
藍帝輝尊老儈浮塔影稚子斷松根
何日天台路相後一問源

竹林寺

龍頭觀

儂館紅塵外龍頭浮借看洞雲氣溫
近席雨聲寒碧畫凝螺黛香迺遍廟
檀牙鐵認題字猶是建隆刊

廢苑驚聲畫荒臺燕麥生韶葉如逝
水粉黛憶傾城野菊金鈿小秋潭玉鏡清
誰憐舊時月曾向日邊明

妝臺

雙塔

安史開元日千金構塔基尊妄福天
道自妄私寶鐸遊絲胃銅輪碧蘇滋
傍騒遺蹟含憤立多時

西葉潭

秋水清無底凉風起綠波錦帆非昨夢玉
色魚郎把釣多磯

The Ming Dynasty

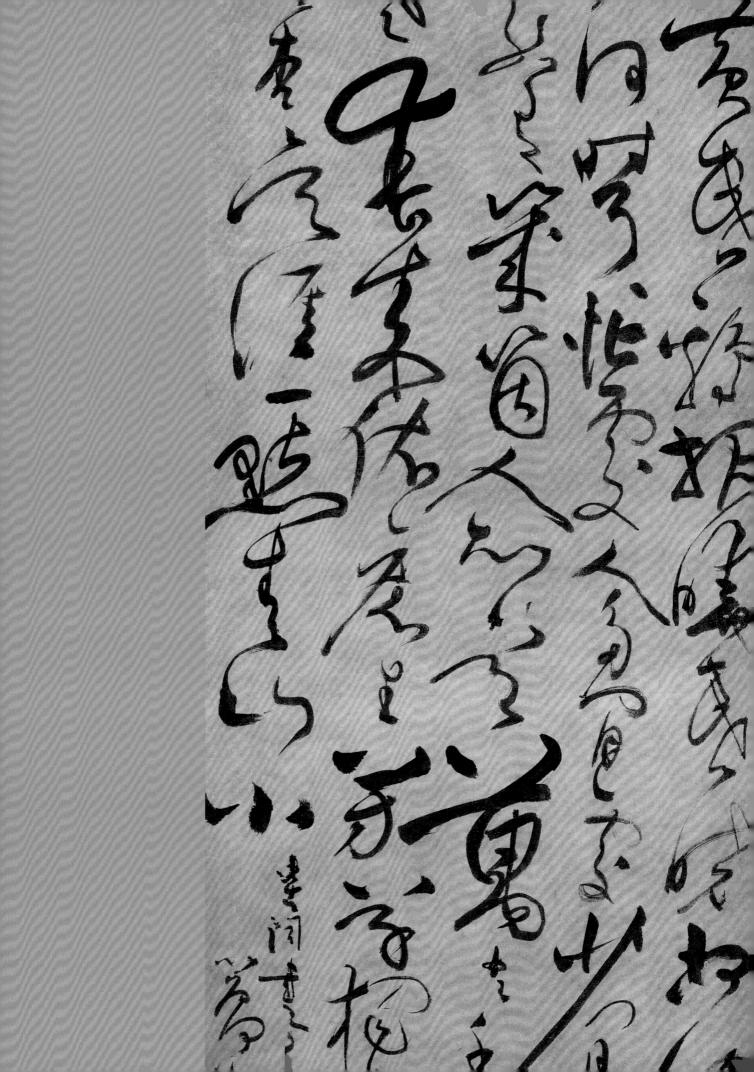

95

Disquisition on the Progress of Learning

by

Song Ke

of

the Ming Dynasty

Hand Scroll, cursive script

Ink on paper

Height 31.3 cm Width 467 cm

Song Ke (1327–1387), a native of Changzhou (present-day Suzhou, Jiangsu), took to swordsmanship and horsemanship when young and aspired to achieve greatness with the art of war that he had acquired in his prime. Yet he refused to work for Zhang Shicheng, the rebel leader who declared himself emperor in the Wu area. From then on, he withdrew from social life and dedicated himself to calligraphy, eventually soaring in fame as an accomplished calligrapher. Early in the Hongwu reign (1368–1398) of the Ming Dynasty, he was appointed as Court Calligrapher and Associate Administrator of Fengxiang Prefecture. Before long, he resigned and returned to his hometown, pleasuring himself with painting and poetic exchanges with celebrated literati such as Yang Weizhen and Ni Zan.

The calligraphy owes its text to the classic masterpiece *Disquisition on the Progress of Learning* (*Jinxue Jie*) written by Han Yu, a renowned litterateur of the Tang Dynasty, to vent his frustrations in career. Signed and impressed with two calligrapher seals (*Dongwu sheng* and *Song Zhongwen*), the work is dated "the 28th day of the seventh month in the *jichou* year during the Zhizheng reign (1349)."

Laced with features of the draft-cursive, the modern cursive script in the present specimen is carefully composed to allow diverse and diffusive brushwork.

Collector seals: *Zhiqiong daoren zhenshang, Shiyou jianding shuhua zhi yin, Yifeng Jingshe Chen Weiquan jianshang zhang, Chen shi Bailiaozhai cang,* and *Luo Zhenyu yin.*

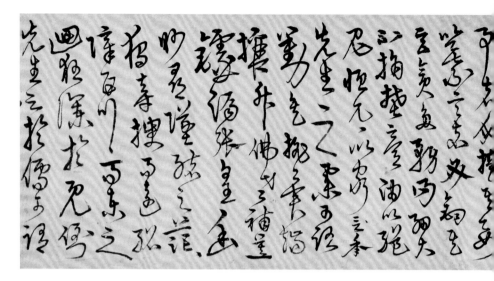

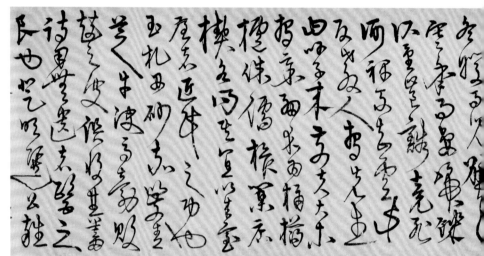

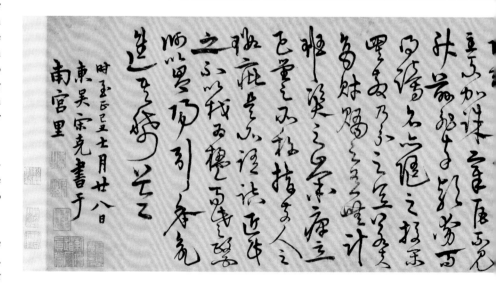

96

Ci-poem to the Tune of Breezes in Pines

by

Song Guang

of

the Ming Dynasty

Hanging Scroll, cursive script

Ink on paper

Height 101.7 cm Width 33.7 cm

Song Guang (dates unknown), a native of Nanyang, Henan, was Associate Administrator of Mianyang and excelled in painting. As for calligraphy, he excelled in the running and cursive scripts, which were derived from Zhang Xu and Monk Huaisu. He ranks with Song Ke and Song Sui as the Three Songs.

Intended as a gift to Lu Dexiu, the calligraphy owes its text to the *ci*-poem *To Ke Jiusi to the Tune of Breezes in Pines* (*Feng ru Song: Ji Ke Jiusi*) composed by Yu Ji of the Yuan. Next to the poem is an inscription by the calligrapher that is signed and impressed with two calligrapher seals (*Song Guang zhi yin* and *Nanyang shijia*). The date given in the inscription is "the 13th year of the Hongwu reign (1380)."

The finesse and the litheness are quintessential of Song Guang's cursive script.

Collector seals: *Xu Xuexuan yin* and *Chen jizi Jide pingsheng zhenshang*.

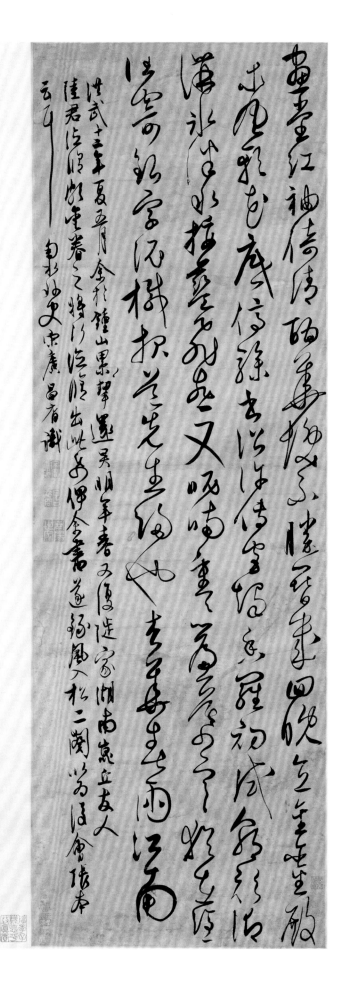

Reply Regarding Song Lian's Additional Anthology

— by —

Song Sui

— of —

the Ming Dynasty

Cursive script

Ink on paper

Height 26.7 cm Width 52.8 cm

Song Sui (1344–1380), a native of Pujiang, Zhejiang, was the second son of Song Lian, who was a high-ranking official in the early Ming. In the ninth year of the Hongwu reign (1376), he was appointed as Secretariat Drafter but was executed in the 13th year of the same reign (1380) for his involvement with the Hu Weiyong case. Besides inheriting the family's legacy, he learned calligraphy under Wei Su and was exposed to the calligraphic preferences of the Yuan Dynasty. Excelling in the regular, running, cursive, and seal scripts, he has been known collectively with Song Ke and Song Guang as the Three Songs.

In this letter to a friend, Song mentions *Song Lian's Additional Anthology* (*Qianxi Waiji*), the rubbing *Cursing the Chu* (*Zuchuwen*) and the scenic Five Falls in Zhuji, Zhejiang, shedding light on episodes in the calligrapher's life.

Crisp and sinuous, the calligraphy evokes Kangli Naonao and is even more superior in terms of liberality.

Collector seals: *Xiang Zijing jia zhencang*, *Wang Wanglin yin*, and *Bian Lingzhi jianding*.

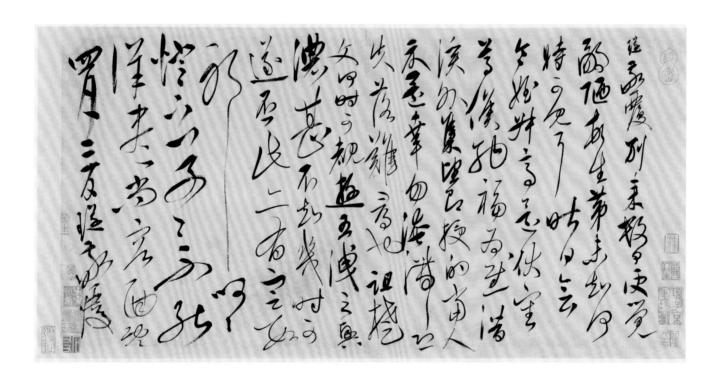

Four Admonitions
— by —
Shen Du
— of —
the Ming Dynasty

Leaves, regular script

Ink on paper

Each: Height 29 cm Width 14.5 cm
Qing court collection

Shen Du (1357–1434), a native of Huating (present-day Songjiang, Shanghai), was promoted to Archivist of the Hanlin Academy by the Ming emperor Chengzu (r. 1403–1424). Accomplished in the seal, clerical, regular, and running scripts, he was a favourite calligrapher of the Emperor, who lauded him as the Wang Xizhi of the Ming Dynasty. Alternatively, he was known together with his younger brother Shen Can, also an accomplished calligrapher, as the Elder and Younger Academicians, both being exponents of the Chancellery Style of the period. The Chancellery Style was prevalent among secretariat drafters at the Ming court, who were required to ensure solemnity, placidity, and discipline in their calligraphy, leading to their espousal of the style of Yu Shinan.

Impressed with a signature seal (*Shen Du siyin*) at the end of each paragraph, the calligraphy owes its text to the *Four Admonitions* (*Sizhen*) written by the great Confucian scholar Cheng Yi of the Song. Governing people's behavior in seeing, listening, speaking, and moving, the admonitions set out norms that are developed from orthodox Confucianism. Admonitions and inscriptions account for a sizeable proportion in the calligrapher's surviving works, which is possibly directly attributable to his formal and upright style.

Exemplary of the Chancellery Style of the early Ming and exhibiting allegiance to the Tang masters, the regular script on grid paper is assured and hefty and yet dexterous and unobtrusive at the same time.

Collector seals: seals of the Qing emperors Qianlong, Jiaqing, and Xuantong, totaling eight in number.

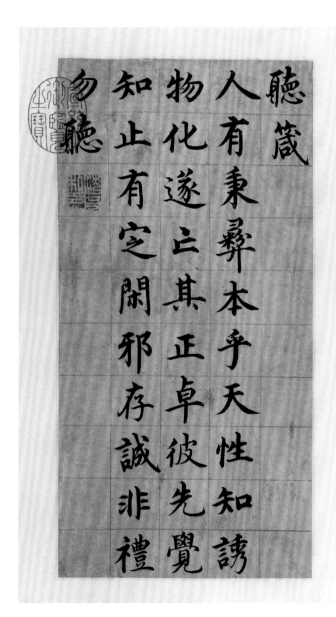
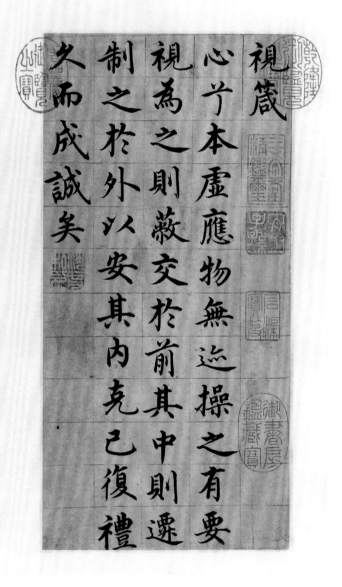

99

Poem on the Seven-star Crags

— by —
Xie Jin
— of —
the Ming Dynasty

Leaf, cursive script

Ink on paper

Height 23.3 cm Width 61.3 cm
Qing court collection

Xie Jin (1369–1415), a native of Jishui, Jiangxi, was qualified as *jinshi* in the 21st year of the Hongwu reign (1388) to become Hanlin Bachelor. His service was often fondly required by Emperor Taizu. Early in the Yongle reign (1403–1424), he was posted to the Hall of Cultural Origins (Wenyuange) and rose through the ranks to become Hanlin Academician, Grand Secretary of the Right Secretariat of the Heir Apparent, and Grand Adjutant. In the fifth year of the Yongle reign (1407), he was demoted first as Assistant Administration Commissioner of Guangxi and then to an outpost in Jiaozhi (present-day Vietnam). In the eighth year of the same reign (1410), he was framed by Prince of Han, or Zhu Gaoxu, and was thrown into prison, where he eventually died. The adept in the wild cursive script wrote his calligraphy without the slightest reservation.

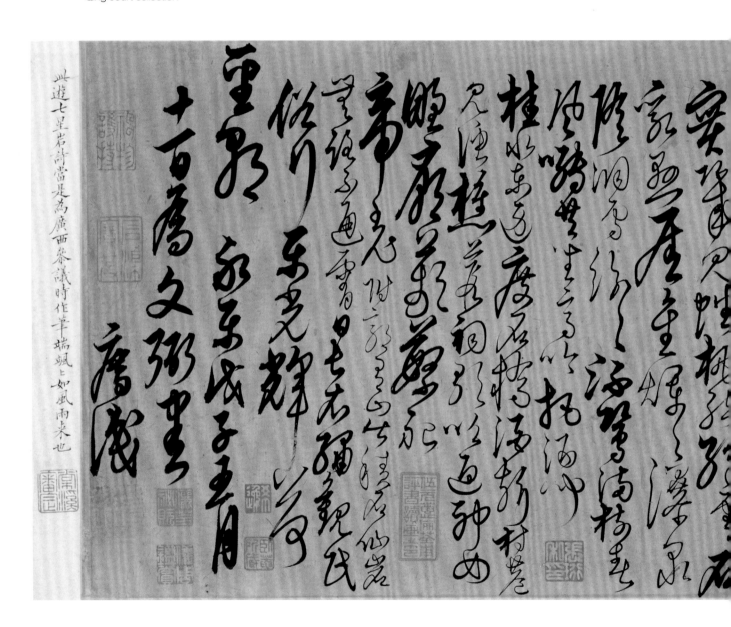

Included in *Collected Works of Xie Jin* (*Wenyi Ji*), the poem calligraphed was composed after a visit to the Seven-star Crags during the calligrapher's tenure in Guangxi. It is impressed with a signature seal (*Xie Jin*) and is dated "the 11th day of the fifth month in the *wuzi* year during the Yongle reign (1408)."

Fusing together the essences of Monk Huaisu of the Tang and Xianyu Shu and Kangli Naonao of the Yuan, the calligraphy is uniquely sublime with its plump forms and brisk movement.

Collector seals: *Xiuning Zhu Zhichi zhencang tushu, Yizhou jianshang, Qianlong yulan zhi bao, Gu Song zhi yin, Pan Hou, Wu Yuanhui Liquan fu pingshu duhua zhi yin*, and *Zhang Heng siyin*.

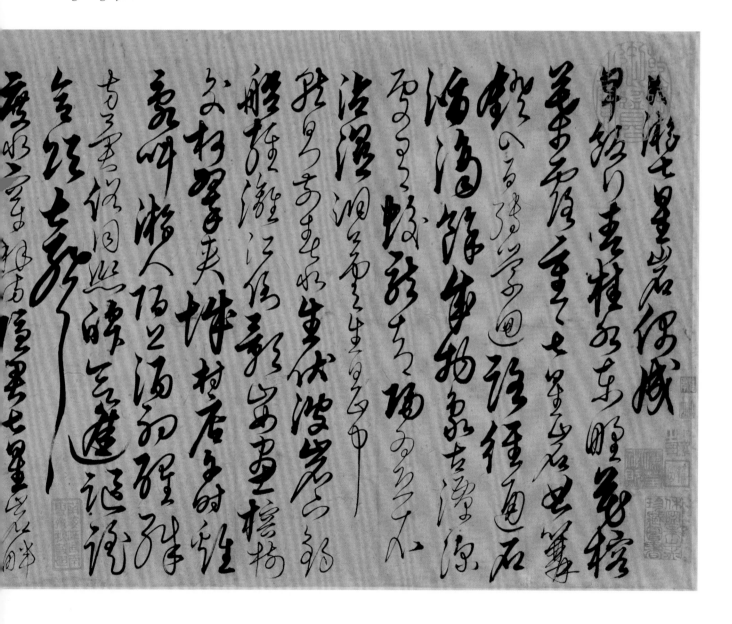

100

Inscription to Painting of the Gongzhong Pagoda with Panegyric

— by —

Yu Qian

— of —

the Ming Dynasty

Leaf, regular script

Ink on paper

Height 29 cm Width 61 cm

Yu Qian (1398–1457), a native of Qiantang (present-day Hangzhou, Zhejiang), was qualified as *jinshi* in the 19th year of the Yongle reign (1412). Early in the Xuande reign (1426–1435), he began as Censor and rose through the office of Right Vice Minister of War to become Grand Coordinator of Henan and Shanxi to the acclaim of the local inhabitants. In the wake of the Tumu Crisis in the 14th year of the Zhengtong reign (1449), he was promoted as Bingbu Shangshu and led his troops in a victorious defence of the capital. When Emperor Yingzong was reinstated following the "gate ramming incident," Yu was executed on a fabricated charge of treason.

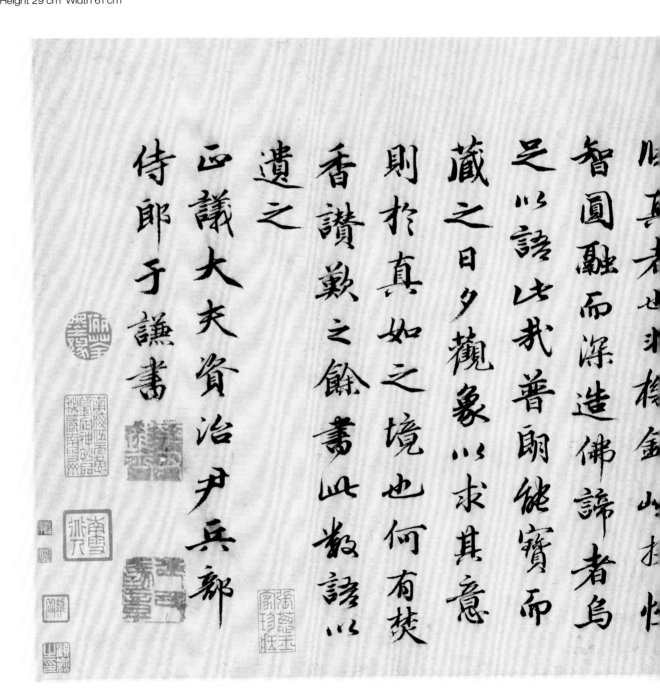

Impressed with three calligrapher seals (*xinchou jinshi*, *Shaosima zhang*, and *Jie'an*), the inscription was written for a painting of the Gongzhong Pagoda with panegyric left behind by the late Monk Guzhuojun of the Xizhao Temple in Beijing. On the strength of the post titles given, it is believed to be calligraphed in the second half of the Zhengtong reign (1436–1449) when the calligrapher was in his 40s.

Evocative of Zhao Mengfu's late style, the calligraphy is uniform, well balanced, dignified, and elegant.

Collector seals: *Yizhou jianshang*, *Wu Yuanhui Liquan fu pingshu duhua zhi yin*, *Zhang Congyu jia zhencang*, and *Pan Hou*.

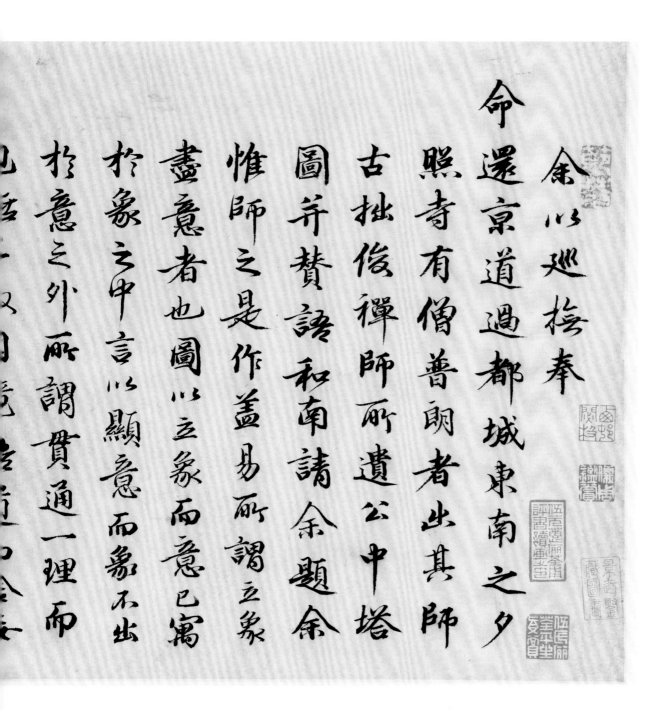

101

Letter to Han Yong

by

Xu Youzhen

of

the Ming Dynasty

Running script

Ink on paper

Height 26.6 cm Width 40.1 cm

Xu Youzhen (1407–1472), originally named Cheng, was a native of Wuxian (present-day Suzhou, Jiangsu). He was qualified as *jinshi* in the eighth year of the Xuande reign (1433) and was appointed Junior Compiler. But there was little advancement for years afterwards. During the Jingtai reign (1450–1456), he changed his name to Youzhen. In recognition of his contribution to the reinstatement of Emperor Yingzong, he was ennobled as earl and made Grand Academician of the Hall of Royal Canopy (Huagaidian). In posterity, however, he has been blamed for the death of the righteous courtier Yu Qian. Frustrated by repeated demotions later on in his life, he sought refuge in nature. During his lifetime, he was celebrated for being an adept in the running-cursive script.

This letter with two heptasyllabic quatrains is addressed to Han Yong, who was Left Vice Censor-in-chief and Military Superintendent of Liangguang (Guangdong and Guangxi) early in the Chenghua reign (1465–1487). Written sometime during this period, the letter references the addressee's suppression of the Yao, Tong, and Miao tribes, making it an important historical document. The calligraphy is signed and impressed with a calligrapher seal (*Donghai Xu Yuanyu fu*).

Dating from the calligrapher's late years, the calligraphy is a departure from the neat Chancellery Style that usually permeates his works. Untrammeled and vigorous, the distinctive style defies all established norms. His influences are also seen in the works of his grandson Zhu Yunming.

Collector seals: *Zhi'antang tushu yin*, *Gu Song*, *Weiyue*, *Erxie*, *Xizeng*, and *Anshan daoren*.

Literature: *Spectacles Viewed in a Lifetime*.

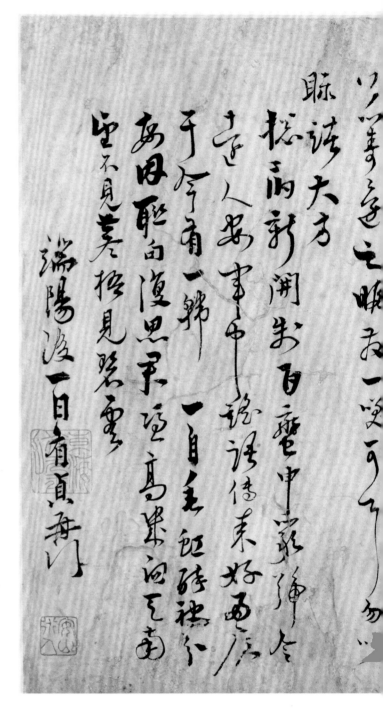

肅頓再拜

知養都憲心奕幕府　伏自抱陵別

後更復何序遷易　眷念之懷役此

當不罢也軍事

未隙洞之高自之涼情誼之

厚申以不盡茅言　蹇拙有弗弘稱

所與重辱拄玩之靳增愧之

感而已俾盍宣玉雪未隙以

奏享宰楫之見施没又略悚不負

圍象信用之重言雨撝郷里文乳祝

益之玉惟共巳重是美言之不勝理

遠之私郤乞葶附之絆畀丸

以申一厚美而還不以表生毀快識哉

102

Ci-poem to the Tune of Butterflies Lingering over Flowers

— by —

Zhang Bi

— of —

the Ming Dynasty

Hanging Scroll, cursive script

Ink on paper
Height 148 cm Width 59.4 cm

Zhang Bi (1425–1487), a native of Huating (present-day Songjiang, Shanghai), was qualified as *jinshi* in the second year of the Chenghua reign (1466) and served the court as Secretary in the Ministry of War, Vice Director in the Ministry of War, and Prefect of Nan'an (present-day Dayu, Jiangxi) at various times. The distinguished poet has been noted for his unrestrained and robust poetry. The same can be said of his cursive script, which is derived from Monk Huaisu. He could, for instance, easily produce dozens of sheets of calligraphy at lightning speed under the influence of wine. His cursive script is so wild and mesmerizing that the calligrapher has been said to be the reincarnation of Zhang Xu, the Sage of the Cursive Script.

Impressed with a signature seal (*Zhang Bi*), the calligraphy owes its text to a *ci*-poem to the tune of *Butterflies Lingering over Flowers* (*Die Lian Hua*) composed by Wang Shen of the Northern Song, only that certain words have been swapped between the two stanzas as professed in the closing inscription.

Zhang Bi distinguishes himself with vigour and caprice in his serpentine calligraphy. In the present specimen, where a tempest and rainstorm seem to be raging, the brush is swiftly manoeuvered with variation in lifting and pressing to attain diversity.

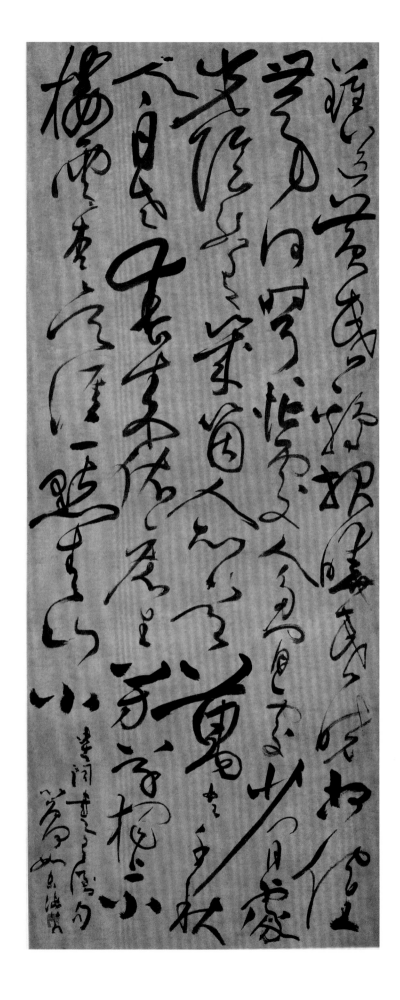

103

On the Big-headed Shrimp

by

Chen Xianzhang

of

the Ming Dynasty

Hanging Scroll, cursive script

Ink on paper

Height 158.5 cm Width 69.9 cm

Chen Xianzhang (1428–1500), a native of Xinhui (in present-day Jiangmen, Guangdong), was appointed as Examining Editor of the Hanlin Academy during the Chenghua reign (1465–1487). Even in his lifetime, he was widely respected as a Confucian scholar and was honoured during the Wanli reign (1573–1620) with the provision of a secondary shrine at the Temple of Confucius. The litterateur's calligraphy is informed by Ouyang Xun, Huang Tingjian, and Mi Fu. Living in an inaccessible mountain village, he made do with a brush made of rushes bound together whenever he ran out of brushes. The calligraphy thus written is so unique and so readily embraced that it has been called the Maolong Style after the improvised brush, which has been named "maolong," or "rush dragon."

The text is an essay written by the calligrapher to advise against arrogance, self-contempt, flamboyance, and extravagance with reference to the ills described as "big-headed shrimps" in local slang. Impressed with a signature seal (Shizhai), the calligraphy is signed and dated "the *wushen* year of the Hongzhi reign (1488)."

Written with a *maolong*-brush that tends to split at the tip, the calligraphy is littered with flying-whites. Presses are particularly pronounced and there is a stark contrast in the thickness of the strokes. Unhalted and yet unconnected between characters, the swift rendering contributes to an impression that is serene despite the motion and skilled despite the lack of adornment.

104

Letter to Chen Qiong

— by —

Li Yingzhen

— of —

the Ming Dynasty

Running script

Ink on paper

Height 27 cm Width 44 cm

Li Yingzhen (1431–1493), a native of Changzhou (present-day Suzhou, Jiangsu), was Zhu Yunming's father-in-law. Qualified as *juren* in the fourth year of the Jingtai reign (1453), he was admitted to the imperial university and appointed as Secretariat Drafter, subsequently rising to the rank of Vice Minister of the Court of the Imperial Study in Nanjing. Passionate about antiquities and insatiable for knowledge, he was a respectable calligrapher in the seal and regular scripts and imbued his regular, running, cursive, and clerical scripts with his upright and unsullied character.

The letter was written in the 14th year of the Chenghua reign (1478) when the addressee Chen Qiong had just been qualified as *jinshi*. Chen Qiong (1440–1506), a native of Changzhou (present-day Suzhou, Jiangsu), was Hanlin Bachelor, Supervising Secretary, and Left Vice Censor-in-chief of Nanjing. He was knowledgeable and accomplished in poetry.

Li wrote in the Chancellery Style in his early years and later switched to Ouyang Xun and Yan Zhenqing to seek inspiration from the Jin-Tang tradition. His advocacy for returning to the past for originality was highly commended by members of the Wu School such as Shen Zhou and Wen Zhengming, who regarded him as peerless throughout the dynasty. Indeed, future hallmarks of the Wu calligraphers are plainly discernible in the present specimen.

Collector seals: *Boshan suo cang chidu*, *Yunting zhenshang*, and *Lanling Wen Zi shoucang*.

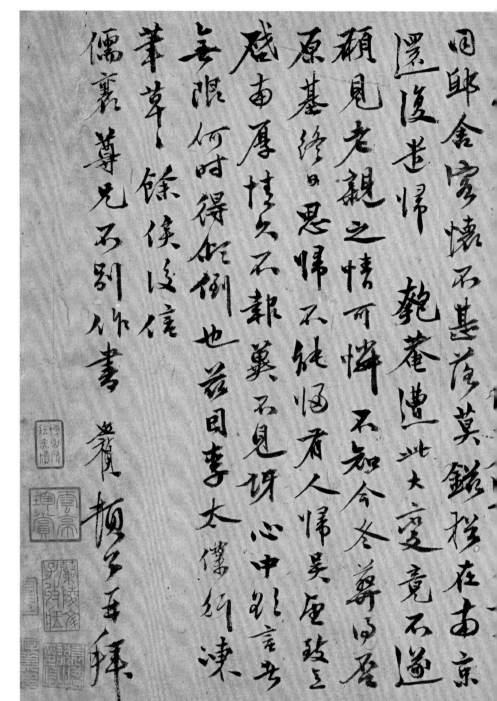

此李貞伯致陳玉汝書 貞伯以孝廉起家官至太僕少卿 玉汝名璿與太僕
同屬長洲人於成化戊戌成進士後官至副都扎稱進士當是初第三年
此紙為成化十四年所作

應賀 稽首奉書

玉汝進士契兄足下 別後承 記憶勤

懇萬見之於原基信中感妮何可言

但在此無好心情至今未能作答雖在

慶厚計不言見怡矣鄭家之事本自

得已淺心狹量輒与之校並不料其遠

生不肖之心怪隨此子今點豈可素何僕

之心力無可施焉只得佳之為何以況在家

病程未瘉又不能来儀之心事可知不知

何時撥歷綸第看有幸早晚承教想非

251

105

Friendship in Poverty

— by —

Zhang Jun

— of —

the Ming Dynasty

Hanging Scroll, cursive script

Ink on paper

Height 153.4 cm Width 62.7 cm

Zhang Jun (dates unknown), a native of Huating (present-day Songjiang, Shanghai), was qualified as *juren* in the fourth year of the Jingtai reign (1453), appointed as Secretariat Drafter in the Hall of Cultural Splendor (Wenhuadian) early in the Chenghua reign (1465–1487), and retired as Minister of Rites. Mentioned in the same breath with Zhang Bi as the Two Zhangs, he was proficient in the running, cursive, clerical, and seal scripts. Despite his indebtedness to Monk Huaisu, his cursive script is distinctive in style.

As revealed in the closing inscription, the calligraphy owes its text to the *ci*-poem *Friendship in Poverty* (*Pinjiao Xing*) composed by Du Fu of the Tang Dynasty to sing praises to friends who remain to be true for richer or poorer. It is signed and impressed with two calligrapher seals (*jinzi qinghua* and *tianguan dafu*).

The calligraphy is sprightly and spontaneous. Although execution is swift, the size and inclination of the characters as well as the length of the strokes are varied so that the characters and the columns interact with each other to bring about an optimum distribution of space, consumating in a coherent and agreeable composition.

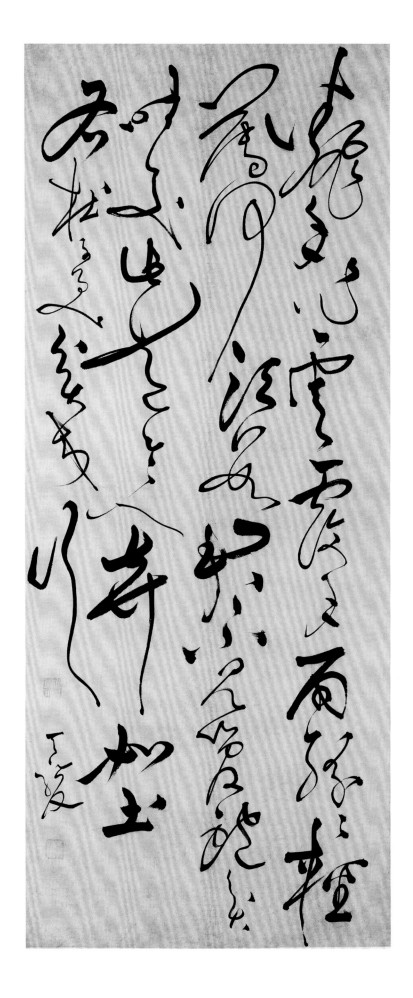

106

Excerpt from Zhang Zai's Eastern Inscription

— by —

Jiang Ligang

— of —

the Ming Dynasty

Album of 8 leaves with 15 pages,
regular script

Ink on paper

Each page: Height 28.7 cm Width 14.8 cm
Qing court collection

Jiang Ligang (dates unknown), a native of Yongjia (in present-day Zhejiang), was made Secretariat Drafter during the Tianshun reign (1457–1464). Literally and calligraphically gifted, he arrived at his own identity through assimilating the merits of Huang Gongwang. More often than not, he was the calligrapher for plaques in the imperial palace and became the standard-bearer for his colleagues in the Central Drafting Office. Eventually, his style acquired a large following, earning itself the name of the Jiang Style.

Impressed with a signature seal (*Yanxian*), the calligraphy owes its text to the essay "Eastern Inscription" (Dongming) in *Rectifying the Ignorant* (*Zhengmeng*), a seminal work written by the Neo-confucian philosopher Zhang Zai of the Northern Song. The essay propounds the idea that the *qi*-energy is the origin of everything.

The legacy of Liu Gongquan is evident in the squarish form, tight structure, and intense ink. Certain strokes, however, do suggest a kind of monotony residual of the Chancellery Style.

The colophon paper is inscribed by Donglu of the Ming.

Collector seals: *Qianlong yulan zhi bao, Jiaqing yulan zhi bao, Shiqu Baoji,* and *Yushufang jiancang bao.*

Literature: *Shiqu Catalogue of Imperial Collection of Painting and Calligraphy.*

東銘

戲言出於思也戲動作於謀也發於聲見乎四支謂非己心不明也欲人

無己疑不
能也過言

非心也過
動非誠也

他人己從
誣人也或

者謂出於
心者歸咎

失扵聲繆
迷其四體

謂己當然
自誣也欲

為己戲失
扵思者自

誣為己誠
不知哉其

出汝者反
歸咎其不
馬
不知孰甚
出汝者長
傲且遂非

駙馬崔俶屏務與姜先生友善得親筆大小書若干
帖苑勁攻習竟不趍得其要後偵余　西直同侍
皇上公餘之暇出此帖邀余視之余備道其美隨索余書
覽而賑弦謂其必獲真傳妙訣不然何太初似之余曉
以讀書作文肓傅寫無傳若欲彩相似何有而似其兩
以和似者吾不可得而加山谷亦世人要識蘭亭面含揆凡
骨彖全丹晃也嘉靖乙卯立秋次日記東盧

107

Epitaph for Lady Han

— by —

Wu Kuan

— of —

the Ming Dynasty

Album of 5 ½ leaves, regular script

Ink on paper

Each leaf: Height 27.1 cm Width 28.9 cm

Qing court collection

Wu Kuan (1435–1504), a native of Changzhou (present-day Suzhou, Jiangsu), was qualified as *zhuangyuan*, or the top *jinshi*, in the eighth year of the Chenghua reign (1472) and appointed as Senior Compiler of the Hanlin Academy. Promoted to Right Vice Minister of Personnel during the Hongzhi reign (1488–1505), he subsequently rose to the rank of Minister of Rites. His poetry is said to be mellow and his calligraphy reminiscent of Su Shi for its unpretentious charm and substantialness although the openness is his own.

From the epitaph, it is learned that Lady Han's husband was Wu Kuan's townsman and a high-ranking official occupying such office as Right Censor-in-chief of the Censorate. Twenty years after his death in the 14th year of the Chenghua reign (1478), he was joined by his wife when Wu was about 65. Impressed with three seals (*Yuanbo*, *Yanling*, and *Gutaishi shi*), the calligraphy is signed with a list of the calligrapher's offices including Grand Master for Excellent Counsel, Right Vice Minister of Personnel, and Historiographer.

Bearing hints of the clerical script, the calligraphy is compact in structure, squat in form, and solemn in ethos.

Collector seals: *Qianlong yulan zhi bao*, *Jiaqing yulan zhi bao*, *Shiqu Baoji*, and *Yushufang jiancang bao*.

Literature: *Shiqu Catalogue of Imperial Collection of Painting and Calligraphy*.

韓夫人金氏墓誌銘

都察院右都御史韓公以成化
戊戌卒于家

朝廷嘗遣官治墳于吳縣雅宜
山之原後二十年其配夫人金
氏沒其子斅其疏告衰

天子識公生時多著勞績而夫人
實公配也將下禮工二部議蓋
大臣妻受封而卒者例

賜祭而治墳後凥合葬者近例

顧特令其家啟壙而有司無預
也至是工部以為非邱典意遂
從之斅歸將其先文圖葬事
來乞予銘惟都憲公為
國朝名臣其擇配必得其人之
稱者當其未貴時其先府君以
冨民徙居京師生公初娶夫人
王氏早亡遺一子即文繼娶得
夫人夫人之先世為宛平人有
曰大和者豪俠人也娶魯氏生
夫人其弟某方為工部員外郎
与公有仕官之好知夫人賢而

可配始娶之未幾公以監察御
史出巡江西夫人謂公曰長洲
故鄉也無第宅可居他日公何
所歸于公以為然明年還過吳
中始卜居東城下而公竟歸老
于此公歷仕中外至長憲臺功
業赫然夫人亦後受封可謂富
貴矣然夫人亦自如未嘗有於喜
色中間公以直道忤人三被降
黜夫人亦不憂且時慰公曰公
心無愧造物者豈令公終在人
下耶己而省驗夫人居家則奉

舅姑以孝後行事公以順公
性爽邁少暇其酒饌与賓佐
樂歡夫人治具畢獨以廳澹自
奉平居衣服亦無紈綺之麗人
不知其為命婦也及公致仕後
儉德益基迨至寡居尤嚴於治
家僮奴箠帖之無敢縱者當病
延子婦請醫禱輒戒以有命則
使瞽篋視之凡檢具無弗備者
可謂明達矣盖年六十九而卒
其生宣德戊申八月二日卒于
弘治丙辰閏三月二十六日葬

以戊午

月　日子男三

文光祿寺典簿娶吉安知府張

其女數工部司務娶浙江布政

司參議寀某女敬側室王氏出

娶安吉主簿朱某女女一適蘇

州衛指揮使謝瑛夫人出也孫

男三勳勤勳勳府學生女三曾

孫男四女三銘曰

憲臺蘇二維韓公江嶺植立功

尤崇夫人来嬪婉德容受

恩錫彌榮則同閨闈內助嗟成

功偕歸于兹全厥躬

帝命守臣爰啓封雅宜山氣俄齎

慈女婦戟克榮始終子孫来視

當無窮　嘉議大夫吏部右

侍郎前史官里人吳寬撰

261

108

Poem on Temple of Sweet Dew

by

Li Dongyang

of

the Ming Dynasty

Hanging Scroll, cursive script

Ink on paper

Height 111.5 cm Width 35.5 cm

Li Dongyang (1447–1516), a native of Chaling (in present-day Henan), was qualified as *jinshi* in the eighth year of the Tianshun reign (1464) and was appointed as Junior Compiler of the Hanlin Academy. The positions he held in his career as an official include Academician Expositor-in-waiting, Grand Guardian of the Heir Apparent, Minister of Personnel, and Grand Academician of the Hall of Royal Canopy. Much favoured by the emperors, he rose to prominence during the Hongzhi (1488–1505) and Zhengde (1506–1521) reigns. His stature at court led to the prevalence of his poetry, propelling him to the forefront of the Chaling School. As for calligraphy, he was a master of the seal, clerical, running, and cursive scripts.

Impressed with a signature seal (*Binzhi*), the text is a self-composed heptasyllabic octave entitled and signed in the calligrapher's closing inscription.

Sometimes dense and sometimes sparse, the elegant calligraphy is written in a continuous flow very much in the shadow of Huang Tingjian.

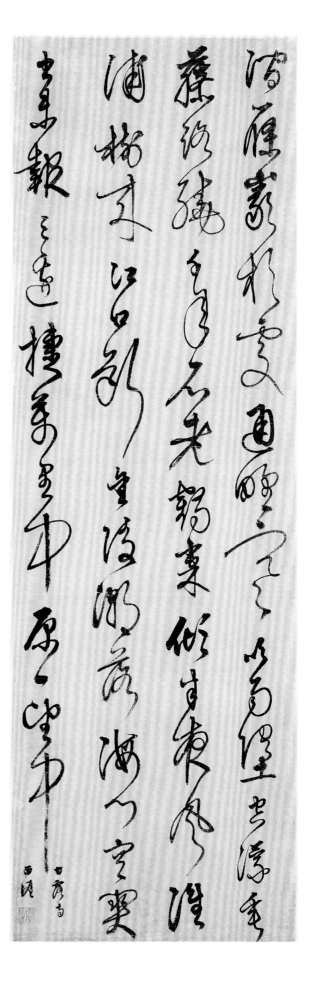

109

Self-composed Poems

— by —

Zhu Yunming

— of —

the Ming Dynasty

Hand Scroll, cursive script

Ink on paper

Height 30.7 cm Width 794 cm

Zhu Yunming (1460–1526), a native of Changzhou (present-day Suzhou, Jiangsu), was qualified as *juren* in the fifth year of the Hongzhi reign (1492) and appointed as District Magistrate of Xingning County. He retired soon after assuming office as Assistant Prefect of Yingtianfu (present-day Nanjing). His genius in poetry has brought him on a par with Xu Zhenqing, Tang Yin, and Wen Zhengming as the Four Talents of Wuzhong, whereas his proficiency in the regular, running, and cursive scripts ranks him with Wen Zhengming and Wang Chong as the Three Masters of Wumen. He was particularly acclaimed for his untrammeled and unpretentious cursive script, which was considered by his contemporaries to rival that of Zhao Mengfu.

With themes such as Lake Tai, Baoshan, and Tiger Hill, the 11 poems that make up the scroll are all inspired by scenic spots in and around Suzhou. Impressed with two signature seals (*Zhu shi Yunming* and *Wujun Zhu sheng*), the calligraphy is signed and dated "the *gengchen* year of the Zhengde reign (1520)."

Swerving from his earlier preferences, Zhu wrote prolifically in the cursive script with features appropriated from Huang Tingjian's in his late years. In the present specimen, untethered diversity is the main disposition. Although the strokes tend to spread out in all directions, the characters are seldom connected since the calligrapher is writing his cursive script as if it were the regular script in the same way that past masters did.

110

A Self-composed Tetrasyllabic Poem

by

Xu Lin

of

the Ming Dynasty

Hand Scroll, seal script

Ink on paper

Height 29.5 cm Width 628 cm

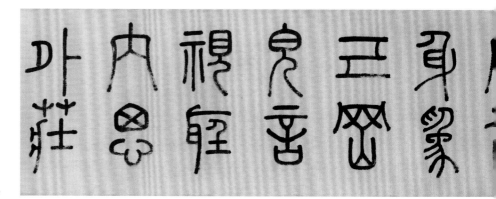

Xu Lin (1462–1538) was a native of Changzhou (present-day Suzhou, Jiangsu) resident in Jinling. Born into a well-to-do family, the magnanimous man of many talents was highly regarded by his bosom friend Wen Zhengming. As far as calligraphy is concerned, his regular script is evocative of Ouyang Xun and Yan Zhenqing, and his large script is almost indistinguishable from that of Zhu Xi. He succeeded in immuning himself from the vogue of the time after turning to Zhao Mengfu for inspiration later on. Exalted as the Sage of the Seal Script, he began writing his seal script with robustness which gradually gave way to simplicity in his late years.

The text comes from a tetrasyllabic poem in the old style entitled *Eulogy to Antiquities* (*Ti Qiwu Zan*) composed by the calligrapher. It is signed and impressed with two signature seals (*Xu shi Ziren* and *Jiufeng Daoren*).

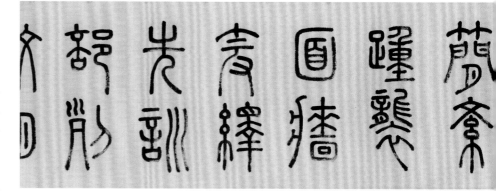

A sublime manifestation of the uniformity of the seal script, the calligraphy is consistently charming from beginning to end. Known in history as the "Jade Chopsticks Seal Script," the style is defined by its strokes that are uniform in thickness and blunt at both ends, and also its rounded elongated character forms. The orderly and appealing brush methods originate from Li Si's *Stele of Mount Tai*.

There is a colophon by Weng Tonghe of the Qing.

只 會 蕎 縣 曰 李 尌 圓 衡
雪 昜 田 象 以 黃 公 步 卅

壽 田 成 開 州 品 來 動 外
常 用 枝 物 形 澡 漸 植 莊

觀 枕 福 白 發 棗 卦 圖 家
當 化 聖 兆 揚 裏 畫 畫 家

書 徐 吳 止 又 戟 居 欽 肜
　 霖 闕 成 文 格 家 家 形

111
Self-composed *Ci*-poems
by
Tang Yin
of
the Ming Dynasty
Hand Scroll, running script

Ink on paper

Height 23.3 cm Width 551.3 cm
Qing court collection

Tang Yin (1470–1523), a native of Wuxian (present-day Suzhou, Jiangsu), ranks among the Four Talents of Wuzhong, the others being Zhu Yunming, Xu Zhenqing, and Wen Zhengming. He was qualified as *jieyuan*, or top *juren*, in the 11th year of the Hongzhi reign (1498) but was disqualified for involvement in an examination fraud at the next level of civil examinations. From then on, he abandoned all hopes for officialdom and earned his living as a painter. Acquiring his art first from Shen Zhou and then extensively from Song and Yuan masters, the painter has been known collectively with Shen Zhou, Wen Zhengming, and Qiu Ying as the Four Masters of Wumen. He was also accomplished in calligraphy especially in the regular-running script that he borrowed from Zhao Mengfu and Li Yong.

There are a total of 24 *ci*-poems that can be divided into three groups according to the tune adopted. Impressed with two calligrapher seals (*Xueputang yin* and *Tang Ziwei tushu*), the signed calligraphy is a gift to a friend by the name of Conghan as revealed in the closing inscription. The top right is impressed with a seal (*Wuqu*).

Quintessential of the calligrapher's mid-year style, the calligraphy is meticulously structured and the brush adeptly manipulated to conjure elegance and spontaneity.

Collector seals: *Jiaqing yulan zhi bao*, *Shiqu Baoji*, *Baoji Sanbian*, *yi zisun*, *Jiaqing jianshang*, and *Sanxitang jingjian xi*.

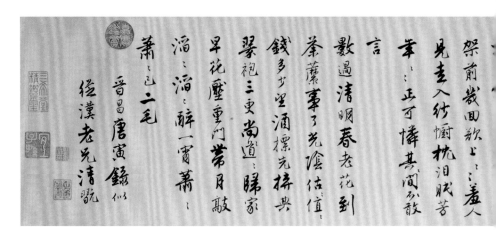

集賢賓

紅樓亞閣天行繞玉人
吹簫一曲涼州聲
中誰家砧杵相送韻丁
冬寒食杏花天易晴春人
晏眠一霎飛絮和風撲芳
菲百囀相思苦纏綿字閑
髮了黃金釧悶懨懨朝雲
暮雨魂夢繞亞山

桐花風掃
閑庭細草天色膩簾
風雨清明萬斛春愁
薰酒病偏不曾容人醒
醒殘花弄影明日是滿
枝青杏金釧冷羅袖上
泪沾紅粉
淚滴孤桃羅更頭
羅袖搵春寒對飛花泪
冷淡和人懷夢悠悠銅壺
孫浪遊光陰水深梨花
子規一庭芳草黃昏後王
殘月照粧樓靜悄悄笙

青鸞信杳魂夢斷十
洲三島春色老盡滿地

萬重行人道路佳人夢
朝霜漸濃寒衣細縫
夢刀尺尺聲相送韻丁
冬誰家砧杵鼓兩月明
寒食杏花天易晴春人
晏眠一霎飛絮和風撲芳
菲百囀相思苦纏綿字閑

常小橋黃驄滿膘天涯
何處無芳草路迢遙歸
期正早瘦損小蠻腰
山坡羊
新酒殘花迢迢寒食
清明前後羅衣冷落
腰肢覆簾樣何時有
畫頭劉髆遠撥還術
蕉芳草天涯人在危燈
樓燈遠進低頭泪

情和愁纏人沉醉月和
燈明人心地為寬家使得
心都碎骨髓情恁教人
緋細燈花燒散灰茶蘼
東水深院黃香珠泪垂
心事數蘭橋路阻春
信迢無憑邊准作誰
闌干邊飛花作誰
何曾安穩東風吹醒
梨花影軟怯身輕草
上塵只愁金錐裹來顏損

蝴蝶杏園春惜芳菲紅
途難

聲數薄情
蕉庭院新禱
明慈聽漏報更低
懺影山際如何捱到
背香燈前壁上形
新霜冷掩翠屏斜司
蓬梗金井遊子風
明月梧桐金井遊子風
遙萬里橋
怎樣撥東風驟得夢
花卷紅燭金錐且漙
香消一枝腰迢
鸞翁杳翠黛潤蛾眉
寂下鸂鷘喝天曉天際王
孫芳草煙波曠蕩
宽

燕子粧樓春曉溏溏臺
眠春老海棠報道花
閑早夜又朝光陰信手
拋有能多浮燈覺夢覺
子樓頭月五萬春宵
嘆舞寥裙腰香漸
漓

112

Two Letters to Wu Yu
— by —
Wen Zhengming
— of —
the Ming Dynasty

Leaves, small regular script

Ink on paper

Leaf one: Height 22.7 cm Width 26.7 cm
Leaf two: Height 22.2 cm Width 27.3 cm

Wen Zhengming (1470–1559), a native of Changzhou (present-day Suzhou, Jiangsu), was a celebrated painter and calligrapher. Excelling in many genres and especially landscapes, he learned from Shen Zhou in his early years before delving into the secrets of Zhao Mengfu, Wang Meng, and Wu Zhen, earning himself a rightful place among the Four Masters of the Wumen together with Shen Zhou, Tang Yin, and Qiu Ying. As for calligraphy, he first studied under Li Yingzhen before retracing the tradition through past masters. His small regular script is refined and ethereal and his running-cursive script fluid and vigorous, exerting a tremendous influence on later calligraphers.

The two letters featured come from the album *Ten Letters*, which are all addressed to the calligrapher's father-in-law Wu Yu. In the first letter, the sender calls himself by his original name of Bi and mentions the birth of his son two days earlier, suggesting that it should have been written when Wen was 30. The second letter should have been written after the calligrapher had turned 42 when Wen decided to go instead by his courtesy name, i.e. Zhengming, as given in the signature. By further inference from the content, it should date from the period when the calligrapher was aged between 42 and 50.

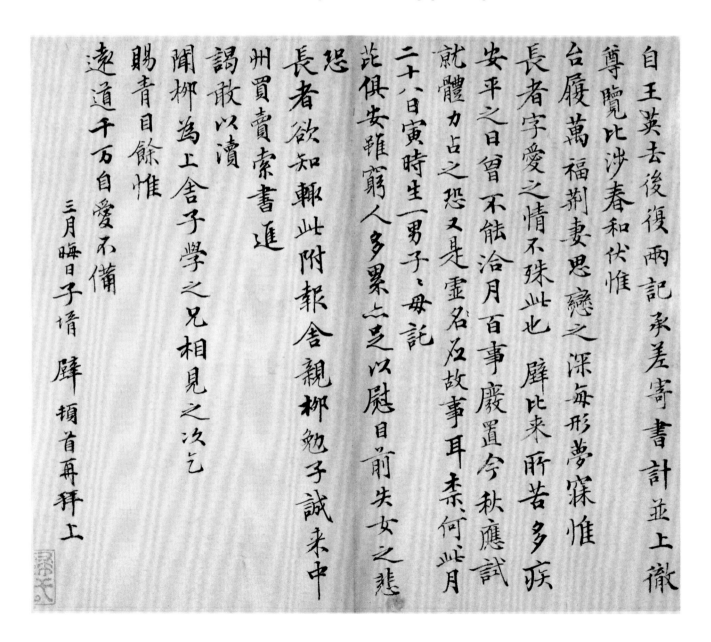

272

The compact structure and lank form in the first is revelatory of the calligrapher's conscious approximation of Ouyang Xun's regular script. The poise and discipline in the second are veined by the characteristics of Wang Xizhi's *the Yellow Court Classic* and *Essay on Yue Yi*. Between the two letters, the calligrapher's stylistic development in the small regular script in his early years and middle age can well be sampled.

The colophon paper contains colophons or signatures by Wang Zhideng and Zhang Fengyi of the Ming and Huang Yi and Qian Yong of the Qing. It also reveals that the work was once in the collection of Liang Qingbiao of the Qing.

The lower left of the letters is each left with a partial collector seal mark.

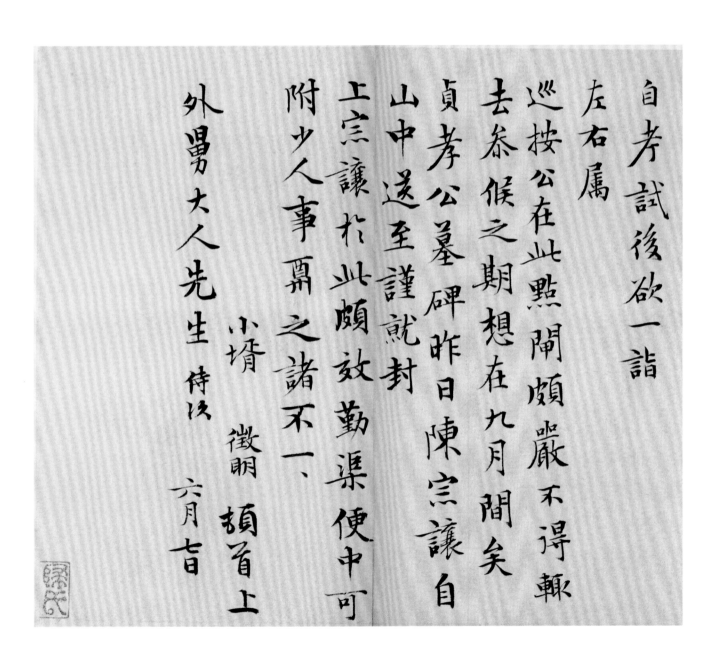

113

Farewell Poems at Longjiang

by

Wang Shouren

of

the Ming Dynasty

Hand Scroll, cursive script

Ink on paper

Height 28.1 cm Width 298.6 cm

Qing court collection

Wang Shouren (1472–1529), a native of Yuyao, Zhejiang, was born into a prestigious family. Originally named Yun, he adopted the name Shouren only later in his life. Another name that he has been commonly known by is Yangming, which was the name of a cave in Kuaiji where he set up home and that of an academy that he founded. The leading exponent of the philosophical School of Mind was qualified as *jinshi* in the 12th year of the Hongzhi reign (1499) but was caned and banished to Longchang, Guizhou, for infuriating the eunuch Liu Jin during the Zhengde reign (1506–1521). When Liu was executed, he was reinstated and ennobled as earl, rising subsequently to serve as Minister of War of Nanjing and Left Censor-in-chief. Wang was also a man of letters and excelled in calligraphy through modelling on Wang Xizhi.

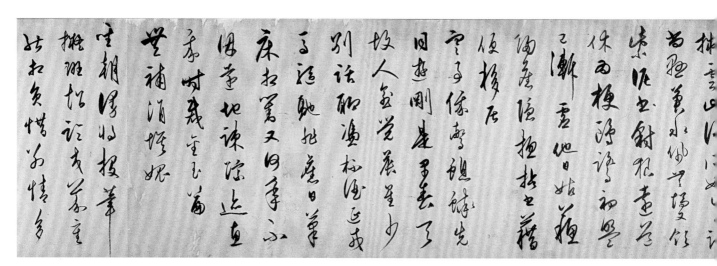

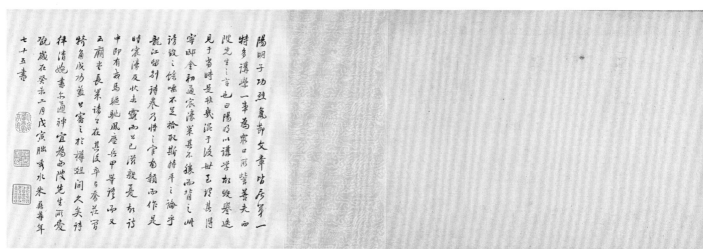

The calligrapher composed the five poems featured in the 11th year of the Zhengde reign (1516) at farewell parties hosted in his honour by Qiao Yu, who was Minister of War of Nanjing, Wu Yipeng, who was Chief Minister of the Court of Imperial Sacrifices, and Zeng Duo, who was Chancellor of the Imperial University, in Mount Qingliang, Jieshan Pavilion, and Longjiang on his departure for the new office of Left Assistant Censor-in-chief in charge of adminstrating a number of districts.

With its sparse columns and compact characters, the calligraphy flows freely without impediment. The variation in ink tones and stroke thickness as well as the occasional tilts induce a sense of inner strength.

The colophon paper is inscribed by Zhu Yizun of the Qing.

Collector seals: *Zhu Zhichi*, *Qianqiuli ren*, *Wo'an suo cang*, and Qing imperial seals.

Literature: *Shiqu Catalogue of Imperial Collection of Painting and Calligraphy: Series One.*

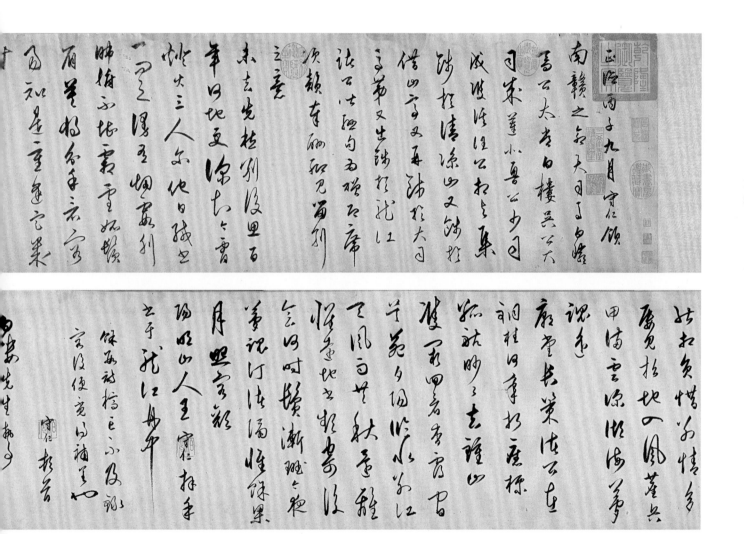

114

Heptasyllabic Poem

by

Chen Daofu

of

the Ming Dynasty

Hanging Scroll, cursive script

Ink on paper

Height 154.6 cm Width 64.5 cm

Chen Daofu (1483–1544), a native of Changzhou (present-day Suzhou, Jiangsu), was originally named Chun but decided to go by this courtesy name of his. Noted as a scholar, litterateur, painter, and calligrapher, he painted and calligraphed very much in his teacher Wen Zhengming's style in his early years but succeeded in forging an identity of his own. On the merits of his painting, he has been ranked on a par with Xu Wei. As for calligraphy, influenced by Zhu Yunming later in his life, he transformed the refinement in his regular, running, and cursive scripts into spontaneity. The dynamism and unpredicatability of his running and cursive scripts fully manifest the literati ideal of self-expression through calligraphy. As a leading exponent of the Extraordinary Style, he heralded the rise of romanticism in late Ming painting.

Signed and impressed with a signature seal (*Baiyangshan zhong ren*), the calligraphy features a self-composed poem that is inspired by the spring scene of a lakeside pavilion in Shihu in the outskirts of Suzhou.

Sophisticated and untrammeled, the calligraphy strikes with its unsparing and snapping ink as is expected from an extraordinary literatus. The irregular composition surprises and enchants, vaguely evoking Zhu Yunming's style and yet imbued with a painterly vigour rather than Zhu's rampancy.

Collector seals: *Qizhan moyuan* and *ceng zai Zhu Qizhan jia*.

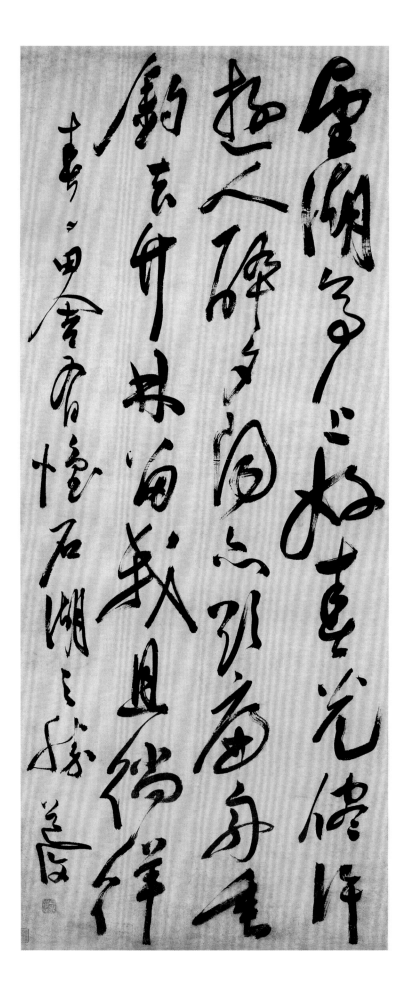

115

A Girl on a Stream

—— by ——

Wang Chong

—— of ——

the Ming Dynasty

Hanging Scroll, cursive script

Ink on paper

Height 82 cm Width 28.8 cm

Wang Chong (1494–1533), a native of Wuxian (present-day Suzhou, Jiangsu) and Cai Yu's student, engaged in studies for his own sake in Shihu after repeated frustrations at civil examinations. Acquired mostly from carvings, his calligraphy is somewhat jerky and halting. His small regular script, inspired by Jin and Tang masters, is placid and simple. Into his mid years, his running and cursive scripts began to change from a fluidity that runs through the freestanding characters to simplicity that is emulative of Song Ke. In recognition of his calligraphic accomplishment, he has been known collectively with Zhu Yunming and Wen Zhengming as the Three Masters of Wuzhong.

Impressed with a seal (*Dayatang*), the calligraphy owes its text to the poem *A Girl on a Stream* (*Chuanshang Nü*) composed by the Tang poet Cui Hao. As told in the closing inscription, which is signed and impressed with two calligrapher seals (*Wang Lüji jin* and *Weiweizhai*), it was executed, confessed to be sloppily, when the calligrapher was drunk. The year *bingxu* given for the date corresponds to the fifth year of the Jiajing reign (1526).

Written under the influence of wine, the calligraphy emits Wang Xianzhi's resonance. Conforming to established rules whether in delineation or character structuring, the uncontrived characters are comfortably spaced and are endowed with a lasting charm in their relaxed and archaistic refinement.

Collector seals: *Qinghuage yin*, *Zhenlang*, and *Yushi shi*.

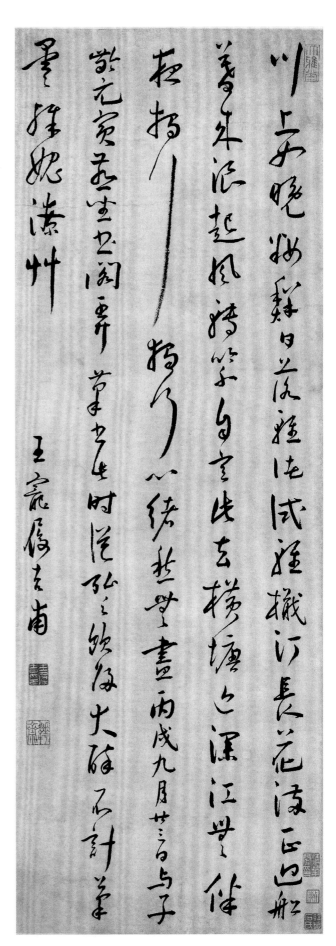

116

Self-composed Pentasyllabic Octave

— by —

Wen Peng

— of —

the Ming Dynasty

Hanging Scroll, running script

Ink on paper

Height 148.4 cm Width 66 cm

Wen Peng (1498–1573), a native of Changzhou (present-day Suzhou, Jiangsu), was Wen Zhengming's eldest son and was the holder of such offices as Instructor of the Directorate of Education and Erudite of the Directorate of Education in Nanjing and Beijing. In his family, painting and calligraphy were handed down from father to son. To master calligraphy, he was first exposed into the Jin tradition and was eventually able to establish his own identity as an expert on various scripts, especially the cursive. He was also a proficient seal carver and has been mentioned in one breath with He Zhen for his impact on posterity.

Signed and impressed with two signature seals (*Wen Peng zhi yin* and *Shoucheng shi*), the poem expresses the calligrapher's thoughts and feelings during a visit to the West Lake in the rain.

Carrying streaks of Monk Huaisu and Sun Guoting rather than those of his father Wen Zhengming, the composed calligraphy exudes vibrancy in the obtuse strokes. Although less sophisticated when compared with his father's, the flowing grace and the diversity are tokens of his own creativity.

Collector seals: *Yichunlu Qin Tongli cang shuhua yin.*

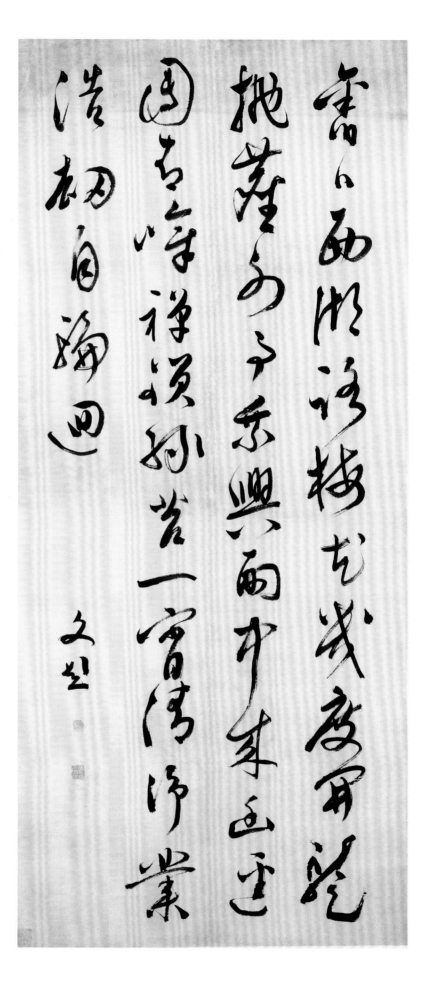

278

117

Self-composed Heptasyllabic Octave

— by —

Xu Wei

— of —

the Ming Dynasty

Hanging Scroll, cursive script

Ink on paper

Height 209.2 cm Width 64.4 cm

Xu Wei (1521–1593), a native of Shanyin (present-day Shaoxing, Zhejiang), had little luck with civil examinations and once worked in Hu Zongxian's private secretariat. Accomplished in poetry, essays, calligraphy, painting, and plays, he was a wayward man by nature and grew even more bizarre in his late years. His calligraphy is shaped by the orthodox ideal of the Jin-Tang tradition and the Two Wangs and tinctured with the essences of Mi Fu. He believed the mind is more important than the hand in calligraphy and hence focused more on the spiritual aspect. Like the man, who was trampled in life, his calligraphy is unreined and unthethered to the fullest extent.

Signed and impressed with two signature seals (*Tianchi Shanren* and *Qingteng Daoshi*), the calligraphy owes its text to the poem *Yeyu Jian Chunjiu* composed by the calligrapher under the influence of wine under a begonia tree when he was staying with his friend Chen Shoujing. The beginning of the calligraphy is also impressed with a seal (*Gongsun Daniang*).

The characters are generally broad and are compact in the centre or in the lower half. Brushwork is defiant and whimsical, manifesting the calligrapher's disregard for rules and conformance that defines his style and his pursuit of purity, charm, and intensity.

Collector seals: *Yushan Zhang Rongjing jiancang*, *Mengchan*, and *Shu*.

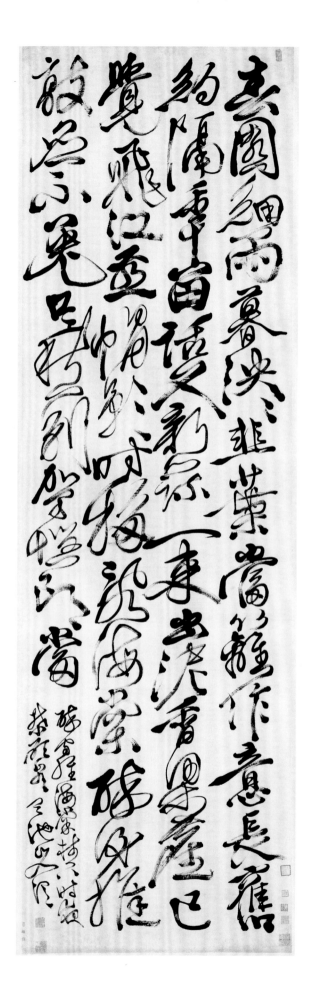

118

Yuansheng Tie

— by —

Xing Tong

— of —

the Ming Dynasty

Hanging Scroll, cursive script

Ink on silk

Height 175.5 cm Width 25.4 cm

Xing Tong (1551–1612), a native of Linyi (present-day Linqing, Shandong), was qualified as *jinshi* in the second year of the Wanli reign (1574) and rose through the ranks to become Vice Minister of the Court of the Imperial Study. After resignation in his late years, he built a pavilion called Laiqinguan in Guliqiu where he devoted himself to studying and writing, publishing among others *Model-calligraphies of the Laiqinguan* (*Laiqinguan Tie*) to feature his own sizable collection. He studiously studied the works of past masters and arrived at a robust mastery that has made him a resounding name in and outside China. He ranks with Dong Qichang, Mi Wanzhong, and Zhang Ruitu as the Four Masters of Late Ming and with Dong Qichang as the Northern Xing and the Southern Dong.

Signed and impressed with two signature seals (*Xing Tong zhi yin* and *Ziyuan shi*), the calligraphy is a copy of Wang Xizhi's Yuansheng Tie.

Robust and devoid of contrivances, the calligraphy shows no signs of hesitation or interruption. Yet the brush methods are less diverse and meticulous than Wang Xizhi's and are more in keeping with the unusualness and crudity characteristic of the late Ming.

Collector seals: *Shixuezhai miji yin*, *Zonghao changshou*, *Shixue jiancang*, and *cunjing yushang*.

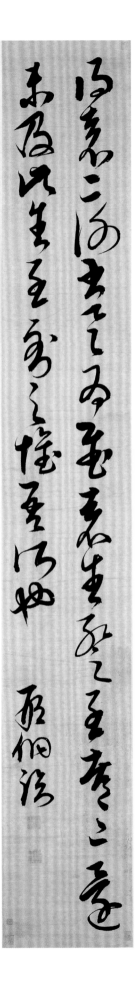

119

Stele of the Guanhou Temple

— by —

Dong Qichang

— of —

the Ming Dynasty

Hand Scroll, running script

Ink on paper

Section one: Height 33.3 cm Width 412.7 cm
Section two: Height 28.8 cm Width 175.3 cm
Qing court collection

Dong Qichang (1555–1636), a native of Huating (present-day Songjiang, Shanghai) was qualified as *jinshi* in the 17th year of the Wanli reign (1589) and rose through the ranks to become Minister of Rites in Nanjing. Despite his late start in learning calligraphy at the age of 17, he attained mildness, refinement, richness, and resonance in emulation of the Jin masters through assiduous copying of ancient masterpieces. His calligraphy is characterized by extrinsic crudity and intrinsic elegance, setting him apart from the masters that he modelled on. He was also an expert connoisseur of painting and calligraphy whose prolific publications on painting and calligraphy theories have had a profound impact on later generations.

The calligraphy consists of a stele inscription and a self-inscription. Written by the Senior Compiler of the Hanlin Academy Jiao Hong in the 19th year of the Wanli reign (1591) and calligraphed by Dong Qichang in the 20th year of the same reign (1592) in Beijing, the stele inscription used to grace the Guanhou Temple, built as the largest of its kind in the city in the 20th year of the Hongwu reign (1388), in the southwest of the Zhengyang Gate in Beijing. Signed, dated, and impressed with two calligrapher seals (*Zhizhigao Rijiangguan* and *Dong Qichang*), the self-inscription was added to document the event 30 years later in the second year of the Tianqi reign (1622) when Dong was posted back to the capital.

The stele inscription is written in the running script with touches of the regular. Back then, although the young calligrapher was still somewhat deficient in his mastery, attributes of Yan Zhenqing, Mi Fu, and Yang Ningshi are approximated, thanks to his enthusiasm about collecting and copying ancient paintings and calligraphies. By contrast, the self-inscription is as serene and unaffected as the elderly artist and is quintessential of his late-year style. On the whole, the calligraphy resonates with a harmony of vibrancy and moderation through the trim strokes, lustrous ink, and uncluttered composition.

Collector seals (13 in number): *Shangqiu Song Luo shending zhenji* and seals of the Qing emperors Qianlong, Jiaqing, and Xuantong.

Literature: *Shiqu Catalogue of Imperial Collection of Painting and Calligraphy.*

廣之祠荒邊裔後在
而有之而芸夫牧墜
婦人女子咸奔走恐
後可謂盛已都城自
舁鼎以眾人物湊輻
縮四方之轂凡有謀
者必禱焉曰吉而後
聖化者非細鳴呼為
怪事中間銷沮為謀
君子而謀有同易筮
拒不西之間無殊嚴
卜非盛德其疇能之
國朝受命宅中百靈
敷職乃太微管室之間
侯實居之儀如環衛
蓋四方以京師為辰
極而南京師以侯為指
南事神其可不茶
余少知鄉註夢蝶之
中果興辰遇屬萬
士大夫謂蓬豆有嚴
而琬琰未列懼言

稜穹籬禁藥度呵
護之乎湳南王那郲
晴靄陰風弓刀楚
於余書昌昌歇之妙
莊然環衛惟蹕
森然環衛惟蹕
瞒山原牽數假予
是尾伏繢臚紛
素目屬余補名款舊
有來士女盛之湘之
子孝臣忠弟友兄
碑名款出程禱生手
阰蘭洲莽卜以蓮
蓁如舍若抨槍鼓
志也郷郲涂於書
謀遍汪廣其冥庇
道愧舍參以應之
顧邑字剖國興恬
邊陸中監醫日腥
然而謂一不屬少者
雲有絲鍾鷹侯甲
弓人矣
瞻之末精鷹其馬乘風
太常寺少卿董國子
奮臂揚天兵鬼斧
學司業董其昌重題
尚載孤家投攘裼
黏永祚皇圖為百
神主牲牷眈醽松
桂湖舞孔蓋低眈
霓裳絲下碑枕金

古觀舊書呂董
不如我三紀
昔不如人今
之中自為今

壬戌六月之相
苑西畫禪室
其昌
識
識

正陽門廟志祀漢前
將軍關侯作也庚廟
祀徧天下而稱正陽
門志爲都城作也侯
名在百世封豨在景
朝而稱漢前將軍者
澤中以一旅之淅卒
庚志也侯方崎嶇草
能佐漢扶將傾之鼎
之際矢死不囬以單
可不謂辟我及艱危
摧強破敵威震天下
其所志此其人與孔子
所稱殺身成仁者豈
有立而中慶者其未
有異此古忠臣烈士欲
竟之志樹於後去翔
書不抹于後去翔
侯之節皭然與日月
争光去哉余行天下
顧瞻廟庭顫蜀至今

而琬琰未列懼無
歌頌遺烈垂之將來
也乃命予碑而銘
之其詞曰

栢柏關侯天挺神
武金節未於如羆
以虎逸氣干霄英
風絶侶流連草昧歸
威榮霞峰勇摧七
將氣吞群旅報曹
詎鑒雲吳非忖炳
炳丹心天高日午惟
期一戰還都帝所究
袁稀除萬國安堵
方倚長城遷傳相杵
權變鬱鬱之遺魂駭霆
怒兩豈其湮淪草木
朽腐蒸哉文皇鷹

霓裳絲下碑軮金
龜鐘橫石廥廙
敕勒銘詞流茶終
古

賜進士及第翰
林院備撰焦竑
撰

賜進士出身翰
林院庶吉士董
其昌書

余石庫常時所書
此出春明三十四年再
石墨刻碑石且湋字
筆摺之衆如榻者維
畫有漫者墓不勝
衆而生卧碑下三日不
去者冬人爲誰一不爲
少耳頑此人云云得

120

Heptasyllabic Verse Lines
—— by ——
Zhao Yiguang
—— of ——
the Ming Dynasty
Hanging Scroll, seal script

Ink on paper
Height 141 cm Width 31.6 cm

Zhao Yiguang (1559–1625), a native of Taicang, Jiangsu, shunned the hustle and bustle of cities by living with his wife Lu Qingzi in Mount Han all their lives. Preoccupied with researches into the lexicon *Dissecting Characters* (*Shuowen*), the expert on the seal script advocated returning beyond the Jin and Tang periods to embrace the Qin and Han under the revivalist influence at the time. His insistence on scholarship and elegance for calligraphy and his invention of the "cursive seal script" by writing the seal script with brush methods of the cursive have earned him an important place in late Ming calligraphy.

Signed and impressed with two signature seals (*Zhao Yiguang yin* and *Fanfu*), the calligraphy owes its text to the heptasyllabic verse composed by the Tang poet Li Bai as a farewell gift to a monk friend.

The calligraphy corresponds with the small seal script of the Qin Dynasty in character structuring. Apparently, the calligrapher has taken special care to infuse vibrancy into the august form. Through emphasizing variety with the masterly use of both the side-tip and centre-tip of the brush, the calligrapher has achieved an overall effect that deviates sharply from the evenness and concealed brush tip characteristic of the "Jade Chopsticks Seal Script" of the Han and Tang dynasties. In place of the formalness of the unimpassioned small seal script, the seal script here is revitalized for personal expression.

Collector seals: *Qin Zhimu jia zhencang.*

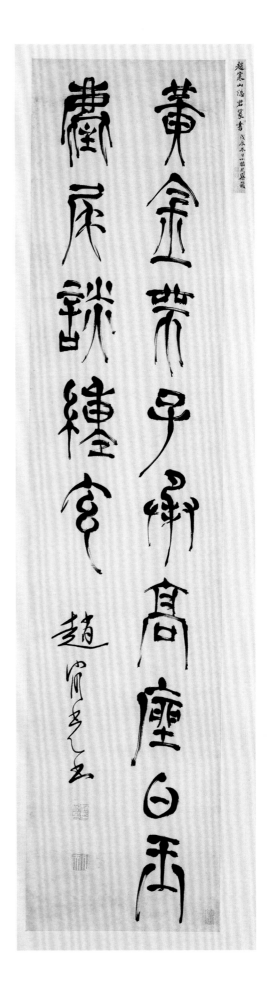

121

Self-composed Pentasyllabic Quatrain

——— by ———

Zhang Ruitu

——— of ———

the Ming Dynasty

Hanging Scroll, running script

Ink on paper

Height 172.2 cm Width 43.5 cm

Zhang Ruitu (1570–1641), a native of Jinjiang, Fujian, was qualified as *tanhua*, or the third top *jinshi*, in the 35th year of the Wanli reign (1607) and subsequently rose to such offices as Minister of Rites and Grand Secretary of the Hall of Establishing Exemplars (Jianjidian). During the Chongzhen reign (1628–1644), he was branded a member of the "eunuch party" and was dispatched home all because he had written an inscription for the shrine of the eunuch Wei Zhongxian while the latter was still alive. Excelling also in literature and painting, he was a pioneer among Ming calligraphers to emphasize personal expression and ranks with Dong Qichang, Xing Tong, and Mi Wanzhong as the Four Masters of Late Ming.

Signed and impressed with two signature seals (*Zhang Changgong* and *Ruitu*), the self-composed poem is probably inspired by the poem *To Wei Mu* (*Zeng Wei Mu Shiba*) by the Tang poet Wang Wei. The top right of the calligraphy is also impressed with a seal (*wenxue shicong zhi chen*).

In the present calligraphy, testimonies to the prevalence of eccentricity in the late Ming can be found in the unpolished corners, deliberate imbalance, fully exposed brush tips, and indulgence in flamboyance.

Collector seals: *Gushi Zhang shi Jinghanxie sizhu Wei shending xukao* and *Zhiren Lishi Wenwu Guan cang*.

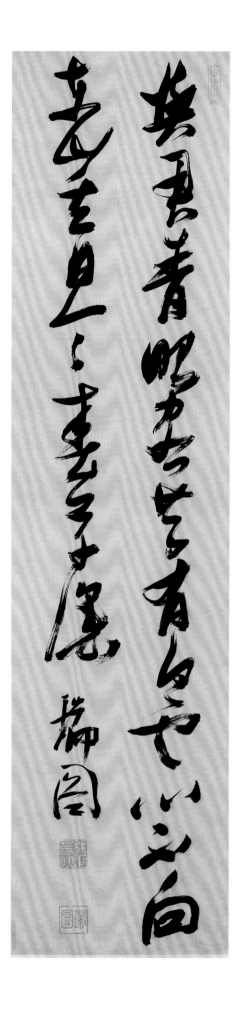

122

Poem on Observations on the Road

— by —

Huang Daozhou

— of —

the Ming Dynasty

Hanging Scroll, running script

Ink on paper

Height 141 cm Width 32 cm

Huang Daozhou (1585–1646), a native of Zhangzhou, Fujian, was qualified as *jinshi* in the second year of the Tianqi reign (1622) and appointed as Junior Compiler. Serving the Southern Ming emperor Longwu as Minister of Personnel and War and Grand Secretary of the Hall of Military Glory (Wuyingdian), he was killed when the regime was vanquished. The scholar was revered for his literature that is lofty in character. His regular, cursive, and seal scripts have also been acknowledged to be stylistically distinctive.

Signed and impressed with two signature seals (*Huang Youxuan* and *Daozhou*), the previously composed heptasyllabic octave was presented as a gift to Senior Wang as revealed in the closing inscription. The top right of the calligraphy is also impressed with a seal (*wu fa san xi kang fu lai*).

With Zhong You's forms blended in, the calligraphy appears to be aggressively jagged and angular. Character structuring tends to be slanting on the whole, whereas the composition is carefully conceived to disassociate itself with weakness and staleness.

Collector seals: *Wuyitang shuhua ji*.

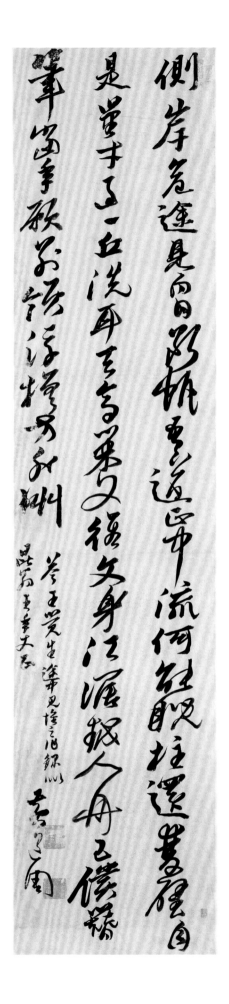

123

Heptasyllabic Quatrain
Xingshu Dumu Shizhou

— by —

Ni Yuanlu

— of —

the Ming Dynasty

Hanging Scroll, running script

Ink on paper

Height 128.5 cm Width 93.1 cm

Ni Yuanlu (1594–1644), a native of Shangyu, Zhejiang, was qualified as *jinshi* in the second year of the Tianqi reign (1622). Early in the Chongzhen reign (1628–1644), he was demoted to Chancellor of the Imperial University following a flawed attempt to depose Yang Weiyuan, a protégé of the eunuch Wei Zhongxian. Important positions he held in his career as an official include Vice Minister of War, Minister of Personnel, and Hanlin Academician. When the capital fell into the hands of the rebel leader Li Zicheng towards the end of the Chongzhen reign, he committed suicide to evince his loyalty. Proficient also in literature and painting, the calligrapher was noted in the late Ming for his vigour and assertiveness.

Signed and impressed with two signature seals (*Ni Yuanlu yin* and *Hongbao shi*), the calligraphy owes its text to the heptasyllabic quatrain *To Master Li* (*Zeng Li Xiucai Shishang Gongsun Zi*) by the Tang poet Du Mu and was intended as a gift, as revealed in the closing inscription.

To challenge stability, the calligraphy is dominated by tilts and slants. References to the seal and clerical scripts are suggested by the brisk manipulation of brush to attain archaistic charm. The unconventional treatment of strokes helps project the powerful drive behind the execution.

Collector seals: *Shi Shouyu yin*, *Kuai Shoushu jia zhencang*, and *Shi shi Chundetang cang*.

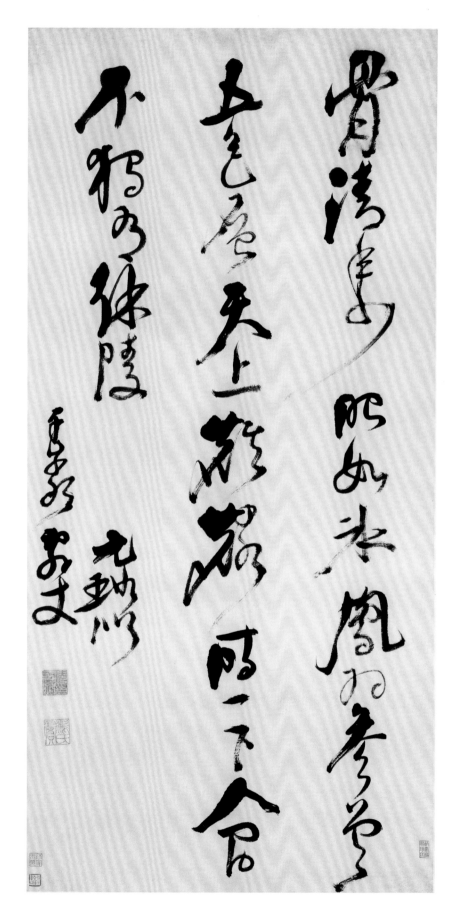

The Qing Dynasty

君他石上再母来

就銘人世假説

氣枸它蔵三

124

Reminiscences of Taizhou

by

Wang Duo

of

the Qing Dynasty

Hanging Scroll, running script

Ink on silk

Height 84.3 cm Width 25.3 cm

Wang Duo (1592–1652), a native of Mengjin (present-day Luoyang, Henan), was qualified as *jinshi* in the second year of the Tianqi reign (1622) and rose through the ranks to become Minister of Rites and Grand Academician of the East Hall. When the Ming empire was defeated, he surrendered to the Qing victors and rose to offices such as Grand Guardian of the Heir Apparent and Minister of Rites, and was entrusted with the compilation of *History of Ming* (*Ming Shi*). Also excellent at literature and painting, the calligrapher was steeped in the tradition through modelling on Zhong You, the Two Wangs, Yan Zhenqing, Mi Fu, and especially *Model-calligraphies from the Chunhuagetie* and was, at the same time, able to experiment for innovation. Practising all the scripts, he was most accomplished in the running and cursive scripts and stood out among early Qing calligraphers for his idiocyncratic vigour.

As professed in the closing inscription, which is signed and impressed with two calligrapher seals (*Juesi* and *Zongbo tushu*), the pentasyllabic octave *Reminiscences of Taizhou* was written under the influence of wine. The given date of the *xinmao* year corresponds to the eighth year of the Shunzhi reign (1651).

Quintessential of the calligrapher's late style, the calligraphy alternates effortlessly between the running and cursive scripts to showcase robustness and mellowness through its generous use of ink.

Collector seals: *Luo Zhaohan yin.*

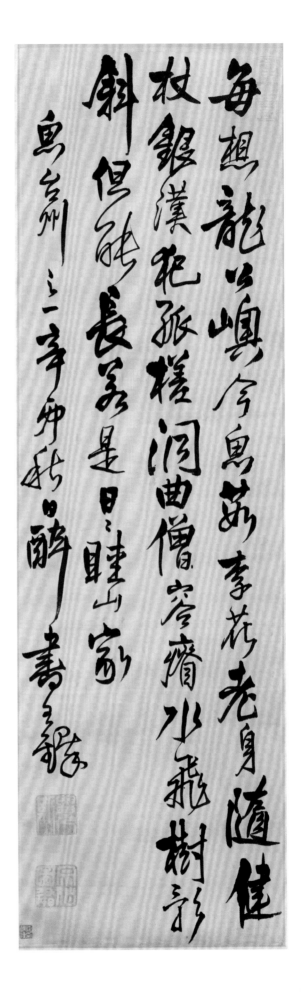

125

Pentasyllabic Octave

———— by ————

Fu Shan

———— of ————

the Qing Dynasty

Hanging Scroll, running-cursive script

Ink on silk

Height 185.7 cm Width 51 cm

Fu Shan (1607–1684), a native of Yangqu (present-day Taiyuan, Shanxi), was a state school student in late Ming. To demonstrate his loyalty to the demised empire when the Manchus took over power, he gave up on officialdom and earned a living by practicing medicine instead. When recommended against his will for sitting an extraordinary civil examination in the 17th year of the Kangxi reign (1678), he procured freedom by threatening to kill himself. An adept in all scripts, he was most distinguished for his vigorous and intuitive cursive script.

The calligraphy owes its text to the sixth of a set of ten poems that the Tang poet Du Fu composed on accompanying Zheng Guangwen on a visit to General He's wood. As professed in the closing inscription, which is signed and impressed with a signature seal (*Fu Shan yin*), this was a gift to a Master Songchu.

The dynamism conjured up by the interconnected characters seen in the present specimen is a hallmark of Fu Shan. Lively and rhythmical, the calligraphy exhibits a sustaining momentum, a natural composition and varied character size, culminating in the vigour and simplicity that have come to define Fu's style from his middle age onwards.

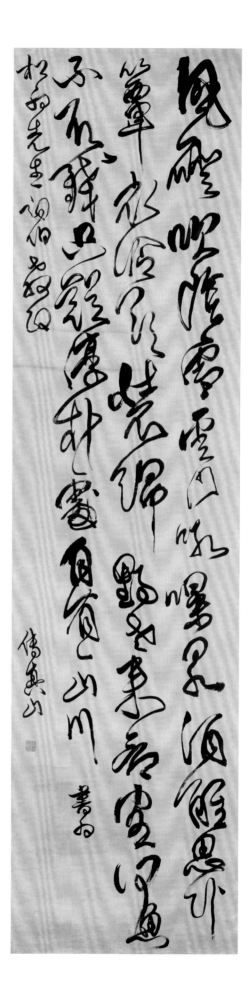

126

Poem on Stone House Mountain

—— by ——

Zheng Fu

—— of ——

the Qing Dynasty

Hanging Scroll, clerical script

Ink on paper

Height 200.2 cm Width 98.8 cm

Zheng Fu (1622–1694), a native of Shangyuan (present-day Nanjing, Jiangsu) and a physician, never joined the civil service. The calligrapher was famous in the early Qing for his clerical script and played a key role in the development of the script in the dynasty. Modelling first on the Ming calligrapher Song Jue and later exclusively on *Stele for Cao Quan* from the Eastern Han, Zheng introduced elements of the cursive script into the clerical to arrive at a breezy style with emphatic stops, turns, and hooks. This facilitated the development of clerical script in the Qing Dynasty to a great extent.

The calligraphy owes its text to the poem *Mount Shishi* (*Shishi Shan*) composed by the Southern Dynasties poet Xie Lingyun. Signed and impressed with two calligrapher seals (*Zheng Fu zhi yin* and *Maiwanglou*), the closing inscription reveals that the poem was written for a person named Shi'an in the *jisi* year, or the 28th year of the Kangxi reign (1689). The recipient Shi'an was either Huang Xiu or Cao Zhenji. Huang was qualified as *jinshi* in the Kangxi reign (1662–1722) and was both a scholar of evidential research and an official rising to the rank of Investigating Censor of the Shandong Circuit. Cao, also a *jinshi* from the same reign, was a poet and Secretary to the Ministry of Rites.

Although very much in the shadow of *Stele for Cao Quan*, this masterpiece from the calligrapher's late years replaces the stele's coyness with masculinity and distinguishes itself with bold violations of established rules and principles.

127

Heptasyllabic Quatrain by Wang Shizhen

— by —

Zhu Da

— of —

the Qing Dynasty

Hanging Scroll, running script

Ink on paper

Height 200.9 cm Width 76.5 cm

Zhu Da (ca. 1624–1705), a native of Nanchang, Jiangxi, was a descendant of the Ming imperial family. He took up Buddhist priesthood in the early Qing and later converted to Daoism. The talented painter-calligrapher ranks with Shitao, Hongren, and Kuncan, who were all loyalists to the Ming, as the Four Monks of Early Qing. As for calligraphy, he sought emulation of Wang Xianzhi and Yan Zhenqing but not without innovation of his own. Appropriating from the seal script, he achieved for his running and cursive scripts an archaism characterized by even lines and smooth turns.

Signed and impressed with two calligrapher seals (*Bada Shanren* and *Heyuan*), the calligraphy owes its text to a poem composed by Wang Shizhen of the Ming to congratulate a friend on his appointment as provincial governor. The text, however, does not tally completely with the version in *Complete Library of the Four Treasuries* (*Siku Quanshu*). The top right of the calligraphy is impressed with a seal (*yao shu*).

By concealing the brush tip and holding the brush upright, the calligrapher has produced strokes that are even in thickness. Regularity is shattered by the occasional connection between columns and characters and by simplification of certain character forms, resulting in queerness and exaggeration without compromising the overall balance and harmony.

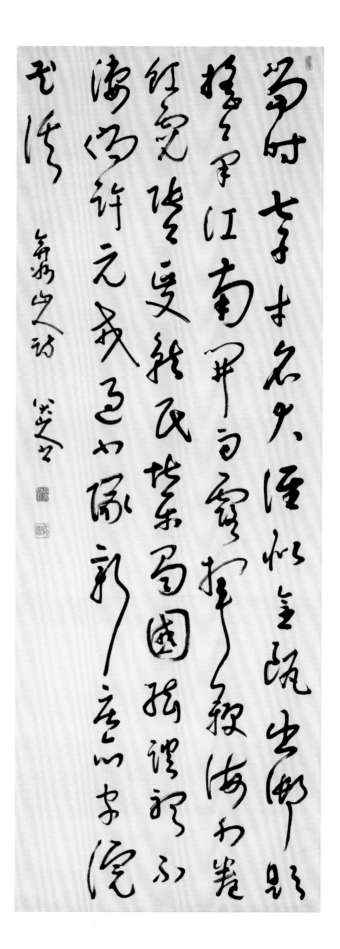

128

Ci-poem to the Tune of Waves Scouring Sands

by

Shen Quan

of

the Qing Dynasty

Hanging Scroll, running script

Ink on silk

Height 178.2 cm Width 44.3 cm

Shen Quan (1624–1684), a native of Huating (present-day Songjiang, Shanghai), was qualified as *tanhua*, or the third top *jinshi*, in the ninth year of the Shunzhi reign (1652) and was appointed as Junior Compiler before rising to offices including Supervisor of the Household Administration of the Heir Apparent, Academician Reader-in-waiting of the Hanlin Academy, and Vice Minister of Rites. Perpetuating the styles of Mi Fu and Dong Qichang, he was Emperor Kangxi's favourite calligrapher for inscriptions to meet various imperial purposes that ranged from steles to screens. He was also one of the Emperor's ghostwriters.

Signed and impressed with two signature seals (*Shen Quan yinzhang* and *Chongzhai*), the calligraphy owes its text to a *ci*-poem composed by the Southern Song poet Zhou Mi to the tune of *Waves Scouring Sands* (*Lang Tao Sha*). In the self-inscription, the calligrapher remarks that Zhou's poetry is as superior as Jiang Kui's.

The calligraphy has remarkably retained Dong Qichang's ethos in the fluid rendering, sparse composition, and calculated structuring. There are also some touches of Mi Fu's deviant structuring that contributes to the boldness and refinement. The excessive obtuseness, however, compares less favorably with Dong Qichang's ethereality.

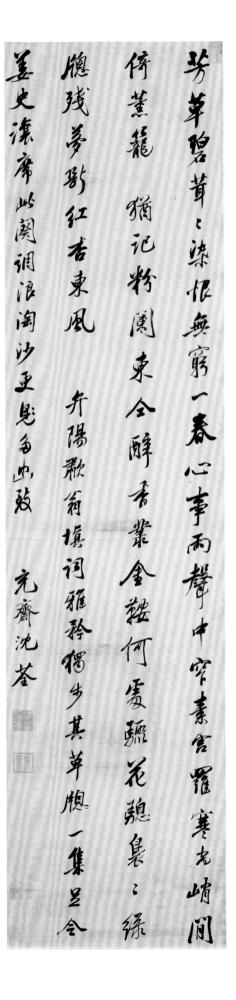

129

Excerpt from Su Shi's Inscription

by

Wang Shihong

of

the Qing Dynasty

Hanging Scroll, running script

Ink on paper

Height 91 cm Width 50.9 cm

Wang Shihong (1658–1723), a native of Changzhou (present-day Suzhou, Jiangsu), was qualified as *jinshi* in the 36th year of the Kangxi reign (1697) and was appointed as Senior Compiler of the Hanlin Academy before rising through the ranks to become Right Companion for the Heir Apparent of the South Study. Passionate about calligraphy since young, he began by extensively copying ancient masterpieces before concentrating on Chu Suiliang and Zhao Mengfu. The seal and clerical scripts being his late-year interests, he was most noted for his running and regular scripts and was often mentioned in the same breath with Jiang Chenying.

Signed and impressed with two signature seals (*Wang Shihong yin* and *Tuigu*), the calligraphy is an excerpt from a long inscription to *Calligraphies by Six Masters Collected by the Tang Family* (*Tangshi Liujia Shu*) in which Su Shi comments on the Sui and Tang masters concerned. The top right of the calligraphy is impressed with another signature seal (*Qiuquan*).

In total agreement with descriptions by past critics, the calligraphy is sinewy, sparsely posited, and spatially balanced. The strokes and dots are particularly vivacious.

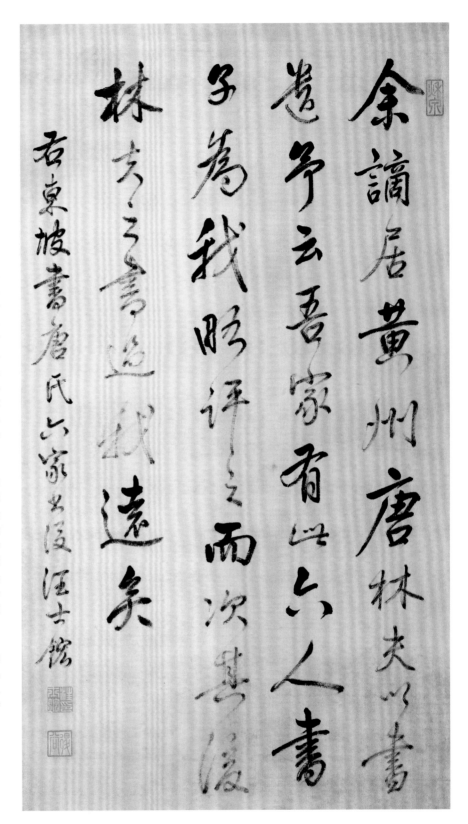

130

Song of the Peach Blossom Spring

——— by ———

He Zhuo

——— of ———

the Qing Dynasty

Hanging Scroll, regular script

Ink on paper

Height 60.4 cm Width 33.8 cm

He Zhuo (1661–1722), a native of Changzhou (present-day Suzhou, Jiangsu), was qualified as *jinshi* in the 43rd year of the Kangxi reign (1704) and was appointed as Junior Compiler. In terms of scholarship, he was an expert on textual research for ancient steles, Confucian classics, and histories. In terms of calligraphy, he liked copying Jin and Tang masterpieces and emulating Ouyang Xun and Chu Suiliang, meriting a place in the "competent class" of calligraphers of regular and running scripts. His fame was most resounding for his small regular script. Together with Da Chongguang, Jiang Chenying, and Wang Shihong, he has been known as the Four Masters of the Model-book School of the Kangxi reign (1662–1722).

Signed and impressed with two signature seals (*He Zhuo zhi yin* and *Qizhan*), the calligraphy owes its text to the heptasyllabic old-style poem *Song of the Peach Blossom Spring* (*Taoyuan Xing*) composed by the Tang poet Wang Wei with some discrepancies from the version adopted in *The Complete Poetry of the Tang* (*Quan Tangshi*). As disclosed in the closing inscription, the brush methods are imitative of Wang Zunxun, a renowned calligrapher who was qualified as *jinshi* during the Shunzhi reign (1644–1661) and was Vice Minister of Revenue during the Kangxi reign (1662–1722).

Precise, wiry, and sparse, the calligraphy has fully captured the charms of Ouyang Xun. Although not at all flaunted, the skill and mastery are simply admirable.

Collector seals: *Cheng Xinbai cang, Gong Bo pingsheng zhenshang,* and *Chunlin.*

春來遍是桃花水不辨仙源何處尋

安知峯壑今來變當時只記入山深

出洞無論隔山水辭家終擬長遊衍

世中遙望空雲山不疑靈境難聞見塵心未盡思鄉縣

初因避地去人間更問神仙遂不還峽裏誰知有人事

月明松下房櫳靜日出雲中雞犬喧驚聞俗客爭來集

竟引還家問都邑平明閭巷掃花開薄暮漁樵乘水入

居人未改秦衣服居人共住武陵源源從物外起田園

遙看一處攢雲樹近入千家散花竹樵客初傳漢姓名

行盡青溪忽值人山口潛行始隈隩山開曠望旋平陸

漁舟逐水愛山春兩岸桃花夾古津坐看紅樹不知遠

右臨退庵老師法

義門何焯

世中遙望空雲山不疑靈境難聞見塵心未盡思鄉縣

自謂經過舊不迷

幾度到雲林

131

A Pentasyllabic Line

— by —

Wang Shu

— of —

the Qing Dynasty

Hanging Scroll, seal script

Ink on paper

Height 71.8 cm Width 49.3 cm

Wang Shu (1668–1743), a native of Jintan (in present-day Jiangsu) resident in Wuxi, was qualified as *jinshi* in the 51st year of the Kangxi reign (1712) and was given an appointment in the Hanlin Academy. Having risen to the rank of Vice Director in the Ministry of Personnel, he returned to Wuxi on retirement. The calligrapher and seal carver was indebted to Ouyang Xun for his calligraphy and in particular to Li Si for his seal script.

Signed and impressed with a signature seal (*Shu*), the pentasyllabic line meaning "as longliving as the southern mountains" is adopted from *Heaven Preserves* under *Minor Odes* in the *Book of Songs* (*Shijing: Xiaoya: Tian Bao*) and may have been intended for conveying good wishes to the emperor.

Prim and highly ornamental, the calligraphy impresses by its uniform stroke width, lithe lines, sinuous composition, and dissimilar character size, attesting to the calligrapher's meticulous conception.

Collector seals: *Wang* (two characters illegible) *zhencang* and *Xiushui Lu shi Yulinshanguan shoucang zhi yin*.

132

Boating in Summer

— by —

Yinzhen

— of —

the Qing Dynasty

Hanging Scroll, running-cursive script

Ink on silk

Height 140.3 cm Width 62.2 cm

Qing court collection

Yinzhen (1678–1735), surnamed Aisin-Gioro, was Emperor Kangxi's fourth son and succeeded the throne as the capable Emperor Shizong, or more commonly Emperor Yongzheng (r. 1722–1735). Inheriting his father's passion for calligraphy, he admired the Two Wangs, the Jin and Tang masters, and Dong Qichang. Proficient in the regular and running scripts, he was a relatively accomplished calligrapher among Qing emperors.

Impressed with two imperial seals (*zhao qian xi ti* and *Yongzheng chenhan*), the poem *Boating in Summer* that affords the calligraphy with a text was composed by the Emperor. Lotus Fragrance alluded to in the poem refers to a palace in the Old Summer Palace (Yuanmingyuan). It was named in the eighth year of the Yongzheng reign (1730) and provided the imperial family with a waterside site for admiring lotuses and boating. By inference, the poem should have postdated the naming, and the calligraphy should have been written even later since it is said in the closing inscription that the poem was composed previously. The top right of the calligraphy is impressed with one seal (*wei jun nan*).

Written with a sustaining momentum and elegant outlook, the calligraphy is so sophisticated that it can rival any Chancellery master and is at the same time impregnated with the simplicity and ethereality of the Two Wangs.

Collector seals: *Baoji Sanbian* and *Shiqu Baoji suo cang*.

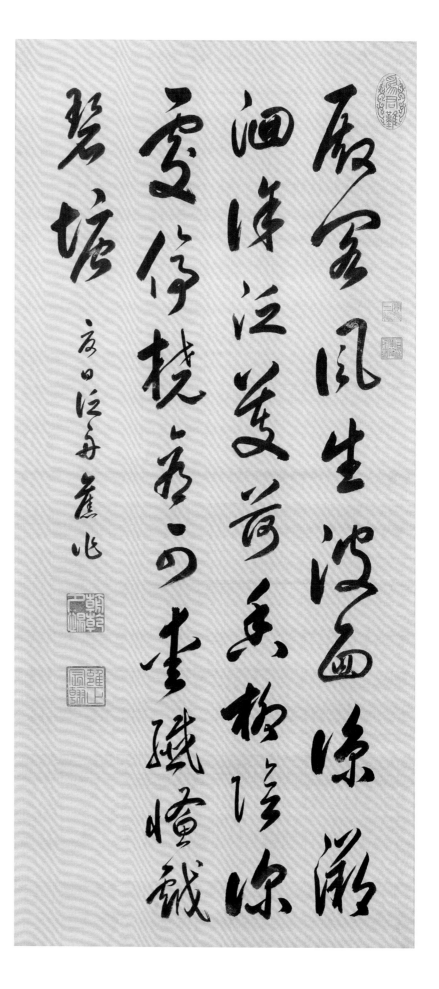

133

Heptasyllabic Quatrain by Su Shi

—— by ——

Chen Bangyan

—— of ——

the Qing Dynasty

Hanging Scroll, running script

Ink on paper

Height 145.7 cm Width 47.6 cm

Chen Bangyan (1678–1752), a native of Haining, Zhejiang, was qualified as *jinshi* in the 42nd year of the Kangxi reign (1703) and appointed as Junior Compiler of the Hanlin Academy in the Nanshufang. He was Vice Minister of Rites early in the Qianlong reign (1736–1795). Deriving his regular, running, and cursive scripts from the Two Wangs and Dong Qichang, he was much admired by Emperor Kangxi and earned himself a place among the Four Masters of the Kangxi Reign.

Signed and impressed with two calligrapher seals (*Chen Bangyan zi Shinan* and *Hanlin Gongfeng*), the calligraphy owes its text to one of the two poems that Su Shi composed in response to requests for calligraphies from two nephews surnamed Liu. The top right of the calligraphy is also impressed with a seal (*Chunhuitang*).

In the calligraphy, which is quintessential of the calligrapher's running script, the legacy of Dong Qichang is detectable in the weightiness of the brush and the ink together with that of Yan Zhenqing in the sparseness and gentility.

134

Canon on Cranes

— by —

Jin Nong

— of —

the Qing Dynasty

Hanging Scroll, lacquer script

Ink on paper

Height 278 cm Width 50.7 cm

Jin Nong (1687–1763), a native of Renhe (present-day Hangzhou, Zhejiang) and He Zhuo's student, settled in Hangzhou later in life to live on painting and calligraphy. The learned man was a man of letters and a connoisseur of antiquities. Starting to paint not until he was already in his 50s, he emerged as a leading painter of the Yangzhou School. As for calligraphy, he was intrepid about experiments and has been noted for his lacquer script.

Signed and impressed with two calligrapher seals (*Jin Jijin yin* and *sheng yu dingmao*), the calligraphy is an excerpt from *Canon on Cranes* (*Xiang He Jing*), reputed to be authored by Fuqiugong of the Han. The book is a comprehensive guide on cranes, which were believed by Daoists to be the mounts for immortals and hence birds that bode auspiciousness. The given date of the *renshen* year corresponds to the 17th year of the Qianlong reign (1752).

The lacquer script was first found as lacquered inscriptions on bamboo slips dating from the Spring and Autumn and the Warring States periods. Midway between the clerical and the regular scripts, Jin Nong's version is highly individualistic. The squat and blocky characters consist of strokes of dissimilar thickness as if they were broadly produced with a lacquerer's brush. Seemingly truncated, the horizontals remain to be level from end to end to contrast with the thin and pointed verticals, diagonals, and hooks. A strong visual effect is achieved through the interplay between the background and the dark, hefty, and regular characters.

Collector seals: *Chengsutang shuhua ji.*

135

Heptasyllabic Octave by Su Shi

by

Zhang Zhao

of

the Qing Dynasty

Hanging Scroll, running script

Ink on paper

Height 143.7 cm Width 54.8 cm

Zhang Zhao (1691–1745), a native of Huating (present-day Songjiang, Shanghai), was qualified as *jinshi* in the 48th year of the Kangxi reign (1709). During the Yongzheng reign (1722–1735), he was Minister of Justice and participated in the compilation of *Collected Statutes of the Great Qing* (*Daqing Huidian*). Subsequently dismissed for misconduct, he was reinstated in the seventh year of the Qianlong reign (1742) and posted to the Nanshufang. Proficient also in literature and painting, the calligrapher modelled on Dong Qichang at first and switched to Yan Zhenqing and Mi Fu in his mid years. An exponent of the Chancellery Style, he very often ghostwrote plaques for Emperor Qianlong in the early years of his reign.

Signed and impressed with two calligrapher seals (*Zhang Zhao zhi yin* and *Yinghai Xianqin*), the calligraphy owes its text to a heptasyllabic octave that Su Shi composed in response to poetry by his younger brother Su Zhe. The top right is also impressed with one seal (*Jizuixuan*).

The calligraphy invigorates with its unencumbered execution and lustrous ink, which is accentuated by the occasional dry connectives between characters. Dong Qichang's comfortable sparseness and Yan Zhenqing's straightforwardness are combined in the present specimen for a distinct personal style.

136

Excerpt from
Evaluation of Past and Recent Calligraphers

by

Zheng Xie

of

the Qing Dynasty

Hanging Scroll, clerical script

Ink on paper

Height 167.8 cm Width 43.5 cm

Zheng Xie (1693–1766), a native of Xinghua (present-day Taizhou, Jiangsu) resident in Yangzhou, was qualified as *jinshi* in the first year of the Qianlong reign (1736) and served as District Magistrate in Fanxian and Weixian, both in Shandong, at various times. Upon retirement, he returned to Yangzhou to live on painting and calligraphy. As a painter, he was noted for his orchids and bamboos. As a poet, he was admired for his originality and sincerity. As a calligrapher, he stood out for his clerical, regular, and running scripts. He was also the inventor of the semi-clerical script, which is a hybrid of the regular, cursive, seal, clerical, and running scripts and is infused with the brushwork for painting orchids and bamboos. Concurrently a seal carver, he ranks with Jin Nong, Li Shan, and others as the Eight Eccentrics of Yangzhou.

Signed and impressed with two calligrapher seals (*Zheng Xie xinyin* and *bingchen jinshi*), the calligraphy consists of three entries, on Kong Linzhi, Li Yanzhi, and Wang Xizhi respectively, from *Evaluation of Past and Recent Calligraphers* (*Gujin Shuren Youlie Ping*) written by Xiao Yan, or Emperor Wu of Liang of the Southern Dynasties. The given date of the *gengwu* year corresponds to the 15th year of the Qianlong reign (1750) when the calligrapher was District Magistrate of Weixian.

Zheng named his innovative script as the semi-clerical script since what should have been the clerical script is now mixed with features appropriated from the regular-running script. Other characteristics demonstrated in the present specimen include diverse spatial arrangement within a character, multifarious stroke qualities, and shapes, and coexistence of the erect and the tilted to conjure up a crazy paving impression.

Collector seals: *Zhupeng jianding*.

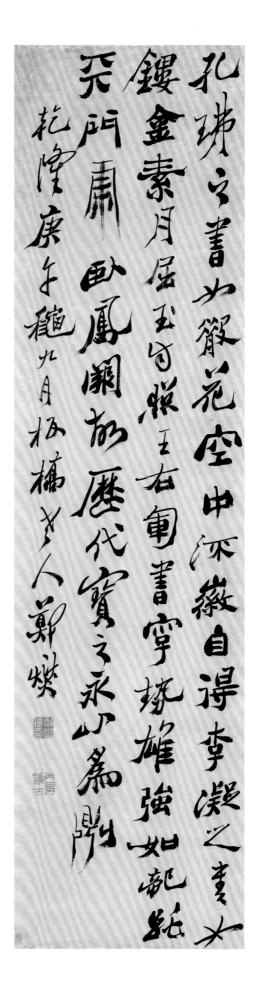

137

Copy of Yan Zhenqing's Letter to Cai Mingyuan

— by —

Liu Yong

— of —

the Qing Dynasty

Hanging Scroll, running script

Ink on paper

Height 76 cm Width 45.4 cm

Liu Yong (1719–1805), a native of Zhucheng, Shandong, was qualified as *jinshi* in the 16th year of the Qianlong reign (1751) and rose through the ranks to hold such offices as Governor-general of Zhili, Minister of Personnel, and Grand Secretary of the Hall of Rites and Benevolence (Tirenge). The calligrapher derived his style from first Zhao Mengfu and then Wei-Jin masters. Ahead of its time, his calligraphy is distinguishable by its fleshy strokes and nimble rendering.

The original calligraphy that is copied in part in the present specimen is a letter that Yan Zhenqing wrote to his student Cai Mingyuan to thank him and others for accompanying him and taking care of him on his long journey to the south. Signed and impressed with two calligrapher seals (*Liu Yong zhi yin* and *Yizi Shanfang*), the copy is dated the *yiwei* year that corresponds to the 40th year of the Qianlong reign (1775). The top right is impressed with another seal (*Xiangyanshi*).

Attesting to the calligrapher's mid-year style, the graceful calligraphy emits an archaistic charm through its juxtaposition of the square and the obtuse as well as the wet and dry.

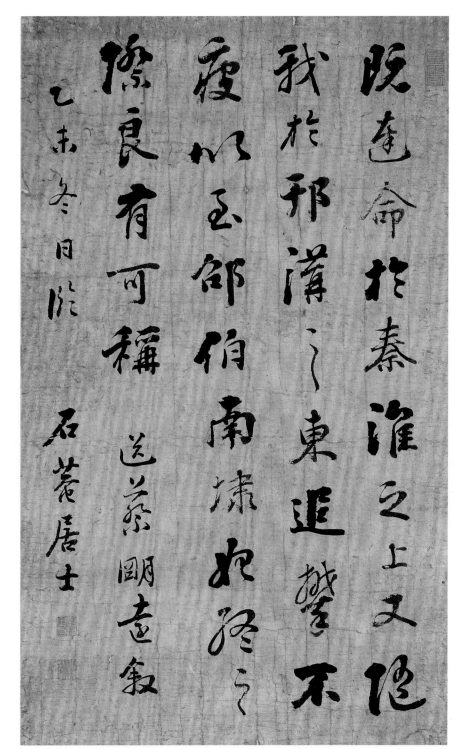

138

Biography of Lady Wang

— by —

Liang Tongshu

— of —

the Qing Dynasty

Album of 2 ½ leaves, regular script

Ink on paper

Each: Height 26 cm Width 11.6 cm

Liang Tongshu (1723–1815), a native of Hangzhou, Zhejiang, was the Grand Academician Liang Shizheng's son. He qualified as *jinshi* in the 17th year of the Qianlong reign (1752) and rose to occupy the office of Hanlin Expositor-in-waiting. Driven by a passion since childhood, he sought emulation of Yan Zhenqing and Liu Gongquan at first and adopted Mi Fu's style in his middle age. His handsome calligraphy remained unspoiled into his 90s. He has been described as a worthy rival of Liang Yan in the antithesis the Liangs of the North and of the South.

The biography is written in respect of Lady Wang, who was the calligrapher's cousin. Although undated, it can be deferred from Xu Zonghao's colophon that it should have been written in the 14th year of the Jiaqing reign (1809), or two years after the lady's passing, thus dating it to the calligrapher's late years.

Discretion dominates the calligraphy in all of its aspects. A cultured grace radiates from the unhurried and unflustered execution.

Collector seals: *Huang Jingmu kanshu duhua ji*, *Suiyuan zhenmi*, *Xu Zonghao yin*, *Shixuezhai miji yin*, *Bao xiaozi cisun*, and *Huaiyin Bao shi shoucang*.

外戚鄰戚稱之絕甘分少教于女慈和有
法度通判君改官直隸始迎安人京寓屢
署劇邑政煩以困寓內事咸安人理之無
內顧憂年方壯積勞內傷得失血證幾殆
者再至嘉慶十三年冬通判君檄往他邑
安人遽以羸疾殞傷哉時十二月十日也

生乾隆三十一年七月二十七日年才四
十有三子一任梁女三長適歸安王丙餘
尚幼安人少旣好學長更篤耆暇輒手一
編嘗輯音韻纂組著干卷搜羅頗富論者
比於錢諷陰時夫書為詩心婉約可誦言
閨閤寸者有取焉安人為不死矣

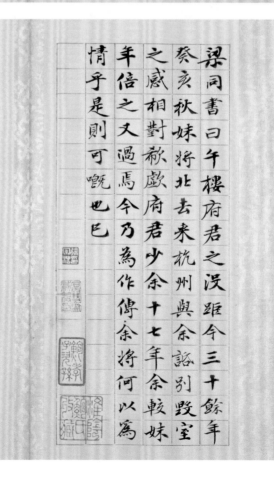

梁同書曰午樓府君之沒距今三十餘年
蔡亥秋妹將北去來杭州與余話別殿室
之感相對歔歟府君少余十七年余較妹
年倍之又過焉今乃為作傳余將何以為
情乎是則可慨也已

勁險駿拔筆：生動　癸酉八月龔承鈞識

山舟學士雍正元年癸卯生嘉慶二十年乙亥卒年

九十三汪安人卒於嘉慶十三年戊辰十二月十日山舟

雖未署年月度當書於次年時先生年八十七矣以生

九之年而一筆不懈為常人所不及余於有清一代書

家喜劉文清小楷沉厚古逸秀韻天成其次則山舟

故多畜之十年前得癸酉所書守梅山館記年九十一

又得丁卯所書萬梅堂墓志銘年八十五皆晚年筆

宜莆孫之丁亥秋七月石雪居士徐宗浩識于葢寒堂

時年六十有八

306

139

Copies of Various Masterpieces

— by —

Wang Wenzhi

— of —

the Qing Dynasty

Album of 11 ½ leaves
regular-running script

Ink on paper
Each leaf: Height 23.2 cm Width 27.8 cm

Wang Wenzhi (1730–1802), a native of Dantu (present-day Zhenjiang, Jiangsu), was qualified as *tanhua*, or the third top *jinshi*, in the 25th year of the Qianlong reign (1760) and was appointed Reader-in-waiting of the Hanlin Academy and later Prefect of Lin'an, Yunnan. The calligrapher was inspired by Mi Fu, Zhao Mengfu, and Dong Qichang and preferred to write in light ink. Together with Liu Yong, who preferred dark ink, he has been known as "Grand Councilor of Dark Ink and *Tanhua* of Light Ink."

Signed and impressed with two calligrapher seals (*Wang Wenzhi yin* and *cengjing canghai*), the album features copies of *Memorial for Further Discussion* (Limingbiao) by Zhong You of Eastern Han, *Zhang Han* (Zhanghan Tie) and *Du Shang* (Dushang Tie) by Ouyang Xun of the Tang, *Certificate of Appointment to Zhu Juchuan* (Zhujuchuangaoshen) by Xu Hao of the Tang, *Letter on the Controversy over Seating Protocol* (Zhengzuowei Tie) by Yan Zhenqing of the Tang, and *The Shu Silk* (Shusu Tie) by Mi Fu of the Song. As revealed in the closing inscription, the album was intended for presentation to a Master Fangzhou. The given date of the *jichou* year corresponds to the 34th year of the Qianlong reign (1769). The beginning of the first copy is impressed with a seal (*Shuchan*) and the end with another (*Menglou*).

The calligrapher's profound understanding and ingenious reenactment of ancient masterpieces are fully manifested in the present specimen from his prime. *Zhang Han* and *The Shu Silk*, in particular, fully capture the originals' form and spirit.

Collector seals: *Longyou jinshi wenzi.*

臣綜言臣力命之用以無所立惟帷幄之謀
而又愚耄聖恩伍佃待以殊禮天下始
定帥土欲戴唯有江東當少當思既與
上同見訪問昨日讌見復蒙逮及雖緣
詔令陳其愚心而臣所懷造膝之事昔
先帝嘗以事及臣遣侍中王粲杜襲就

問臣臣所懷未盡冀益絲髮乞使侍中
與臣議之臣不勝愚款懷之情謹表
以聞

張翰字季鷹吳郡人有
清才善屬文而縱任不拘

時人號之為江東步兵
後謂同郡顧榮曰夫有
四海之名求退良難
吾本山林間人無望於
時子善以明防前以智

雲後榮執其手愴然
因見秋風起乃思吳中菰
菜鱸魚遂命駕而歸
勳左衛兵曹參軍莊

308

若訥等氣質端和藝

理優暢早階秀茂俱

列士林或見義爲勇

或登高能賦擢居品

允玆良選

佳威副才名宜楀乃官

右唐太子少師會稽郡公徐浩字季海

書鍾紹縣令朱巨川告樓宣和書譜載

內府所藏三小字存想法寶林寺詩興

此告也宣政四角印文隱然猶存至元

丙戌購于武林明年重裝又明年囙

秘書郎喬仲山官瀕西攜書譜見

訪遂得詳考書于卷末歸于樞佰

幾父記

且鄉里上齒宗廟上齒朝

廷上位皆有等威以關長幼

故得彝倫叙而天下和平也

且上自宰相御史大夫兩省

玉忽以上俱奉官自有一行十

309

二衛大將軍次之三師三公令
僕師保傅尚書左右丞侍郎
自唐一行九卿三之程古柴
未嘗錯此魚軍容階雜
開府官即監門將軍朝廷

利住自有次敘俚以功績院為
恩澤莫二五入王命稟人不
敢而此不可令居本住須別
亦有尊榮只可軍相師保
庄南橫安一住以溝史臺鼎

尊知難事溝史別置一榻侯
百寮與得瞻仰不忘可乎
里翁云宗四大家皆學顏敢惟爭坐
一種耳此學顏吾知之惟爭坐一
種則不能知里翁精鑒必有確授
兆蜀弘此家省鳴墨帖而不此解
法帖之意目見筆輕文後乃知之楷
未自臨數百過也

世或有謂神仙可以學得
不死可以力致者或云上壽
百二十古今所同過此以往莫

非天妄者此皆兩失其情試
粗論之夫神仙雖不目見記
籍所載前史所傳較而論
之其必有矣似特受異氣
稟之自然非積學所能致

也主於導養得理以盡性
命上獲千餘歲下可數百
年可有之耳而世皆不精
故莫能得之何以言之夫服
藥求汗或有弗獲而愧情

一集渙然流離終朝未湌
則枯然思食而曾子銜哀七
日不飢夜分而坐則低迷思
寢內懷殷憂則達旦不瞑
勁刷理鬢醇醴發顏僅

乃得之壯士之赫然殊觀植
髮衝冠由此言之精神之於
形骸猶國之有君也

右唐弘文館學士藝太子率更令銀青光
祿大夫渤海縣開國男歐陽詢字信長書

度尚帖元豐己未官長沙獲于南昌魏

泰廄亮帖壬戌歲遇山陽獲于今中散

大夫鍾離景伯各著半古印適合縫文曰

清河圖籍之印乃昔一書也究延平之化

豈不有神奈孔璧之遺亂云殺誤元祐

庚午冬至蕭關外舍痕贊曰渤海臭

怅字亦險絶真到內史行自屬佳莊若

對越俊如跳擲後學莫窺遐趣在方

送王渙之彥舟

集英春殿鳴捎歇神武天臨

光下澈鴻爐初唱第一聲白面

王師年十六神武樂育天下造不

使傳敲拜使傳道衣錦東南

第一州辣壁湖山雨清臨襄陽

野老漁華客不愛紛華愛

泉石相逢不約·無逆輿擔

古書同岸憒溫明壓叢初相

慕濯髮酒心求易憲翩遠

鶴雲中侶土茸厓鶵那一顧

途來為業何深至湛其區

無底沁可怜一點終不易枉駕

殷勤尋漫仕漫仕平生四方走
多与英才並肩肘少有俳辭
雄罷毗老學鷗夷漫存口一官
聊具三徑資取捨殊塗冀
迴首

右臨古帖卷自鍾太傅而下凡七家
奉呈
方舟老父臺大人是政時已丑穀雨
後三日
治弟王文治

米南宮襄陽人自言從瀟湘
得畫境已隱京口南徐江上
諸山絕類三湘奇境墨戲長
卷令在余家余洞庭觀秋湖
暮雲良然曰大悟米家山法

140

Heart Sutra

— by —

Weng Fanggang

— of —

the Qing Dynasty

Album of 4 leaves, regular script

Ink on bohdi leaves

Each: Height 16.5 cm Width 9.2 cm

Weng Fanggang (1733–1818), a native of Daxing, Shuntian (in present-day Beijing), was qualified as *jinhsi* in the 17th year of the Qianlong reign (1752) and rose to the position of Academician of the Grand Secretariat. Learned in disciplines such as bronze-and-stones and artistically accomplished in painting, calligraphy, and poetry, he had a enviable collection of books. His calligraphy is indebted to Ouyang Xun of the Tang and is veined by the clerical script of the Han especially *Stele of Shi Chen* and *Stele of Ritual Vessels*, meriting the calligrapher a place among the Four Masters of the Qianlong Reign with Liu Yong, Yongxing, and Tie Bao.

Signed and dated the sixth year of the Jiaqing reign (1801), the calligraphy features an excerpt from the *Heart Sutra*. Impressed with two calligrapher seals (*chen Fanggang* and *jingshu*), the mounting of the last leaf carries an inscription by the calligrapher to read, "It was 35 years ago that I watched monks gathering bohdi leaves for making gauze." It is apparent from the language in the inscription and the self-reference as "*chen*," meaning "subject," in one of the seals that the calligraphy was intended for presentation to the emperor.

Restricted by the quality of the bohdi leaves, the ink is relatively dry. The slender characters, steady rendition and precise delineation evoke the sternness of Ouyang Xun and Yu Shinan. Despite the lack of drama, the calligraphy exemplifies the calligrapher's sophistication nonetheless.

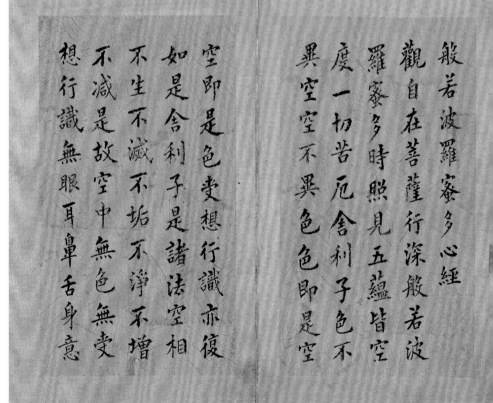

無色聲香味觸法無眼界
乃至無意識界無無明亦
無無明盡乃至無老死亦
無老死盡無苦集滅道無
智亦無得以無所得故菩

提薩埵依般若波羅蜜多
故心無罣礙無罣礙故無
有恐怖遠離顛倒夢想究
竟涅槃三世諸佛依般若
波羅蜜多故得阿耨多羅

三藐三菩提故知般若波
羅蜜多是大神咒是大明
咒是無上咒是無等等咒
能除一切苦真實不虛故
說般若波羅蜜多咒即說

呪曰
揭帝揭帝波羅揭帝
波羅僧揭帝菩提薩婆訶
般若波羅蜜多心經
嘉慶六年八月七日翁方綱敬書

昔於菩提樹下觀寺僧摘葉作鈔今三十有五年矣

315

141

Couplet of 37-character Lines

— by —

Deng Shiru

— of —

the Qing Dynasty

Pair of hanging scrolls, regular script

Ink on paper

Each: Height 137.2 cm Width 28.3 cm

Deng Shiru (1743–1805), a native of Huaining (present-day Anqing, Anhui), went by this courtesy name of his because of naming taboo of Emperor Jiaqing. His real name was Yan, which is the same as that of Emperor Jiaqing. The calligrapher, who was also a seal carver, was most noted for his regular, seal, and clerical scripts. Informed by various ancient masters, his distinctive style had a great bearing on the development of calligraphy in the mid- and late Qing.

Signed and dated the first year of the Jiaqing reign (1796), the exceptionally long couplet is written in a symmetrical format called "dragon gate." Consisting of a string of famous scenic spots, the upper line is antithetical to the lower one, which is in turn a string of masterpieces of art and literature. There is an inscription by Kang Youwei under the signature, reading "The calligraphy is as solid as to have been cast in iron."

The calligraphy is vigorous and unaffected, synthesizing the clerical and regular scripts and betraying the calligrapher's familiarity with northern steles.

142

Literary Works by Past Masters

— by —

Yongxing

— of —

the Qing Dynasty

Set of four hanging scrolls,
Regular-running script

Ink on paper

Each: Height 74.6 cm Width 25.5 cm

Yongxing (1752–1823), surnamed Aisin-Gioro, was Emperor Qianlong's 11th son and was ennobled as Prince Cheng. During the reign of Jiaqing (1796–1820), he was given an office in the Junjichu. A possession that the calligrapher was proud of was Lu Ji's *Letter on Recovery*, which led to the depository being named "Yijinzhai," meaning a studio for passing down the Jin heritage. Making extensive reference to past masters, he attained accomplishment in the regular and running scripts.

Impressed with a number of seals, the four hanging scrolls owe their texts, not without discrepancies, to literary works from the past, with that written by the Southern Dynasties poet Jiang Yan in regular script, and those by the Southern Qi poet Xie Tiao, the Northern Song poet Wang Anshi, and the Tang Grand Counselor Li Deyu in running script.

In the calligraphy, the regular script is prim and refined, testifying to the calligrapher's devotion to Ouyang Xun and Zhao Mengfu, whereas the running script is handsome and sparsely structured to project refinement.

披庭聘絕國長門失歡讒相逢萋萋

蕪聲罷熊團扇花蘇亂散鏢風簧

入雙蓋徒使妾悲睞坐惜紅頼复平

生一顧重風昔手金賤坟人心尚爾故心

人外見

謝元暉

廣成愛神鼎淮南好丹經此山真鸞鶴往来盡

仙靈瑤草正翁毷玉樹信慈青絳氣下縈薄白

雲上杏寞中坐瞰蜿虹偓伏視流星不尋遷悝

極則知耳目驚日落長沙渚曾陰萬里生籍蘭

多素意臨風默含情方學松柏隱羞遂市井名

幸承光誦末伏思託後榷

江淹

右側（詩）

黯然三月閉叢葭綠蔡陰勿匆滿
城自是念爭遠與少妻鳳
雲不堪行奴功無路去無田桃飲
荒城度歲年強學歩閒兒如然
亂我花竹養風煙　臨川絕句

左側（文）

右按史記仲尼在位獄訟之詞有可與人共者也伏以漢魏
以來朝廷大政為令以須奏議講求理道博盡羣情而以政必有經
人皆筋學著在史策粲然可觀臣等如有事關禮法羣情繫滯者
各望令本司申尚書都省下禮官樂官詳議意見於自者任為別此如是
而獄六令法古同議於後孤郎以下詳具可咨聞奏如有郎吏能駁雜者
皆許上聞益須先授經義其次取正史策故事不浮自為煮見言涉
浮華如禮官樂官士識出人議論精當者向後擢授臺省官郎吏別與
遷擢所異漢魏之風復行今日　李衛公議禮法等大事

143

Notes from the Zen Painting Studio

by

Tie Bao

of

the Qing Dynasty

Hanging Scroll, running script

Ink on paper

Height 113.7 cm Width 39.8 cm

Tie Bao (1752–1824), a Manchu of the Plain Yellow Banner, was qualified as *jinshi* in the 37th year of the Qianlong reign (1772) and rose through the ranks to become Governor-general of Liangjiang (Jiangsu, Anhui, and Jiangxi) and Minister of Personnel. Also excelling in literature, the calligrapher derived his regular script from Yan Zhenqing and his running-cursive from Wang Xizhi although without neglecting Monk Huaisu and Sun Guoting.

Signed and impressed with two calligrapher seals (*Tie Bao siyin* and *Mei'an*), the calligraphy owes its text to an excerpt from Dong Qichang's *Notes from the Zen Painting Studio* that discusses how immersion in painting blessed the Yuan painter Huang Gongwang and the Song painter Mi Youren with long lives.

By and large, the calligraphy resembles Su Shi's. Influences by Liu Yong are detectable from the substantial strokes, compact structuring, and inner strength. Unfortunately, the widely separated rather than connected characters have a negative impact on the consistency of the flow.

144

Pentasyllabic Couplet
— by —
Yi Bingshou
— of —
the Qing Dynasty
Pair of hanging scrolls, clerical script

Ink on paper

Each: Height 109.3 cm Width 25.3 cm

Yi Bingshou (1753–1815), a native of Ninghua, Fujian, was qualified as *jinshi* in the 54th year of the Qianlong reign (1789) and served as Prefect of Huizhou and Yangzhou at various times. Also excelling in poetry, the calligrapher was widely acclaimed in his lifetime for his running, regular, seal, and especially clerical scripts. Learning calligraphy from Liu Yong, he forged an identity of his own with vestiges of Yan Zhenqing in ethos and of Li Dongyang in character structuring. Together with Deng Shiru, he has been regarded as the patriarchs of the Stele School of the Qing Dynasty.

Signed and impressed with two calligrapher seals (*Moqing* and *Dongge Meihua*), and the frontispiece seal (*Yanzuo*), the couplet was intended for presentation to a Master Fangxi. The date given corresponds to the 12th day of the second month in the 12th year of the Jiaqing reign (1807).

Dating from the calligrapher's late years, the calligraphy is bold and majestic. In a departure from the conventional structure and brush methods of the clerical script, the squat characters have rounded rather than flaring ends and stout verticals that contrast with the slim horizontals. Artistry is carefully masked by simplicity.

145

Scripture of the Inner Effulgences of the Yellow Court

by

Guo Shangxian

of

the Qing Dynasty

Hand Scroll, regular script

Ink on paper

Height 36 cm Width 268.5 cm

Guo Shangxian (1785–1833), a native of Putian, Fujian, was qualified as *jinshi* in the 14th year of the Jiaqing reign (1809) and served the court as Chief Minister of the Court of Judicial Review and Right Vice Minisiter of Rites at various times. The scholar and prolific writer was well versed in Yan Zhenqing and availed himself of the merits of Ouyang Xun and Chu Suiliang for grace and refinement.

Dating from the Wei-Jin period, *the Yellow Court Classic* (*Huangting Jing*) offers Daoists life-nourishing tips for eventual attainment of immortality. It comes in two parts, namely the *Inner Effulgences* (*Neijing Jing*) and the *Outer Effulgences* (*Waijing Jing*). The calligraphy owes its text to *Neijing Jing*. Signed and impressed with a signature seal (*Lanshi*), the present specimen is an excerpt from the former and was intended for presentation to a Master Disheng as revealed in the closing inscription. The date given is "the fourth year of the Daoguang reign (1824)."

肺神皓華字虛成，肝神龍煙字含明，翳鬱導煙主濁清，腎神玄冥字育嬰，脾神常在字魂停，膽神龍曜字威明，六府五藏神體精，皆在心內運天經，晝夜存之自長生。

肺部之宮似華蓋，下有童子坐玉闕，七元之子主調氣，外應中嶽鼻齊位，素錦衣裳黃雲帶，喜視無災害之，呼吸廬間入丹田。

心部之宮蓮含華，下有童子丹元家，主適寒熱榮衛和，丹錦緋裳披玉羅，金鈴朱帶坐婆娑，調血理命身不枯，外應口舌吐五華，臨絕呼之亦登蘇，久久行之飛太霞。

肝部之宮翠重裏，下有青童神公子，主諸關鏡聰明始，青錦披裳佩玉鈴，和制魂魄津液平，外應眼目日月精，百疴所鍾存無英，同用七日自充盈，垂絕念神死復生，攝魂還魄永無傾。

腎部之宮玄闕圓，中有童子冥上玄，主諸六府九液源，外應兩耳百液津，蒼錦雲衣舞龍幡，上致明霞日月煙，百病千災當急存，兩部水王對生門，使人長生昇九天。

脾部之宮屬戊己，中有明童黃裳裏，消穀散氣攝牙齒，是為太倉兩明童，坐在金臺城九重，方圓一寸命門中，主調百穀五味香，闢卻虛羸無病傷，外應尺宅氣色芳，光華充。

膽部之宮六府精，中有童子曜威明，雷電八振揚玉旌，龍旗橫天擲火鈴，主諸氣力攝虎兵，外應眼童鼻柱間，腦髮相扶亦俱鮮，九色錦衣綠華裙，佩金帶玉龍虎文，能存威明乘慶雲，役使萬神朝三元。

脾長一尺掩太倉，中部老君治明堂，厥字靈元名混康，治人百病消穀糧，黃衣紫帶。

322

The calligraphy borrows its broad and squarish form from Yan Zhenqing and its meticulous strokes from Zhao Mengfu to arrive at sublimity.

Collector seals: *Song Li xinshang*, *Guhuanshi cang*, *Tiegao zhenshang*, and *Jilin Song Lizi Guhuanshi shoucang jinshi tushu zhi yin*.

黃庭內景經

上清紫霞虛皇尊太上大道玉晨君閑居蘂珠作七

言散化五形變萬神是為黃庭曰內篇琴心三疊舞

胎仙九氣暎明出霄閒神蓋童子生紫煙是曰玉書

可精研詠之萬過昇三天千災已消百病痊不但虒

狼之凶殘六以却老年永延上關元左為元

少陽右太陰後有客前生門出日入月呼吸存

氣所合列宿分紫煙上下三素雲灌溉五華植靈根

七液洞流衝盧閒回紫抱黃入丹田幽室內明照陽

門口為玉池太和官漱咽靈液災不干體生光五內

香蘭却滅百邪玉錬顏審能修之登廣寒晝夜不寐

乃成真雷鳴電激神泯泯黃庭內人服錦衣紫華飛

幕雲氣羅丹青綠條翠靈柯七蕤玉籥閉兩扉重掩

金關密樞機元泉幽關高崔巍三田之中精氣微嬌

女窈窕翳霄暉重堂煥煥揚八威天庭地關列斧斸

靈臺磐固永不襄中池內神服赤朱丹錦雲袍帶虎

符橫津三寸靈所居隱芝翳鬱自相扶眉號華蓋

謹修靈宅既清玉帝遊通利道路無終休眉丹田審能

蓋覆明珠九幽日月洞空無宅中有神常衣絳生死岸出

見之無疾患若遇之昇天漢至道不頃訣存真

青入元二氣煥子若遇之昇天漢太元腦神精根字泥

泥丸百節皆有神髮神蒼字玄元鼻神玉龍字靈堅耳神空閑字泥

九眼神明上字英元鼻神玉龍字靈堅耳神空閑字

幽田舌神通命字正倫齒神崿峯字羅千一面之神

323

右孫堅基理室之中八壽隻汲於夫人當中立長名元

鄉統郊邑六龍散飛難分別長生至慎房中急何為

死作令神泣忽之禍鄉三靈浽但當吸氣錄子精寸

田尺宅可治生若當決海百瀆傾葉去樹枯失青、

氣亡液漏非已形專閉御景乃長保我泥丸三奇

靈恬淡閑視內自明物、不干泰而平懇矣匪事泰

老復丁思詠玉書入上清常念三房相通達洞得視

見無內外存漱五牙不飢渴神華執巾六丁謁急守

精室勿令泄閉而存思百念視節度六府修治勿令

宮近在易隱括虛無寂可長活起自形中初不潤三

九室正虛神明舍念存視節度六府修治勿令

故行自翺翔入雲路之道了不煩但修洞元興

玉篇無行形中八景神二十四真出自然高拱無為

竟眇安清淨神見與我言安在紫房幃幕閑立坐室

外三五元燒香接手玉華前共入太室璇璣門高研

恬淡道之園內眹盡觀真、人在已莫問鄰何

遐遠索求因緣隱景藏形與世殊含氣養精口如朱

帶執性命守虛無名入上清死錄除三神之樂由隱

居倐嶽遨遊無遺憂羽服一整八風驅控駕三素秉

晨霞金輦正立從玉興奚不登山誦我書嶽:窈:

真人壜入山何難故躊躇人間紛:臭如邗五行相

推及歸一三五合氣九:節可用隱地迴八術伏牛

幽闕羅品列三明出華生死際洞房靈象斗日月父

曰泥丸母雌一三光煥照入子室能存元真萬事畢

一身精神不可失高奔日月吾上道齋儀結璘善相

保乃見玉清虛無老可以回顏填血腦口銜靈芒攜

玉皇要呎帶篆風金當屬笑妾主宴東蒙元元上一

324

明堂廕字靈元名混康治人百病消穀粮黃衣紫帶

龍虎章長精益命賴君王三呼我名神自通三老同

坐各有朋或精或胎別執相望延生華芒男子可

回九有桃康道父道母對相望師父師母丹元鄉可

用存思登虛空殊途一會歸要終閉塞三關握固傳

含漱金醴吞玉英遂至不死三蟲亡心意常和致忻

昌五嶽之雲氣彭亨保灌玉廬以自償五形完堅無

炎殃上觀三元如連珠落：明景照九隅五靈夜燭

煥八區子存內皇與我遊身披衣衛虎符一至不

久昇虛無方寸之中念深藏不方不圓閉牖窻三神

還精老方壯羿眼內守不爭競神生腹中衡玉瑯三靈

注幽關那淂惢琳絛萬尋可仗蔭三竟自清帝書命

靈臺鬱藹望黃野三寸異室有上下間關榮衛高元

受洞房紫極靈門戶是昔太上告我者左神公子發

神語右有白元併立處明堂金匱玉房門上清真人

當吾前黃裳子丹氣頻煩借問何在兩眉端內俠日

月列宿陳七曜九元冠生門三關之中精氣深九微

之內幽且陰口為天關精神機之為地關生命扉手

為人關把盛襄若淂三宮存元丹太一流珠安昆侖

重：樓閣十二環自高自下皆真人玉堂絳宇盡元

宮琁機玉衡色瑯玕瞻望童子坐盤桓問誰家子在

似重山雲儀玉華俠耳門赤帝黃老與我䰯三真扶

我身此人何去入泥丸千二百：自相連一：十二

胥共房精津五斗煥明是七元日月飛行六合間帝

鄉天中地戶端面部竟神自相存呼吸元氣以求仙

仙公：子巳可前朱鳥吐縮白石源結精育肥化生

開通百脉血液始顏色生光金玉澤齒堅髮黑不知

白存此真神勿落之常憶此宮有坐席眾真合會轉

相索隱藏羽蓋看天舍朝拜太陽樂相呼明神八威

正辟邪脾神還歸是胃家溉養靈根不渡枯閉塞命

門保玉都萬神方酢壽有餘是為脾建在中宮五藏

六府神明王上合天門入明堂守雌存雄頂三光外

方內圜神在中通利血脈五藏豐骨青筋赤髓如霜

玉霜太上隱環八素瓊溉益八液腎受精伏於太陰

漿澹然無味天人粮子丹進饌肴正黃乃曰琅膏及

脾挾七竅去不祥日月列布設陰陽兩神相會化玉

見我形揚風三元出始青悅忽之間至青靈戲於廳

臺見赤生逸城熙真養華榮內眄沉黙鍊五形三烝

徘徊得神明隱龍遁芝雲琅英可以充飢使萬靈上

蓋元之下席章沐浴盛潔棄肥薰入室東向誦玉篇

約得萬遍義自解散髮無欲以長存五味皆至正氣

還夷心窘悶無煩寃過戲已畢體神精黃華玉女告

子情真人既至使六丁即受隱芝太洞經十讀四拜

朝太上先謁太帝後北向黃庭內經玉書暢授者曰

師受者盟雲錦鳳羅金鈕纏以代割髮肌膚全攜手

登山噯液丹金書玉景乃可宣傳得可授告三官勿

令七世受冥患太上微言致神仙不死之道此其文

道光四年六月十四日錄奉

莆田郭尚先

笛生四兄同年省覽

保乃見玉清虛無老可以回顏填血腦口銜靈芝攜

五皇腰虎帶籙佩金璫駕姦接生宴東蒙元上一

竟眇練一之為物巨卒見須得至真始顧眄至忌死

氣諸穢賊常完堅閉口屈舌食胎津使我遂鍊獲飛仙：

金齋常完堅閉口屈舌食胎津使我遂鍊神根玉莖

道士非有神積精繁氣以成真黃童妙音難可聞玉

書絳蘭赤丹文字曰真人巾負甲持符開七門

火兵符圖備靈關前昂後甲高下陳勑劍百丈舞錦

幡十絕盤空扇紛紜火鈴冠霄隆落煙安在黃闕兩

眉間比非枝葉實是根紫清上皇太元君太元和

俠侍端化生萬物使我仙飛昇十天駕玉輪晝夜七

日思勿眠子能得之可長存積功成鍊非自然是由

精誠亦由專內守堅固真之真虛中恬淡自致神百

穀之寶土地精五味外美邪魔腥臭亂神明胎氣零

那從及老得還嬰三竟忽：眇廉傾何不食氣太和

精故能不死入黃寧心典一體五藏王動靜念之道

德行清潔善氣自明光坐起吾俱共棟梁晝日耀景

莫閒藏通利華精調陰陽經應六合隱卯酉兩腎之

神主延壽降適斗藏初九知雄守雌可無老知白

見黑急坐守肝氣鬱勃清且長羅列六府生三光心

精意專內不傾上合三焦下玉漿元液雲行去臭香

治蕩髮齒練五方取津入明堂下溉嚨神明

通坐侍華蓋游貴京飄：三帝席清涼五色雲氣分

青蔥閒目內眄自相望使心諸神還相崇七元英華

開命門通利天道存元根百二十年猶可還過此守

道誠甚難惟待九轉八瓊丹要漠精思存七元日月

146

Manuscript

— by —

Lin Zexu

— of —

the Qing Dynasty

Hanging Scroll, running script

Ink on paper

Height 125.8 cm Width 27.4 cm

Lin Zexu (1785–1850), a native of Houguan (present-day Fuzhou, Fujian), was qualified as *jinshi* in the 16th year of the Jiaqing reign (1811) and was the holder of such positions as Governor-general of Liangguang (Guangdong and Guangxi), Huguang (Hunan and Hubei), Shaangan (Shaanxi and Gansu), and Yungui (Yunnan and Guizhou). He has been best remembered for his adamant opposition against opium trade and his massive destruction of the drug in Humen. The thinker has also been acclaimed for his poetry and calligraphy.

Signed and impressed with two signature seals (*Lin Zexu yin* and *Shaomu*), the calligraphy owes its text, with certain alterations, to an excerpt from the Ming calligrapher Dong Qichang's *Notes from the Zen Painting Studio* that discusses the niceties of brush methods in painting and calligraphy. As stated in the closing inscription, it was intended for presentation to a Master Jicheng, and the given date of the *wuyin* year corresponds to the 23rd year of the Jiaqing reign (1818).

Rooted in Ouyang Xun's style, the calligraphy is characterized by its soberness, placidity, and logical proportion, with hints of strength in the fluid and uncontrived rendition.

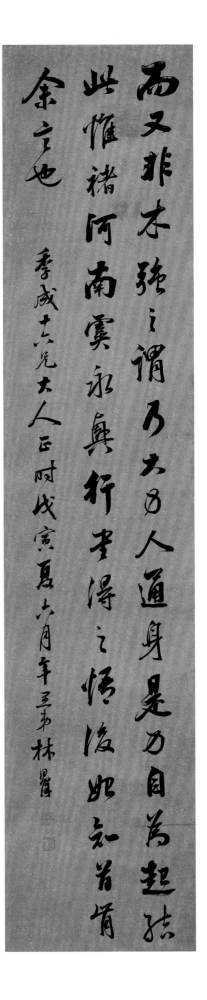

147

A Miscellany
— by —
He Shaoji
— of —
the Qing Dynasty

Album of 12 leaves,
regular and clerical scripts

Ink on paper
Each leaf: Height 22.8 cm Width 13.3 cm

He Shaoji (1799–1873), a native of Daozhou (present-day Daoxian, Hunan), was qualified as *jinshi* in the 16th year of the Daoguang reign (1836), appointed as Junior Compiler, and served as Coordinating Editor and Compiler-in-chief of the Hall of Military Glory and the Historiography Institute. He was Examining Official of Provincial Civil Examinations in Fujian, Guizhou, and Guangdong and Education Commissioner of Sichuan at various times before teaching at academies in Luoyuan, Shandong, and Changsha, Hunan. For his calligraphy, the preeminent scholar modelled on Yan Zhenqing and familarized himself with the ancient seal script of the Zhou, Qin, and Han periods as well as the steles of the Northern and Southern Dynasties. As a result, his regular and running scripts emit an archaistic charm while his seal and clerical scripts an archaistic simplicity.

The album comprises works written in either the regular or the clerical script, namely a heptasyllabic poetic inscription to Yan Liben's masterpiece *Tribute Bearers* by Su Shi of the Northern Song copied in regular script, another poem by Su in regular-running script, a saying in clerical script, an excerpt from *Scripture of the Outer Effulgences of the Yellow Court* (*Huangting Waijing Jing*) in small regular script, and a heptasyllabic verse in small regular script. Discrepancies from the original versions of these texts can be spotted here and there. The album is signed and impressed with various calligrapher seals (*He Shaoji yin*, *Zizhen*, and *Jiuzi Shanren*) and was intended for presentation as told in the closing inscription.

As seen in the album, He's dignified and unadorned clerical script is inspired by the hefty *Stele for Zhang Qian* of the Eastern Han. His small regular script is robust and sophisticated, while his regular-running emphasizes appropriate pauses and simplicity on the basis of Yan Zhenqing's style, with the primarily obtuse interpretation punctuated by angularity for the sake of variation.

Collector seals: *Sizhen* and *bei yang niao zhua shi*.

閻立本職貢
圖
正觀之德表

萬邦浩如滄
海吞河江音
容儈獷服奇

龙橫絕巘海
喻濤瀧琤禽
瓌產爭韋扛

名王解辮御
蓋幢粉本遺
墨開明窗我

喟而作心未
降魏徵封倫
恨不雙

今年洞庭春
玉色絕非酒
賢王文字飲

洞庭春色
二年洞庭秋
香霧長噀手

醉筆龍蛇走
既醉念君醒
遠餉為我壽

鉼開香浮座

巉凸光照牖

方傾安仁韲

應呼釣詩鉤

亦號掃愁帚

君知蒲桃惡

莫遣遠公覷

要當立名字

未用問升斗

正是媒母黥

湏君灩海杯

澆我談天口

唐君元巖
西入太守
先嚮記陳
畱謝渡奮

樂孫有所
仰廬何過
閒華興邑
天趙宋岷

東畢方承
高范會時
夾董晉唐
景寬安定

反陶易剔
前僧仲喜
堂厨眾將
寫氣

中池有士服赤朱橫下三寸神所
居中外相距重閉之神廬之中
務脩治元靁氣管受精符急
固子精以自持宅中有士常衣
絳子能見之可不病橫理長

尺約其上子能守之可無恙呼
噏廬間以自償保守完堅身
受慶方寸之中謹蓋藏精神
還歸老復壯俠以幽闕流下
竟養子玉樹令可壯

蘢蔥佳氣儼山川南渡開基大寶
傳為有文章京樣好中興留得幾
遺編太清樓本無完字遺紙無來
已再傳不愛女官元祐腳墨皇新
攝紹興年集賢臺閣接飛檐九
杇還摹土筆尖天慶喜存原粉

本金章曾是弟兄集
仲雲姻世講屬
子貞何紹基

148

Perfection of the Mind

by

Zhao Zhiqian

of

the Qing Dynasty

Hanging Scroll, regular script

Ink on paper

Height 128.5 cm Width 36 cm

Zhao Zhiqian (1829–1884), a native of Shaoxing, Zhejiang, was qualified as *juren* during the Xianfeng reign (1851–1861) and served as District Magistrate of Poyang and Fengxin in Jiangxi at various times. The expert on bronze-and-stones was an adept painter and seal carver. Modelling on Yan Zhenqing at first, he switched to Northern steles for calligraphic inspiration and has been most highly regarded for his regular script. As a forerunner of the Shanghai School, he made tremendous contributions to the development of painting and calligraphy in the modern era.

Signed and impressed with two calligrapher seals (*Zhao Zhiqian yin* and *Han hou Sui qian you ci ren*), this calligraphy of an excerpt from the Sui monk Zhiguo's *Perfection of the Mind* (*Xin Cheng Song*) was produced at the behest of Hu Shu, a bosom friend who excelled in seal carving and the seal script. Monk Zhiguo, a skilled calligrapher well versed in Wang Xizhi's brush methods, published his insights on calligraphy and manipulation of the brush in *Perfection of the Mind*, which entered wide circulation in the Qing Dynasty following annotation by Yao Peizhong. The given date of the *yichou* year in the closing inscription corresponds to the fourth year of the Tongzhi reign (1865).

Quintessential of the calligrapher's early style and his influence by Wei steles, the calligraphy impresses with its straight strokes, chunky forms, undiluted ink, and tidy execution.

Collector seals: *Shi shi zhencang* and *Shi Shouyu yin*.

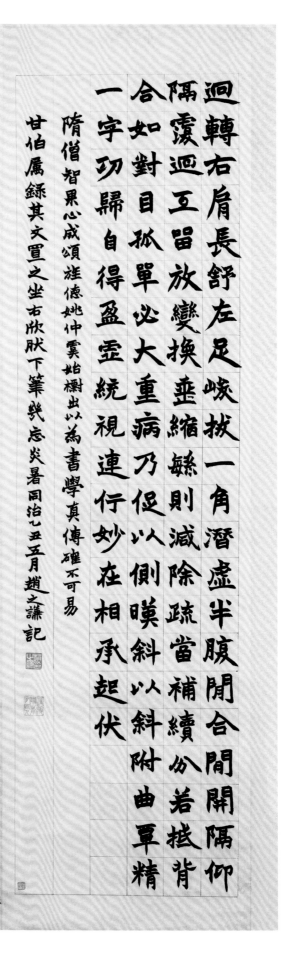

149

Copy of a Stone-drum Inscription

— by —

Wu Changshuo

— of —

the Qing Dynasty

Hanging Scroll, seal script

Ink on paper

Height 149.5 cm Width 82.3 cm

Wu Changshuo (1844–1927), a native of Anji, Zhejiang, went by this courtesy name of his instead of his original names of Jun and Junqing. He started practicing calligraphy when young and took up painting in his middle age. These two forms of art became his means of living after his resignation as a petty official. In addition, he was also a skilled seal carver who was known for his poetry. The patriarch of the Shanghai School was a groundbreaker as far as his calligraphy especially the running script is concerned. His excellence in copying stone-drum inscriptions has been widely known in particular.

Named after the shape of the boulders on which they are found, stone-drum inscriptions date from the Qin Dynasty and were discovered in the early Tang. A total of ten tetrasyllabic poems are inscribed in large seal script on the ten boulders, but the texts are often fragmentary and hence incomprehensible. Signed and impressed with two signature seals (*Junqing zhi yin* and *Changshi*), the calligraphy is a copy of the inscription on the third stone drum. The given date of the *yimao* year corresponds to the year 1915.

The vigorous calligraphy is faithful to the original but not without personal creativity as evidenced in the variation of the stroke thickness to avoid monotony. Character structuring is likewise varied and imbued with majesty.

150

Self-composed Heptasyllabic Quatrain

by

Kang Youwei

of

the Qing Dynasty

Hanging Scroll, running script

Ink on paper

Height 179.8 cm Width 47.7 cm

Kang Youwei (1858–1927), a native of Nanhai (present-day Nanhai, Guangdong), was originally named Zuyi. Qualifying as *jinshi* during the Guangxu reign (1875–1908), he was Secretary in the Ministry of Works and was a principal advocate of the Hundred Days' Reform in 1898. Esteemed for his calligraphic theories and calligraphy, he championed modelling on the Northern steles and the calligraphers Bao Shichen and Zhang Yuzhao. Greatly inspired by the *Inscription on the Cliffside of Rock Gate*, he disdained abidance by the conventional rules of neatness in strokes and character structuring.

Signed and impressed with two calligrapher seals (*Kang Youwei yin* and *weixin bairi chuwang shiliunian sanzhou dadi youbian sizhou jing sanshiyi guo xing liushiwan li*), the self-composed poem was calligraphed by the then elderly calligrapher as a gift to Di Yongtang.

The vigour of the calligraphy is enhanced by the use of a dry brush to produce uncoiling and tremulous strokes with flying-whites. Untethered by established rules, it is a personalized embodiment of the grandeur of Han and Wei calligraphy.

Four inscriptions by Chen Jing and others of the Republican period are found on the mounting on either side.

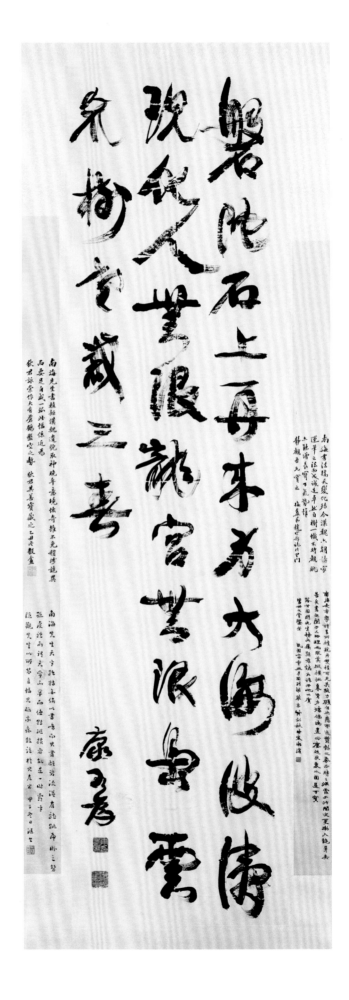